COLLECTING SOULS, GATHERING DUST

GERALD

L. BELCHER

AND

MARGARET

L. BELCHER

PARAGON

HOUSE

NEW YORK

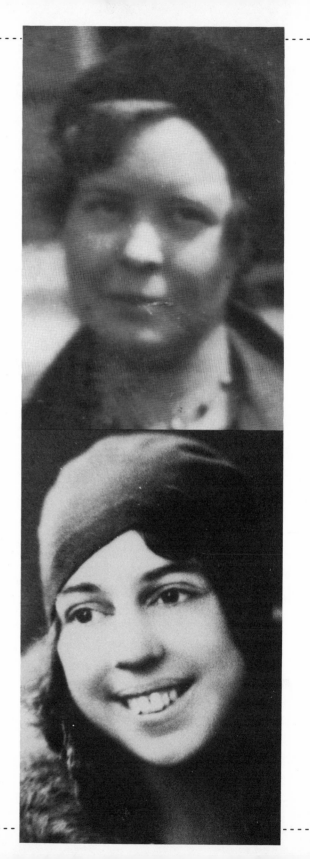

Collecting Souls, Gathering Dust

The Struggles of Two American Artists

Alice Neel and Rhoda Medary

FIRST EDITION, 1991

Published in the United States by

Paragon House
90 Fifth Avenue
New York, N.Y. 10011

10 9 8 7 6 5 4 3 2 1

Library of Congress Cataloging-in-Publication Data

Belcher, Gerald L., 1941–
 Collecting souls, gathering dust : the struggles of two American artists, Alice Neel and
 Rhoda Medary / Gerald L. Belcher and Margaret L. Belcher. — 1st ed.
 p. cm.
 Includes bibliographical references and index.
 ISBN 1-55778-336-5
 1. Neel, Alice, 1900—Criticism and interpretation. 2. Medary, Rhoda, d. 1981—
 Criticism and interpretation. 3. Women painters—United States—Biography—
 History and criticism. 4. Feminism and art—United States. I. Belcher, Margaret L.,
 1943– . II. Title.
 ND237.N43B45 1991
 759.13—dc20
 [B] 90-38684
 CIP

BOOK DESIGN BY BARBARA M. BACHMAN

Manufactured in the United States of America

 The paper used in this publication meets the minimum requirements of American National
Standard for Information Sciences—Permanence of Paper for Printed Library Materials, ANSI
Z39.48-1984.

CONTENTS

IV TRIUMPHS

ACKNOWLEDGMENTS

A number of people contributed to this book who were not formally acknowledged within the text or the notes. Most important to acknowledge are P J Dempsey, our editor at Paragon House, who skillfully guided the manuscript through several drafts while keeping her good humor, and Holly Medary, Rhoda's granddaughter, who when she was sixteen years old inherited responsibility for Rhoda's paintings and memoirs. As Holly dispersed her grandmother's estate, she knew intuitively that she had to keep the collection of fifty paintings and the single typed copy of the memoirs together. When we finally found Holly, several years after Rhoda's death in 1981, she said simply, "I have some papers for you that Granny wanted you to have." These papers were Rhoda's memoirs.

Pam Bernstein of the William Morris Agency showed a great interest in an earlier version of the manuscript, and showed it to, among others, Nan Talese, who gave us good advice when we needed it most. Among the other people who helped us at important points were Leigh Bauer, attorney; Diana Bulman of the Robert Miller Gallery, New York City; Marrietta Bushnell, librarian of the Pennsylvania Academy of Fine Arts School; Lawrence Campbell of the Art Students' League, New York; Jack Davis and Zina Goldsmith, formerly of the Beaver College Fine Arts Department; Carolyn Dearnaley and Suzanne Kinnard of the Beaver College Library; June Donovan, Rhoda's niece; Jean Dowdall, dean at Beaver College; Frank Goodyear, former director of the Pennsylvania Academy of Fine Arts; Lynn Miller of Douglass College, Rutgers University; and Barbara Strausberg at the Alumnae Office of Moore College of Art.

We extend a special thanks to Rob Auspitz, Fine Art Photography, Bensalem, Pennsylvania, and Charles Ashton for their expert photographic work and their generous doses of enthusiasm. We also received assistance from Peg Bachman, Craig Belcher, Eric Belcher, Frank Besau, Annet Bonfanti, Julie Brodie, Dr. Bernard Mausner, Sue Ryan, Anne Shahan, Betsy Steinmetz, Grace Swaim, Peter and Susan Van Voorhees, and Susan Pachuta.

We would also like to acknowledge the help of the staffs of Paragon

House, the Whitney Museum of American Art; the Archives of American Art in both Washington D.C. and New York City; the Pennsylvania Academy of Fine Arts; Moore College of Art Library and Alumnae Office; the College Art Association; the University of Pennsylvania Library; and Beaver College.

PREFACE

--

"I wanted," said Alice Neel, "to see all things and their opposites." This book grew from our similar belief that the richness and the power of life are best seen through its contrasts. Seen in contrast to each other, the lives of the two women who are the focus of this book illuminate much about life and art, and about the struggles encountered by women who try to break out of the roles society expects them to fill.

One of the women, Alice Neel, eventually broke out and chose a life in which she subordinated everything to art and emerged, though only after decades of struggle, as one of the century's most celebrated painters. The other, Rhoda Myers Medary, eventually gave up a promising life of painting by choosing the conventional roles of wife and mother and emerged, after struggling through those same decades, as a devastated woman whose life seemed over until it was rescued by art.

The book began from our curiosity about why these two serious and talented friends in art school in the 1920s made different life choices, and what their choices tell us about the problems faced by women in this century who wanted to be serious artists. What emerged from our research is a story of the relationships of two very talented painters to art from 1921, when they met, to 1975, when they finally received validation as artists. The book follows their separate journeys over forty years until they are reunited when one was famous while the other had given up her quest.

Because their experiences were so different, but their attachment to art so profound, we became interested in the influences—their childhoods, mothers, and relationships with men—that might account for these two women who possessed what appeared to be such similar values while living such dissimilar lives.

Although this book focuses entirely on the lives of two women, it is not a biography in the traditional sense, that is, the definitive life story of Alice, the only one of the two who would ordinarily merit a biographer's attention. Because we were searching for understanding, we ignored and

omitted information, however interesting, that did not contribute to our purpose, that is, to the development of the story. Our stance has been similar to Phyllis Rose's work on Josephine Baker (*Jazz Cleopatra*, Doubleday, 1989); we have been more interested in fitting facts together to find meaning than in turning up every fact that exists on Alice Neel.

Nevertheless, for those who are interested primarily in Alice, this approach offers a wealth of new information about her life and new perspectives from which to view it. Her incredible life is known primarily through her own words in interviews and talks given during the last twenty years of her life. While we rely heavily on Alice's interpretation of her struggles, we are also able to step outside of her viewpoint and look at her life from some completely different perspectives, such as Rhoda's and those of important people during the decades when Alice was almost completely outside the public eye. Their explanations fill in critical gaps in her remembrances.

Rhoda's life, in contrast to Alice's, is easily recognizable by its contours, and normally would be of little interest to people who had not actually populated it. But because she had been, as a young unmarried woman named Myers, a successful painter, friend, and mentor of Alice, her life assumes an interest, perhaps an importance, that it would otherwise lack. Rhoda recognized the possible value of her story to others when, as a seventy-four-year-old woman, she began to write her memoirs. The story of her life not only gives insight into the place of selfish activities in the lives of wives and mothers in American values, but, by its vivid contrasts, illuminates even more dramatically Alice's achievement.

If this book is not biography, neither is it art history. We have included photographs of paintings by both women, but generally they are intended to be illustrative of their work, often referred to in the text, and of their lives, as visual social history.

The sources for this book are somewhat unusual because, for most of their lives, neither woman had need or occasion to keep the records from which history is pieced together. Neither had reason to maintain correspondences, and both were too busy for decades simply trying to survive. Fortunately, near the ends of their lives Alice and Rhoda had opportunity and reason to "remember" publicly. We rely heavily on such remembrances. Memoirs and interviews were the core of our reconstruction of their pasts because we were very interested in how each of them viewed,

from the vantage point of advancing age, their odysseys across the twentieth century. What did they see as the influences behind and the reasons for the choices that gave shape and direction to those journeys? We wanted to know what role art had played in determining who they finally came to be.

G.L.B. M.L.B.

PROLOGUE:

PICTURES AT AN

EXHIBITION

- -

T h e triumph was sweet. It swirled around inside her like the white wine in the glass she held. Alice sat as a queen in the spacious second-floor gallery of the Whitney Museum of American Art, surrounded by dozens of her paintings and hundreds of her admirers. Artists, celebrities, family, old friends, bohemians, establishment dignitaries, and left-wing intellectuals clustered around to pay her tribute.

Energy saturated any room that Alice Neel inhabited, but the opening of her long overdue retrospective was especially festive with a mix of excitement and anticipation. The crowd, which spilled out the doors, tightened itself into a marginal imitation of a line of admirers who approached her chair to offer congratulations, roses, and gifts that piled up on a chair next to her own. If she had felt better she most likely would have led them on a triumphal progress through the maze of pristine white panels where, with spaced elegance, her portraits and figures dating back to 1933 were hanging.

The year was 1974, and Alice Neel presided over her court with an effortless authority. The ease with which she accepted congratulations as her due, talked irreverently about sacred things, and told stories about the people in the paintings that ranged from provocative to bawdy, marked her as a savvy, practiced star.

Actually, she was not. Her one-woman retrospective at the prestigious

Whitney Museum on the Upper East Side of Manhattan was Alice's first at a major museum, but she regarded the show as evidence that the art world was finally coming to its senses, and thought it appropriate that they should place her among the pantheon of great twentieth-century painters. But despite her conviction that she deserved the show, at seventy-four years of age she could not entirely suppress her natural childlike sense of fun. "Isn't this just wonderful?" she gushed at one point, sweeping her hand across the room.

The evening grew from an invitation that had been extended nearly a year before, in May 1973, by John I. H. (Jack) Baur, director of the Whitney. Jack told Alice that they would like to give her a show, a major retrospective of her work over the previous forty years. Jack did not see her immediately after he sent her the news. But when her health permitted a meeting, he was sure that her deceptively gentle smile said, "Of course you do."[1]

Was she grateful? Jack read satisfaction, not gratitude, in her eyes, but he did not fully appreciate her feeling of justification until after he told her that the museum was planning to make space available on the second floor for thirty of her paintings. In September, Alice and a representative of her major gallery connection in New York, the Graham Gallery on Madison Avenue, met, at Alice's request, with Jack Baur.

Alice sat across the table looking as innocent as ever, reminding Jack, as she always did, of a grandmother, pleasantly plump, with a round, soft face, fine graying hair falling in wisps across her forehead, and a smile so gentle that he could imagine her saying nothing harsher than "goodness me." He pictured her standing in a farmhouse kitchen making pancakes, until she started negotiating. Alice told him that what she really needed was space for sixty of her paintings. She thought that her show should, in fact, take up the entire second-floor gallery.[2]

The exhibition, which opened on 7 February 1974, consisted of fifty-eight paintings and took up the entire second-floor gallery. It was one of the major art events of the year.

Alice greeted her guests in the midst of an entourage of people she had known over the past forty years, all captured forever on canvas, a collection of souls who over the decades had brushed against her own soul. These included friends and neighbors who would have remained forever

invisible if Alice had not chosen to paint them: Nadya and Nona, unintentionally seductive women whom Alice had met forty years before when her self-image as a woman lay in pieces scattered across the landscape of her life; a tubercular neighbor in Spanish Harlem who reminded her of a crucified Christ; and Georgie Arce, the little boy who played at cutting Alice's throat with a rubber knife while she painted him. Included as well were historical figures whom Alice had helped to imprint as part of America, such as Max White and Virgil Thompson.

But most of the paintings came from Alice's lighter palette of the previous fifteen years: family, neighbors, New York characters, recognizable figures on the art scene, and an eclectic mix of recent sitters, including a recently wounded Andy Warhol, subdued and vulnerable, a nude John Perreault, the art critic, a dapper Walter Gutman, a confident Timothy Collins, the diminutive Soyer brothers, and a peacockish Duane Hansen.

Among the carefully selected canvases were examples of genres that Alice helped to pioneer, an important part of her signature as a painter: a pregnant nude; a mother holding a child, both apprehensive about the world; nude women together; and families that seem to reflect the ambiguity of their times.

Although Alice had wanted her still lifes and cityscapes included in the exhibition, Jack Baur insisted on figures only. The reason for his insistence, however, seemed quite logical to Alice. Jack made it clear that the museum wanted to celebrate the work of an artist whom he regarded, along with John Singleton Copley, Thomas Eakins, and Edwin Dickens, as one of the four most significant figure painters in American history. He also was unequivocal in his belief that Alice was, as she claimed, a collector of souls, a painter who almost single-handedly preserved the art of painting the figure for four decades.[3]

Among the hundreds of people who celebrated Alice's achievements that cold February was Rhoda Myers Medary. When Alice was sure that she was going to be given a major retrospective, she knew that she wanted Rhoda to be there.

Rhoda was living again in Philadelphia, where Alice had met her over half a century before, in 1921. She had once been a painter, perhaps as good as Alice, but her life had not worked out as she had intended, and

Alice understood the pain of Rhoda's broken dreams to become a great artist. She knew that all Rhoda had from those distant years of promise was an insistent, nagging feeling of regret and a basement full of dozens of fifty-year-old canvases gathering dust. Alice and Rhoda had been good friends back in art school when Alice needed a friend, and Rhoda had once taught her much about art and life. They had not kept in touch at all over the decades, but their reunion the year before had bridged the miles and the years, allowing them, unexpectedly, to rekindle one of the few real friendships that either woman had ever had.

Alice called Rhoda to invite her up to New York to stay with her overnight and attend the show.

Rhoda listened to Alice's invitation and asked, "Is that damn nude of me going to be in the show?"

"No, it's a forty-year retrospective. I did that in 1930."

"Then I'll come."

It had been fifty-three years since the two women had first met, back at the Philadelphia School of Design for Women. At that time, Rhoda was the leading student in the fine arts and Alice was the shy new woman who was studying illustration.

Daughters

A Meeting

of Minds

E v e r y b o d y noticed the new woman. It wasn't that she tried
to draw attention to herself. In fact, she was quiet to the point of shyness.
Unfailingly polite when spoken to, she almost never initiated conversa-
tions. Even in the easy, superficial ambiance of the chair-lined corridor
that served as the school's lunchroom, she usually sat alone reading amidst
a constant din of gossip and laughter. She did not seem aloof as much as
reflective, but her voluntary separation, which she accomplished without
a hint of rudeness, transformed her from just another new student into an
object of considerable curiosity. After only a few weeks as a student at the
Philadelphia School of Design for Women, Alice Neel was something of a
mystery woman.

For one thing, she was strikingly beautiful. Her face was creamy, the
shape of an egg, a perfect oval except for her delicate chin. A serious
expression, which was her constant companion, only accentuated her
small blue eyes, which seemed to be fixed in a permanent stare of wonder-
ment. She had a small, delicate nose, and a down-turned crease of a mouth
that rested as a pout but could turn up effortlessly into a gentle smile. She
wore her blonde, almost strawberry, hair invitingly, loose and longer than
the girlish cuts of the other students. Beautiful women often seem unap-
proachable to other women, and most of the students found it especially
difficult to take the initiative with Alice, for she possessed that combina-

tion of beauty and reserve that, without the slightest intention, intimidates.

But it was also obvious that this new student was not just another of those rich dilettantes who seemed to be attracted to the School of Design and who helped to perpetuate its reputation among the nearby men's colleges as the Philadelphia School of Designing Women.[1] Alice's clothes firmly fixed her as one of the middle-class girls who populated the vocational courses; her dresses were conservative, almost plain, reflecting the practical, quiescent personality of a woman who was at best unimaginative and probably boring. At least that was the initial assessment made by Rhoda Myers.

Although Rhoda was beginning her fourth year at the school in the fall of 1921 when Alice arrived, she was only nineteen years old, several years younger than her peers and, she would discover, two years younger than Alice. Tall, gangly, homely, doggedly unconcerned about her appearance, gregarious, and engagingly personable, Rhoda was the yang to Alice's yin, an almost exactly opposite being. Rhoda and Alice came from entirely different backgrounds, looked at the world from quite different perspectives, and had enrolled in art school for wholly different reasons.

But even before Rhoda discovered any of these things, she had sized up the "new girl" and presumed that, like most of the students at the School of Design, she was going to be one of the "others."[2] That was the designation that Rhoda had fixed onto the rich, obnoxious socialites at one end of the spectrum and the boring commercial students at the other, or, as Rhoda always called them, "the ones who took fashion and the ones who took illustration and design."[3] As one of the leaders of a small circle of students who liked to think of themselves as the school's resident intellectuals and iconoclasts, Rhoda could spot one of the "others" immediately. It was not hard from her vantage point, at what she considered to be the top of the pecking order.

Rhoda had evolved over the years as the natural leader of the small cadre of fine arts majors at the school. Her coarse, shrill laugh filled the echo-chamber corridors as she centered herself in the cluster of fine arts students and poked fun at the "others." Her self-assumed mission was to make the fine arts students feel special, the elite.

The school where Rhoda initially dismissed the new woman, but where she and Alice would soon choreograph themselves through that initial

curious-stares-and-polite-nods stage of a budding friendship, was an eclectic old institution. It occupied the stately mansion formerly owned by the actor Edwin Forrest. The old brownstone residence stretched for nearly a block of land from the corner of North Broad and Master Streets to Fifteenth Street in what was then a distinguished, sedate neighborhood of brown brick or locally quarried gray stone mansions. Physically, the school fit comfortably into the adjacent world of money, for it conveyed an image of a proper finishing school for young ladies of good breeding. Students were permitted neither to arrive at nor leave the building unless they wore gloves and a hat; and wealthy families that had children in attendance, such as the Whartons, ferried them from their family homes in chauffeured limousines.[4]

Although far from prestigious, the school had a comfortable reputation as a respectable finishing school where unmarried young women could learn interior design or fashion was no small marketing feat. It was basically a trade school that taught much-needed skills to women from the middle and lower-middle classes, many of whom would go out into industry as designers or illustrators. But after eight decades of existence, its main emphasis still reflected its original charge "to teach women practical arts which can be practiced at home without interfering with household duties." Parents, from whatever class and for whatever reason, could feel that they were sending their daughters into a safe environment, into the hands of the very conventional principal, Miss Emily Sartain, and, after 1920, into the hands of her even more conventional niece, Miss Harriet Sartain, whose oft-repeated truism "Tradition is our springboard" was the school's guiding principle.[5]

In 1921, the Fine Arts Department was the jewel in the crown, although a pitifully small jewel, graduating four to eight students annually, out of senior classes that numbered over fifty women. And while the school was proud of its fine arts program, the department was undistinguished and was declining from its heyday at the turn of the century. There had been a time, in the 1890s, when famous painters could be lured from New York, or from the prestigious Pennsylvania Academy of Fine Arts, to teach. Robert Henri, founder of the Ash Can School, taught there for three years, and Emily Sartain's close friend Thomas Eakins often lectured. But with the end of the Great War came an increase in the demand for "practical" programs, and Emily, a serious painter who had exhibited at the salons in Paris, was replaced by Harriet, whose background was in

design and education as well as painting. The school settled into a comfortable, less demanding existence as Harriet further dwarfed the painting program by expanding the curriculum of the school to include advertising and art education.

Rhoda relished and nurtured the "them" and "us" psychology that permeated the beleaguered Fine Arts Department. The "them" cluttered the halls and filled the air with mindless chatter. Most of "them" did little more than "worry about their clothes and who they went with and who they were going to marry." The worst group, to Rhoda, were those "pompous social creatures" who were "simply waiting for their coming-out parties."[6] While this group was the most irritating, the most wearisome of the uncultured barbarians were the numerous girls in the commercial courses who showed absolutely no appreciation for art. "We had," said Rhoda, "the fine idea that we were the highest art and the others really didn't exist."[7]

Judging the world from a self-proclaimed superior position was a novelty for Rhoda, and she loved it. Three short years before, she had started at the School of Design as an intensely unhappy sixteen-year-old. She entered without any background in art or, for that matter, any real sense of what art school was about. She had fled into the undistinguished old institution as a welcomed escape from the exclusive private school where she had spent ten miserable years.

Art school for a long while had been more of a symbol for Rhoda than a place. It represented a set of values that were the opposite of her mother's aristocratic, materialistic ideals, and that was reason enough for Rhoda to seek sanctuary there. And it worked. "From the first day I put my foot in the front door, that was the place I wanted to be," Rhoda wrote later. "I found my niche."[8]

From an angry, rebellious child, she changed quickly, as a summer afternoon thunderstorm gives way to a crystal-clear evening, into a model student. After only a few months in drawing classes, where all day Mondays, Tuesdays, and Wednesdays the first-year students stood in front of plaster busts and statues attempting to reproduce their line and nature, she began to discover that she could reproduce them accurately, without great effort. The discovery delighted her as nothing ever had.

The Great War in Europe had ended amidst wild celebrations the fall

that Rhoda began her art studies. She had scarcely noticed. The world outside the walls of the school barely existed for her because of the novelty of emerging sensations that previously had been nonexistent in important parts of her life—enthusiasm, optimism, and a sense of satisfaction with herself. So much of her life was new that she reveled in one experience after another. As she recalled, "I never seemed to have any trouble at art school. Everything seemed to go my way. I sailed on top, mowing down any obstacle in my way."[9]

Redirected, the fire of her youthful rebellion metamorphosed not only into artistic, but into social, energy. Her happiness infected those around her as her dramatically changed attitude spilled over into relationships. Having grown up hating the snobs at Miss Wright's School in exclusive Bryn Mawr, and her mother's pretentious friends, and having grudgingly coexisted with her five brothers and sisters, Rhoda at last found herself among people who understood a set of values that her mother had called perverse. These people possessed an irreverence for social status, a disdain of material possessions, and a love of art. Consequently, she made her first real friends. It was no small breakthrough for her to admit that "I loved everybody and most people liked me," for she had been unable to say that about her life until she found herself surrounded by other artists.[10]

It was at this point, when she was imbibing the heady sweetness of painting and elitism, that Rhoda encountered Alice, a new student in one of the "lower" arts, illustration.

Not only did Alice's dress indicate that she was an "other," but everyone knew that she was studying illustration. Although on Mondays and Tuesdays all beginning students took drawing, on Wednesdays, when the beginning fine arts students remained yet a third day in the great front hall drawing from plaster casts, the illustration students went to the second floor for an all-day class in lettering. The "blonde girl" always spent Wednesdays on the second floor lettering. Alice could have been ignored forever by the cliquish fine arts students, as her peers in illustration were, except that she didn't behave according to the stereotypical caricatures by which Rhoda and the other "artists" could immediately stereotype one of the "others."

First of all, she was very talented. It is nearly impossible in a relatively small school to keep excellence a secret, and very soon students and

faculty were talking about Alice's skill at drawing from the plaster casts. Like Rhoda and a handful of fine arts students, she stayed past the end of classes to sketch, and it soon became apparent that she was a serious student, too serious for most of the students who still generally stayed away from her. As one classmate said, "We were so frivolous, and she was more than serious—she was driven."[11]

Alice seemed unaware that she was the mysterious object of so much talk. Although for the first time in her life she was touching the edges of happiness, the combination of that strange environment and her own natural passivity conspired to keep in place the wall that she had long ago erected to protect herself from the intrusion of others.

At twenty-one years of age, Alice still approached life tentatively. She had little experience with creative people and virtually no contact with confident, happy women. She seemed to watch, from afar, the coterie of fine arts students and to envy them their animated conversations, the effortlessness with which they smiled and laughed. They seemed more interesting than the people she had experienced previously and infinitely more interesting than she thought herself to be. She would not have known how to break into that tight little circle; she was too insecure to try.

The environment of the school encouraged easy friendships and casual conversations. When the students were not passing each other in the crowded corridor or on the broad staircases, they gathered naturally in the enclosed courtyard, around the fountain. Standing alone in the middle of the bustling activity, Alice usually avoided involvement by sketching, appearing to be preoccupied if, in fact, she was not. What was perhaps the first conversation she initiated occurred on a warm afternoon in October when she asked another illustration student if she could sketch her seated on the edge of the fountain. The fine arts students often sketched each other, but illustration students generally did not. A small group gathered to watch over her shoulder when Alice, apparently embarrassed, hurried to finish, tore the sheet off, handed it to her sitter, and almost ran into the school. Rhoda and some of the others who were watching Alice make the drawing went over and looked at it. The sketch was so good that Rhoda said she could not imagine a mere illustration student making it.[12]

Alice did not dare make the same type of advance with any of the students in fine arts, especially Rhoda, who was alluringly self-possessed, not sophisticated but confident, at ease with teachers as well as students,

respectful and irreverent at the same time. Even before they met, Alice greatly admired Rhoda, for she seemed to be everything that Alice was not.[13] For that reason, as well as a lifetime of conditioning, Alice did not presume to take the initiative and introduce herself.

The two might not have met if Alice had not transferred from illustration into fine arts. She had not wanted to major in illustration, but her mother would have objected in her imperious way if Alice had quit her perfectly good job to study something as frivolous and self-indulgent as painting. So, inevitably, Alice had begun to dread Wednesdays. She hated lettering, she hated watching others paint while she, at the age of twenty-one, practiced forming neat letters because her mother thought it was the sensible thing to do. Consequently, she neglected to tell her mother when she transferred into fine arts, but the other students found out immediately, and, as a new member of the "highest art," she was automatically elevated to a status worthy of their attention.

Alice's and Rhoda's meeting was remarkably easy once Alice qualified. In the hallway that served as the cafeteria, Rhoda condescendingly complimented Alice on her sketch in the courtyard and on other of her renderings, which Rhoda later remembered as a genuine compliment of work that she thought was nearly as good as her own.[14] Alice smiled a slight smile, her tight lips in an upturned crease, her eyes looking out from under lowered lids. This expression made her look closer to fifteen than twenty-one, vulnerable and unsure, like a child. But instead of thanking Rhoda for being so kind to notice, Alice complimented Rhoda's work, saying that some of her's was quite good also.

Even having met, these two dissimilar people might never have become friends but for an immediate mutual appreciation of each other's artistic ability. They knew, from the beginning, that they were the best artists at the school.[15]

Consequently, their first shared bond, which provided that much-needed common interest where friendships begin, was drawing. They discovered that they each loved the statues and plaster casts in the giant front parlor that served as the school's main studio. Alice, coming from a small town, was overwhelmed by so much art in one room; Rhoda thought that the scores of pieces, strewn about, were exotic. Soon after their meeting, Rhoda and Alice could be found, along with another student, Ethel Ashton, in the studio sketching together and critiquing each other's work.

Ethel, the third person in the trio that would set the standards for excellence in the Fine Arts Department during the next two years, was serious, quiet, and one of the oldest students at the school. In 1921 she was twenty-five years old. The daughter of a vice president of the Philadelphia National Bank, Ethel had been a student at the Moore Institute of Art, Science and Industry before transferring to the School of Design. She was six years older than Rhoda, and was both well traveled and well-read. Rhoda had never had the opportunity to travel and had scrupulously avoided reading, but Ethel attached herself to Rhoda soon after entering the school because Rhoda was one of the few students who, like Ethel, was serious about her art.

By the time Alice declared herself to be a fine arts major in late 1921, Rhoda and Ethel had already become minor celebrities because of Rhoda's brash claim that they both intended to become nothing less than great artists, important American painters. Few, if any, of the other women at the school were either foolhardy enough to aspire to greatness or, if they were, to admit it.

Rhoda had initially been attracted to Ethel not only because of her talent but because of her impatience with gossip and talk about boyfriends and dating. Rhoda had never had a boyfriend. She had never actually had a date.

One had only to look at her to understand why. Rhoda was painfully thin and, except for her exquisite long-fingered hands, awkward. The smallness of her head was emphasized by her large, round nose and her receding chin, and by the apparent absence of a neck. She always seemed to have her head buried in her hunched-up shoulders and would have appeared a shrinking violet were it not for her constant motion, incessant talking, and the shrill, explosive laugh that invariably punctuated her conversation. She possessed an engaging smile, but had considered herself to be an ugly duckling for so long that she did nothing to enhance her appearance.

Ethel always looked larger than she was. Not plump, but "big boned," she was content to appear to others as she saw herself, as a serious-minded woman with little patience for decoration or frivolous dress. She possessed what would have been a pleasant face if she had had a propensity to smile more often. As it was, she looked severe, and even when she was amused by Rhoda, she rarely laughed out loud. Ethel was a gentle and generous woman who was misrepresented by her appearance.

The absence of any kind of social life apart from school, or of boy-friends to compare, probably contributed to the two women's disdain of the kind of small talk that constituted the glue of friendships among most single women and served as the social lifeblood of the school during the times between and after classes. Their friends teased them constantly about their being "doomed to old-maidhood" because all they liked to talk about was art, so Rhoda and Ethel justified the absence of boyfriends by claiming that, as serious artists, they were too busy to think about men.[16]

In Alice, Rhoda believed that she and Ethel had found a kindred spirit. Alice did not talk about her family or her life and, despite her beauty, she did not appear to be interested in men or dating. To Rhoda, this was not at all curious, once she got to know Alice, for her new friend was a serious intellectual who professed no time for distractions. Alice liked to talk about painting and painters and the new writers who were then revolu-tionizing thought and sensibilities in the wake of the Great War. She was capable of talking about people such as Picasso and Virginia Woolf. Ethel, who was also a voracious reader, although her tastes were more tradi-tional, found Alice to be intelligent and well-read.

Not many women at the school, including the fine arts students, read books or seemed interested in life outside of their own experience. Conse-quently, the three became the odd ones out at the School of Design. Usually people of their talent and seriousness were picked off like flower petals by the more prestigious Pennsylvania Academy of Fine Arts. Each, however, had her reasons for staying at the School of Design.

For Rhoda it was to be the leader of such an elite. She liked to think of herself as an intellectual, for that was part of the mystique of being a painter, but in truth, poor Rhoda had scarcely read anything. For most of her nineteen years, she had studiously avoided becoming educated, but with Ethel's influence during the previous two years, she had begun to take an interest in the life of the mind.

Rhoda was not very disciplined about it, but she listened with awe while Alice and Ethel talked, occasionally inserting wisecracks, but other-wise being respectful. As a whole new world opened up to her she began to write bibliographical jottings in her sketchbook next to her drawings, which probably proved quite useless as future references: "Dunsany— writes queer things about funny worlds," "Joseph Conrade [sic]," "The Enchanted April by Elizabeth."[17] The notes may not have been useful,

and the books may not have been read, but Rhoda approached her conversations with Alice and Ethel with the zeal of the convert as she enthusiastically tried to make up for lost time. Consequently, throughout the following two years, as Rhoda said, "We, Alice and Ethel and me, talked and worked, and read things like H. G. Wells and D. H. Lawrence."[18] But in fact, until that time, Rhoda had never heard of either author.

If being among an elite of painting students invested Rhoda with an enriched ego, being with the two intellectuals in that elite filled her with a pride that, when married with youthful exuberance, emerged as the boasting of exclusive ownership: "If anybody wasn't interested in art, an intellectual, artistically speaking, then we didn't have anything to do with them."[19] Since Alice and Rhoda did not have much to do with the other students anyway, whatever snobbery grew out of this relationship was Rhoda's, existing in her mind as secret gloating. She was, however, incapable of portraying the role of a prima donna. She would always laugh at the wrong time.

Alice did not know how to respond in this exuberant, carefree milieu. She was a loner. She had never experienced living with cheerful, confident people, especially women. But she found herself among these people, and she didn't mind. All of her life she had obeyed adults, been respectful to teachers and employers and polite to other children. Living within such an interconnecting set of sterile circles had not prepared her for the kind of lively, undisciplined friendship that Rhoda so freely offered.

In order to accept this friendship, Alice had to overcome another problem that had been deposited in life's path by her past. When she was growing up, she had always been more serious than girls her age, and didn't feel comfortable around them. Perhaps sensing this, along with the added threat of her beauty, girls did not like her very much. But Alice had no refuge for she was also uncomfortable around adults. If adults had lost the power to terrify her, they could still unsettle her. For safety as much as satisfaction, Alice learned to prefer the company of boys to girls. Their interests in her were direct and uncomplicated. In high school they swarmed around her like drones around the queen bee, and during the years she was working she was being pursued all of the time. Up to the time she met Rhoda, her close relationships, what few there were, had been with boys.

But, as much as she had enjoyed their attention, most of the boys and men in her life were never really friends. They were dates and, increas-

ingly, distractions. "Boys," as Alice called her dates, took her to the city, to clubs where the Black Bottom was pushing out the older, more sedate dances, or to the cinema to see Theda Bara in *The Blue Flame*. It was Alice's awareness of how attractive men were to her, but how unsatisfying a life of superficial dating was, that helped her to decide to study art at the School of Design. Unlike the other art schools in the city, it was a women's institution. When Alice made the decision to quit work and attend school, her seriousness led her to choose a school where there were no men, because she was acutely aware of how susceptible she was to men who gave her attention. If "boys" were around, "I could only think of . . . how I looked and try to be charming and I wanted to learn to draw and paint without distraction."[20]

Alice fit in comfortably with Rhoda and Ethel because, like them, she seemed too serious as an artist to date. What they did not know was that her abstinence was self-imposed. She was a self-admitted "grind" because she knew that she had to protect herself from temptation, for if she let down her guard, she might easily be lulled back into the unsatisfactory, frivolous life that she had just put behind her.

But Alice surprised herself by enjoying Rhoda and Ethel. At first, their relationship was just fun, superficial, and safe. The initial bond was art, and it was here that Alice first reached out. She admired Rhoda's style, which was not the traditional academy style taught at the school, but was bold, with broad brush strokes, a liberal use of paint, and often the addition of a black outlining technique that Alice had not seen before.[21] She began to practice some of the techniques that one day would mark her famous style. Much later in life, Alice was asked who influenced her the most. She answered, "The girls at the school who painted well," and the ones who painted the best, she added, "were the dumbest in everything else." Rhoda! Ironically, while Rhoda was trying to learn how to become an intellectual from Alice, Alice was deciding that an education might be a hindrance and was trying "deliberately not to be able to add or spell."[22]

In the midst of painting together, critiquing each other's work, and talking about suitably neutral topics, Alice began to learn about Rhoda, who had no hesitation in disclosing the unkempt corners of her family life. Rhoda was a walking education. Alice learned that Rhoda had been raised by servants and had seen her family's wealth dissolve; she was a child of a broken home in an age when the word "divorce" was whispered

surreptitiously as one would whisper "cancer" or "Communist"; she was an unattractive young woman who did not need good looks to command the center of attention.

Despite all this, she exuded the essence of life itself! Nothing seemed to bother her, dampen her spirits, or diminish her enthusiasm. Instead of lamenting the loss of her family fortune, she laughed at the rich. Rather than hide the stigma of divorce, she regaled her friends with hilarious stories about her family, especially about her mother's vanity, which had precipitated the family breakup. She told equally funny stories about her rebellious youth, always being careful to relate as impish pranks what at the time must have been angry retaliation.

Alice had stories, but she was not ready to tell them. Like Ethel, she was an intensely private person. Both listened greedily, however, to Rhoda, wondering how a woman emerged from such a childhood so confident, so seemingly whole. They listened enthusiastically to Rhoda although they sometimes sensed the intrinsic tragic quality that often lurked just under the surface of her humor.

But Rhoda's humor was always there, and it was difficult to be around her and not get caught up in the way she made fun of people who were pompous on the one hand and just plain dreary on the other. Her humor was not malicious, but it was smug, so Alice, with a background that had not permitted smugness, did not come to it easily, but, in the free and easy environment of the school, so different from her home, she learned to laugh at Rhoda's impersonations of the "others."

It seemed to Rhoda that Alice took forever to laugh hard, that kind of spontaneous eruption of the soul. The eruption came abruptly and unexpectedly one afternoon on the third floor, where the fine arts students held some of their classes. Rhoda was making fun, not of one of the "others," but of Ethel, whom she accused of dressing like the illustration students. The normal dress for fine arts students was either skirts and sweaters or suits from which they would remove their jackets in order to put on their required smocks. Ethel wore a dress with a great bow hanging from the neck, and Rhoda, mimicking broadly the gestures of a pinched little personality, accused her of trying to be like either one of the "others" or, worse, one of their mothers. To everyone's surprise, Alice laughed.[23]

Thereafter, Rhoda's harmless silliness provided the three with hours of amusement, especially on Sundays, when they would meet at the Graphic Sketch Club in the city. The club always had at least one model available

on Sunday afternoons, and students from all over the city were invited, free of charge, to paint. What was most attractive to Alice and Rhoda were the models, for, unlike the conventional and artificial models at the School of Design (who were dressed up as Indians or ballet dancers or Hawaiians), they were real people, including old, poor, and city people, an Asian and a black child.

Those were stimulating afternoons, not only because of the models, but because the three often found themselves painting next to Postimpressionists or expressionists, painters whose styles were not taught at the School of Design. The afternoons were stimulating beyond anything they encountered at their school, producing a highly spirited threesome who rode the trolley back to the train station, where they would separate to go to their separate homes, Rhoda to her mother's twenty-room home on Wister Street in Germantown, Ethel to her parents' large and comfortable home on the fashionable five thousand block of Chestnut in West Philadelphia, and Alice to her parents' small twin in modest Colwyn, a village on the edge of southwest Philadelphia.

Rhoda thrived on their outings, for they contributed to her image of herself as a free spirit, an iconoclast, who, if she was not actually a rebel, liked to portray herself as one. She once said, "Oh, we, Ethel, Alice, and me, we were rebels."[24] She wasn't really a rebel, at least not at the school, but she loved to play the part. It was fashionable in the vocational environment of the school for the fine arts students to think of themselves as rebels against convention. That was, after all, part of the mystique of being an artist.

Alice and Ethel were anything but rebels, but Rhoda dragged them along on whatever adventures she considered romantic or exotic. She tried to convince them to sneak out from the old mansion without the required gloves and hats, to take their easels to the Reading Railroad yards or to the Italian Market on South Ninth Street to paint, knowing that if they were caught they would have to serve detentions. She also led hastily gathered groups in assaults on the Academy of Music on South Broad Street to see Leopold Stokowski conduct the Philadelphia Orchestra. They would try to arrive just before the doors to the amphitheater were opened, and then Rhoda would lead a screaming, whooping group up four flights of stairs to cheap, high-backed wooden seats, first come, first served. Alice and Ethel could never keep up with the whooping leader of the thundering herd, but Rhoda always saved them seats.

Rhoda was too enamored of the way her life was unfolding to risk anything that would actually disrupt the serene school, but it seemed important to her to incorporate the concept into her image as a way of keeping alive her sense of independence as well as her myths about what artists were like.

Alice had never before encountered women who behaved in such outrageous, yet appealing, ways. She wavered between an unsettling attraction and a familiar fear of allowing herself to lose control. Alice, raised to abhor self-indulgence, found herself indulging, tentatively, in stimulating and fun activities, such as the time Rhoda wanted the three of them to dress up like flappers and go to a jazz club. They did not actually go, but the planning, the daring, and the threatening provided hours of fun.

Alice was being exposed to provocative perspectives, such as the idea that intelligence and discipline may not be enough to produce art. Just maybe, the traits that she had been raised to regard as frivolous— emotionality, spontaneity, independence—or as immoral—irreverence, rebellion, self-love—might be the essential sources of creativity, the elements of art.

At the School of Design, these alien possibilities persistently nudged Alice with such tantalizing intimacy from people like Rhoda, that reevaluation elevated them from deviant traits to necessary qualities for a true artist. For all Alice knew, these qualities might be struggling to surface from inside her, half-smothered by the debris from years of repression.

Alice was already experiencing novel and powerful emotions because of her art. By the time she got to the School of Design, she had already felt the freedom, the escape from "real life," in the power she experienced when she sat in front of a canvas.[25] And after she arrived at the school in 1921, she not only felt but exercised that power. After her first semester as a fine arts student, she was invited to join the life class, where students drew from a nude model. Most students had to wait until their second year. On her first day of life class, she had stretched a large canvas, one she had to struggle with to get through the door. Her instructor smiled and said that he was glad to see that she was so ambitious.[26] He was right. Art was the one area of her life where she dared to be ambitious.

But, at twenty-two, Alice had virtually no experience with self-expression except on paper or canvas. If she had complaints in other areas of her life, with the control her mother exercised or her own timidity, she

was not yet ready to assert her needs when they ran counter to those of others. But, after nearly two years of art school, she was growing in ways that life had not, until then, permitted, and Rhoda was one of her most important models.

Rhoda's outrageous humor and her rebel stance were not entirely artistic posturing. Rhoda effected the "persona" of the artist not just because she fancied the role. Her role was, in part, the vestige of a deeply embedded childhood need to strike back against her mother; her identity as an artist was more important to her than to most art students, for it was the source of her first positive self-image. She might be facile and superficial, undemanding qualities that helped to make Alice feel safe in the friendship, but, beneath the surface, Rhoda was a wounded bird.

Alice and Rhoda were two unlikely candidates for the kind of friendship they were developing during Alice's first two years at the School of Design. Some of the other students thought them an odd pair, and, with Ethel, an odd trio. Yet when they met in 1921, they were being propelled toward each other by their childhoods. Alice was subconsciously searching for a Rhoda to give her insight into her place in her own life. Rhoda's reaction to an almost equally unsettling childhood had already begun to shape her into a brash, independent young woman, an unsuspecting catalyst in the life of the searching Alice.

You're Only
a Girl

2.

A l i c e may have begun to rub her Rip Van Winkle eyes when she
was twenty-two, and looked around with fascination at the strange world
in which she was awakening, and she may have mused about the exotic
concept of independence, but she still had far to go before she would be
able to declare herself to be an autonomous being. She would one day
write, "I doubt if I was really myself until my mother died."[1] Her mother
died when Alice was fifty-four years old.

Alice rebelled, often and mightily, before her mother's death, but for
most of those decades she did not venture far enough away to break the
emotional bonds. During the most estranged of times, Alice went to her
mother for emotional strength.[2] Her measurement of most decisions that
she made was her mother's reaction. At the time she met Rhoda, however,
Alice had scarcely made any decisions by herself. They had been made,
the important ones anyway, by her mother.

The new century was twenty-eight days old when Alice was born in
Merion Square, Pennsylvania. The third of five children born to George
Washington Neel and Alice Concross Hartley, she was given the first name
of her mother and the middle name of her mother's family. She became
part of a respectable family, middle-class, edging more toward the bottom
than the top, yet proud, boasting a modest claim to distinction by being
descended on her mother's side from Richard Stockton, a signer of the

Declaration of Independence. Her father's family was not from the same cut. His Irish lineage had produced several generations of opera singers in Philadelphia, his parents the last. They made money and spent it robustly, so that by the time they died, when George was twelve, they left him a legacy of poverty and a strong prejudice against reckless, bohemian lifestyles.[3]

Alice never had very many happy memories of her childhood, but her most beloved ones were of her father. Fatherless by the age of twelve and without benefit of a formal education, he worked at odd jobs until he was seventeen, when he began working at the Pennsylvania Railroad. There he managed to raise himself to the position of head clerk in an accounting department.[4] He was a small man, barely above five feet, responsible and hardworking, a quiet and conservative man who kept to himself. George Neel was the quintessential Victorian husband and father. Alice remembered him as kind and good and philosophical. He was also negligible in her life, the distant "provider" who had long ago retreated into passivity in the face of a more forceful presence.

Alice painted him into a "family" portrait in 1927, describing him as "my little, gray father" and portraying him as frail and stooped over, the despair of the inevitable written on his face, carrying a bucket of coal up from the basement. It was difficult for her to look at him without feeling a little guilty.

Alice did not talk much with her father. Alice's mother answered questions and gave direction. Alice grew up in what she called "a mother-dominated" household.[5] She felt close to her father only later, in memory when he also had become, in her mind, a victim. The force that dominated, and victimized, was her mother.

Diminutive in appearance, only four feet, eleven inches tall, Mrs. Neel had a quiet face that masked a troubled soul. One of five daughters born to a mother who was a puritan of the severest code and a father who was a great drinker, Alice Concross listened to her mother's preaching, but snuck out of bed to let her father in late at night.[6] She had been promised to George Washington Neel by the time she was sixteen years old. Her marriage and the birth of her first child took place in such rapid succession in the early 1880s that Alice Concross Neel had no chance to finish her education or to be on her own. By 1890, she had given birth to Hartley, Albert, and Lilly. She lost Hartley in 1895 to diphtheria, when he was nine

years old, but she gave birth to Alice in 1900 and to another son, whom they called Peter, in 1905.

Alice Concross Neel herself was a victim of that chemically reactive combination of personal frustration with life and a belief in her own ability that bubbled and brewed inside intelligent Victorian women who were allowed too few outlets for releasing their emotions and their ambitions. The unvented mixture produced the gases of rigidity, intolerance, and arrogance, which had to be carefully bottled up within an enclosure of public reserve, but which exploded in the privacy of the household. Mrs. Neel resented her place in the world. Feeling trapped in a penurious and confining life with a husband who was less intelligent and less successful than she deserved, she may have resented him for relinquishing control of the family to her, and she may have resented a society that would not allow her to control anything else.

Alice, at least in retrospect, understood her mother's private torment. She believed that Mrs. Neel "could have done anything, run a big business establishment. She was very well-read, very intelligent, and she had a terrific capacity."[7]

Alice was terrified of her mother, but like any child, she was dependent upon her and attracted to her. She called her mother the most stimulating person in her life, much more "interesting" than her father because "she was brighter, she knew more, and she was quicker on the draw." It was her mother who took her into Philadelphia to see *Faust* and the Pavlova Dance Company and Sarah Bernhardt.[8]

But Alice also understood from an early age that her mother possessed the power to shape her life in dark ways. The other adjectives that sprouted in Alice's mind to complete her portrait of her mother were "imperious," "uncompromising," "nervous," and "strong, independent, autocratic."[9] Mrs. Neel was not malicious; she was "tormented,"[10] a woman whose sense of familial responsibility manifested itself erratically, sometimes as harsh and abrupt commands, sometimes as stiff, puritanical lectures, sometimes as anxious outbursts. When Alice was in psychoanalysis, in the late 1950s, after her mother's death, her psychiatrist told her that she probably developed her interest in painting portraits because she grew up constantly watching her mother's face, trying always to read it, "to see whether she approved of things or not."[11]

Alice, like her mother and because of her mother, learned to wear her

own mask of reserve. She was a beautiful child, with blonde hair, softly textured white skin, and green-turning-blue eyes. From her earliest years, she was a perfect child from an adult viewpoint, quiet and compliant, seen and not heard. But inside she churned. An atmosphere of restraint, and perhaps despair, radiating from her mother, filled the rooms of her childhood house, settling on every surface. What Alice called a "terrible puritanism" permeated that atmosphere, stifling the simple pleasures that should infest childhood—laughter, creativity, curiosity, hope. With her antennae always up, Alice walked gingerly through her youth, gauging reactions, looking for signs that should direct her behavior. At first it was just her mother whose facial expressions had to be watched for cues, but Alice learned her behavior well. As she grew, she began to watch everyone, for "everybody could knock me off base."[12]

Alice's sensitivity to others' reactions was but the first line of defense in protecting herself. Like many girls of her age, Alice learned from her mother a "tremendous willpower," an ability to repress whatever feelings or beliefs or needs she had if she determined them to be contrary to those expected of her. By the time she was "three or four," she was aware of a wall between her and "the reserve" of her mother, a wall that prevented communication. Her job was not to express herself, but to listen and to mind. To avoid her mother's anger, she found it easier and safer simply to give in. Like a climber who, with fatalistic resignation, recognizes the superiority of the mountain, Alice adjusted to the terrain; she learned to read people and to be what they wanted her to be. She was, by her later admission, "the most repressed creature that ever lived," and she summed up her childhood by observing, "I'd make such an effort to be what they wanted, a pretty little girl, that I wouldn't be myself at all."[13]

In an environment that demanded conformity and obedience more than honesty, Alice learned to internalize everything, to swallow whatever nascent dreams she may have had, and to pull back into the growing darkness of her own soul the fears and anxieties that, when released, become normal parts of childhood. Consequently, Alice evolved into a normal-appearing girl who quietly lived in terror of the dark, of spiders, of a neighbor's stuffed cat, of adults.[14]

In her private world, Alice was "attracted by the morbid and the excessive and everything connected with death."[15] Women terrified her. She would have convulsions if a fly landed on her. Once, she was brought

home from church crying hysterically after hearing about the crucifixion. In the abandoned loneliness of night, in her room, her imagination ran riot:

> When I was very small, at night I'd turn on my side in bed and look out the door at the gaslight in the hall. With one eye I could see the light, and with the other I couldn't, and I thought the eye that couldn't see was blind. I was always afraid of going blind. The minute the light went out, I thought I was blind, so I was terrorized at night.[16]

One day Alice's "hypersensitivity" would evolve into her distinctive gift of seeing beneath the exteriors of her models with an insight and a depth that eludes most painters. But, to Alice as a child, the acute delicacy with which she dissected life and subjected it to analysis only heightened her fears of a world that she was too young to understand. Coupled with her tendency to internalize everything, Alice's compulsive fearfulness pushed her into a chronic state of indecision. Even in the small decisions that do nothing more than connect the parts of each day, "I wouldn't know, but not only would I not know, I'd go into a fever of trying to decide. My whole life was a matter of never knowing what I wanted."[17] Trying to understand herself, Alice plunged into narcissistic preoccupation.

There were, in her early life, not nearly enough stimuli to distract her from herself. Colwyn, the town that Alice grew up in from the age of three months, was little more than a hamlet that cropped out of the Delaware Valley countryside, a turn-of-the-century suburb of Darby, separated from the city of Philadelphia by a single hamlet and an aeon of sensibilities.

Alice always referred to Colwyn as "benighted,"[18] unenlightened, obscured by darkness. A stifling and puritanical pinprick of geography. The train from Philadelphia passed through, stopping at the top of the hill, but no one of importance ever got off at Colwyn. The town offered a bright and curious little girl virtually nothing to excite her imagination. Among the events that shaped Alice's memory of the town was the time a man exposed himself in a window and the time the grocer's wife committed suicide.[19]

Alice grew up hating her town. She remembered a childhood of boredom in which she would pass the time by sitting on her porch, "trying to keep my blood from circulating."[20]

She even lacked a playmate with whom she could share the intimacy of a child's secret world. Her sister, Lilly, who had been born in 1890, was, by the time Alice was born ten years later, already a young lady, older than her years, serious about emulating her mother as housekeeper, cook, and seamstress. Lilly seemed to enjoy mothering Alice and, soon, sewing dresses for her. She was an attentive sister, but she was almost an adult. Alice's two brothers bracketed her in age, but seemed connected to her by nothing else. Her surviving older brother, Albert, had been born in 1888, and was thus twelve years her senior. Alice did have a younger brother born in 1905, George Washington, Jr., who soon was called Peter, but if Alice helped to care for him or played with him, the memories did not stick. She did not have a playmate and dearly missed having someone her own age around. She thought that life in her intolerable little town would have been "wonderful" if she could have met herself.[21]

As it was, the best times of her youth were those times when she was alone. The same sensitivity that magnified ugliness also brought her some of her greatest pleasures. Her hometown might have been boring, but it was physically beautiful. She absorbed her joy through her eyes.

Her twin house stood on Colwyn Street, on a steep hill that descended from the main street of the town. It had once bordered a pear orchard. Three rows of pear trees still grew and especially in the spring, when the trees presented themselves to her as blossomed sentinels, Alice believed it was the most beautiful street in the world. And the color! It was the color of her childhood that lodged itself in that part of the brain that collects the material from which nostalgia grows. Well into her seventies, Alice remembered, with an affection usually reserved for beloved pets, the elephant ears, the four-o'clocks and scarlet sage, the gloxinia, the pansies, and the lilacs. They still generated a warmth inside her in 1973, when she painted these youthful companions from memory.[22]

Her father had planted maple trees in the backyard and a garden with lilies along the brick wall that ran across the backyard. But the beauty that ornamented the plain house, which Alice also remembered on canvas half a century later, came from the blue hydrangeas that grew along the sides and in the front.

But even while Alice was young, the rich imagination that could conjure up spiders out of shadows became equally adept at fantasizing romantic images. From a world of humorless puritanism, she extracted moments of pleasure and created her own images of beauty. Hers was the

sensibility of the artist, and she knew this from an early age. From at least the age of eight, when she received painting books and watercolors for Christmas, Alice wanted to be an artist. She was attracted to the painting books of romantic couples and flowers. She received a Katzenjammer Kids coloring book when she was ten and refused to paint in it because she found it so offensive.[23] Instead, she taught herself to draw flowers and painted them with vibrant colors.

She graduated to drawing heads, insecurely at first, arranging for them to spill off the edge of the paper at difficult points. Alice later acknowledged that she was drawn to painting portraits as a way of combating her fears, a form of therapy, although she would not have understood the concept or the dynamic when she first tried to draw faces. She did not try to draw her mother or father, but settled on her older brother Albert playing his saxophone, a safe choice, distant and nonthreatening. She said, ". . . art was a way of getting rid of overreaction and later of expressing opinions and even a philosophy of life."[24]

Long before Alice could explain or understand the forces at work, art became the dominating facet of her secret life. She had no role models for this attraction, no artists whom she admired, only one young man, an architect, who "was something of a help" because he used to talk to her about art. But he did not really understand art, for he believed that sculpture and painting were noble because they were the handmaidens of architecture.[25] So, the discovery of the importance of art was hers alone, and she kept it as her secret garden.

While it was neither unusual nor unhealthy for little girls to draw and paint, it would have shocked her family if they had had an inkling of the centrality of art in their daughter's life. And Alice was uncomfortably aware that her parents would not be able to understand the "nobleness" of painting.

She had been raised with multiple expectations, all of them low and mundane, and none of them capable of encompassing her personal feelings, especially if those feelings were deemed to be either selfish or irresponsible. Hers was a family that adhered rigidly to what Alice called "a very ordinary philosophy of pragmatism."[26] People had to contribute to their collective welfare by working, being responsible citizens, and fulfilling the roles that society had cast for them.

Alice was, as a matter of course, expected to take a practical curriculum in high school and then go to work to help support her family until she married. Anything beyond these meager expectations was worse than fanciful; it was frivolous, the first great sin against the puritan ethic. To compound the pressure on her, Alice had to live not only within the values of pragmatism, but within the even more limiting confines of gender stereotypes. Every time Alice risked articulating a dream—although never about her art—her mother reminded her, "I don't know what you expect to do in this world. You're only a girl."[27]

So Alice remained passively silent about hopes and dreams and dutifully played out without protest at least the first part of the scenario laid out for her. She felt such an obligation to her family and to their chronic financial plight that she continued to repress her needs and her desires throughout her teen years.

Alice was fourteen when she "began to feel terribly sad" about her parents and the lives they were locked into. That kind of perceptiveness, along with all of her fears, were the chains that bound her passively, day after day from 1914 to 1918, to the uncomfortable chairs in stifling high school courses in typing and stenography at Darby High School. She took no art courses at all and, like a recovering alcoholic, would not even walk past the art room for fear that she would weaken and go in.

Even after the superintendent of schools tried to convince her parents that "it was mad" for her to take a commercial course because she was so bright, they did not change their minds. It was not only a matter of money. The Neels were saving in order to send Peter to college when he was old enough. They knew the value of a college education. But to provide one for "only a girl" would have been a foolish waste of money.

Young women in Alice's social class were supposed to learn a trade, find a husband, and settle down, work to help build a small nest egg until the first child came along, and then, of course, give up their jobs for their God-ordained calling, motherhood. As Alice ground her way through high school, she seemed to be carrying out the prescription. Among the boys at Darby High School, Alice was one of the most popular girls.

If Alice's school work bored and depressed her, she made up for it by dating, going out with all of the "boys." She was beautiful and she knew it. And she gloried in "being chased" by so many would-be suitors. On weekends, she dated. This was the time she relaxed and laughed, for she was always with people who wanted to please her. She would not settle on

a single young man, as if to keep this part of her life light. Fun activities, group activities, school functions—all were uncomplicated and frivolous. It was with young men that Alice captured the fun of childhood.

If one of her many dates appeared to get too serious, Alice drew back. She understood that social life was supposed to be fun. What she probably did not understand was that dating helped to drain away some of the stress that was her constant companion, for she found the attention that she received from "all the boys" to be at the center of whatever good feelings she had about herself.

To be "only a girl" meant, of course, that her primary skills were in handling "boys" and her main asset was her beauty. Society channeled Alice into all the proper cattle chutes, teaching her to focus on her appearance. Later in life, Alice would loathe her beautiful face, but at the time she grew both practiced and skilled at being the demure, pretty girl whom all the boys chased.

Driven by her sense of duty and her worry over her parents' finances, Alice worked hard and did well, giving her parents every reason to be proud. But they were not demonstrative people.[28] If men were the source of her good feelings about herself, any sense of accomplishment that she got had to come from herself, and from that quarter she got virtually none. She was, according to her needs, accomplishing nothing important. At seventeen, she was a miserable young woman, anxious, nervous, tense. She would break out into convulsive crying at the slightest provocation. But who noticed? Hysteria, early in the century, like other ailments that today signal the lurking presence of depression, was seen as one of the many curses of being a woman. And Alice's other manifestations of incubating psychological problems—sullenness, chronic indecision, complaints of headaches and fever—were also regarded as natural conditions for the weaker sex.

When she was seventeen, Alice experienced what she later called "a small nervous breakdown." She said that for months she was unable to hold her head up, attributing her condition to "repression."[29] It is possible that at the time no one paid much attention to a young woman who walked through life more withdrawn than usual, and it is almost certain that Alice had no understanding at that point of the reasons she felt so tired and unhappy. Conventional wisdom, generated from the puritan ethic and contemporary values, taught that life was serious business; people were not expected to like, much less enjoy, life. They were supposed to work

conscientiously, live soberly, and do their duty earnestly. Personal misery was an inevitable companion, but that was the price one paid to be a responsible and successful contributor to society.

Alice's mind and spirit may have rebelled against this pervasive philosophy, but physically she conformed. Secretly, she continued to live, when she was able, in her private garden, nurturing her secret of art. She would not have known the word therapy, but painting became nothing less than her lifeline to sanity, a homemade remedy for a problem that had no name.

Art could have been created by some benevolent God with Alice in mind, for, at its center, art is the cultivation and celebration of self. It exalts the individual's perception of the world and declares it to be valid. It allows a person to step outside of the life that others have ordained and create new worlds, subjective realities whose shapes and very essences exist to be responsive to their creator's touch. Art is power and control and freedom. As Alice later said of her art, it "was my world. It was mine."[30] And, of equal importance to Alice, it was outside the bounds of the puritan ethic, a hole through which she could escape. "The moment I sat in front of a canvas, I was happy. Because it was a world, and I could do as I liked in it."[31]

Alice drew and painted in watercolors in her spare time—nothing serious, not enough to alarm anyone. Her mother was not opposed to art, as such. She simply did not understand it, although she most likely believed that it was at best frivolous and at worst immoral. Alice was careful never to give the appearance of being too interested, so no one suspected that the innocent, if silly, act of drawing was what gave Alice enough reinforcement and satisfaction to conform during her days at work.

From 1918 until 1921, Alice spent her days working as a clerk for the Army Air Corps in Philadelphia. By all of the "conventional" standards of measurement, Alice's transition from high school to the "real" world was quite successful. She earned a very high mark on the civil service examination and landed her first job immediately as a typist and filing clerk. Her wages of twenty-two dollars a week were "considered very good money."[32] Living at home, she supplemented her family's income. The play of life progressed through act one as it had been written for tens of thousands of women.

But Alice began to ad lib. She discovered that she could take classes in the evening at the School of Industrial Art, and signed up to take drawing

classes and a painting class at a center city Philadelphia school.[33] These were the first formal art classes that she had ever taken, and, although the teaching was mediocre, she juggled an exhausting schedule in order to maintain her tenuous liaison with art.

During her day life, she did not talk about her painting; during her long evenings, she was able, at least for a few hours, to forget about her mundane days. During her day life, she moved up from job to job within the civil service, up at least as far as money went—to thirty-five dollars a week by 1921[34]—but during the evenings she saw her dream of working seriously at art evaporate disappointingly into the blur of the chronically exhausted.[35]

Alice's complex schedule collapsed when she had a run-in with her art teacher. He gave her an instruction on how to put in the hair on a portrait. She replied, in perhaps her first contrary statement to an adult in her life, that she did not want to do it his way. He warned her that before she could conquer art she would have to conquer herself, and she told him that before he criticized her he should remember that he was only her "beginning" teacher.[36] In defending her art, Alice took her first stand against an authority figure. The assertion of her will filled her with scary, conflicting emotions, with fear and pride. Normally she would have acquiesced and changed the way she painted the hair, but she could not. Somehow the point was too important.

The incident nudged her to quit school. She may have been frightened to go back, but more likely she was genuinely angry and not willing simply to repress it. But leaving school also signaled exhaustion and frustration, not a lessening of her still-secret intention to become an artist.

Her blowup, however, forced her to decide if she was an artist or a terminal civil service worker. In early 1921, Alice was twenty-one years old. Her skill and attitude almost insured that she would rise within the civil service. The prospect scared her. When a new job in industry came available in Swarthmore, Pennsylvania, Alice quit her job and applied. As usual, she was very impressive in the interview, and she was offered the position. But when that job was offered to her, the starkness of the life that would follow her acceptance loomed larger than life across the horizon of her future.

She almost collapsed at the prospect, for it clashed violently with her vision of how, deep inside, she wanted her life to unfold. That vision did not include work as her parents would define it. Her admission of "how

discontented she felt just going to work every day"[37] startled her, not just the idea itself, but the revelation that she was capable of admitting the idea to herself. But the difference between not wanting the job and not taking the job was as vast as an ocean separating two continents. If she behaved as she always did, she would do the right thing and accept the job even if it meant repressing her own desires. Her first real act of independence was writing to the company in Swarthmore and turning down the job offer.

As she neared her twenty-second birthday, Alice was, by traditional definition, an unemployed spinster, living at home, too beautiful not to have been three years married and twice pregnant—unless, of course, there was some sort of "problem" with her. There was one. She wanted to go to art school. It had taken what was for Alice an unreproducible amount of courage to leave a respectable position and a dependable, not insignificant, income; she left herself insufficient courage to take the next step and enroll as a fine arts major in an art school. Her mother would not have accepted that, or, more likely, Alice felt so guilty enrolling in art school that she would have deferred to her mother's wishes without a word spoken.

She was, however, able to convince her skeptical and naturally concerned mother to allow her to delve into her savings for the princely sum of one hundred dollars for a first year's tuition at the Philadelphia School of Design for Women. Alice, ever the supplicant, told Mrs. Neel that it was a practical choice, that the school was for women like herself to learn a good skill that would help them in life. The catalog said that the School of Design was noted for having graduated over "11,000 women in the practical arts," primarily in interior decoration, furniture design, garden architecture, textiles, and illustration.[38]

Mrs. Neel relented, so Alice, three years out of high school, once more became a full-time student, again in a practical field. She enrolled as a student in the Department of Commercial Illustration. But what Alice didn't mention was that the School of Design also had a small Fine Arts Department.

POOR LITTLE
RICH GIRL

3.

W h i l e Alice was brooding her childhood summers away on her
front porch, acquiescing to the conspiracy of class, family, and town that
shrouded her life with a pall of boredom, Rhoda was fighting her way
through a childhood of summers that were too structured and too de-
manding.

On the first Thursday of every June, her parents hired a private coach
from the Pennsylvania Railroad to take their six children and their nannies
to the great house at 624 Wesley Avenue, Ocean City, New Jersey, the
estate of Rhoda's maternal great-grandfather. There they would stay until
the last Thursday of September, when the social season at the shore ended.
For four months, the Myers family would adhere rigidly to the conven-
tions that governed life and regulated relationships among the summer
community of Philadelphia "society."

Rhoda's typical summer day began with a loud, and often combative
sibling breakfast, almost never in the company of her parents, who broke
their fast alone. The nannies then dressed the three girls and three boys in
starched whites for the walk to the beach. At the beach house, the nannies
changed them into their swimming attire, long trunks and shirts for the
boys, one-piece costumes with skirts, stockings, and bathing shoes for the
girls. While their mother sat in the pavilion or under her ever-present
parasol, always at a comfortable distance from the noise and demands of

playing children, and gossiped with the other mothers, the nannies supervised the children as they played in the sand at the edges of the surf, then dressed them, and took them home for lunch and mandatory rests.

After having been dressed again for the afternoon outing, all of the children would be entertained by their nursemaids with a walk along the boardwalk or a ride on their ponies, or, on rainy days, with games. They would all return in time to dress in more appropriate attire for dinner. Their lives, to Rhoda, seemed always governed by activities arranged by a bewildering variety of adults, for which she was forever changing her clothes.[1]

Formal and structured, Rhoda's summer days were worlds removed from Alice's. Nevertheless, shared remembrances from their disparate childhoods sprang from those hot months that separated one school year from the next. Just as Alice detested the summers of her youth, Rhoda loathed hers!

Outsiders, when observing someone else's life, are restricted by their vantage point from seeing little more than events and artifacts. A voyeur of Rhoda's early life, watching from the distance that space or time imposes, could easily be seduced into romanticizing, in sepia tint, turn-of-the-century summers spent riding a Shetland pony on the grounds of an ancestral estate, taking dignified strolls with a corseted mother along the parade grounds of the boardwalk, or touring in the jump seat of the island's first automobile as it traveled to a great-grandfather's plantation in a town that bore the family's name, Somers. Rhoda's life was full of events and cluttered with the artifacts of the rich. The stables contained two stallions to draw her mother's carriage, all brought, along with the trunks, the dogs, and the cats, on a rented baggage car. Once a summer, her father would rent a sailboat, with captain, to take the family crabbing. If the weather turned unexpectedly chilly, they would send to Philadelphia for their fur coats.[2]

But Rhoda, as a child, was unable to stand outside of her life and marvel at its elegant exterior. As a participant, she lived with its rigidity and formality, with adults behaving with numbing repetition, acting out lives that were imposed upon them by the unseen hand of convention. Like Alice, she lived under the oppression of boredom. The taboos that restricted Rhoda's freedom, however, were not those quaint, plebeian moral strictures from some lengthy puritan codex, but the hundreds of rules of etiquette and proper social behavior that allowed life among the rich to be

carried out with a minimum of thought or embarrassing individualism. Wealth creates its own forms of tyranny.

If Alice remembered most fondly the color of summer, Rhoda's cherished memories were of the few free and unstructured times, occasionally mischievous, always spontaneous—sailing toy boats in the basement when it flooded, climbing onto a fence and peeking into the embalming room of the local undertaker on a dare, racing crabs along the kitchen floor after their annual outing, the one time they were allowed in the kitchen to fraternize with the black cooks and get their hands dirty.

Rhoda loved to visit one particular aunt's house because there she was allowed to go barefoot outside and on the first floor, both prohibited in her great-grandfather's house. For a similar reason, she greatly envied one of her acquaintances who was allowed to eat lunch while wearing her bathing costume. Rhoda's mother told her that they were "common" types who did such a thing, but Rhoda was not listening. She grew to think that living in Ocean City "on the wrong side of the tracks could have been fun."[3]

What for most people are everyday acts—wiggling one's toes in the sand or running out after lunch for another swim—were forbidden her. Occasionally, Rhoda's father would take the older children back to the boardwalk in the evening for ice cream or, if they all dared, to the new cinema. Then the dress was casual. But such times were all too rare. As a consequence, simple things assumed great status in Rhoda's life.

The summers, however tedious, were at least played out with a modicum of civility. Back home, in the elegant Overbrook section of Philadelphia, away from the intolerant presences of tradition and convention, the Myers family fell apart. They lived much less structured lives, but, as the imposed formality lessened, the distances that separated father from mother, sibling from sibling, and parents from children, seemed to lengthen. Without the benefit, or the excuse, of rigid definition, the multiple relationships within the family had little to hold them together. These estrangements, interlocking in Byzantine fashion, grew to become the signal characteristic of the Myers family, its curse, the cause of its slow emotional death.

The marriage of Rhoda's parents might best be compared to a merger, the choices made and the arrangements finalized because they were inescapably logical, beneficial to both parties, and acceptable to both parent companies. Her mother, Nellie Somers Haddock, was descended from the

brother of the naval hero, Richard Somers, who sacrificed himself and the *Intrepid* at Tripoli in 1804, and from the settlers of Somers Point and Ocean City, New Jersey. Nellie inherited her fortune from her grandfather, Captain John Somers, by whom she was raised and to whose house she brought her family in the summers.

Nellie's mother, Emma, was from a family that was not as wealthy as the Somerses, but eminently respectable. The grandaughter of Jno Haddock, the distinguished and conservative editor-in-chief of the *Philadelphia Press*, Emma died of pneumonia when she was twenty-six and when Nellie, an only child, was only three years old. Her grandfather, a widower, physically removed her from her father, who had the bad timing to be engaged in an affair at the time of his wife's death, and consequently became a leper in the Somers household. Captain Somers simply told Nellie that he was dead. She never saw him again.

Thereafter, Nellie's paternal family, the Haddocks, played no role in her life. The only evidence that she had a paternal family was a single portrait in her home of her grandfather, Jno Haddock. It hung in the attic.

Nellie also grew up without a strong maternal presence. Family legend had it that Captain Somers compensated for the loss of her mother by indulging her every wish, or demand, and that she grew up as a "spoiled, strong-minded child" who was "quite a problem for the staid old sea captain to handle." Legend also hinted strongly that Captain Somers arranged with the Myers family to marry off this "beautiful, high-spirited girl" at an early age, before she could get into trouble.[4]

The man to whom she was entrusted, or to whom she was abandoned, was named William, the quiet, undemanding son of Jacob Myers, a Philadelphia builder who had pieced together, by hard work and shrewd business acumen, one of the largest construction companies in the city. Lacking the pedigree of the Somers family, the Myers were nonetheless a socially acceptable family, for Jacob had earned an admirable reputation among the monied community of the city by building such structures as the Federal Reserve Bank, Jefferson Hospital, and St. Joseph's College. Jacob and his wife resided in a stately stone house of towers and stained glass windows in the prestigious Main Line suburb of Ardmore. Although they did not live on the scale of Captain Somers, their needs also were catered to by servants, cooks, and a coachman.

Both families arranged for the financial well-being of the young Myers clan as it grew. Captain John Somers, who died while his great-

grandchildren were still young, left his fortune, almost entirely tied up in income-producing property in Ocean City, most of it land, in a trust for his great-grandchildren. As trustee, Nellie received four checks a year from the estate as well as holding in trust the family house at the shore. Jacob Myers employed Rhoda's father and his two brothers at a larger than normal income, and always planned to make them partners in the business, renaming it "Jacob Myers and Sons." Rhoda's parents began their married life financially comfortable, with the prospects of enjoying lives of wealth and luxury.

Rhoda and her brothers and sisters were born in a three-story house of thirty-two rooms on Woodbine Avenue in Philadelphia. She was the fifth child, but the first to be, she thought, unwanted. Rhoda was born in 1902. She followed two girls, Grace and Lorine, and two boys, Somers and Russell, all four born closely together so that their mother would regain her girlish figure quickly. Rhoda came after a gap of four years. Her younger brother, Malcolm, was not born for another five years, but, for reasons she did not understand, he seemed to be more than wanted. He became the center of adult attention.

Her childhood home was staffed with a cook, two maids, and a live-in nurse during times of illness. All of the children attended the most select and expensive private schools. They possessed ponies and wagons and, during the daytime, each child had a nanny with whom to play.

What was missing from the family was the core. At the center of this stately household was wood rot. Rhoda's mother should not have had children, for she herself was a child who spent two families' fortunes to indulge her passion for the public presentation of herself.

Show was everything. Nellie Myers's primary concern in life was her appearance. She was always beautifully and expensively dressed, always patronized the most expensive dressmakers and tailors. Her outfits perfectly matched—gloves, shoes, purse, jewelry, and hats. She prided herself in not attending her beloved card parties in the same outfit twice, and she played cards every afternoon![5]

Hosting these card parties was her second extravagance. On those days when it was her turn, she prepared by purchasing new cards, new table linens, new crystal, and new silver. Displaying her children, coordinated in their costumes when they went out, always dressed just right for the occasion, the boys in tailored suits, the girls in gauzy, lacy dresses, was her

third indulgence, or, more accurately, an extension of her first two extravagances, for finely dressed children were part of her presentation of self.

Nellie absorbed from her cultural milieu the definitions of what a lady was, and then organized her life around being the quintessential lady, proud and pompous, assuming that everyone watched her and either admired her or wanted to possess her. She was a beautiful woman of great charm, but even greater vanity. Despite the fact that her feet were size five and a half, she insisted on wearing size four shoes. She stuffed her feet into her fashionable shoes and then had a podiatrist visit the house once a week to treat her swollen, aching feet. The suffering and the inconvenience were simply the price that one paid in order to keep up appearances.

Long before anorexia nervosa was named, insecure women like Nellie Myers were torturing their bodies in order to satisfy a deeply embedded need to possess a negligible waist. Once, when there was a fire at the Ocean City house in the middle of the night, Nellie awoke and rushed outside with the children, then returned to the house while it was still blazing, and saved her corset.[6]

Rhoda grew up with a mother for whom social position was the hungry god in the temple, needing always to be fed. That meant appearing at the right places, going to the right tailors and seamstresses, and entertaining the right people. Almost always forgetting to leave the cooks instructions for the children's lunch, she would wobble out to the hired car to be whisked away to someone's house for the afternoon or, on those occasions when she entertained, would spend her mornings at home, in the parlor, "taking short, slightly limping steps" and breathing short, corseted breaths, as she choreographed the staff, which for these occasions included a hired butler, arranged her flowers, which on standing daily order were delivered from an exclusive downtown shop, or shuttled the small children at home off to banishment on the third floor, so they would not be seen in ordinary play clothing.

The expressionists, then beginning to redefine the world, would have identified Nellie's life as a bourgeois façade. Freud would have guessed that the façade masked a darker world from public view. Both would have been right. Behind the sententious stage flats, hidden from the view of the audience, a play was being performed that was tragic, more like the brooding work of Chekhov than the civilized Oscar Wilde play being shown to the public. To keep herself stage center, in front of the foot-

lights, Nellie, backstage, tyrannized her husband, manipulated her children, and squandered their inheritance.

First was the matter of money. Rhoda and her brothers and sisters not only grew up wealthy, but assumed, with childish trust, that they would always be rich. Captain Somers's complex estate had been designed for one purpose—to provide comfortable lives for all of his great-grandchildren. Nellie was to be given use of the house in Ocean City until her death, and, along with a bank, was to administer, on her children's behalf, the income from the land in Ocean City. At her death, the principal of the estate was to be divided among the great-grandchildren. By the time Rhoda was sixteen, her mother not only had spent all of the annual income from the estate, but had consumed much of the principal. She systematically sold off almost all of the Ocean City properties except the family house and those that were locked up too tightly in the trust, and spent all of the proceeds.

Her grandfather had lived very comfortably on the income generated by his investments; Nellie found herself unable to make ends meet from one quarterly check to the other. As bills accumulated, Nellie chose destructive responses. She made a game for the children of running to meet the mailman down the street, take the bills from him, and secrete them to her through the back door, all in order to avoid one of her husband's "scenes."[7] When creditors pursued her, and this was one of Rhoda's clearest memories, Nellie hocked some of her jewelry, paid off the most pressing bills, and then retrieved the jewels with the next quarterly check from the trust.[8] However, four times a year, when the checks arrived, she would go on buying sprees that would keep delivery vans parading in front of the house for days. One time, Nellie received a nine-thousand-dollar inheritance from the Haddock family and spent it within a month on furs, jewelry, and Oriental carpets for the card parlor.

As the Somers money dwindled, Rhoda's parents' marriage sagged, for Nellie began to try to plunder the Myers treasury as well. The marriage had never been a passionate union, or even a loving one. By the time Rhoda began to absorb memories into her mind's porous surfaces, the marriage was already a sham by any other measurement than appearance. One of her earliest memories was her mother telling all of the girls that the only purpose of their father was to provide them with money.[9] Lorine, Rhoda's sister, used to go with her mother from store to store all day, buying anything that was in the way and having it charged to her

father, almost with a vengeance, as if, along with her mother, she were fighting a war with money.

Nellie fought her war with William on other fronts, also. At home, she ignored her husband, treating him with open contempt and carrying on a long affair behind his back, an affair that secretly produced the sixth child, Rhoda's younger brother, Malcolm.[10] While she catered to her father-in-law, Jacob, and insisted that the children visit him every Sunday, "because he had the money," Nellie made it a point to diminish her husband in the eyes of her children. She was always tastelessly complaining that he was a crude male who only wanted "one thing" from her. She slept in a separate bedroom during the last ten years that he lived at home, until 1918, when Rhoda was sixteen, and kept her oldest son, Somers, in her bed. Nellie also used her teenage son as, in Rhoda's words, "sort of a gigolo," making him take her out to the theater or to concerts, places where a "lady" needed an escort.[11]

The "enemy" in this melodramatic parental war, Rhoda's father, William, made scarcely an imprint on her childhood. He was an indistinct figure who, in memory, became a blurred photograph. During her childhood summers, he sometimes took the children to the Ocean City boardwalk in the evenings, as if removing all of them from their mother for a few stolen moments of mindless fun, and treating them to a movie while he indulged himself by playing shuffleboard with the other fathers, bribing the children into silence with ice cream.

Back home in Philadelphia, he was largely absent from the house and from Rhoda's life. He was the payer of bills whose stock response was to complain, as a man with a chronic backache, but whose only defense was to utter, passively, what Rhoda took to be a prayer, "Come day, go day, God bring Sunday. Bills! Bills!" in hope of hastening that one day when the stores were closed. To his children, he would often say, with a kind of fatalistic resignation to each freshly lost battle, "Some day you will know the true story."[12]

While her father was alive, Rhoda did not uncover the meaning of his cryptic prophecy. While she was growing up, she felt very little toward him one way or the other. She believed he was stingy because that is what her mother etched into her mind, but the only response he seemed to generate was bafflement. He was a man who paced in front of her mother's bedroom door, massaging himself (or, as Rhoda remembered thinking at the time, "loudly scratching his upper leg"), and protesting.[13]

Rhoda watched the war being fought from afar, at first as a detached observer, then as a victim. She watched as mother and father absorbed fresh troops into their ranks, mother winning over Grace, the oldest girl, and Somers, the oldest son, father taking in Russell. Sister Lorine tried to get along with everyone, the suffering servant. Mother and father fought viciously for the affections of Malcolm, adored by both, a grotesque irony since Mr. Myers was unaware that he was not the biological father. And Rhoda? Her most profound perception was that she was not wanted by either parent. This belief shaped her childhood.

Rhoda was five years old in 1907 and fascinated by the novelty of her mother being pregnant. But she could not understand why her mother was looking forward so much to the birth of another baby because her mother had told her so often that she had neither planned nor wanted Rhoda. "She always said that she did everything she could not to give birth to me," Rhoda once wrote, "and after I came anyway she never hugged me or kissed me or allowed me to sit on her lap unless there were visitors."[14] Reminded always that she was the ugly duckling of all the children, Rhoda grew to understand that if there was to be a place in the world for her she was going to have to fight for it.

While still young, Rhoda entered the ongoing family war, carrying out, "in a child's way," a guerrilla campaign to make her mother regret "even more my birth." If her mother and her mother's card-playing friends thought that she was an "ornery, contrary" child, then, as Rhoda later recalled, "you can bet I showed them how right they were every chance I got."[15]

Her "attacks" were of two kinds, those that were intended to frustrate her mother in her impatiently carried-out mothering tasks, and those that embarrassed her mother in front of her friends, her most vulnerable points. Rhoda wet the bed until she was seven, on purpose. At bedtime, Nellie would put Rhoda on the toilet, shake her, and order her to "wet, wet." Rhoda refused, holding in her bladder until she had been dragged to her bed. After her mother left the room, Rhoda would empty her bladder. She always said that she did not mind the discomfort because she knew that her mother would be livid in the morning.[16] Continually told that she was a spiteful child, she became spiteful.

Rhoda also learned at an early age that it was exceedingly important to her mother that the children reflect well on her when in public. Nellie put so much emphasis on show that she rendered herself vulnerable to Rhoda's

precocious sense of revenge. Once, at the wedding of her aunt, Rhoda, who was then six years old, served as the flower girl. She behaved impeccably during the wedding, and, as the guests complimented her mother, Rhoda was summoned, she supposed, so that her mother could take the credit and divert some of the attention to herself: "My mother was sitting along the large bay windows with the other guests, looking her usual beauty, and dressed in a pan velvet light blue dress. I walked outside, then rushed up to her and climbed on her lap and deliberately wiped the soles of my shoes up and down the skirt of this lovely blue dress."[17] Rhoda knew that her mother would be unable to retaliate because Rhoda was being so apparently affectionate, and poor Nellie would have to suffer the humiliation of walking around the rest of the afternoon in a soiled dress.

If Rhoda had been a lower class boy, she would have become a gang leader, the "streetwise" kid who figured out the angles. From her many clashes with her mother, she discovered that she could get attention by being a nuisance "to whoever was available." Her grandfather, Jacob, usually offered her a quarter if she would "just sit down and shut up for five minutes." At the exclusive Miss Wright's School across from Bryn Mawr College, her teachers always singled her out for her lack of cooperation and reported her disruptiveness, which settled over a classroom as a constant struggle of wills. She was, by her own admission, a square peg in a round hole and her mission was to make everyone understand that.

A second discovery about how life works emerged more slowly, but took hold of her at a deeper level. She learned that while being ignored or rejected by her parents made her feel alienated, their neglect also gave her a great deal of freedom. From the time she was seven or eight, Rhoda stopped trying to punish her mother, and began to ignore her, not because she felt any diminution of hostility, but because she learned that her mother would make no demands of her if Rhoda but stayed out of her way, that Nellie did not really care what she did so long as she did not interfere with her life or embarrass her.

After that discovery, Rhoda said, "we really managed to get along very well because neither was restrained by love for each other."[18] Through mutual benign neglect, the two crafted a truce that both could tolerate, creating a condition that Rhoda, as she grew older, was able to redefine into a virtue. As a defense mechanism, Rhoda elevated an unhappy arrangement to the level of idealized status. Simply, she convinced herself that because she was not loved, she could act as she chose without

fear of hurting anyone or feeling guilty because she might hurt some-
one. There was no one to hurt. For her, rejection was rearranged into
freedom.

Armed with this convenient explanatory device, Rhoda worked out her
adolescent identity. She became the outsider, independent and free, who
could rebel without consequences against anyone who threatened to re-
strain her or otherwise interfere with her freedom. Like anyone who
converts a disability into a virtue, Rhoda wore her freedom like a badge.
She stopped going to Sunday school. But not quietly or secretively. Her
parents did not go to church, but insisted that the children attend the
Sunday school of a Presbyterian church that was a trolley ride from their
house, then walking distance to grandfather Myers's house. Along with
the others, she took the trolley to the church, but then stayed outside,
sometimes right outside the window of the Sunday school class, and then
walked to her grandfather's house to let him know that she was not in
church. The minister's inquiries about Rhoda's absences died, un-
acknowledged.

Rhoda also began a pattern of working on her assignments at Miss
Wright's School in fits and starts, according to some mysterious internal
set of needs. By the time she was fourteen, she had stopped doing her
assignments altogether, and her mother preferred to allow her to fail
courses quietly, rather than threaten a confrontation with Rhoda or,
worse, a scene with her teachers. Rebellion became a source of power as
well as independence.

No child, however, grows up rebelling against everyone and every-
thing. Rhoda was strongly attracted to several adults as she grew older, all
of them, considered in retrospect, sharing two characteristics: They all
loved art, and each of them made Rhoda feel important.

Her favorite adult was her mother's aunt on the Haddock side, the black
sheep side, one of the few members of Rhoda's family who was not
wealthy. Aunt Mary lived in a single room in the déclassé Powelton section
of Philadelphia, and taught piano for a living. What impressed Rhoda most
about Aunt Mary was her unconventional view of life; she dressed "color-
fully" in full wool skirts and puffed-sleeve jackets, and she always wore
hats decorated with a wildflower or pussy willow or holly; she took Rhoda
on walks in the woods to gather wildflowers; and she talked confidently
about a range of subjects. Rhoda thought that her life-style, living alone

and playing classical music on the piano, was "romantic," and she was proud that Mary "seemed to like me best of us six kids."[19]

The gulf of understanding that separated Rhoda and her mother was epitomized in their views of Aunt Mary. Nellie always made fun of Rhoda's aunt for exactly the reasons that caused Rhoda to admire her: She had no husband; she had to work at a menial task in order to scratch out a meager existence; she dressed funny and wore those outrageous "things" in her hats.

The second woman who influenced Rhoda positively was also unmarried. A teacher at Miss Wright's School, she was "the only human being who seemed to guess the fact that I was neither stupid nor dumb." Miss D. had had a sister who had been an artist, but who had died at an early age, and she may have recognized in Rhoda those artistic qualities that she had seen in her sister, but that the other teachers saw only as rudeness— that is, independence, impatience, and imagination. Miss D. took Rhoda to her home occasionally, where the grown-ups talked in ways that Rhoda never experienced at home, and she once impressed Rhoda immensely by scolding her for not eating the crust on her bread, reminding her that there were people in the world dying of hunger. At home, no one cared what or if she ate. Not only did Rhoda interpret the scolding as affectionate concern, she was startled by the image of starving people. "This was the first time," she wrote later, "that I ever even thought there were other people in the world, I was so busy fighting for my spot."[20]

The third woman to influence Rhoda was married, but she was a loving wife and an accessible mother. She was also a devout patron of the arts and a sponsor of many painters, authors, and musicians. Rhoda came into contact with Mrs. Joseph Lynn because Mrs. Lynn held an open house every Wednesday afternoon and Rhoda would trail after the two Lynn girls from Miss Wright's School to stand in the doorway and peek at the celebrities who gathered for tea. Mrs. Lynn would "allow us in if she felt there was some one person we should meet."

These adults talked with Rhoda in ways that her parents never did, and behaved in ways that were unfamiliar to Rhoda. They talked about art and literature, men and women together, as equals. And Rhoda was overwhelmed by the contrast: "The Lynn household was so completely different from my home with card-playing parties, gossiping ladies playing bridge and all outtalking one another."[21]

Mrs. Lynn began to include Rhoda in many of her daughters' activities. With the Lynn family, Rhoda attended the theater, the opera, and concerts of the Philadelphia Orchestra. When Mrs. Lynn purchased several books from a local artist, Joseph Pernnal, she bought a set for Rhoda. On those weekends when Rhoda was invited to stay over, she always found on her night table "just the right books," and was flattered that Mrs. Lynn "instinctively knew I was a future artist."

Rhoda, however, could never remember when it was that she realized she wanted to be an artist. Other artists, like Georgia O'Keeffe or Alice Neel, remembered clearly loving to draw from an early age and thinking that they had always wanted to be painters. The awareness seems to have grown in Rhoda slowly and dawned on her late. And her path to that awareness may not have started with a love of drawing so much as with her fierce independence.

If art is an outlet, a sublimation, Rhoda may have gravitated to it because it was a clear form of rebellion from her parents' world, yet acceptable to those whose opinions of her mattered. Artistic sensibilities and Rhoda's sense of the artistic life-style might well have been, initially, more attractive to her than the actual creative process of producing art. If the few sympathetic adults in her life attributed her behavior to an artistic temperament, Rhoda may have begun to accept their explanation. Certainly, her adult models manifested those sensibilities.

By the time she was a teenager, in 1915, Rhoda had begun to think of herself as an artist. Up to that point, unlike Alice, she had not lived a secret life through her art; she used to play "for hours on end" with paper dolls, fashioning paper houses and cutting out furniture from magazines, and then making up elaborate stories about the families she created. Her favorite heroine was a "greatly loved crippled child." As for drawing and painting, she seems to have developed a love for them after she understood that her place in the world was as an artist, independent, single, and unconventional. She knew that she wanted to lead a life that was uncluttered with possessions and free from hypocrisy and acrimony. Hers would be a happy, unfettered life, as different from her childhood life as possible.

Circumstances became her ally. In 1918, just after she turned sixteen, two of the gathering storms in her life matured in confluence and burst. Her father finally mustered his courage, or his rage, and moved out of the house, threatening divorce proceedings. He declared that Nellie would no longer have access to his family's money, leaving her to live on her Somers

inheritance. Shocked and outraged, Nellie refused to acknowledge that he had left or that her income had been reduced. She screamed anger down the hallways to no one in particular, perhaps her most mature response to having been deserted. Within a few months, Nellie virtually declared bankruptcy, a desperate act signaled by her sale of the Somers home in Ocean City, and the distribution of the money among a larger than usual army of creditors.

To most teenagers, the dual disintegration of family and fortune, as if in an eye's blink, might well be disasters of holocaustic proportions. To Rhoda, however, the prospects of divorce and what her mother called poverty were twin benevolences granted to her by some god with a sense of poetry as well as justice. While she never intimated any satisfaction at seeing her mother brought low by her own hand, Rhoda always attributed to these events a fundamental shift in the fortunes of the family away from her mother and toward her, from strictures to freedom, from money to art.[22]

Nellie fell almost immediately into rough waters and was buffeted by mean winds. Trying to navigate unfamiliar seas without having been trained when to tack and when to trim her sails, she floundered and almost sank. Having sold the house in Ocean City, Nellie should have learned from her crash course in experience to pull back, to try to budget her remaining resources, most of them now jewelry. Instead, she seemed almost to double her efforts to keep up appearances so that, like a child, she might change reality by denying it, or at least hiding it from the neighbors. Soon after, in the fall of 1918, she was forced to sell the house in Overbrook and buy a house at 424 Wister Street in Germantown, a much less fashionable part of the city. The move affected Rhoda scarcely at all; she said only that it was "very agreeable" to her.

There would be no more dreaded summers in Ocean City, for which she was very grateful; there would be no more formality imposed by social competition, at least at the levels that Rhoda found suffocating; and, most importantly, there would be no more private school.

Rhoda credited her own perverse willpower as the force behind her expulsion from Miss Wright's School. As she remembered the events, she simply served her time until she could engineer her escape. She worked hard, she said, "to fail every subject until I got to go to art school." In truth, her mother could no longer afford the luxury of private schools,

and her father, who had moved into a room in the center of the city, would pay only for his beloved youngest son, Malcolm, to attend private school, the very expensive Penn Charter School. By 1918, when these dislocations rippled through the family, Rhoda was the only other child in school, so her father's decision left her out in the cold. While she was hurt to be the forgotten child again, she worked her usual mirror tricks and saw the bright side. At sixteen, she had been relieved of three more years in her exclusive prison.

Also working in her favor was the family's dread of public schools. No Myers or Somers had ever attended school with the masses, so when Rhoda suggested an inexpensive alternative, her mother rushed to accept, to avoid the stigma of having a child in Germantown High School. Precocious and resourceful, Rhoda searched until she found an art school in the city that admitted girls from age thirteen and that required no previous knowledge of drawing, the Philadelphia School of Design for Women. It cost only one hundred dollars a year, and, as an eighty year old, she recalled, "To art school or wherever, it was like sending me to the sun as far as mother was concerned."[23]

Bypassing her final years of formal academic education, Rhoda began her first formal education in art, not even knowing if she could draw, and, perhaps, at that point in her life, not yet caring. She felt only relief as she deposited her childhood on the steps of the converted Broad Street mansion and, like an immigrant from a war-torn country seeking sanctuary, rushed eagerly into a hopeful future in a more hospitable land.

A PARTING

OF WAYS

I n 1918, at the same time that Rhoda was fleeing Miss Wright's School, Alice was graduating from Darby High School. On opposite sides of the city, on opposite sides of the tracks, the two girls prepared for the next phases of their lives, Rhoda with unparalleled excitement, Alice with a grim fatalism. And their experiences over the next three years justified Rhoda's hopes and Alice's fears. When they met, in 1921, Rhoda had, at least on the surface, shed the baggage of her journey through her youth while Alice limped imperceptibly into the School of Design still entangled in the octopus tentacles of her mother's domination.

Their early lives dictated that Rhoda would lead during those first years of their friendship and that Alice would follow, that Rhoda would teach and Alice learn. Alice lacked her friend's vivacity. She was unable to duplicate the way that Rhoda dealt with her mother. Could she imagine a child challenging her parents' authority? The idea of rebelling against them was as foreign to Alice as the idea of growing up with house servants. And while she, along with everyone else, laughed at Rhoda's stories about soiling her mother's dress or sneaking her mother's bills into the house, Alice must have listened with a mixture of shock and greed when, in unguarded moments, Rhoda's ribald tales grew serious or slipped into surprisingly venomous remembrances of her mother.

★　★　★

It is impossible to know exactly when another person's emotional responses to the world veer off course and sail into uncharted waters. Most people are probably unaware when it happens to themselves. Ideas that have been accepted for a lifetime no longer ring true. Authority figures begin to look tarnished. An evolutionary process, which has taken a lifetime to unfold, grinds to a stop, then changes course so that it begins to move, with the same slowness, in a new direction. New attitudes have to form and mature; new behaviors need to be tried out and tested.

The profound changes that would, one day, create the Alice Neel who defied convention with vengeance probably began to germinate during her first years at the School of Design. It was through her developing relationship with Rhoda as well as with art that she began to make the connections that would one day play such an important role in her paintings and her life: the connection between authority and hypocrisy, repression and unhappiness, rebellion and freedom.

At one level, Alice's and Rhoda's relationship was delightfully superficial and undemanding. At the level of their art, it was more involved and more rewarding. But to penetrate beneath those comfortable surfaces took time. Neither Alice nor Rhoda wanted to have serious discussions about life and relationships and families. Ethel, who was still quite close to her parents, especially her father, did not intrude on the safe nature of the evolving relationships because she rarely initiated anything. She was content to follow.

Rhoda did not let the full scope of her complex emotions regarding her mother intrude on her friendship with Alice until Alice's second year at the school, maybe then for her own reasons, maybe because Alice asked her. Rhoda's story about her rebellion against her mother certainly contributed to Alice's beginning to act in ways that ran contrary to her upbringing, for it was that spring of 1923, when Alice was twenty-three and in her second year at the School of Design, that she began to insist on having her way.

Not surprisingly, her first real expressions of independence appeared on canvas, for it was there that she was learning to assert herself. Her sense of ownership over a canvas invested her with a confidence she did not yet possess in "real life," a confidence that helped her to feel "free and powerful." During her first year at the School of Design, she had accepted without question the assignments given to her. By the end of her second

year, she was ignoring many of the strictures placed on her painting by her teachers.

Henry Snell taught still-life painting. He was a kindly old man whom most of the students called "Uncle Harry" because of his comfortable demeanor, his cardigan sweater, his thick Kaiser moustache and his ever-present curved pipe. Henry would not allow his students to use black.[1] Alice began to paint with black. He used to stop at each student's easel and suggest changes. Previously, Alice had faithfully made the changes, but no longer. Once Henry told her that her painting contained too much horizontal line and proceeded to add some vertical lines. He walked away. She erased them.[2] Eventually, Henry Snell stopped making suggestions. He would walk around the studio commenting on the canvases and offering encouragement, but when he got to Alice's station, he just nodded and walked on without saying a word.[3]

Alice had to pay a price for her small disobedience. Many of the students, either in awe or shock, discreetly distanced themselves from her. And Snell, who took a group of his better painting students to his cabin in Maine during the summers,[4] did not invite Alice. But Alice was willing to suffer the consequences, because her art was important to her. It was the one area where she could take some control over her life, where she could rebel and express her infant, but growing, sense of self.

When she asserted her independence as a painter, Alice was not being petulant as much as impatient. After nearly two years at the school, she had progressed to the point where she felt confident in her judgment and talent, and she had begun to think that the school was not preparing students to become serious artists. Alice became either good enough to realize, or bold enough to admit, that she considered the school to be a "conventional" place, run by a "conventional" lady, tradition bound, and unimaginative.[5] Where once Robert Henri had stressed the need for painters to embrace "a fresh, new concern for everyday objects and an awareness of new trends in painting," Harriet Sartain gently reminded her "girls" that art is nothing more than "beauty in the highest sense."[6]

Rhoda and Ethel were the only other students whom Alice found to be serious about becoming better painters, and the only two who seemed neither shocked nor embarrassed by her actions. Rhoda cheered her on and teased her, warning that Uncle Harry would not ask her to be May Festival Queen if she wasn't nicer to him. While most of the students at

the school did not seem to drive themselves at all, let alone toward excellence, Rhoda said of the three of them, "We were really working for something."[7] The "something" was greatness. The "three musketeers," as Rhoda liked to call them, talked about setting up a studio together. They needed to learn as much as they were able. It is no wonder that the three came to depend on each other, the painters at the Graphic Sketch Club, and their own instincts for support and direction.

Their collaboration produced works that were strikingly different from those painted by the other students. In the school's catalogs for the years that Alice and Rhoda were in residence, paintings by the fine arts students were included in the spaces between the litanies of rules and the course descriptions. With two exceptions, all of the paintings were portraits executed according to the style of the academy—heads of Indians and old men and austere women, or still lifes or landscapes—all quite conventional, and executed cleanly, without brush strokes to distract from the realistic effect.

Alice's figure took risks, exploring a young woman who appears to be troubled and meditative, a pensive exterior of an intriguing interior. Her deeply set, shaded eyes are downcast, her tilted head rests on the knuckles of her left hand, her disquieting presence captured not as she sat for an artist, but as she thought through some absorbing matter.[8] Rhoda's painting is a darkly shadowed urban scene, the boldly stroked paint depicting the intersection of a web of railroad tracks at a deserted rail yard at either dawn or dusk, certainly painted at a time when a respectable "lady" would not be near such a rough part of town.[9]

Ethel did not have a painting in any of the catalogs, but several paintings of this period, 1923–1925, were equally unconventional, including a bold self-portrait in the style of George Bellows, and a wonderfully innocent portrait of Alice, whom she represents as a teenager.

If art is a metaphor for life, these paintings represent independence, the ability to break away from what was taught and what was probably expected.

Alice had, of course, made what for her was a bold gesture in the direction of independence when she changed her course of study from illustration to fine arts. But, in order to avoid incurring her mother's certain displeasure, she took extraordinary pains to orchestrate her announcement. As a child, she had learned the devices she needed to reduce or deflect her mother's anger. She still needed them at twenty-two. First,

she did not tell her mother about the change for months, and then seems to have broken the news only when she was also able to announce that the Department of Fine Arts had awarded her a full scholarship for her last three years.[10] Alice probably did not think of her change of majors as an act of rebellion as much as an action that she desperately wanted to take, whatever the consequences.

Rebellions begin when denial yields to honesty. Alice's perception of the problem was most likely still very vague as her second year ended, but she had given it life. And Rhoda was the willing, enthusiastic midwife. She saw Alice as herself a long time ago when she also had lived uncertainly within the orbit of the cruel sun that had spun her off, and expressed her usual strong opinions of mothers who "try to control their kids and lead their lives for them."[11]

Alice, however, was still a dutiful daughter when, in June, Rhoda graduated. Rhoda had been awarded the school's coveted George W. Elkins Fellowship for study in Europe. Given to the graduating senior for "achievement in the Fine Arts," the year-long grant was intended to "provide Post-Graduate study in Europe" for the student who showed, among other qualities, "promise as an artist."[12] Rhoda would not only be graduating, she was about to leave the country.

There was no question about Rhoda accepting. Although she had never been farther away from Philadelphia than Ocean City, and was, frankly, intimidated by the prospect of going all the way to Europe alone, she also understood that the Elkins was the school's highest award. She felt that she deserved it because, as she wrote, with that confidence which was her hallmark, "for the five years that I went there, I was the leading art student in the Fine Arts Department."[13] And she knew that a serious artist had to make a pilgrimage to France and Italy, a rite of passage for painters who learned their craft in the adolescent culture of America. But going away to Europe meant leaving Alice and Ethel, and putting on hold their plans to set up a studio after they graduated. Also, Rhoda was unsure about living alone in strange cities and about whether she should leave Ethel without a studio mate.

Rhoda had only to wonder about such questions aloud, and Ethel mentioned them to her father, who allowed himself to be persuaded to send her to Europe for the year with Rhoda. The two women decided that there was no rush in setting up the studio, for, even if they returned after a year, Alice would still be in school. Excitedly, that unlikely duo, inex-

perienced Rhoda at only twenty-one years of age and twenty-seven-year-old Ethel, began to make concrete plans, to order steamship tickets and buy books about the great museums of Europe. As their plans fell into place, Alice's future began to unravel.

When Alice began her third year at the Philadelphia School of Design, in September 1923, she found herself alone. On 24 July, Rhoda and Ethel had sailed to France, and it seemed to Alice that they had deserted her. The school was not the same without them. The other third-year students returned to school excited over the prospect of starting life classes after two years of drawing from the plaster casts. But Alice had been painting from figures for nearly a year. The contrast exaggerated even further the gulf that seemed to separate her from the other women.

It was not only experience and age that made the difference. While Alice, at twenty-three, was older than her classmates her feelings of separation came from her sensibilities. She shared neither the enthusiasm nor the adolescent interests of the other students.

Rhoda's absence resurrected many of Alice's old insecurities. Having been raised to think of herself as "only a girl" who should be a dutiful daughter while preparing to be a faithful wife, Alice seemed to have made substantial progress toward independence during her first two years of art school. A committed "grind,"[14] she had given up men for art, almost never going out on dates and allowing herself to get involved with no one. But, her independence was more illusionary than substantial. Rhoda had met enough of her needs to patch over deep problems, but they came rushing out in the fall of 1923.

A loner, Alice did not like being alone, if "alone" meant having no one around her to nurture her still embryonic feelings of self-worth, purpose, and identity. While she had trouble actually getting close to people, she needed people—almost always men—to reinforce her fragile opinion of herself. That was almost certainly the reason she dated so much in those years before art school. When she made the decision to change her life by becoming an artist, Rhoda and Ethel assumed the role of helping Alice feel good about herself, and helped to diminish her guilt about indulging herself by painting.

When Rhoda left for Europe, she took with her that reinforcing presence. Alice soon began to feel anxious, as she used to feel in high school,

wavering in her infant belief that working to become a great artist was a sufficient reason to give up dating. Was art a powerful enough presence in her life to provide her with the strength she needed to feel good about herself? There were a lot of people in her life who wondered why such a pretty girl would want to spend her time in dreary old studios in an art school.

Alice fought private wars in the fall of 1923, and art lost. As her insecurities returned, Alice began to date again. The men in Colwyn, with whom she had had such good times while she was working, had not stopped asking her for dates when she went off to art school. She had simply stopped accepting. She again became available, and by fall her date book was filled up on weekends. The sight of Alice primping in front of the hall mirror must have overjoyed her mother. She must also have been heartened when, in the middle of the term, Alice showed other signs of returning to her senses. She began complaining about art school.

Without the distractions provided by Rhoda and Ethel, Alice came to see the School of Design for what it was—mediocre. She had lost her respect for Henry Snell early on, and in her third year she decided that everyone else there, with one exception, was "bad," "insipid," or simply "negligible."[15] She complained that they "liked pictures of girls in fluffy dresses with flowers," and expected her to do little more than pour tea at the school's many social functions.[16] The cheerful compliance of the other girls began to grate on her, and while she did not cause any outward disturbances, she withdrew again, this time not from shyness, but from disgust.

The distance that had grown up between her and the other girls was dramatized when Alice maintained even the façade of respect for only one teacher. Alice greatly admired a drawing instructor, Paula Balano. She thought that Paula was the only teacher who challenged students and pushed them to improve. She was the only teacher at the school with standards, according to Alice. The other students were almost all frightened of Paula. She often made them cry by telling them that they were all spoiled. She told them again and again that they had to suffer in order to paint, and that they had not suffered enough to be painters.[17] The teacher whom Alice thought to be a strong, determined woman was seen by the others as a bully who "wanted to pound" her knowledge into them.[18]

Most of the students were captivated by being in an environment where they were encouraged to call the principal "Aunt Harriet," and where

"Uncle Harry" played Santa Claus at the Christmas party. One earlier graduate probably summed up the opinion of most of the women when she wrote that the great delight of Henry Snell was that "he was just there, to cheer or comfort us."[19] Alice did not want to be patronized, but she did want to be challenged, respected, and admired. As she felt less and less fulfilled, she dated more and more.

Alice's life had fallen into a monotonous pattern that was numbingly unsatisfying except when she was sitting in front of her easel; then one morning in early November 1923, Rhoda and Ethel walked into the School of Design. Surprised, delighted, and, probably, like everyone else, confused, Alice joined the swelling ranks of fine arts students in the long hall who gathered around Rhoda, at stage center, like excited children greeting a returning hero after the Great War. Where had she been? What had she seen? What was she doing home already? She and Ethel were supposed to be away a year; they had been gone for barely three months.

They had been to Paris and Rome and Florence and London. They had seen the masterpieces of the Louvre and the Vatican and the Uffizi and the National Gallery. Rhoda scattered verbal trinkets of her journey to her adoring crowd, souvenirs to delight them until they, too, could experience art at the mountaintop. They had to see the Velázquez painting of Pope Innocent the Tenth if only for the vivid colors; there is no place in the world like the Louvre except, perhaps, the Vatican, not so much for the ceiling of the Sistine Chapel as for the Raphael frescoes; the Titians alone are worth the trip to Florence; but if you are tight on time, skip England— the British primitives are not worth the shilling fee, the Tate would be stronger if they would just throw out half of the Turners, and the National Portrait Gallery is full of paintings done with no imagination.[20]

But, why had they come back six months early? Rhoda had her public stories ready. Ethel was exhausted from the whirlwind schedule. Ethel got a chill in Perugia and never quite got over it in the constant dampness of European pensions. Rhoda was unable to paint because of the lack of time and her inability to concentrate. The light in Italy was unbelievable, but she was unable to capture the values on canvas. She and Ethel both missed their friends. The stories, the newly gained wisdom, flowed most of the day, until the triumphal entry gradually mellowed into quiet talk among a few friends.

Privately, Rhoda admitted to Alice that she had gotten homesick, that Italy and France were great places to visit, but that she could not imagine

living there. The people were dirty and usually rude. And as fall began to turn harsher, Paris had become bleak and soulless. In fact, Rhoda and Ethel had spent all of October in England. There, she told Alice, they found the people nice, but the place was so expensive. The art was mediocre, but London was the only city in which they felt comfortable. They did not want to go back to the continent, she confessed, but they did not want to stay in England and squander their money if they were not seeing good art. So, they decided to return to Philadelphia while she still had most of her fellowship money and Ethel her parents' gift money, and open a studio with their unexpected wealth.[21] Plan one was back on track.

Every day over the next few weeks, Rhoda and Ethel scoured the newspapers and knocked on doors to find the perfect studio. While Rhoda told Alice everything, her adventures became secondhand stories. Even when Rhoda and Ethel found a studio that exceeded their wildest hopes, Alice was unable to share that first wave of ecstasy with them. However hard Rhoda and Ethel tried to involve her in the vision of the future that the three had once created, Alice was, by circumstances, the odd person out.

The signs of a different relationship were unmistakable. *They* invited her over to see the studio. *They* showed her around. *They* stayed at the studio all day preparing it while she had to attend classes. When *they* told her about each new furnishing, she should have shared their pleasure, but as *they* grew more animated, she appeared to grow more desolate. At any other time, under any other circumstances, Alice, the artist, would have gloried in the studio, for it was more than any of them had ever hoped for, a luxury leased with unspent travel money.

They rented the second floor of one of the old colonial-period buildings that surrounded Washington Square in Old Philadelphia. The square was a romantic tree-filled park that occupied one of the many square blocks that William Penn had set aside for greenery. Located on the south side, at 622 South Washington Square, the studio overlooked the park with its intersecting walkways, lined with benches, and a fountain in the center. The neighboring row houses contained the studios of some of the city's increasingly famous painters, including Ben Spruance, Harry Rosen, Ned Watkins, Gertrude Rowen, and Franklin Watkins.

Rhoda, who had fantasized about such a studio, thought it to be one of the most romantic places she had ever seen, and this after Europe! She

gushed about the winding staircase up to their floor, the northern exposure with two large windows that let in the north light, the fireplace in the back room, and the ethereal quality of the square at night or in the rain.[22]

Actually, it was a dilapidated old place consisting of three rooms, a kitchen, and a bathroom. The paint was peeling away from the outside walls and the old wooden floors were covered with stained, cracked linoleum. The two front rooms were stuffed with a hideous collection of Victorian furniture. In the brightness of day, the square was home for tramps and runaways from nearby orphanages as well as a lunchtime refuge for businessmen from the nearby publishing houses, and a playground where mothers brought their children.

The studio was inconveniently far away for Alice. It was several miles from the school, and to get there she had to take the trolley down Broad Street to Locust Street, then walk the seven blocks to Washington Square. She dared not go there during school hours. The school did not tolerate absences very well, and when she did cut a studio class to make the trek into center city, she had to serve a detention on the third floor, drawing patterns, a not-so-subtle reminder that the freedom and independence represented by the studio were Rhoda's and Ethel's. Alice painted there, at an easel kept in place for her, but usually it was easier, emotionally as well as physically, simply to go home after school. She began to think differently about her hometown, for at least there were men there to give her attention and to make her feel needed.

But they did not satisfy her. She was dating, almost to the exclusion of everything except painting, but men left her increasingly unsatisfied. She would go out with a man two or three times and then decline further invitations, for if she found one of them physically attractive, she did not think he was interesting, and when she went out with someone whose mind she admired, she could not stand him physically.[23] She grew to hate dates, the forced gaiety and the "jumping up and down dancing,"[24] but she continued to allow herself to be taken out almost every night into the world of gaiety and dancing. By the end of her third year in school, in 1924, Alice was dating compulsively. However much she disliked the superficial life of the clubs, she was unable to give up the admiring looks of the men, the ease with which she became the center of attention, and even the looks of envy and jealousy she aroused among the other women. She flirted with the dates of other women sometimes just because she knew that she could win any man's attention if she wanted to.

Rhoda was shocked when she discovered that Alice was seeing men at all, let alone every weekend and many weeknights. Soon after their return from England in the fall of 1923, Rhoda and Ethel became aware that Alice was not herself. When she came over to the studio and painted with them, she was polite as usual, but she was not nearly as excited about the northern light as Rhoda thought she would be. Something was definitely wrong when they asked her to join them at the Sketch Club on Sunday and she politely declined. After a while, Alice dropped by only once a week or so, and then she seemed shrouded in melancholy.[25]

Rhoda and Ethel could not figure out what exactly had happened to their friend. They all used to make fun of the "others" for organizing their lives around men, but now Alice's long absences and her constant tiredness suggested that she had become an "other." None of the three had actually had a date since they had known each other. Dating violated some unspoken covenant among them. Even though they were all in their twenties, Ethel, twenty-six, Alice, twenty-four, and Rhoda, twenty-two, they had consciously sidestepped this frivolous behavior. Consequently, shock passed into impatience. Rhoda understood only that Alice was wasting a lot of valuable time, that she was "oversexed or boy crazy or something."[26]

If Alice baffled Rhoda, she was beginning to alarm herself. She was becoming aware that she really did not like the constant dating, that it made her feel tired and irritable, but she could not stop. She wondered if she was a serious and independent artist or simply a "girl" doing those things that "girls" are supposed to do to find happiness and fulfillment. If she no longer wanted to be a frivolous and undemanding ornament to some man, why couldn't she just stop the treadmill and get off? For the past two years, she had worked to find a new identity through her painting and her association with Rhoda and other artists. What had happened to all of that?

As her third year wound itself out, Alice had become painfully aware that she had locked herself into a life-style of almost frenzied dating, as if her self-esteem depended on the number of men who asked her out. If it had not been for her painting, she might well have given in and allowed her past and her parents' values to swallow her up and deposit her at some altar to be married. But the attraction of her easel would not let her go back. During the spring of 1924, she consciously began to paint every day, as a discipline that she needed in order to break free from her past and let

art alone define her. Was she strong enough to be an artist? As her personal crisis deepened, Alice recognized that she was not yet confident strong enough to develop a strong sense of self from art alone.

Alice nearly collapsed in the spring. Her parents became concerned that she was becoming "totally exhausted"[27] from following slavishly her two demanding masters. Although she was twenty-four years old, she still maintained her role as daughter, and at her own wits' end, she relinquished to her parents the responsibility over her life.

They determined that she had to get away, out of the city, so when the term ended they enrolled her in the Chester Springs Summer School of the Pennsylvania Academy of Fine Arts. While they would have preferred that she give up art altogether, their compromise was to send her to the country. They hoped that she would be able to "rest up" in the fresh air. Instead, she met Carlos!

If ever a woman was primed to fall in love with a man like Carlos, it was Alice in the summer of 1924. She was taut as a piano string, totally frustrated with her inability to create a satisfying balance in her life and disillusioned with the "boys" who populated it. But Carlos was so different—tall, swarthy, and sophisticated—and, she thought, the most gorgeous man she had ever met. He was her age, but in comparison to the young men she had been dating, who seemed so juvenile, he was mature and worldly. He was a painter and an intellectual, an aristocratic Cuban who was exotic beyond imagination to a repressed young woman from parochial Colwyn. Seemingly untouched by the conventions and the stifling values that had controlled so much of her life, he emitted pure excitement.

Alice fell deeply, hopelessly, in love with Carlos. From the first day they met, the electricity of their relationship crackled through the school, and their behavior scandalized the small, staid artists' colony. After years of behaving politely, Alice "cut loose" with Carlos, not caring what others thought. She and Carlos disappeared from classes and spent long hours walking, holding hands like teenagers or sitting in the woods talking about all of those aspects of life that she had never talked about because she had never before felt close enough to anyone to discuss her most intimate

feelings. They met in the evenings outside of the scope of the chaperoned activities, and when they did appear at the school's costume party, they shocked everyone when he came dressed as a flapper and the repressed, serious Alice came dressed as a man and laughed harder than she had ever laughed in her life. But most of the time they were simply absent, off by themselves. Their romance had a childlike quality of discovery to it. It was not sexual, but romantic and rebellious, a breakaway adventure in which no one else seemed to exist in the world, a first love.

At the end of the third week of school, Carlos was expelled. Not only had their behavior shocked everyone, but the officials became increasingly concerned that if Alice were to "get into trouble" the school would be held responsible.[28] They wired his parents in Havana and notified the Neels. Alice's mother insisted that she return home. Would she? Her only reality was Carlos. Deep within her, buried under a lifetime of repressed emotions, she had discovered a capacity for love so intense that it smothered caution, discretion, and all those anxieties that had plagued her during the past year. And beyond the love for a man, she had carried her rebellion to a deeper level.

Alice had decided over the last few weeks that Carlos represented not just the first man worthy of her love, but also truth and authentic values, values that opposed those of her family's values, her society, her culture. What she thought that she was experiencing was nothing less than revelation, the sudden apprehension of truth. Years later, when Alice was a socialist and a political radical, she looked back on that summer as her coming of age, when she first realized that her whole world had been wrong, that she hated America, the "American Idea," the "conformity." She learned that she "couldn't stand Anglo-Saxons . . . their soda-cracker lives and their inhibitions."[29] Her explosion was twenty-four years in the making, and it devastated the countryside.

But as suddenly as her new and thrilling life began to unfold, it came to an abrupt halt. Carlos was called back to Cuba by his father. Señor Enriquez de Gómez was a doctor in Havana whose enormous wealth came from his role in the international sugar trade. When Carlos received the instruction from his authoritative father to return home immediately, he obeyed. Surprisingly, shockingly, he obeyed. It was Alice's turn to be devastated. She did not want to part from Carlos. She might have gone off with Carlos if he had asked, but once his father demanded his return he left alone. He promised to return, to work things out, but he did not

protest or fight back. He obeyed. Alice had nowhere to go except home and back for her final year at the School of Design. But she reentered her old life changed, and aware that her separation from Carlos would be temporary.

Alice's final year at the School of Design was much like a compulsory military duty, performed by an unenthusiastic participant mechanically, minimally. She went through the motions of fulfilling her requirements, marking time until another letter arrived from Carlos, until his return from Havana. While she remained superficially polite, she lost whatever vestige of respect she had for the school, which in her mind was no longer merely mediocre, it was bad. But that seemed to suit her fine. She wanted to be left alone, and they let her do what she pleased.

What she "pleased" was to paint life as she saw it. If the school would not challenge her, she challenged them. For one critique, she submitted a portrait of a "sailor type with a lighted cigarette," naked from the waist up, one of the characters that the three musketeers lured into Rhoda's and Ethel's studio to pose for the price of a meal. The man was tough, virile; the painting was purposefully provocative. It was an especially difficult one to paint, according to Alice, because the flame of the cigarette created such a broad range of hues, "from bright fire to shadow," all playing suggestively against his body. Her teachers did not comment on the difficulty of the painting. Their only reaction was that the subject matter "shocked them."[30]

Life offered few satisfactions for Alice in the fall and winter of 1924–1925. School became increasingly unsatisfying and, of course, she was not dating. Life at home was tense. Not only was she living a soda-cracker life at home, devoid of any significant artistic values, but her mother was still shocked by her behavior over the summer, and made life for Alice uncomfortable by comparing her at every turn with her sister Lilly, prim and proper, an excellent seamstress, who married well to an engineer and was living in Teaneck, New Jersey. Thereafter, Lilly became the model for Alice to follow and, consequently, Alice grew to hate the sister she once had liked.

Alice began spending more time at Rhoda's and Ethel's studio. When Alice was with Rhoda, she complained that the problem at the school was that it was bourgeois, hopelessly middle class. The teachers' tastes were pedestrian and the students were even more obnoxious and class-conscious than when Rhoda was there. The only decent part of the school,

its soul, became for Alice the workers who toiled to run the buildings. Hugh and Mary Coyle had been the janitor and the cook at the old mansion since 1900. While they were called "Mom" and "Pop" by the students, the nicknames signified familiarity more than affection. Like most "below-the-stairs" workers in proper establishments, they knew their place. "Mom" was the formidable presence of law and order, "Pop" the quietly efficient handyman who stopped his work to help serve lunch. Alice began to feel sorry for them, and, when she wasn't painting, she could usually be found with Hugh, talking, although rarely with Mary, who had little patience with her.

Alice knew intimately the pangs of guilt, for it had been her constant companion since childhood. But now her guilt began to redefine itself. As she convinced herself that the problem was not with her but with American society, she started feeling guilty for being among the privileged while there were so many suffering poor people. Consciously, she distanced herself still farther from the other women students. She noticed, as if for the first time, the "many old gray-haired scrub women" who passed her as she entered the school in the morning, "on their way home from cleaning office buildings all night."[31] And the sight would oftentimes make her think that in comparison maybe learning to paint was "unimportant and unjust." She recognized oppression in lives other than her own.

Alice sought out relief from the injustices of the world by going to Rhoda's and Ethel's studio. She continued to feel like an outsider, but it was not anything that they did to make her feel that way. They always welcomed her as a friend and future partner. But, even as Rhoda sat opposite Alice at their easels, painting the same subject, and tried to lure Alice back into their old, fun relationship, she intuitively knew that she would not succeed. Alice had become a victim of her distraction with Carlos, and her anti-American tirades were aimed erratically at society, the School of Design, puritanism, hypocrisy, wealth, greed, class, and every other institution that dared to intrude upon her life, except her mother, who was conspicuously absent from her litany of sinners. This unwanted political side was a shrill reminder to Rhoda of how much Alice had changed.[32]

Over the year, Rhoda and Alice drifted apart, imperceptibly, not with a climactic scene or an emotional confrontation, but in stages, recognized as part of a pattern only in retrospect. By the spring of 1925, Alice had also

detachment from school. Although most of the other women did not attempt to socialize with her anymore, the better students still recognized her as the strongest painter in the school. All of them were shocked, therefore, when, at the graduation exercises, she was not awarded the Elkins European Fellowship, for there was no question among the fine arts students that Alice deserved it.[33] The denial might have caused a small scandal if she had been better liked.

Alice was not as hurt as she was fatalistic. She knew that she had deserved the fellowship. At the end of her third year, she had won the highest prize for the class, the Keen Dodge Prize for the Best Painting in Life Class. Her fatalism stemmed from her awareness that the teachers and administration did not approve of her.[34] The woman who, four years before, had quietly and politely entered the school had become "too rough for them." Others attributed the denial to her behavior the previous summer or her dropping out from all but the minimal requirements for earning a certificate. But Alice was sure that it was because the School of Design was being run according to a discriminatory system, and that, as an outsider, she never stood a chance of winning the award.[35]

Alice was angry, but would she have gone to Europe if she had won? Probably not. The episode of the award and graduation simply removed obstacles to realizing her dream, to reunite with Carlos.

And almost as soon as Alice graduated, Carlos returned to Philadelphia, and the two rekindled their fire with a speed that caught Rhoda off guard. She had hoped to meet the phantom who had haunted her studio for the past year, but Alice had no intention of sharing him with anyone except when necessary. She and Carlos scorched their way through another intense period, just the two of them, emerging finally to announce that they were married.

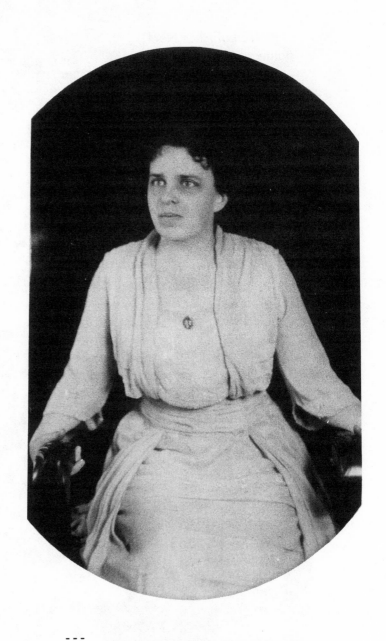

1. Photograph of Rhoda's Mother,
Nellie Haddock Myers, as a young mother.
(Collection of June and Mike Donovan.)

2.

Portrait of Alice Neel,
painted by Ethel Ashton,
c. 1924.
(Collection of Christine
and Charles Ashton.)

3.

Photograph of Skinny
and Rhoda at
her Washington Square
Studio, c. 1926.
(Collection of Christine
and Charles Ashton.)

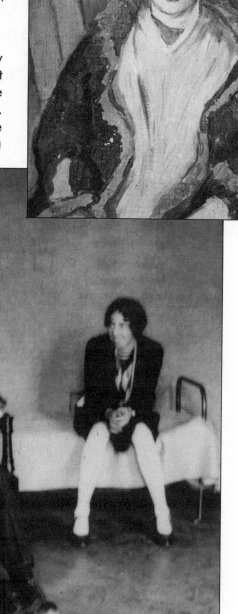

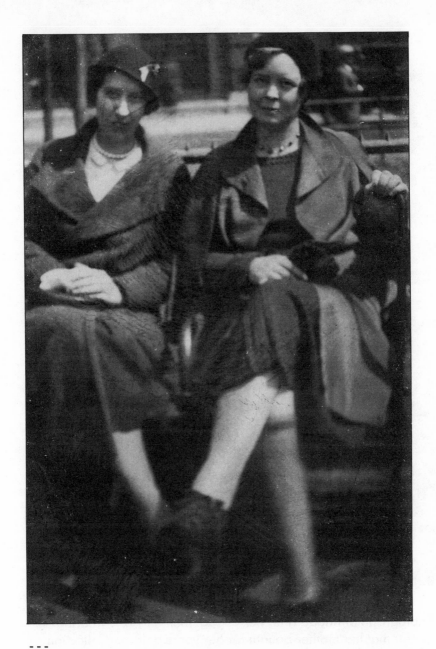

4.

Tintype of Ethel Ashton and Alice (on right) in New York, 1929,
soon after the birth of Isabetta. Notice that Alice is wearing a
stocking for her postpartum phlebitis and her left hand is
resting on a cane. (Collection of Christine and Charles
Ashton.)

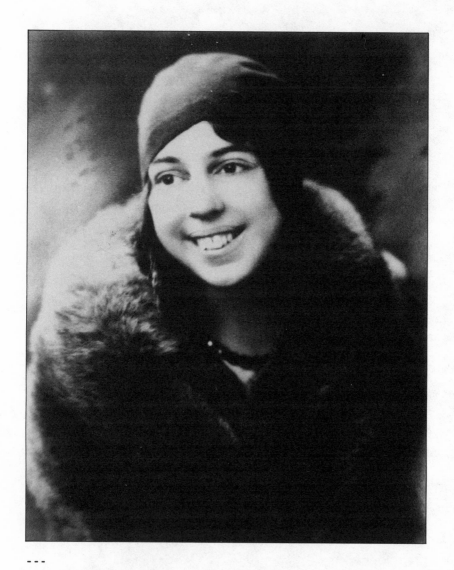

- - -
<u>5.</u> Photograph of Rhoda after her engagement in 1929, wearing
the fur that her mother bought for her years before. (Collection
of Holly Medary.)

II

Artists

To See all
Things and
Their Opposites

5.

I t was almost a form of treason, deserting to the enemy. Alice, married. She proclaimed the man, Carlos, to be a painter like herself, but to Rhoda and Ethel the distinction between him and any other man was irrelevant. He was still going to take her away from them and the studio. And they had not even met this Carlos, for Alice did not bring him to the studio. She was at her home in Colwyn preparing to sail with him to Cuba.

Mr. and Mrs. Neel welcomed Carlos into their modest home, and Alice's sister Lilly came down from Teaneck, New Jersey, to help get her sister ready to go off to live in Havana. The Neels were charmed by Carlos and awed by his economic class. Alice had finally, at the age of twenty-five, landed a man, and a rich, cultured one at that.

Suddenly, Alice stopped cold in her preparations. Without warning, she told Carlos that she could not go to Havana with him. The unusual gaiety in the Neel household dissolved in disbelief. Even erratic Alice would not jeopardize a new, exciting marriage by refusing to go with her husband! Her mother was incredulous, her sister was shocked, and Carlos was baffled, but Alice's intention remained firm. She could not go to Havana with Carlos.

Rhoda and Ethel became distant observers of a painful drama over the next tense weeks. Carlos wanted to return to his family home with his

new bride. Mrs. Neel, who became his ally, moved from disbelief to irritation as her daughter balked at an arrangement she herself would have grabbed without a moment's hesitation. But Alice, who claimed to love Carlos, and who had endured months of waiting for him to return, now left him almost daily at her house and fled to the studio to hide, to get away from the pervasive air of disapproval, and perhaps just to postpone decision.

Confusion was but another of the extreme emotions that yanked Alice in opposing directions in the summer of 1925. Rhoda had seen her in moods where she had expounded on exactly what was wrong with the world; now she did not seem to know what was wrong in her own life. Alice was unable to explain her inability to accompany her husband. She was still experiencing the agony of indecision when Carlos left Colwyn to return to Cuba, whether in anger or defeat Alice never said.

Mrs. Neel was quietly furious with Alice, who felt more comfortable at the studio on Washington Square, where she spent most of her days that summer. But even there she lapsed into long periods of sullen silence, unwilling or unable to talk about her bizarre behavior. She probably would not have been able to explain exactly what had happened during the past year. When she first met Carlos in the summer of 1924, she had been a tightly lidded, bubbling Vesuvius, and during that summer she erupted. A lifetime of repressed emotions—love, anger, fear, passion— poured out, spewing across the adjacent landscape.

Beginning to feel purged of her past, she lived her final year in school longing for a future with Carlos that not only would repudiate her past, but take her away from it, geographically, emotionally, ideologically, completely. Her idyllic vision only increased in intensity when Carlos returned. But with the marriage, something stopped her cold. The vision clouded over, her future suddenly blurred.

Her decision to marry Carlos probably tumbled naturally from the frenzy of their reunion. But the prospect of moving with him to Cuba presented Alice with the inevitability of momentous change in her life, and its implications threw her back into the chronic indecision of her youth. "I couldn't go," she lamented later, "I couldn't go. It was the worst agony, because I really wanted to go."[1] And, as it was when she was young, she did not know why. What she understood was that while she had had "too much experience of a kind," she had never experienced what she called "the real thing." And it terrified her. She wrote later of her

feelings: "He thought that I was a normal American girl. I had every appearance of being utterly normal and beautiful. But I couldn't go."[2]

There had been a time, not so long before, when Alice would have gone with Carlos unthinkingly. She had always bent with the strongest wind. But this time a piece of her resisted. She was not yet the woman who would, one day, sail headlong into any wind, but she was no longer just a reed. When she expressed the fear that Carlos thought that she was a "normal, beautiful, American girl," she expressed an admission that she was not. The "real thing" slapped her in the face like a cold shower after a twenty-five-year nap.

She loved Carlos. She could imagine herself painting with him, frolicking with him, laughing with him, but he was a man and as her husband he would want more. He would expect children, a commitment of a new kind. He would want control over her life and would make demands of her, foremost among them that she would become the mother of his children.

Alice, years later, after she had given birth to four children, still remembered the agony that the commitment to marriage and motherhood had caused her. At the time of her marriage, in 1925, her fears paralyzed her. She was not ready to assume the frightening new responsibilities that might transform her into a mother and doom her to live unfulfilled. She was an artist and not her mother.

Alice's response to what she thought to be insoluble problems was to spend her waking hours in Rhoda's and Ethel's studio. There she could try to escape again by painting and there she would find uncritical acceptance. Ethel was a kindred spirit who knew that Alice would not intrude if the roles were reversed; Rhoda seemed to understand only that Alice was back. Despite having to take a train and then a trolley, she would sometimes be on the doorstep of the studio before Rhoda arrived, and would accompany her down Ninth Street to Washington Street, to the Italian Market, to buy bread and cheeses for lunch. The three women would then spend much of the day painting, in front of the north windows or walking the streets in search of subjects. Studio life had become so normal so rapidly. Rhoda did not appreciate that they had entered the eye of the hurricane, the deceptively calm interior of a raging storm.

Alice loved Carlos. The feeling intruded on every thought, every action. Painting, she discovered, could be only a temporary escape. When she stopped to eat or sleep or sit in enforced idleness on the train, her

private agony sat with her, an insistent companion. She continued to waver, wanting to be with Carlos as much as she had ever wanted anything in her life, but still she was unable to force herself into a commitment. She had expected her mother to oppose a marriage between her nominally Protestant daughter and a Roman Catholic from a foreign culture. But Mrs. Neel was so impressed by his wealth and with his obvious breeding that she continued to remind Alice of her folly.

Alice marked her twenty-sixth birthday—she did not celebrate it—in January 1926, with her life on hold. She might have remained in that curious emotional netherworld forever if Carlos had not, unexpectedly, returned. After eight months of marriage, on paper, Carlos, still a mystery man, confronted Alice and demanded that she return to Havana with him to live as man and wife in his ancestral home.

Perhaps she was happy to be ordered. Maybe she was just weary, emotionally drained. Possibly living at home with a mother who wore her down helped to settle the issue. Alice never said. In any case, she packed her bags and her paints and sailed with her husband to the land of his family to become a wife.

When Candide stumbled onto El Dorado, he did not find himself in a land that was stranger and more unfamiliar to him than Carlos's Cuba was to Alice. From provincial Colwyn, she moved to one of the most exciting cities in the world, into the cosmopolitan, Latin culture of Havana, where almost every expression of life, from the staccato chatter of the native language, which she did not understand at all, to the torrid, erotic Afro-Cuban dances, was as alien to Alice as the maid who catered to her every wish.[3]

Havana was exotic beyond imagining to a woman who was younger in experience than in years, whose only exposure to a city was staid old Quaker Philadelphia, with its geographic symmetry and its ideological orderliness. The city that loomed up suddenly as her steamer chugged between the old "Punta" fort and the grim, gray walls of Old Morro, twin guardians of the harbor, was at once seductive and startling.

Bright, red-tiled roofs, accented by white towers and steeples, gave the city a washed look, inviting, exciting, a playland for rich Americans. The clutter of life—blocks of shanties pushed together as if by some giant child, buildings squeezed into agonizingly serpentine mazes of streets and alleys, people littering the wharves and docks with languid ambiance, boats from the great masted vessels of Americans to the trash-cluttered

harbor boats that carried hawkers of all manner of goods out to meet incoming passenger ships—all stood in stark contrast to the orderly cadence of life in Philadelphia and, certainly, the boring predictability of life in Colwyn.

Alice had never seen such extremes of life. Beggars crowded around passengers as they disembarked. Disorderly children and older men pressed against them, grabbing for the luggage carried by porters. The hawkers followed them to their awaiting car. But as they drove from the harbor and into the city, they passed from narrow streets to broad boulevards with elegant shops and tree-lined avenues almost free of people except for baby strollers pushed by uniformed nannies.

Alice's dislocation was exaggerated even more when she marveled at the incredible differences between her small but respectable twin house on its cramped, sloping street in Colwyn and her new home, a stately, ornate sand-colored mansion with marble floors and long, echoing corridors, a "palace" where she could stand on the private balcony of her bedroom. The unreality of her new life always hit her freshly as she sat in her father-in-law's Rolls Royce and rode around Parque Central with its ring of scarlet-flowered flambeau trees, or along the Malecon, where the family often strolled on manicured lawns around the Ionic-columned pavilion. It was at the end of the Malecon, with its seven miles of parks, mansions on one side and the sea on the other, that the Enríquez de Gómez family lived, in the Vedado, a vast and austere residential district for the very wealthy, the world to which Alice moved with her husband. Had Alice expected so much wealth? Had Carlos, who had acted in such a bohemian fashion in Chester Springs, prepared her to live with a family who were major exporters of sugar, the Cuban national product?

The sheer physical contrasts between the life she left and the one she acquired might have provided poetic backdrops for a Cinderella story. Like the heroine in the story, Alice had also grown up feeling repressed, unloved, the outsider. And her handsome prince came to pluck her from a life of quiet suffering, marry her, and take her away to a fantasy castle where she would be the served and not the servant. All of the ingredients for a fairy tale were there, except that Alice refused to play the role of Cinderella and live happily ever after.

First, she hesitated those long, agonizing months at Rhoda's and Ethel's studio, wavering between fear and passion. And when she finally consented to leave with Carlos, it was not with the mindlessly light heart that

makes good fairy tales. In order to screw up her courage to go at all, she had to construct an elaborate fiction. She convinced herself that she was going to Cuba not with a husband so much as with a painter, a handsome, exciting man, another free spirit, to paint and to experience life. As she told herself, she had to go; as a painter, she owed it to herself "to see all things and their opposites."[4]

The life that Alice lived in 1926, was, at the same time, a thing and its opposite. The "thing" was painting with Carlos, a source of great happiness; the opposite was living in the Vedado and being waited on. Dr. Enríquez de Gómez, like his son, spoke excellent English, but Alice was more comfortable in the kitchen practicing her Spanish with the cook than conversing with the family. At first, she dutifully went with the family at 6 P.M., the "Hour of Promenade," to see and be seen as they drove down Fifth Avenue, along the Malecon, around the bandstand, down the Prado, and then around again.

She preferred, however, to ride the bus with Carlos into the heart of the capital and paint the poor people who sat in the shadows after the central bazaar had closed. Carlos's parents lived in a luxury that her parents would have been unable to imagine, yet they acted in many ways like her parents. Their conservative values mirrored those that had repressed her as a child. The few months that she lived in their house were as tense as any she had suffered through at her own home, filled with the same incomprehension at her behavior, smothered by the same pervading pall of parental disapproval. But in Colwyn, her only sin had been to be an artist in a conventional household; in the Vedado she was always a complete outsider, a blonde, North American, non-Catholic, unconventional woman who had been rudely deposited in a closed, conservative family by an errant son.

Alice's growing unhappiness sprang not only from living again in a "puritanical" house. She felt very uncomfortable living in the midst of such enormous wealth, and grew increasingly guilty about the ocean-wide gulf that separated her parents-in-law from the desperately poor people who inhabited the shanties on the fringes of Havana. Especially in that city and in that culture, wealth imposed a life-style of rigid conventions and defined roles. She and Carlos violated many of them. He became her bohemian companion who roamed the city with her to paint, but it began to bother Alice that their artistic life-styles were like playacting, for they lived in Carlos's parents' house on an allowance from his father.

Cuban "society" divided the world sharply between rich and poor, the cultured and the philistine. Alice and Carlos empathized with the poor and lived their lives away from home as poor artists. Society also rigidly divided the world between men and women. Women from the upper classes were expected to live within the confines of home and club: the Havana Yacht Club, the Havana Biltmore Club, and the exclusive Vedado Tennis Club. Women rarely went out by themselves, and then only in the afternoons and only into "certain" districts. Alice learned quickly that her husband's class "thought it was dreadful if a woman was in the streets too much."[5] And what irritated Alice the most was that the women, while "not stupid," followed the rules and lived the lives that convention imposed upon them.

Alice would not. But the only way to get out from under her identity as a woman, with all that implied, was physically to leave the household. More and more, she absented herself from the house and went into the city with Carlos, not so much as husband and wife, that is, man and woman, but, she liked to think, as comrades, walking the streets of Havana "like Van Gogh with our paint boxes."[6]

Her happiest hours occurred when she and Carlos were out painting. Every day, whenever she could, Alice put on a costume of native dress, roughly woven cottons, hand dyed in colorful prints, outfits that must have occasioned a symphony of critical comments in the de Gómez household. If Carlos was embarrassed by his wife's behavior, he swallowed the criticism and went out with her every day. They explored the recesses of the city and drank sweet wines at cafes in the artists' quarter, near the wharves, and sometimes ate communal meals over open fires with the night people. They played hard in the evenings and into the night, almost always in disreputable parts of town where the poor escaped the monotony of their lives by dancing and drinking with an abandon that Alice admired more than the civilized pastimes of people who had nothing to escape from.

Alice, as usual, was not quiet in her support of the have-nots. She was learning to speak Spanish, not the upper-class dialect, but the language of the people. She painted them and she talked about them, the opposites that embarrassed Carlos's family. She was scarcely a popular family member.

The tensions created by Alice's and Carlos's consciously bohemian lifestyle and egalitarian values, always just submerged and barely tolerated,

surfaced with vengeance after March when Alice discovered that she was pregnant. She denied her class, but she was unable to deny her gender. She hadn't planned to get pregnant. She didn't want to be pregnant. Regretting that she had not had "some birth-control thing," and unable even to consider abortion in Catholic Cuba, Alice panicked. She did not want to have a baby at all, but she especially did not want to have her baby in that house, within that class of people. She began to sense more strongly the restrictions that Latin motherhood was about to impose on her freedom.

Her pregnancy threatened to transform an uncomfortable situation into an intolerable existence in which those who suffered her presence would try to take control of her life. If she stayed in the Vedado, she would be subjected to intense pressure to conform to the practices of the culture, that is, to suffer quietly the enforced inactivity appropriate to her delicate condition as much as to her station in life. She turned to her only ally, Carlos, to express her growing impatience with the customs of gentility and tried to make him understand why she could not continue living in his father's home. Then she reacted to the inevitability of a restricting, confining motherhood as she had learned to react to repression in any form. She rebelled.

Alice was almost four months pregnant, in July 1926, when she and Carlos moved out of his parents' house into a waterfront apartment in the artists' quarter of Havana. Shabby and cheap, situated at the edge of Caballera Wharf near the Produce Exchange, their cramped rooms were less congenial than the cook's quarters in the Enríquez de Gómez house. But, they represented freedom. The two probably left in their wake an angry, hurt, outraged, or simply uncomprehending family, but Alice had to break the ties before they were pulled tightly into knots.

During the summer and fall of 1926, Alice and Carlos lived an almost frantic free-spirited existence, as if to stuff into a finite amount of time a lifetime of experience living among artists and intellectuals, poets and political refugees, the poor and the old, the mulatto dancers and the unattached women who frequented the cafes at the edges of the Plaza de Armas until dawn. They "painted every day and went out sketching every night."[7] She painted the Havana of the "opposites," beggars, poor mothers, and blank-eyed children, black dancers, and quietly desperate old people who, nonetheless, sat erect and dignified.

These months were the happiest of the marriage. For the first time, Alice and Carlos were living on their own, according to their own sched-

ules, without being constantly judged by disapproving family members. Away from his father, Carlos visibly relaxed. He and his bohemian friends who frequented their small apartment laughed uproariously as she learned from them words in Spanish that were not used in Carlos's household.

Those months in 1926 were also among the most important in Alice's political education. Years later, she would recall, in understatement, that there was "a very nice art world there, because they were all friends, the writers and the artists."[8] At the time, Alice regarded the art community with a combination of curiosity and envy, for it was a type of community that had no parallel in Philadelphia and that Alice, therefore, had never experienced.

Made up of expatriates from other Latin countries and the United States as well as native Cubans, the community in the artists' quarter of the city was composed of a politically conscious intelligentsia that mingled freely and, in fact, overlapped with painters and sculptors. In cafes and cramped apartments, the richly diverse members of this fringe community read their fiction to each other and argued about the morality of the Cuban government of Gerardo Machado, which was then beginning its march to dictatorship. They debated the meaning of Marxism and read poems about Rosa Luxemburg and explored, in word and paint, the world of the "opposites." How different from the insulated, almost pristine, art world that had provided Alice her education.

Alice later said that her short time in Cuba contributed "much" to "my later psychology."[9] It did, for it was there that she began her political education. Earlier, in Rhoda's studio and during those sterile hours at the School of Design in her last year, she used her art to exercise her freedom. To try to counter the appeal of dating, she worked to make the process of producing art the central process by which she defined herself as an autonomous individual. What she learned in Havana, in the midst of political crises, watching a would-be dictator close the country's universities, was that art itself was a political act. Painters were part of the intelligentsia. They worked most honestly when they were outsiders, and their art could speak as eloquently, or protest as clearly, as the treatises and poems of the writers.

As a consequence of her marriage, Alice was almost accidently exposed to the type of education that many American painters sought in Europe. In Havana, Alice experienced an artistic "coming of age." She discovered

that art was inevitably bound up with the human condition. It was not only style, but substance; not only form, but content. Alice had known these relationships before Havana, but her experience there made them real to her, and intensified their importance. Alice's painting would never again be devoid of profound commentary on human emotions, needs, or beliefs.

For a decade, she was unable to name what she was trying to do through her art, but in the midtwenties she began to paint poverty, condemning its brutality while admiring the strength that it often conferred. She painted society's outcasts by way of condemning the society that produced outcasts; she painted suffering and pain because they were real facets of living and because they represented what one day she would call the *zeitgeist* of the age, its character, warts and all.

It is this "capturing of things essential" quality that emerged in Alice's paintings in 1926, and which invested her with a growing reputation in the artistic/intellectual community. As a privileged and beautiful American woman, she had a lot of stereotypes to overcome, but she consciously camouflaged her comeliness and learned to project herself as the intellectual and probing artist that she was learning to be. Her efforts earned her credibility in the fall of 1926, when she was given her first exhibition.

Alice did not give many details about her first show. It contained a relative handful of paintings, about a dozen. They were all painted in Cuba; all were of the "opposites," the beggars, the women, the mothers and children. Her show was possibly given to her by the owner of a small, local gallery, patronized by the other starving artists in Carlos's and her circle. Perhaps the gallery operator liked Alice or admired her style or was attracted to her subjects. Or perhaps Alice's work was suggested by an admiring poet or by her Argentine writer friend Alejo Carpentier to the proprietor of one of the many counterculture bookshops that had small spaces in the back for a few paintings.

Chances are that her parents-in-law did not go to the gallery to see her work. Not only was the gallery almost certainly in the wrong part of town, but the subject matter would have been highly inappropriate for people of taste. It was not meant for them or for the art establishment of Havanan society. Alice was painting the underbelly of Cuba, of Western urban society as a whole. But, however unacceptable her show may have been to the wealthy, it represented Alice's acceptance by the community that she admired.

A first show, however modest, is a watershed for an artist. To be an exhibiting painter is equivalent to being a published author, an elected politician. A private intention explodes into public existence as the validation of a talent that was only shadow and promise.

But Alice's first show was important to her for another reason. It reinforced her identity as a painter at a time in her life when new ambiguities were threatening her sense of self.

As Alice was immersing herself in the life of the artist, her pregnancy was, inexorably, moving to term. She knew that her life was going to change dramatically, and she dreaded the possibility that the baby would interfere with her intertwined needs to paint and to be free. A baby would create a whole new category of responsibilities that Alice would have to fulfill, and, simply, she did not feel maternal. Other women looked at children and wanted to "mewl over" them; Alice wanted only to paint them.[10] Consequently, she approached her baby's birth not only with apprehension, but with ambivalence.

The prospect that had immobilized her the previous year in Pennsylvania became reality on 26 December 1926, when Alice gave birth to a girl. They named her Santillana. Later, Alice remembered the event for its pain, not its joy. She did not want to deliver the baby in the manner of the "Anglo-Saxons," her catchall term for the respectable middle classes of America, but in the manner of lower-class Cubans. They were, said Alice, "more animal" than Americans, and "for them to have a child is the most normal thing in the world."[11] She gave birth without anesthesia, and she suffered frightful pain through an eight-hour labor. Was it a form of punishment for not being Latin? Alice had more cause for resentment that she had been born white and American.

If she was not "animal" enough to give birth easily, Alice also was not Latin enough to have her prenatal fears swept away by the ecstasy of motherhood when the baby actually arrived. Inevitably, she felt more trapped. Santillana demanded time. She was a distraction who took time away from the day and night painting schedule that had been established before her birth.

But the baby was not solely responsible for Alice's feelings of being trapped. Carlos's father naturally wanted his granddaughter raised properly, and that meant in his house. Once again, Carlos was caught between the competing demands of family and his difficult wife. While Alice would not return to the Vedada, Carlos was able to convince her to move

out of the waterfront area of the city to a "little place" that he rented in La Vibora, just outside the city, away from the community of artists and writers that had given her so much pleasure.

Carlos insisted on the move, and his father certainly paid for it. Handsome, aristocratic Carlos. Weak, vacillating Carlos.

The glare of love that induces blindness to faults and diminishes flaws cools in the shade of reality. The reality that greeted Alice and Carlos during those months following Santillana's birth forced Alice to confront Carlos's faults. Evidence of a dependence, financial and emotional, on his father had been there from the beginning, but their "life boheme" had not created the occasions that demanded reassessment of her "comrade." There was the evidence of 1924, when, in the middle of their first torrid affair, Carlos's father abruptly recalled him from Chester Springs, and Carlos obeyed. He had not ignored his father or tried to convince him to let him stay. He had submissively returned to Cuba. And when in January 1926 he had returned to Colwyn to claim his reluctant bride, Carlos had taken her, not to "their" house, but to his family's house.

Alice and Carlos lived in Cuba on his parents' money, an allowance, and that conferred power. His dependence on his father caused him to move his family to La Vibora. This act was a compromise with his father. If Alice would not move back into his father's house, at least he would remove the baby from the alleyways of the inner city. Carlos seems to have been one of those rich children whose life-style is consciously different from their parents', but who do not really break away from a dependence upon them. Like the hero in Thomas Mann's novel *Tonio Kroger*, Carlos was "a bourgeois who strayed off into art." He would have instinctively understood Tonio's lament: "I stand between two worlds. I am at home in neither, and I suffer in consequence. . . ." Had Alice sensed that, like Tonio, Carlos felt that respectable, traditional households were "the source of all warmth, goodness, and humor"? Had she begun to feel that his dependence on his father was a serious threat to their independence, to hers?

It seems likely. She must have felt as if walls were closing in. How much longer would Carlos be able to withstand the pressures from his family to take control of his wife and bring his daughter back into the family household? How much longer would Carlos want to live at odds with his family?

Alice could not be sure of the answer to either question. Within four months of their move to La Vibora, in May of 1927, Alice packed her paints, bundled up her baby, and fled Havana, Cuba, and Carlos.

THE AWFUL
DICHOTOMY

6.

L a t e r in life when she was asked why she returned to the United States after only a year and a half in Cuba, Alice usually explained that Cuba was too constricting for her life-style and much too conservative for her tastes. The relentless pressures to conform kept her from experiencing the happiness that she had originally felt.[1] She complained that Carlos's family never left her alone after the baby arrived, but when she relented and took her daughter to visit them, she was forced, despite her protests, to defer to their social mores and sit apart—with the women.

The real issue in her leaving for America, however, was Carlos. Her departure seems to have been an attempt to force him to choose between the world of art and the world of the bourgeoisie, the world of independence and the continued dependence on his father for whatever income he received. Did he love her enough to leave his comfortable aristocratic culture, follow her to America, and live the life boheme with her in New York?

Alice was not able to go to New York from Havana. She had no money and carried with her, of course, her five-month-old daughter, Santillana. She reluctantly returned to Colwyn, to a home that had changed scarcely at all since her departure. The house was still too small. Her older sister

Lilly had married and moved out to New Jersey, but her two brothers were still living at home; her younger brother Peter, who was twenty-one, was home from college for the summer, but he kept to his room. Her older brother Albert, however, spread all over the crowded house. At thirty-nine, he was getting ready to leave home for the first time, but, until he left, his dogs continued to live scattered around the house, and his homing pigeons perched in his room.

Since the front parlor was still used only when guests came, the clutter and the chatter of life centered around the large round oak table in the dining room, and there Mrs. Neel ruled supreme. She accepted her daughter back home as a matter of course. That was the duty of mothers. But she was not happy to have Alice either leave Carlos or bring a baby into the small house. She accepted Alice back as her duty, but she expected Alice, like everyone else, to adjust.

Alice, the girl who had spent her life adjusting, was no longer good at adjusting. At first she sullenly resisted the return to bourgeois customs by violating basic Anglo-Saxon values of cleanliness and good manners. She did not bathe, and her eating habits had deteriorated to the point of almost mocking the absurdity of table manners. In the summer of 1927, she was in no mood to adjust to the rhythms of respectable life, even if she was a supplicant of her parents. Tension settled again on the Neel household.

Alice resented having to go home in the first place, but in her time of crisis she understood that she needed to draw from her mother's emotional strength. On the surface, she rejected her mother's life-style and values. She despised the superficial level at which her mother lived. In her conversation, Mrs. Neel, who used to be the most stimulating person Alice knew, rarely strayed from the topics of the weather, the price of goods, and how things were much better "before the war."[2] How Alice longed for the passionate discussions that filled her days in Havana! Mrs. Neel was tedious to Alice. But at a deeper level, Alice remained emotionally dependent on her mother. However much she resented her mother's values, she wanted her approval. The problem, of course, was that she rarely did anything to merit it.

Alice's attempts to paint were thwarted at every turn. The disabilities of motherhood and poverty, of dependency on her mother, all conspired against her. She had been settled in her old bedroom, in the back of the house, facing south. She thought that if she only had a northern exposure

at least she could paint in her room while Santillana slept. She asked for the larger front bedroom, which had a northern exposure. It was her mother's bedroom. Mrs. Neel refused to consider it. Defeated, and unable to buy paints and canvas anyway, Alice was reduced to buying watercolors, and these with borrowed money.

During the following two years, Alice would develop an appreciation for watercolors and would produce dozens that captured a special flavor of New York City, but in 1927 painting in watercolors inside her house must have seemed cruel punishment inflicted by some philistine god. The subjects that she chose to paint chronicle her view of life from the prison of Colwyn—her alienated family living on separate floors (or in different worlds), and her hapless father and Santillana, two ever-present children. Years later, Alice would remember fondly the great royal blue hydrangeas that ringed the house, but she did not paint them during the summer of 1927. She probably was incapable of seeing much beauty in her world.

Surprisingly, Alice did not escape to Rhoda's and Ethel's studio. When she needed to get away to talk and paint during her first crisis with Carlos in 1925, she had made her way to their studio, where she found sympathetic ears, canvas, paint, an easel, and a northern exposure. But in 1927, either she did not want to see her friends or she did not have the opportunity to see them.

Mrs. Neel, who frequently was angry with Alice that summer, was not generous in helping Alice care for Santillana or in giving her money, so Alice may not have been able to get away to the city. But she does not seem to have made the attempt to reestablish Philadelphia ties, as if she did not want to display her failure to friends who had warned her, or did not dare to admit that her separation from Carlos might be permanent.

She simply may have been unable to motivate herself to do anything purposeful, for that summer she was weary, miserable, and lethargic. She had not wanted to leave Carlos, especially for a life at home, but he was weak, and if she had not forced the issue, the two of them might have existed in Havana forever, pretending to be free spirits, but tethered to his father's house.

She accompanied her parents to the Jersey shore for their summer vacation, but mostly she moped, sometimes sitting listlessly on one of the two old green wicker chairs on the porch, and sometimes, as in the boredom of her childhood, on the front steps, living, as she had then, a half-life.

What would Alice have done if Carlos had not followed her to Colwyn? Become a doting mother, sitting all day with her baby on her lap, dabbling in watercolors? Become the recorder of "events" that she once said Colwyn lacked? In her watercolor "Family," painted during those months separating her arrival from Carlos's, Alice depicts herself sitting with Santillana on her lap, watching her skeleton-faced mother, on hands and knees, scrubbing the floor, a premonition perhaps of her own future.

But in October Carlos arrived. Ever the gentleman, he brought with him one of his paintings of downtown Havana for Mrs. Neel. She hung it in her parlor, in the prominent space between the two oak chairs. Of Alice's work, she had hung only a single still life from art school days, in the dining room, in the small space between the doorway and the wall.[3] Carlos had come for Alice, to take her to New York City. He was ready to choose the world of art.

New York City as an art capital could not yet compete with Paris, but by 1927 it had emerged as the epicenter of American painting. It was brashly trying to muscle its way into the hegemony that was Europe's. Ever since the aggressive Armory Show in 1913, when provincial Americans were confronted with the works of Matisse, Cézanne, Braque, Picasso, Kandinsky, and Duchamp, the city was evolving into a Mecca for American painters and sculptors who sought the new and the vital in art. Alfred Stieglitz's Gallery 291 was already legendary for its pioneering of the newest styles; Gertrude Vanderbilt Whitney's MacDougal Alley Studio had evolved into a space for experimental pieces, and the more recent "Société Anonyme," the first museum for modern art in the country, moved the new art "uptown" and "upscale."

And New York boasted the Art Students League, a collection of well-known teachers who taught their individual theories and styles to fiercely loyal groups of students, and where every new school of art was represented and promoted. Would-be artists such as Louise Nevelson, who migrated from Maine, and Isabel Bishop, who traveled from Michigan, knew that they had to study in New York. They, like Georgia O'Keeffe before them, were sucked into the intellectual maelstrom that was the Art League and, like hundreds of other young artists, reveled in the stimulating artistic communities that dotted the island from lower Fifth Avenue and Greenwich Village to Forty-seventh Street.

Alice, too, had been drawn to New York City because of its reputation as an art capital, but once there she discovered more than she expected or could have imagined, a city that was as demanding as Alice herself. Philadelphia and Havana were places, but Manhattan was *life* as Alice had fantasized it. New York was her city, the stage upon which she was destined to strut her part.

The artistic/intellectual community was not a tiny, embattled enclave pressed against a harbor; it was made up of hundreds, thousands, of painters and sculptors and poets who injected the city with perpetual life, rendering meaningless the rest of the world's distinction between night and day, art and life. Manhattan presented life in all its richness and complexity, and Alice learned early to read its moods from the quiet shadowed walkways of Riverside Park to the violent labor strikes in the chaotic garment district.

Alice easily fell prey to the deadly combination of the city's charm and its arrogance. If New York possessed the capacity to arouse her passionate love, it could also pull her violently in the other direction, sending her into profound disappointment and, helplessly, into depression. During her two and one half years there with Carlos, from 1927 to 1930, the city presented the two of them with its most impenetrable side. It tantalized and teased; it lured Alice into thinking she could become a part of its rich art world, but gave her nothing.

She existed in the city, but she could not penetrate to its vital center. She and Carlos were outsiders who were unable to participate fully in this new and stimulating world. She could daily witness others living the bohemian life that she had lived in Havana, but she was unable to recapture that life for herself. She and Carlos had no money; they had no contacts; they had no way in. And they had lost the freedom that at least allowed childless couples to work according to their own needs exclusively.

All they could afford to rent was a single furnished room far up on the West Side, on Eighty-first Street, off Broadway, out of art's way. Alice did not mind the inconvenience of trying to live three in a room, tiptoeing around as Santillana slept behind a thin curtain drawn across a corner of the room, or of sharing a common bath with others on the floor. She did not need middle-class conveniences. What she missed was the stimulation of the artists' colony. The price of their independence was poverty and isolation.

As long as they stayed in Havana, Carlos's parents had provided an

allowance—the bribe for seeing their granddaughter, a not-so-subtle form of control. When Carlos left Cuba, he virtually cut himself off from his parents' generous support. In New York, Alice and Carlos continued to receive an allowance, but, pointedly, it was a meager amount, not enough to live on. Consequently, they had to live where and how they could best manage.

The prospect of living in poverty did not seem to occur to Alice at first. She was giddy with the excitement of Carlos's return and their move to New York. She later said that they had forgotten about incidentals, such as eating and living.[4] Besides, Alice was sure that they could make it as artists, not really knowing anything about New York, but aware of her talent.

In the fall of 1927, reality began to set in. As usual, the two did not have enough money to enjoy the life boheme, but Alice cheerfully ignored reality as long as she and Carlos could paint. Santillana was ten months old in October, and was her parents' constant companion when they roamed the city as they had in Havana, carrying their paint boxes with them everywhere. They walked every day into new areas and began to paint the face of the city. At first, they painted all the time.[5] The major difference between Havana in 1926 and New York in 1927 was that the paints they carried with them that autumn were usually watercolors. They could rarely afford oils and canvas.

Although Alice continued to paint people, especially women and their children, she focused on the scape of the city that surrounded their building. Even with a child to care for, Alice could walk to Riverside Park in the evening and paint the deserted walkways, or sketch the boat basin at Seventy-ninth Avenue and Riverside Drive. She painted life on West Eighty-first Street and life in her one room where bathing was a public event. Alice learned a lot about the neighborhoods on the West Side of Central Park. One day she would return there to live.

Her other discovery during those months, and the following year, was also the result of her poverty. She learned to paint, expressively and with control, in watercolors. Oils, of course, was the medium of serious artists. But if Alice had been able to stay with oils alone, she might not have developed the crisp new style with the bold lines that became her hallmark after 1930. Her rich, dense impasto style could not be adapted to water-

colors. The eyes of her paintings in Havana, whether of Carlos or the beggars, were really only dark recesses peering out from under dense layers of paint, hiding emotions and masking souls.

Alice's watercolors of 1927 begin to strip away instead of add on to the faces of her subjects. Unlike oils, watercolors are thin, almost skeletal; they lie close to the paper. The faces that Alice painted in "Mother and Daughters" became flat and clear. Like Alice's "The Family," it focuses on the face as a pathway rather than an end in itself. The economy of water paints transforms the outline of a face into a stark, empty surface demanding to be filled in. Eyes and mouths become distinct, laid on individually. In "Woman on a Train," Alice painted a pencil-line face, bold and sharp, seeming to possess one powerful, vacant eye. It is the style that would emerge on canvas in her "Ethel Ashton" and "Rhoda Myers in Blue Hat" in 1930.

But in 1927, all of that existed not only in the future, but across a chasm of terrible, unimaginable events. In December, Santillana died. Two weeks before her first birthday, healthy, beautiful Santillana suddenly came down with a fever. Alice burned a spiritus day and night in their room to relieve her strained breathing. Her irritation at constantly having to care for a sick baby passed to concern and then to panic when the fever would not break. But attentive mothering proved to be no weapon against diphtheria. Santillana succumbed days before she was to become one year old.

Alice had not wanted a baby. Her feelings toward motherhood had been ambivalent at best. And toward Santillana? She once described her as beautiful, but in her interviews later in life, Alice referred to her in relation to the agony caused by her birth and the pain by her death. But ambivalence dissolves in the face of death; it is always transformed into something stronger, an emotion fixed at the moment of death. For Alice, it was guilt.

If Santillana's birth had interrupted the flow of Alice's paint, her death hardened the fragile watercolors into a leaden lava. Alice could not paint. Guilt immobilized her. The quiet closing of Santillana's life opened Alice's to the kind of brutal scrutiny that only tragedy has the power to summon. And, forced to look at herself not as a painter with a child, but as the mother of a dead infant, she could not avoid blame. Guilt over the mother she had been fused in the most grotesque way with profound regret to create one consuming, demanding need.

Alice had to redeem herself from the blame that she believed was hers for not being the kind of mother who was able to save her child. Alice did not want to become a mother again, but she felt that she had to. She needed another chance. Alice determined to have another child.

Whatever demons would be exorcised by another child had to be confronted. Guilt always demands a sacrifice. Forty years after that existential winter of 1927–1928, Alice said, lamely, "All I could do was get pregnant again."[6] She recognized that she had been caught in the "trap" of being a woman as well as a painter. Choices are for male artists.

Eleven months after Santillana's death, in November 1928, Alice gave birth to Isabella. She christened her new daughter in watercolors, in the telling and articulate painting "Well Baby Clinic," a bright white arena of combat in which pathetic, skeletal new mothers are set against the small, ugly "pieces of hamburger" that they had committed themselves to care for. As Alice admitted, the painting betrayed her attitude toward childbirth as still "very dubious."[7] Motherhood did not so much diminish Alice's sense of guilt as give it a sibling emotion, renewed anxiety, starting again the destructive cycle that leads to ambivalence.

Alice suffered. From the first weeks after birth, when she was confined to the hospital with phlebitis and cut off from her regimen of painting, she succumbed to the depression that frequently follows delivery and always lurks near anxiety. She rarely stirred herself to cook or to clean.

It was Carlos who fed Isabetta, as he called their daughter, and bathed her. Although he would have preferred a boy, he was thrilled with her and she became the center of his life. Almost certainly with money from his father, who responded both to the news of a grandchild and the appeal for financial help, Carlos arranged for all of them to move from their room, with its ghosts, to an apartment on Sedgewick Avenue, on the Harlem River, to a fresh start in more spacious, if not more elegant, quarters.

But new surroundings rarely change personalities. Alice continued to go through the motions of life as a shadow of herself. Caught again in a descending spiral of competing needs, she watched emotionlessly as her marriage disintegrated. Carlos devoted himself almost entirely to Isabetta and, like Alice, invested smaller amounts of time in the marriage, for it was apparent to both that the emotional bonds had never been strong and were not surviving these difficult times. Carlos, on a visit to Colwyn, complained to Mrs. Neel that he had to care for himself almost entirely. She thought it sad that such an aristocratic man was reduced to washing

his own underwear.[8] Alice did not actively seek the destruction of her marriage. Her attention was simply elsewhere.

As always, Alice's most demanding need was to paint. It was still her escape. In the early months of 1929, as the phlebitis began to subside, she began to leave the apartment with her painting box, but she went out alone. She walked painfully with the help of a cane. Her relationship with Carlos had degenerated into little more than an increasingly tense emotional estrangement that sometime erupted with an edge of bitterness in crude attempts to attack each other on paper. What Alice later called an artistic rivalry was almost certainly a mutual expression of other powerful emotions that had bullied their way into the marriage—anger, hurt, or jealousy. Sometimes he was reduced to drawing a tunnel where her vagina was and she a perpetually erect bridge in place of his penis.[9] The meaning was intensely private, but the intent must have been to hurt or taunt.

Increasingly, Alice broke away from the confines of her depressingly ordinary existence and entered again the magic world of artists and intellectuals. She spent at least one day with Ethel, who came up to New York to see Alice, but mostly she tried to reach out to bohemians whose freedom ridiculed her own life.

She began to paint once again with regularity and intensity, and what splashed from her brush were people, interesting and offbeat, who became the center of her existence. Nadya, vacant eyed but compelling, Fania Foss, actress and "intellectual," whose stories dazzled Alice, and an army of others who lived beyond the edge of respectability, began to populate her watercolor paper and later her canvases. Did she ever paint Isabetta during those months?

Her painting "Intellectual" speaks volumes of her perspective on her own life as Isabetta grew from infant to toddler. Fania and a friend are pictured sitting to one side discussing intellectual topics. Alice, who is excluded from the conversation, sits on the other side of the paper, tending to Isabetta and wholly absorbed by her. Alice painted Fania with her breasts unconsciously exposed, unconventional, liberated. She painted herself with three arms and three legs because, as she explained, "I was so busy with the little girl."[10] The "little girl" was distracting, but, worse, she robbed Alice of her hard-fought-for autonomy.

Harried and frustrated, Alice might escape her various forms of imprisonment for short periods of time, but reality was unrelenting. From "those crazy kids"[11] who had come to New York to grab the art world by

its arrogant throat, she and Carlos became just another estranged couple negotiating a relationship more from necessity than conviction.

In these circumstances, the meager allowance from Carlos's family was just enough to remind him of what he had given up. He was reduced to free-lancing art work for newspapers, responding to a plebeian problem with a plebeian response. He could, however, work only part time and at home because Alice had been forced to take a full-time job at a bank, a new source of tension, and he had to care for Isabetta essentially full time. How often did he reflect on the accumulating number of taunting reminders of the compromises he had made to live with Alice in New York?

Alice attributed their "breakup" to "the terrible rivalry" that grew up between them in 1929,[12] and to a conspiracy of his friends and family. She said that at the time she believed that Carlos took Isabetta to Cuba with him to visit his parents. He was going to send for Alice, but the stock market crash had so lowered the price of sugar that it wiped out his family's fortune and they could not afford to bring her to Cuba. His friends, having him there with them, took advantage of the opportunity to turn him against her and his life in New York. They accused him of having become a "petit bourgeois," a mundane working man, domesticated, reined in. To save him, they conspired to send him to France where he would come to his senses.[13] Alice may have believed the story at the time. She may have needed to believe it.

Or she may have understood that Carlos had, one early spring day in 1930, packed a meager bag, taken his seventeen-month-old daughter, and fled their marriage to have Isabetta raised by his parents. When, early in the year, Carlos's parents stopped sending money entirely, did she understand that it again forced Carlos to choose, and that he lacked the commitment to make still more sacrifices? Whatever she understood, she reacted to his departure with elation.[14] He was gone! The "little girl" was gone! She was freed from the weight of relationships that had become too heavy to carry and from the ambiguities of mothering. Was it now possible that she might again be an artist without guilt?

It seemed so. Alice had been spending time during the past year away from her apartment with Nadya and her group of friends, but after Carlos left, she was rarely at home. Her life shifted to the bohemian existence of Nadya. Dark, sultry, and mysterious, Nadya was Alice's fantasy self.

Alice did not say where she met Nadya, but Nadya and her husband, whom she generally ignored, moved in a fairly disreputable circle of acquaintances. Despite being married, Nadya was an autonomous being. Although she lived with a man, she was not accountable to him, for she supported herself. Alice marveled at this novel set of relationships that helped to make Nadya as exotic to Alice as Carlos had been in the summer of 1924. She represented nothing less than decadence.[15]

Nadya was also proud of her body and aware of its seductive powers. Alice had never before known a woman who wore her sexuality so naturally. Over the years since her revolt against the middle-class values of her parents, Alice had learned to move easily within the circles of artists and intellectuals who talked open-mindedly about life and sex. But she was still remarkably inexperienced in the culture of the sexual woman. And her fascination with Nadya continued her education.

Alice painted Nadya. Unlike her earlier paintings of people she encountered, she painted Nadya nude. Alice had, of course, painted nudes in life classes, but they had always been demure women in classical poses. Nadya was not demure, and Alice captured her in anything but classical poses. Nadya exuded raw, naked, animal magnetism or bored sensuality on Alice's canvases, not caring how the world judged her. Alice was drawn to her like a pupil to the master, compelled and scared at the same time. Alice once stayed overnight with Nadya and slept in the same bed. She was terrified at the power of the provocative, voluptuous sleeping body next to hers. Nadya made no threatening gestures at all, but Alice was so afraid of what she imagined might happen that she could not fall asleep.[16]

As she pushed herself to paint and to experience the life of an unfettered woman, she may not have been capable of knowing if she really wanted Carlos to return. She may have actually believed that Carlos would send for her and that their separation was temporary. Or she may have understood that he was neither coming back nor sending for her. Alice was a thirty-year-old woman whose life was almost totally in the hands of Carlos. He would decide if she would have a husband and if she would again be a mother.

Her reaction when she received his letter from Paris telling her that his parents could not, or would not, send money to her to join him, was to recognize that this was "the end of everything . . . it was finished."[17] Carlos had left her. She was stunned, but as she reread the letter she got

more and more angry. Anger, undiluted anger, was her strongest response to his weakness and his cowardice. Did she look in the mirror at her unkempt hair or the spreading hips that made her look older than her thirty years, or at her unwashed clothing? Did she remember the neglect or the arguing over her insistence that the tall handsome man whom she once painted in his elegant white dinner jacket care for the baby and the apartment?

It was easier to blame Carlos, and she was furious that he was so weak. But Alice's emotions were too confused and too complex to stop at condemning Carlos. Anger was but the opening note in an agonizing overture to her emotional collapse.

She had been abandoned and betrayed, but she had also been robbed of her daughter. Could she get Isabetta back? Did she want her back? When Alice was with her friends she complained bitterly about Carlos's treachery, but did she do anything to get Isabetta back?

Carlos had left Isabetta in Cuba with his parents when he went to Paris, and Alice did not know how she felt about his obvious intention to keep their daughter. Would they give her up? Events had conspired to force Alice to confront two very strong drives: "I loved Isabetta, of course I did. But, I wanted to paint."[18] Confused and growing increasingly frantic, she did not want to be separated from her daughter, but she did not actually want Isabetta to come back to live with her. She deluded herself into thinking that Carlos's parents would send Isabetta to her in New York if she asked. The Enríquez de Gómez family almost certainly would have refused to return Isabetta, but Alice was not to know that for she did not ask.

For the second time in a little more than two years, Alice was faced with the loss of a child. Back in the winter of 1927–1928, she had had no choices to make, no power to bring Santillana back. In 1930, however, Alice could have been an active participant in her own life, but her "awful dichotomy" again immobilized her. She agonized over the unfairness of life when she lamented, "Woman's guilt is twofold. On the one hand she is supposed to marry and have children. Then if you do have children, you have the feeling that you're not doing all you should for them because you're too busy painting. . . . Painting is a very obsessive thing. . . ."[19] And she knew, deep down, beneath the layers that convention had laid, that she would be unable to relinquish her obsession.

Painting was the anchor of her still-fragile sense of self. Motherhood

was an obligation. Standing at an unambiguous fork in the road on life's journey, Alice wanted to go one way, but felt an obligation to go the other. Guilt nudged her to take a path between the two roads.

Her feeble attempt at salvaging some self-respect from her private anguish was to ask her mother to take Isabetta into her home. Alice knew that she was testing a strained relationship, but she was desperate enough to swallow what little dignity she still possessed after three years of being battered by an unforgiving relationship in an unforgiving New York City. It was the only way she was able to conceive of carrying out her obligation as a mother and still paint.

Mrs. Neel's answer was unequivocal. "Oh, no. I've already raised one family and that is enough."[20]

And Alice did not ask her again. Her humiliation at asking her mother for any favor was too great to allow her to ask a second time. That would have required pleading. With her mother, she said, "I couldn't show any emotion."[21]

Alice had no follow-up plan. She made no further attempt to secure the return of Isabetta. The young girl was a casualty not only of Alice's "awful dichotomy," but of Alice's still-tender fear of her mother. Whatever Alice felt deep within her was quietly smothered by either the unrelenting hand of pride or the demands of art. Perhaps she consoled herself with a memory of that great house in Havana where Isabetta would play with servants; perhaps she thought about the barren life that any child would have with her, penniless and driven. Perhaps Alice was unable to find solace in any rationalization and simply gathered her guilt around her like a shawl to keep out the cold memories.

Mrs. Neel would not sacrifice her life for Alice's mistakes, but she was still Alice's mother, and she knew that her daughter was in trouble. Every time the fire in Alice died down, Mrs. Neel worried and, as she had in 1924, when she sensed her daughter was heading for trouble and sent her off to Chester Springs, she softened. Mr. and Mrs. Neel went to their daughter in New York. They stayed with Alice and tried to revive or distract her by taking her into the city or out to Coney Island. When that simple therapy failed to interrupt the crescendo of depression that was building in Alice, they insisted that Alice accompany them home. With faint protest, a defeated Alice returned with them to Colwyn.

It was a mistake. The memory-laden village contained too many ghosts of the terror and the boredom of her childhood. As she had learned during

those months in 1927, there was nothing there for the adult she had become. The return again to her childhood bedroom, to her mother's dining room, resurrected too fervently the destructive behaviors of mother and daughter, behaviors that had led to estrangement in the first place. Within weeks, Alice fled back to her apartment with its newer, less frightening specters. She tried to paint, and conjured up emotionless, defeated faces from memory, reflections in a watercolor mirror.

But painting, this time, could not empty her mind. She grew frantic as escape routes closed and her world, emptied of its familiar contents, closed in on itself.

She needed sanctuary, a place where she could find acceptance without judgment. She remembered Rhoda and Ethel, and in late May 1930 she fled New York for Philadelphia and the studio on Washington Square.

Photos 6 to 13 are of paintings done by
Rhoda during her years at the Washington
Square Studio, Philadelphia, 1924–1930

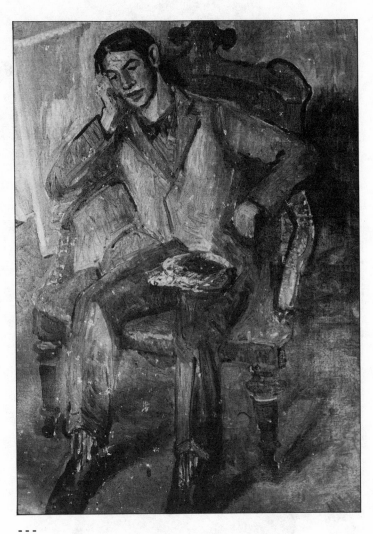

6. "Skinny." (Collection of the authors.)

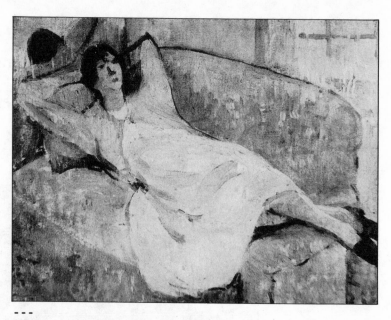

8. "Resting in the Side Room."
(Collection of Holly Medary.)

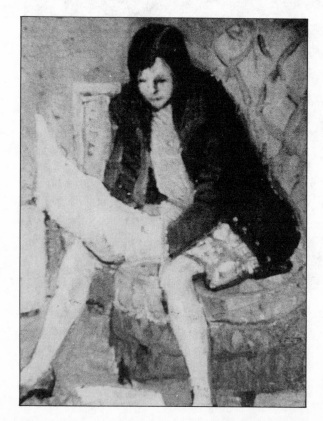

7.

"Reading the Paper."
(Collection of the authors.)

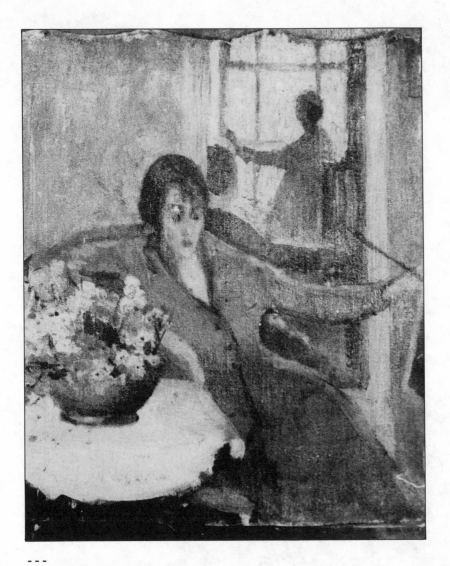

9. "Painting at the Studio."
(Collection of Holly Medary.)

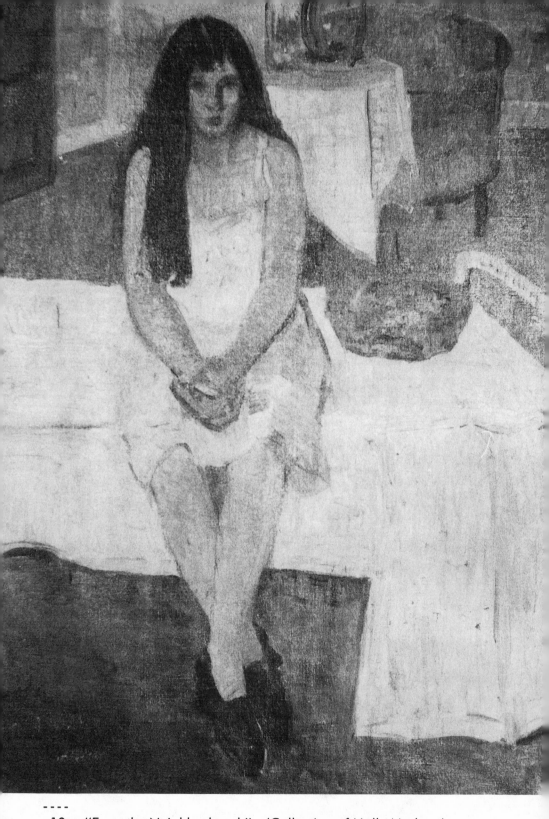

10. "From the Neighborhood." (Collection of Holly Medary.)

11. "Manayunk." (Collection of Holly Medary.)

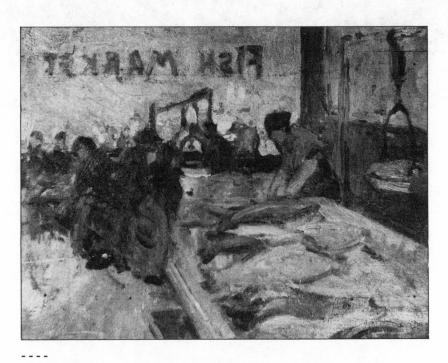

12. "The Fish Market." (Collection of the authors.)

13. "Washington Square in Spring."
 (Collection of Holly Medary.)

PORTRAIT OF THE ARTIST AS A YOUNG WOMAN

7.

R o u g h, dry cornstalks dotted the field in irregular patterns, converging into indistinguishable smudges of maize on the distant horizon. Swirls of gray somehow organized themselves into low-hanging clouds; rough blurred streaks of browns, oranges, and greens managed to suggest a neglected field in the foreground. Altogether, the painting splashed autumn across the canvas.

Rhoda had painted the cornfield on an unexpectedly cold October morning in 1928. She had arrived in the country near dawn, having boarded a bus in the dark in order to catch the fresh morning light. As she stood in front of her canvas composing her bucolic scene, the gathering coldness numbed her toes and, worse, her fingers. She knew that she was not going to finish the painting before the temperature forced her to quit. The foreground on the canvas was still virgin white when she could stand the cold no longer. With an unpainterly haste, she squeezed yellow and burnt sienna, green, several shades of brown, and titanium white directly onto the pristine surface, picked up dry leaves from the ground and smeared them into the paints until the space was filled with a chaotic blend of autumn colors and pulverized leaves.

In a few short moments, she finished, packed her paint box, and rushed to the warmth of a farmhouse to await the next bus. She was back in her studio framing the canvas before the thick impasta of dead leaves and oils

had dried. The next morning, she wrapped the picture and delivered it to the Pennsylvania Academy of the Fine Arts as her last-minute submission to the Jury of the Academy's annual show.

Rhoda had been grooming several portraits to impress the august panel, but on impulse, almost an impish whim, for she never took competitions too seriously, she entered "Cornfield," still wet from its birth. The judges selected it with praise for its fresh quality. Its acceptance in Philadelphia's most distinguished art show is an apt metaphor for Rhoda's life during the years that paralleled Alice's marriage to Carlos, for they were carefree, satisfying, successful, and, even more, promising.

Rhoda wrote of the years 1923 to 1931, when she and Ethel shared their studio on Washington Square:

These times were great times for me. I was sending pictures to all the local shows and some art critics would mention my name as a promising young artist in the Sunday art column. I am sure none of this turned my head for I remember not caring too much what they wrote. I never cut one column out of the paper to keep. I was too busy painting, and always wanted to do better. I would get a 30 by 40 canvas and practically paint it in one sitting. Many times I painted five or seven hours without even sitting down, although I was frail and very thin. I seemed to be consumed with a burning fire to paint and paint.[1]

Rhoda had consciously shaped her life after graduation as she thought painters should. As she had expected, Ethel and then Alice came to share it with her. When, after those long months during which angst sat as a fourth presence in the studio, her brooding friend suddenly bolted to Havana, Rhoda reacted with ambivalence. She was both angry at Alice for her desertion to the enemy and relieved to have her gone. Possibly she had already given up on Alice, who showed irritating signs of becoming just another woman who was obsessed by men. More likely, Rhoda was uncomprehending, uncomfortable with a friend who had become mysteriously complex and emotional. Rhoda did not like life to become too complex.

Superficial people, however, tend to be resilient. Whatever Rhoda felt, her first concrete response to Alice's departure was to figure out a way to make up for the loss of Alice's expected contribution to the studio. She arranged to rent out the kitchen, bathroom, and one bedroom to Tommy,

a student from the Academy of Fine Arts. Rhoda and Ethel wanted to keep their fine studio. For Rhoda, it was one of life's few imperatives, for although she slept at her mother's house in Germantown, the studio was the foundation of her carefully constructed artist's world.

The same was true of Ethel. She also spent her waking hours at the studio. She lived in West Philadelphia with her parents, who gave her an allowance to rent the studio. Rhoda was supposed to contribute half of the rent, but since she would not ask her parents for money, she seemed to consider Tommy's rent her portion.

When they rented out their spare rooms, the two women kept the side room with its ornate fireplace and, of course, the front room with its large windows that gathered in the precious northern light they had used to tempt Alice into joining them. Their furniture was, by any standard, garish and dilapidated, mostly Victorian residue: an ebony parlor suite with shiny gold upholstery, marble-top tables with curved legs, and a stuffed pink and green chaise whose legs were modestly covered with a long fringe. Amidst such clutter, Ethel and Rhoda spent their waking hours, either standing in the front room painting or, on cold evenings, sitting in front of a stubborn fire coaxed into burning rolled-up newspapers or, on lucky days, pieces of wood collected from the square.[2]

Possibly they could have afforded wood or better furniture but Rhoda probably thought that too many middle-class amenities violated her image of the bohemian life of the artist. Their bare studio floor was covered in places with a scuffed and tattered linoleum tile, layered with dust, and the sink in the bathroom, which they kept, was, according to one visitor, the world's dirtiest sink.[3] Neither Rhoda nor Ethel cleaned. Neither seemed to care about mundane concerns such as cleanliness. Artists simply did not.

The neighborhoods adjacent to Washington Square were a sea teaming with people, mostly poor immigrants, laborers and hawkers, delivery men stocking up at the warehouses that abutted Independence Hall, longshoremen and sailors from the nearby river, merchants and clerks, and, occasionally, blacks who lived on light feet. Derelicts inhabited the shells of eighteenth-century row houses and the streets were dry stream-beds for a steady flow of mothers with hordes of children heading toward or returning from the anarchy that was the Italian Market on Ninth

Street. For struggling painters, the area was a mecca of character-filled faces whose owners could most likely be persuaded to sit for a handout or a simple display of friendliness.

Rhoda and Ethel prowled the Washington Square area in search of just the right people to lure or bribe into posing for them. They crafted permanent images of boys and girls, mothers who coaxed their children into sitting still with them, runaways, transients, and, when necessary, Tommy, the student who rented their rooms.

Rhoda's favorite model was a laconic boy of sixteen who lived, or was supposed to live when they could hold onto him, in a somber Catholic orphanage around the corner from the studio. She never learned his name despite the many times she painted him, so she called him Skinny and put onto canvas his gaunt face and his sorrowful eyes. She and Ethel always knew where to look for Skinny—on the bench beneath their window, his eyes lifted hungrily and hopefully toward them. Skinny enchanted Rhoda by playing his harmonica and when he died that year of tuberculosis, she grieved not only for the loss of a young friend and model, but for the waste of talent "crying for appreciation and encouragement." She considered him, like herself, another unloved gifted child.[4]

Art was easy for her. She worked hard at it, but she accepted the challenges that painting presented to her only if they fit in with her easy life-style.

Even though Rhoda painted the face of poverty, she did not probe deeply enough to empathize with the lives masked by the faces. The shy black girl whom Rhoda lured as a model from the square, and painted as she sat demurely on the edge of a bed, interested her because her face presented a challenge. She did not find out much about her, not even her name. While Alice immersed herself in the ideology of the poor and struggled to find ways to use paint to invest suffering with dignity, Rhoda was fascinated with the faces of homeless men without giving much thought about the lives that produced such interesting models.

Once, in the summer of 1927, Rhoda and Ethel came across a twelve-year-old boy who they thought was living in the streets. They "adopted" him during the day. As it turned out, their waif's mother had a daytime job, and he gladly attached himself to them also. For weeks Rhoda took him with her on her errands and visits, bought him a pair of roller skates, and even talked her friend and former teacher at the School of Design,

Paulette von Roekens, into taking him to nearby Glenside for a week in the country. On one of her frequent visits to the Chestnut Street studio of Paulette, Rhoda had her boy in tow as she "breezed in." A few weeks later when she dropped by, she was alone. She had moved on to another interest after weeks of having enjoyed him greatly, the way that grandparents enjoy their grandchildren on a finite holiday. There was nothing calculating in Rhoda's treatment of her young friend. Most adults would never have noticed him in the first place. To Rhoda, only an artist would do something so unconventional.[5]

From her own childhood, Rhoda drew on a wealth of appreciation for neighborhood mothers who loved their children, loved them and sacrificed for them. Unlikely as it was for Rhoda to pay money for models, the exception was a Hawaiian woman who lived in two shabby rooms with her son and daughter. Mrs. Kahaki may have been surrounded by squalor, but her two rooms were immaculate. Her only possession of any worth was a new carpet on which she played with her children. She supported herself by posing nude for life classes at the Pennsylvania Academy. As often as she could, Rhoda scraped together money to hire her, although she did not consider Mrs. Kahaki an especially interesting subject and, in fact, later painted over the canvases of her. Rhoda's friendship was reciprocated when Mrs. Kahaki allowed Rhoda to paint her children in the nude, a priceless opportunity for a figure painter at that time.[6]

Rhoda struck up easy conversations with mothers who sat on the park benches protectively watching their children at play. She would only befriend those women who she thought both loved and respected their children, the ones who did not interfere in their play or scold them because they played too loudly. But she rarely explored relationships beyond the levels of politeness and courtesy. Even with Skinny and Mrs. Kahaki, Rhoda kept her friendship shallow and safe. She truly liked them because they were kind or talented or thoughtful, and she never minded helping people whom she liked. She was wary of commitment or involvement that would cause too much distraction from painting. Young and uncomplicated, Rhoda was organizing her life the way she had shaped her art school years, to be fun and pleasurable and edged with relationships that she could manage without much effort. Artists, she thought, should live for art. It was that simple.

Rhoda claimed that the only thing she worried about during these years

was becoming a great artist. What she claimed was her driving ambition in art school passed blithely into her studio life, for it was the core of her identity.

During these "studio" years, from 1923 to 1931, Ethel was Rhoda's almost constant companion. At the height of their studio years, between 1926 and 1930, when the two painted contentedly for hours a day to the exclusion of any major distractions, Ethel was over thirty years old, yet she still deferred to Rhoda. It was the younger Rhoda who scurried around the town, "Ethel in tow."[7] They painted in the same style and put on canvas many of the same people and cityscapes. Since Ethel destroyed many of her canvases before her death, keeping those that she thought best represented her work, it is impossible to know if she painted people such as Skinny or if she was also invited to paint Mrs. Kahaki's children. But the two artists were as compatible as painters as they were women.

After painting every day for hours, Rhoda and Ethel retreated to their side room to relax and talk. It was during these conversations that Rhoda experienced nagging questions about how someone became a great painter. She was growing vaguely aware that she should have studied while at Miss Wright's school, and should have been more disciplined during art school when Alice and Ethel talked about books. She needed to become, she thought, "a more substantial" person, more knowledgeable, although about what she was not sure. "I knew," she wrote later, "that I had a great talent for color, emotion and technique, but I needed more brains back of what I was painting." In her usual naive exuberance, she realized that "to be a really great painter I should have more gray matter along with my exceptional God-given talent."[8] So when she was not at her easel, she diligently plowed through the "better" novels that Ethel recommended and tried her hand at philosophy and psychology. Such studious determination to learn an academic discipline seems to have accomplished little more than at art school. Again she got a smattering of Freud, an acquaintance with Thomas Hardy, and a familiarity with the lives of *fin de siècle* painters to whom she often referred, but about whom she knew very little.

Her inability to learn new information or fresh perspectives in any systematic way defines Rhoda during these years as accurately as any trait. She claimed that during this period she was pushing further in her painting and that she "hungered" to be better. She did change her subjects occasionally, moving from portraits and figures to still lifes and land-

scapes, but she never strayed from the safe, familiar framework of the impasta style that seemed so revolutionary during her art school days. Thereafter, she played with her style, delighted in it, but rarely pushed it too far, and never significantly altered it. Her tested style fulfilled her needs, psychological as well as artistic.

Rhoda's undemanding life never required, or even politely asked, her to grow beyond her wide brushes and her palette knife. It bestowed upon her the rewards she craved: acceptance as an artist and recognition by the Philadelphia art community that she was a good painter. She and Ethel regularly entered the Academy of Fine Arts annual juried show during the last part of the 1920s and usually had either oils or watercolors accepted. Other Philadelphia shows were eager to display Rhoda's newest works, and she was delighted to show them. They would have been happy to show some of Ethel's work, but she would not submit them. The Art Club, quite a well-known gallery in center city, requested some of Rhoda's paintings to put up for sale, and sold the only two Rhoda ever sold.

She was good.

Without question, she had mastered her style and the genre of figure painting of interesting people in informal poses, reading newspapers, languishing on a settee, or painting. Her urban scapes move breezily between the dusky haze suggestive of a Turner and lines of laundry hanging from tenements, so typical of the Ash Can School. Rhoda moved effortlessly and skillfully within her milieu. Her life seemed to be governed by the rule: If it is fun, do it.

Rhoda's formula for local success, however, was not really sufficient to earn recognition by the art world beyond the increasingly cozy environment of the City of Brotherly Love. While perfectly adequate for her circle, and still quite radical among the monied brahmins of the city, her style would have been passé in New York. Alice, at that same time, carried with her to Manhattan the same textured style, but poverty and her own need to grow pushed her into watercolors and into a new consciousness about art. Conversely, nothing in Rhoda's life required her to experiment, to grow. She was not in the least affected by the styles that swirled through Europe or New York. She did not continue her art education and she had no mentor to push her. But, unlike Alice, that was by choice. Like a child with her favorite toy, Rhoda clutched her style to herself lovingly, a prized possession.

It was not that Rhoda was unaware of artistic possibilities. Her eye was critical. She knew that radically different styles had always existed; during her European trip in 1923, she had formed strong, unambiguous opinions of the various schools and artists. Baroque had thrilled her. The exaggerations of El Greco had severely strained her limited vocabulary as she attempted to record her feelings of awe. While European art had all but overwhelmed her, she was, on that European trip, neither adventuresome nor driven enough to overcome homesickness, stay the entire year, and extract every ounce of learning from her experience. Rhoda's sense of life limited her eye's power. So she stopped looking.

People who encountered Rhoda in the late 1920s always commented on her carefree demeanor. Ethel was good-natured enough to indulge Rhoda her spirited artistic existence even though it often ran counter to her own reserved nature. Usually she just followed Rhoda's lead. That meant that when Rhoda was not in one of her erratic "learning" moods, they talked mostly about art, "nothing really serious,"⁹ that they always carried their sketching or painting boxes with them as they "flitted" around town, and that they acted like artists. Their friendship during these years sat solidly on a foundation of the satisfying, undemanding nature of their lives.

Their ability to live their artistic life-style was due to Ethel's sense of responsibility. Somebody had to pay the bills. Rhoda, studiously, did not pay very much attention to money. The immaterialist bohemian was an integral part of her image of the artist. She needed money to pay her part of the rent for the studio, to buy small quantities of food and large amounts of paint and canvas. Once she was sure that Tommy's rent money would allow them to stay in her beloved studio, she treated money matters casually. She claimed that she "painted too hard" to worry about money. Consequently, she never got a job, which she thought would be too distracting from her art. Nor would she seriously consider selling her work, which she thought would compromise art itself. During her productive years, 1925–1930, Rhoda sold only two small paintings.

Occasionally Rhoda managed to dislodge money from her grandfather's chaotic estate or from her grasping mother, but her needs were few. She dressed slovenly, or artistically in her mind; she indulged in no entertainments outside of fifty-cent tickets to the Philadelphia Orchestra. She had no social life. When she ran low on art supplies, she simply asked Lorine, her older sister, for money. The children of the estranged Myers parents were not close themselves. They never visited each other, and

Lorine never saw either Rhoda's studio or her work. But she never refused Rhoda money, showing not the slightest curiosity about the art she was supporting.

Rhoda claimed that she and Ethel worried only about painting, "about being great artists." Fortunately, Ethel also worried about money. It was Rhoda's compliant and friendly studio mate who, more often than not, paid their rent and supplied their food, quietly, without a fuss. She was still being financially supported by her father, and her allowance was generous, expanding to include trips to Europe whenever Rhoda went, and a small wardrobe of conventional clothes, dresses and heels, which she preferred. So she saw no problem in spending money for the two of them.

Rhoda was either not aware of the imbalance in their contributions or chose to ignore it. Her ideal of the dedicated, struggling artist's life rendered poverty romantic. If it had not been necessary to devise substitutes for stretchers and to paint on the backs of already-used canvases, she probably would have done so anyway. Sacrifice was an essential part of the mystique, a virtue ennobled in the service of art.

Rhoda lived at home during these years in the 1920s. Her parents had been separated since she was sixteen, back in 1918. Mrs. Myers continued to live in her more modest home of only twenty rooms, and did not have a servant for the first few years, although she eventually employed two. Her extravagances were smaller in scale than when Rhoda was growing up, but most of her indulgences lingered, some because they served her insatiable vanity, some only to irritate her estranged husband.

Mrs. Myers periodically reminded him of the weight of his responsibility by running up large bills at local department stores. One day, in 1926, Mrs. Myers took all three of her daughters to Wanamakers, and bought them and herself, of course, full-length fur coats and sent the bill to him.[10] Rhoda would not wear hers for several years. When Grace, Rhoda's oldest sister, wanted to marry, she asked her mother for a simple wedding. Mrs. Myers insisted on an extravagant wedding. When Grace came down with tuberculosis, Mrs. Myers sent her to the most fashionable and expensive sanatorium in Asheville, North Carolina, and had the bills sent to her husband. When she wanted Rhoda to go abroad to pursue a man she wanted Rhoda to marry, Mr. Myers civilly agreed to pay.

Rhoda had removed herself from participating in this spiteful aftermath of the marriage by ignoring her mother as much as possible. She was rarely at home and generally abandoned the roles of daughter and companion to her older sister, Lorine, who quietly accepted the responsibility to care for Mrs. Myers for the next forty years. But, while Rhoda emotionally divorced herself from her mother, she was unable to bridge the chasm of ambivalent feelings that estranged her from her father.

While William Myers had always been a distant figure in her life, after he moved to his small room on the third floor of the Art Club, he seemed to shrink his life to match his habitat. The friendships he developed were within the small community of men who also lived at the club. He was not an old man when he fled his marriage in 1918 to live at the Art Club, barely forty-five, but he seemed ancient, defeated by life. He usually could be found simply sitting in the window of his room looking down on Broad Street. He husbanded the once-substantial resources from his father's estate, most of them still in trusts for Jacob's six grandchildren, but he paid his wife's unrelenting stream of bills without apparent protest. Guilt reduced him to a passive reed in the rushing waters of his wife's revenge. Rhoda rarely saw him, but then she rarely saw any of her brothers or sisters. When the family broke up, it shattered whatever patina of cohesion had previously held it together.

Lorine occasionally visited their father, but she was the only daughter to do so. Rhoda felt sorry for him, but she was unable to outgrow the images of him that had been implanted over the decades by her mother. As Rhoda said, "I wasn't too much associated with him because mother was always closing our minds about Daddy. She poisoned our minds."[11] The most that she could bring herself to do was to walk down Broad Street every once in a while, stand across the street from the Art Club, and wave to him. She also accepted from him whatever gifts her mother had arranged for him to pay for. The most significant of these was a trip to Europe in 1928. It changed her life. She met Ben.

In the lives of many, perhaps most, women who were born near the turn of the century, the exterior scarcely reflected the interior it masked. In an era when girls were herded into a few acceptable roles, the women they became rarely emerged from childhood intact. Most grew into adults who had learned to accept whatever role man or God had cast for them,

quietly smothering whatever desires they might have. Others, like Alice, unexpectedly rebelled, then agonized for months or years in the effort to overcome their guilt.

Some women, however, like Rhoda, were rebels as children and managed to retain their sense of autonomy as adults, without guilt or regrets. Rhoda seemed perfectly happy as an artist, as the woman whom her rebellious childhood had created—until she met Ben. Then she was forced to confront the question of whether or not her adult identity was really her or if buried under her tenaciously held artist's persona was another woman entirely.

Nellie Myers finally decided that Rhoda should be married. Rhoda was twenty-six years old in 1928, when Nellie, after years of benign neglect, made her decision. It may have been spontaneous, a decision to send her wayward daughter on a cruise to Europe because the son of a social friend, a more than acceptable bachelor, was on the ship. Or her decision may have grown from deeper roots, her embarrassment with her youngest daughter's life. Her eldest, Grace, was married and was the mother of a son; Lorine, taught physical education at Girl's High School, not a job that Mrs. Myers would have preferred, but one that provided a steady income and, more especially, allowed Lorine to care for her, often providing ever-needed money for her indulgences. Rhoda had shown no signs of responsibility since entering art school ten years before. A husband was the answer.

The eligible bachelor that Nellie had selected was sailing for Southampton in June 1928. Nellie demanded of her erstwhile husband that they send Rhoda. William Myers, as usual, consented to whatever demands his wife made on behalf of their children. What is surprising is that Rhoda accepted. Having regretted the juvenile way that she had handled her first European trip in 1923, she and Ethel had talked about how it would be different if they were to return. Ethel asked her father if she could go and, as always, Mr. Ashton was generous with his only daughter. Rhoda and Ethel signed on for the trip aboard the student-class ship, and they sailed in June for a month in England and Europe.

On the passage over they met two women art students from the Academy of Fine Arts, and with other students on board enjoyed the kind of light ambiance of their own art school days. Neither seemed to acknowledge that at thirty and twenty-six years of age, they were any different

from the students. In many ways, they were not. Their only difference was that they had to close their studio for a month instead of giving up college classes.

Rhoda never bothered to meet the unnamed man of her mother's choice. She had not gone on the trip for romance. On the other hand, her trip was not exactly an artist's pilgrimage to Mecca as it had been five years before. By 1928, Rhoda had been painting seriously for over five years. A trip to Europe dropped in her lap should have meant a chance to grow, either to see the great masterpieces that she missed the first time or to expose herself to the *au courant* movements that any breathing artist knew to be seducing Americans in Paris. But Rhoda did not want to study. She wanted to sketch. She and Ethel carried their sketchbooks everywhere and, with architects' precision, drew the façades and the decoration of Medieval Europe, Baroque France, Renaissance Italy.

They enjoyed their breezy, undemanding month, knowing that it was not going to be a year. When they returned in August, they had no residue of Gertrude Stein's Paris clinging to their minds, but they had had a good time. The major consequence of their European adventure was the appearance, later in the summer, of a young man who had just emerged from the gleaming red Packard convertible parked at the curbside in front of 622 South Washington Square.

Rhoda first met Milton Bennett Medary III on the ship as it sailed eastward toward Europe. She did not remember him very clearly from that first encounter. But that was to be expected. At twenty-six, her experience with men was so limited and her mind was so set against involvement with them that she did not categorize the men she met into marriageable and nonmarriageable. She claimed that she simply did not think about men. Her two notable encounters with men who had made advances toward her had been most unsatisfactory.

The first occurred when, at twenty-four years of age, she was invited to the studio of a student from the Academy of Fine Arts who told her she was skinny and needed a good, home-cooked meal. After a dinner of pork chops, potatoes, and cheese, quite an investment for a student, he said, "Let's neck." Rhoda, having no awareness at all that there might be a *quid pro quo* for the meal, and certainly having not the remotest idea of what she possessed that she could possibly give him anyway, answered, "What's

neck?" He promptly walked her home and took back the scarf that he had given her earlier in the evening. [12]

The second incident came about when she met the man who had bought one of the only two paintings that she had ever sold, a painting of the Roman Catholic Cathedral, Sts. Peter and Paul, on Logan Circle. The buyer was a tall, bald-headed bachelor, fifteen years older than Rhoda, whom she remembered vividly as slightly built, with exquisite, sensitive hands, but who aroused her suspicion by having "short eyeteeth." He habitually hung around art shows, charming the "old maid" artists and teasing them by shrouding himself and his occupation in mystery. Rhoda did not enjoy playing the game that was popular among these "lesser artists" of trying to guess his line of work and, in the process, elevating him into a local celebrity on Locust Street. She considered him the philandering type, "a small Disraeli." He always behaved as a perfect gentleman around the doting ladies, until one day, after telling Rhoda that he had purchased one of her paintings, he tried to kiss her. In horror and fear, she ran away and never allowed him to get near her again. [13]

The woman who gazed through the studio's north windows at the man emerging from the red convertible was armed only with these experiences and the array of misinformation about sex that was usual for daughters of Victorian mothers. The main secondhand knowledge of men that she had gleaned from her mother was Mrs. Myers's frequently uttered axiom, that men want only one thing from women, and if they cannot have it they suffer terribly and turn into animals. Mrs. Myers never talked to her girls about sex, of course, so Rhoda's only "formal" instruction came from an old black "mammy" who lived in the tenant house on the farm of a friend's parents, near the gate into Valley Forge Park. When Rhoda was an impressionable seven years old, this woman told Rhoda of a girl who had "acted foolish" with a man and given birth to a kindle of kittens. A resultant fear of pregnancy came when she was eight and a dog touched his nose to her bottom while she was relieving herself behind the barn on that same farm. She worried for days that she would have puppies. [14]

When Ben knocked on her studio door and asked her out, however, she accepted. When he told her that he had tried to locate her all over Europe through American Express, she was surprised that a man would spend so much effort on her. When he took her in his elegant automobile to the Inn at Valley Green, nestled in a wooded glen next to a rushing creek, and treated her to tea and cinnamon toast in front of a colonial fireplace, she

had to confront the possibility that a man, a young, obviously rich man, was interested in her.

This time she did not run away. He did not "try anything." They talked, and although he was the serious type who appeared to Rhoda to be quite "straight," she alarmed even herself with the strong attraction that rippled through her. When he asked her out another time and then a third, she leapt at the invitations. Whatever fear or disinterest she carried with her into the budding relationship melted in the presence of a real, live man who was interested in her: spindly, gawky, unloved, interested-only-in-art Rhoda.

The suddenness and the completeness with which Rhoda fell in love with Ben must have given Ethel a chilling feeling of *déjà vu*. Like Alice's surrender to Carlos, Rhoda's reactions were most unexpected; they came seemingly from nowhere. One moment in life's easy course, she was a dedicated painter who had forsaken any kind of a social life for art, and who expressly dismissed marriage as both too conventional and too distracting. In a blink of an eye, Rhoda, the lovesick girl, had blossomed into full bloom. Her infatuation was not even with another artist, but with an architect who wore suits.

Ben Medary, moreover, was the son of a famous father, Milton Bennett Medary, Jr., who had designed many prominent buildings in the city as well as the Gothic chapel at Valley Forge and the Bok "Singing" Tower in Florida, and who was an erstwhile colleague of Frank Lloyd Wright, until the two had a falling out. Dynamic and decisive, Mr. Medary had made his son into an architect to carry on the business and had introduced him to the world of money and power, and to the life that wealth could buy.

Rhoda's first impressions of him, however, were focused almost entirely on his physical presence. Ben was six feet, two inches tall and had been given a large, soft, face that people are immediately comfortable with, a "beautifully" shaped mouth that smiled easily, a "long, sensuous neck, straight and proud" and "the best-looking legs that I ever saw on a man."[15] She thought him very sure of himself, radiating an aura of confidence that she called aristocratic. He never appeared to Rhoda to be two years younger than she. He was altogether an unexpected choice for a woman who claimed that if she ever did marry it would be to another artist. Then again, love rarely respects intentions.

Lorine thought that Rhoda was shameless in her pursuit of Ben.[16] Rhoda was. She could see only a handsome prince, the perfect mate. For

he, like her, had long suffered under the tyrannical hand of a domineering parent. In Ben's case, it was his father who, according to Rhoda, forbade his only son from following his passion, painting, calling it "women's employment." Rhoda knew that despite appearances, he was an artist yearning to break free. Rhoda did not mind his apparent wealth. She objected to the values that wealth encouraged, and Ben, in her mind, would do likewise once he was out from under the domination of his father. They would know how to handle money so as not to be dominated by it. And they would paint together.

With that same infectious enthusiasm that had become her hallmark, Rhoda so romanticized her future that not even Ethel could convince her that Ben was what he appeared to be, not what she wanted him to be. Ethel, who was unaccustomed to asserting herself with Rhoda, preferring to follow in her wake, loathed Ben and told Rhoda emphatically that marriage for an artist was not a wise choice and marriage to this man would be disastrous. Her honesty strained their friendship, but Rhoda was too distracted to care.

By early 1929, she wanted to get married. She still professed her intention to become a great artist, but her more immediate and compelling prospect was "to become the wife and mother that I had not seen in my family life."[17] How long that secret desire had lain ignored, or unrecognized, inside her not even Rhoda probably knew. But the speed with which it emerged, at the first opportunity, suggests that it was both deeply rooted and just below the surface. Ben wanted her. She did not ask why a wealthy young man, not exactly handsome, but with a pleasant, gentle face, would want to marry her. It was enough to know that she, Rhoda Myers, was wanted.

If Ben had entertained thoughts of marrying in 1929, his plans were repeatedly thwarted. In the summer, his father sent Ben back to Europe. Perhaps it was a serious business trip; perhaps Mr. Medary was alarmed at his son's taste in women. However, he had controlled Ben's life to the extent that a manufactured reason for a lengthy separation was not out of the realm of possibility. While Ben was abroad, a telegram reached him announcing that Mr. Medary had suffered a fatal heart attack. Very soon after Ben's hasty return to Philadelphia, the stock market crashed. Within the space of three months, his world had turned upside down.

Ben's father's death rattled him. For all of his twenty-five years, he had lived under the giant shadow of Mr. Medary. When he stood in direct

sunlight, he felt not free but exposed, unsure of himself. When he returned from Europe in 1929, Rhoda noticed that he was a changed man, lost and ambivalent about life as well as work.[18] She became the beneficiary. What had been affection for her evolved into need. While she had shamelessly pursued him the previous year, now he seemed to possess that same powerful desire to be loved that had driven her to him.

Ben had no professional reputation; friends and associates knew that he was not in his father's league. Unlike his famous father, he was a journeyman architect, competent without the gold-plating of genius. The only job he had ever known after his graduation from the University of Pennsylvania in 1926 was in his father's firm, Zantzinger, Borie, and Medary at Forty-seventh and City Line Avenue. While the son of one of Mr. Medary's associates had been taken in as a junior partner, Ben had not. Moreover, the business for which he was being "groomed" shriveled as contracts were withdrawn and placed elsewhere. The stock market crash buried Mr. Medary's fresh estate and whatever hopes Ben harbored for an indefinite extension of the comfortable life that he had so far lived.

Rhoda had noticed even before Ben's father's death that his work habits were casual; with his father gone, they became erratic. When the firm faltered in 1930, Ben was one of the first of the young architects to be released before it was buried under the ruins of the crumbling economy. Firm after firm closed in 1930 as new construction dried up in the face of shrinking demand.

Certainly, Rhoda's need for Ben, money or not, had not wavered; it was as great at the end of 1929 as it had been at the beginning. But with the shrinking of the firm, Ben lost his job, so, by mutual acknowledgment, a wedding could not take place at least until he could provide for the two of them.

While Ben supposedly tried to find work, Rhoda's life went on almost as it had before. By 1930, the early stages of the Depression had scarcely touched her. She knew that her parents, in their separate spheres, were experiencing some new difficulties, but it would be a while before the fallout descended to her level. She painted. In the spring of 1930, she submitted her work to her usual safe shows. She made plans with Ben. Only at home did life alter its pace, for Ben came over every evening and, without the funds to support other entertainment, would "stay forever."

Rhoda's newly recognized dreams, along with those of millions of Depression-ridden Americans, had been put on hold. The only discern-

ible change in the studio was the appearance of tension. Her previously comfortable studio life with Ethel was now serrated with the prickly edges of Ethel's disapproval of Ben and of Rhoda's plans to marry. One day in May, into this uncustomarily tense atmosphere, Alice, who had been gone for nearly five years, reappeared.

FUTILITY OF

EFFORT

- - - - - - - - - - - - - - - - -

8.

- -

A l i c e and Rhoda stood facing each other across the doorway. They had often found themselves standing on opposite sides of that second-floor doorway, years ago. They understood then that their studio was her sanctuary. So, here again was Alice, standing outside, needing to be admitted to the one place that might shelter her from the pain of loss and failure.

It was obvious even to Rhoda that her prodigal friend looked defeated. Her blonde hair was shorter and darker, accentuating the shadows on her face. Her cheeks were at the same time both round and sallow, the telltale combination that results from a steady diet of starches and worry. The piercing blue eyes had been emptied of their innocent sparkle and their rebellious glint. Rhoda was familiar with many of Alice's faces. She had seen her hide shyness and flash anger, radiate satisfaction and mask fear. But never before had she seen Alice's face drained of its expression.

Radiant would be too strong, and too elegant, a description of Rhoda in May of 1930, as she opened her door to the ghost of her friend. But she glowed with that same strong aura of anticipation and wonderment that radiated from her at the beginning of her years at the School of Design. Ben, of course, was the cause, and would have been sufficient to account for her glow. But Rhoda also basked in what had become her usual late spring triumph. She had just learned that once again one of her portraits

had been accepted for the annual show at the Pennsylvania Academy of Fine Arts.

At that moment, the threshold that separated the two women might as well have been the space of a century. Alice must have felt as if she had already lived a long and exhausting life. The surprised woman who looked out at her from her studio was still fresh and young, inexperienced and as optimistic about the future as a farmer planting in rich bottomland. Their summer together began in contradiction. It ended in dark contrasts.

For the second time in three years, circumstances had forced Alice to move home, to her mother's house. This time, she had no hopes or plans for moving out. She had subleased her apartment in New York and fled in defeat from the city that she had intended to conquer. She was humiliated and hurt and lost, an emotional *Titanic* limping away from the scene of the collision, listing ominously, threatening to go down.

Mrs. Neel, whom Alice partly blamed for forcing her to return home, offered her usual and confusing signals of acceptance and judgment, and Alice at first responded with her usual and confused mix of dependence and rejection. Mrs. Neel had no doubt that Alice was to blame for Carlos's leaving, and Alice sensed this in every despairing look, every quiet negotiation about living arrangements or meals. It was soon evident that it was too difficult an arrangement. She fled her home for Rhoda's and Ethel's studio.

Rhoda and Ethel were disturbed at the way Alice looked, but the only concrete translation of their concern was to invite Alice to join them. Rhoda had learned years before that Alice worked according to her own rhythms. She and Ethel would learn in good time what stories their troubled companion was hoarding. Rhoda knew only that Carlos had "left her with all these bills to pay and no place to go."[1] That was enough for Rhoda. She would have happily welcomed Alice back as if nothing significant had interrupted their plans of five years before. But Alice's withdrawn, almost pitiful, demeanor kept even Rhoda subdued at first.

Rhoda and Ethel set up a third easel in front of the north windows. Instinctively, they knew that Alice needed to paint. It had been her therapy five years before, and it might be again.

They may have remembered from happier times their hours of talking

(when they still were able to discuss life in theoretical terms), when they argued that art was, without question, at the center of each individual's life. Perhaps for Alice, painting could become her reality and conquer whatever was consuming her soul. If they hoped to lure Alice into painting as a way to reassemble herself, they initially had reason to feel hopeful. Alice totally immersed herself in painting.

Ethel and Rhoda willingly provided supplies even though Rhoda had to borrow money from her sister Lorine to buy them, and Alice used them hungrily. Every day, as she had in 1925, Alice arrived at the studio early, often before Rhoda or Ethel. Some days, not having enough money for car fare, she would still devise a way to get to the studio. Often she came without money for lunch, and they would feed her. Every day, she would stand in front of her easel and paint. Stripped of all social pretense, Alice showed no interest in Rhoda's vaguely impending marriage, but focused tightly on herself, her work, and her life. Rhoda became a bit irritated by Alice's sometimes rude preoccupation with her own masked world, but, as usual, she did not let someone else's troubles diminish her own enthusiasm, especially if that someone was "kind of out of her head."[2]

Alice's presence altered, in subtle ways, an atmosphere in the studio that was already uncharacteristically tense. Rhoda and Ethel were experiencing the first disruption in their partnership. The cause, of course, was Ben. Perhaps Ethel was a bit jealous of the intruder, or possibly she worried that her life would change dramatically if Rhoda left, but Ethel was, most likely, honest in her concern that Rhoda was making a great mistake in marrying Ben Medary, or marrying at all. Ben was pleasant enough, and always a gentleman, but he was aloof. And that was not Rhoda. Ben's aristocratic reserve, which even Rhoda made fun of, bothered Ethel. She told Rhoda that she did not think that she should marry, period, and certainly not to a man who was so different from her.[3]

When Ben and Rhoda postponed the wedding from 1930 until the next year, Ethel overcame her usual reluctance to assert herself and tried to talk Rhoda out of the marriage. The postponement, however, seemed only to make Rhoda more vigilant in holding on to Ben. If she was worried, she did not show it. Her only change was to work at her art with infinitely more diligence than before. Like Alice, painting became her preoccupation, a way to avoid talking about Ben.

So, when Alice brought her miserable mood into the studio, she tested the old camaraderie of the three. Rhoda and Ethel were curious and a bit

uncomfortable, but because Alice was their returned friend, and because she gave both women a respite from their sparring over Ben, Alice unknowingly choreographed the steps and set the tempo of life at the studio. When Alice painted, Rhoda and Ethel painted; when she stopped to talk, they stopped and listened. When, infrequently, Alice dug out remnants of her former self, Rhoda responded like an anxious parent hovering over the sickbed of a child who sees color returning to its cheeks. One day when she asked for a book, Rhoda, without finding out the title of the book, gathered up all of the available books in the studio and brought four or five from home the next day.

The days unfolded into weeks, and the summer of 1930 crescendoed in intensity. As Alice withdrew increasingly into herself, her paintings exploded in expressiveness. Her line grew bolder as her morbid preoccupation with herself grew stronger. What Rhoda had hoped would be therapeutic for her friend convulsed into obsession as Alice painted her way through canvases with a ferocity that transformed the placid Washington Square studio into a cyclotron of creative and emotional energy. Alice remembered that summer as one of her most creative bursts, "a short period of time" in which she "turned out any number of great paintings."[4] She called her production of June, July, and early August "some of my best paintings."[5]

Alice Neel painted Rhoda nude, seated on a high-back chair. The painting followed from one of the lighter moments in the studio. Rhoda, who had begun the session clothed, playfully took off her clothing piece by piece, like a stripper, until Alice yelled for her to stop. Trying to look erotic and keep from laughing at the same time, Rhoda ended up wearing some beads, her blue broad-brimmed hat, and what was supposed to be a provocative sneer on her face. The portrait that Alice painted was not the happy-go-lucky Rhoda, but a woman of the world, bored or jaded, a tigress only tenuously held in check, her half-closed eyes bordering on seductiveness, her upper lip opened to a curl, exposing the beginnings of an animal snarl. Perhaps the painting was Alice's way of teasing her for finally acquiring the female wiles necessary to have attracted a real, live man.

Alice also painted a figure study of Ethel. Her painting of Ethel reveals as much about Alice as it does about Rhoda's studio mate. She painted Ethel crisp, an individual distinct from her surroundings. She is sitting on the gaudy chaise with the floral pattern, but the heavy fabric seems to blur

against the pure and undiluted line of Ethel's body. Her color is white, an ovoid form in marble light, interrupted only by equally distinct shadows. Altogether, Ethel is given her vital presence by a "strong new line" of expressionism.[6] Alice had never painted so forthrightly, with such cleanness of line. The clarity and economy of her brush strokes suggest her watercolors from New York, but the genesis of this painting was of a different nature.

Alice was above all cruel in this painting. She painted her friend with massive legs and great sagging breasts, not just heavy, but corpulent, spread out in layered folds. Ethel was heavy, as she called herself, "bigboned," but she was not fat in that way that Alice laid her out on her canvas. And if Ethel's body was captured without consideration for friendship, her face, and possibly her mind, seemed exposed to the same scrutiny. Those great open eyes look up at the artist like a puppy's, anxious, wanting to please. Alice thought that she captured the essential Ethel, "almost apologizing for living."[7]

Ethel had almost always been the passive presence around Rhoda and Alice, but Alice captured more than passivity in her painting. Ethel was becoming increasingly apologetic. She was thirty-four years old in 1930, no longer a developing young woman. As she grew into a mature woman, her natural timidity transformed into a professional and personal insecurity, which Alice seemed to notice before anyone else. Although Ethel was an excellent painter, it was the area of her greatest growing insecurity, a feeling that one day would lead her to stop showing her paintings, even to her friends. Alice may have caught that in Ethel's face. She may also have painted onto her friend's face her own powerful sense of apologia that summer. Ethel was hurt and offended by the painting, and even forty years later it was capable of arousing her anger and embarrassment.

That summer witnessed the conception of Alice's expressionist style. But she was not experimenting as much as trying to distract herself from interior demons. Her compulsion was to move from one canvas to another, maybe to probe continually into others as a way of avoiding looking inside herself. Whatever the source of her embryonic style, she employed it not only to paint Rhoda and Ethel, but also a telling portrait of Rhoda's fiancé, Ben.

A white, Anglo-Saxon male who radiated the traditional values that both bored and frightened Alice, Ben represented the world she had fled. He did not have a very interesting face. He was not the type of person

whom Alice enjoyed painting. But, he frequented the studio of his bride-to-be, at least until the middle of the summer when he sensed the tension he caused and stopped coming, seeing Rhoda at her mother's home during the evenings. Alice probably painted Ben because he was available and he was free, and he tried to be accommodating. It is doubtful that Rhoda asked Alice to paint him. She did not paint her fiancé that summer. So Alice painted him, certainly the most conventional sitter she had painted since her school days.

Her portrait of Ben was, perhaps, more revolutionary than her paintings of Rhoda and Ethel. It resulted from the successful marriage of her new flat style and her dangerously penetrating eye. In Alice's world, her canvas, Ben became a man whose life was one of uncluttered simplicity in color and line. Ben is gray: his business suit, tie, hair, and personality. Alice painted his lapels and his hands with a childlike simplicity, bold and without the detail that was thought, at the time, to mark the superior painter.

But the style, fresh and immediate at one level, spirals into complex symbolism at another. Ben's body is subtly distorted by its flatness into what would have appeared at the time to be an amateurish asymmetry. His eyes, separated by the sharp, distinct edges of the ridge of his nose, are cast downward, as if either he did not want her to see into them or she preferred not to. They are also set unevenly on his face, a capturing of his soul, a critique of his bourgeois values.

Alice had long ridiculed the conventional morality of the white bourgeoisie. Ben was the first representative of the class, outside of her family, that she had painted, and she portrayed him not as an individual, but as a representative of that misshapen ideology. Alice began to paint the truth about people that summer. She might have told Ben what she once told another sitter: "You won't like this portrait because I am making you look askew, but you are a little askew."[8]

Great art often emerges from troubled minds. What the world accepts as the fruits of *avant-garde* daring may be the physical manifestation of unusual sensitivity or intelligence in the face of depression or despair. A mind that does not quite make connections or an attitude that has been soured distorts perception. Alice had never painted faces like those of the summer of 1930, and the art world later determined that no one in 1930 was painting nudes like those that stormed out of Alice.[9] Alice attributed her radical new style to the fact that "your senses are never more acute than

before you have a nervous breakdown. You're hyped up."[10] Certainly, Alice saw the world differently that summer. Whatever the peculiar mix of emotions, need, and intention that went into her work, the resultant paintings were revolutionary.

Rhoda also painted Ethel that summer, and Alice. She caught Alice candidly in a pose that had become familiar at the studio, Alice reading. On the canvas, she is stretched out, lying on the busy floral pattern of the chaise longue, facing forward. The book rests on her abdomen. Her face is expressionless, possibly absorbed in the book, possibly in herself. She is wearing only a half-length pink chemise, shoes and stockings rolled down to her ankles. It is perhaps the most unflattering painting that Rhoda ever did. And while it may represent Rhoda's opinion of Alice that summer, distant, preoccupied, and unattractive, the painting may also be, finally, an attempt by Rhoda to capture complexity.

Alice, who always seemed so much more substantial than Rhoda, and whose life experiences dwarfed Rhoda's, may have been the catalyst for Rhoda's new seriousness about her work. Her nude of Alice was her first attempt at doing more than a comfortable life study. And, while her work is not nearly as revealing of Alice as Alice's is of her, she took some of the same risks that Alice had taken in "Rhoda with Blue Hat." The noncanonical pose, the unorthodox clothing, and Alice's enigmatic face all mark the most serious advance in Rhoda's work since art school.

Like Alice's painting of Ethel, Rhoda's was also a nude of her sitting on the same chaise. Their renderings of Ethel dramatize the divergence between the two women that had grown since art school, in style, and, certainly in perspective.

In Rhoda's rendering, Ethel grows out from the canvas tentatively, her green-tinted flesh almost a part of the dulled red and blues of the chaise, the colors sprinkled from a prism, bleeding into each other to create that fusion of hue and shape that the impressionists had used to blur the sharp lines of objective reality. Heavy, with ham thighs and sagging breasts, Ethel's body is crafted from a palette of yellows and pinks and whites and intersected by great strokes of green shadow that blend and mix with the other colors. This painting shares more than a few stylistic qualities with Alice's paintings of the 1920s, but almost nothing with Alice's paintings of that summer.

Rhoda, by her own admission, experienced the most productive period in her short career and turned out some of her best work.[11] If Ethel painted Alice, Rhoda, or Ben, she kept none of the canvases.

In the summer of 1930, the women painted furiously. It may have served not so much as a substitute for talking, but as a way of talking to each other. In 1930, Alice was not yet very skilled at telling people what she thought, especially if hers was a contrary opinion. This inability to express herself honestly in words would contribute significantly to her emotional breakdown at the end of the summer, but in July it was only another manifestation of her self-repression.

She does not seem to have told Rhoda what she thought of Ben. Alice, like Ethel, disapproved of him. He was too rigid, an archetype of a set of values that she knew from experience to be inimical to art. Alice may have been trying, in her way, to warn Rhoda that Ben was askew.

Moreover, he was a man. He would want children. Marriage would, as it had for her, distort the processes of art. It is more than likely that Alice did not talk to Rhoda about marriage and children, but her whole presence was a living articulation of warning.

Alice produced masterpieces that summer, but at the time all she was trying to do was survive. She was innovating a style that would one day reinvigorate figure painting in America, but at the time she was simply aware of dissolution and disintegration. Her art was intense and powerful, but she was overwhelmed with her own powerlessness.

As June submitted to July and July succumbed to August, Alice painted more and more feverishly. If she was unable to speak about the massive failure that was her life, she was likewise unable to control herself from painting her most frightening secrets. She disgorged from her turbulent mind a series of memory paintings. From the fringes of her past, she painted such remembrances as a couple on what Alice called, perhaps from faulty memory, "Coney Island Boat," when her parents had visited her: the demure, dependent woman resting on her husband's shoulder, his hat on her lap. Alice's anger spills onto canvas in her work of a couple on a train, a dual portrait in which "he is smug and self-satisfied. She is wretched. And that's the way it is."[12] But when she drew out of herself the emotion-laden "Futility of Effort," she penetrated to the core of her past. In one of the simplest of her works stylistically, she painted a stark, powerful image of death as a thin black line departing from a baby in its crib. A parent sits unaware and, therefore, powerless, in the next room.

Was Alice the submissive woman on the "Coney Island Boat," or the wretched woman on the train? Did her own turbulent emotions distort Rhoda's face? Was that Alice reaching out from the supplicating eyes of Ethel? Was Alice the parent who sat in the other room as her baby died?

The long suppressed ambivalence over the death of Santillana may have leaked to the surface in her painting of the dying baby. But the title, "Futility of Effort," does not focus on the death of a child, but on the frustration of the parent. Death made all that effort so futile, the carrying of the fetus, the painful birth, the inconvenience of a demanding baby. It probably would have been better if the parent had not made the effort at all. Perhaps Alice was unable to paint about the death for two years, not because her grief was so great but because she dared not delve too deeply inside to confront her motives for grieving.

Over the summer of 1930, Alice began to penetrate those depths. Finally, she struck too many long-submerged feelings. Her perilously listing soul was tipped to the brink and began an agonizingly slow descent. In the middle of August, after she had returned to her mother's house from the studio, she complained of chills and went to bed. Her chronic depression that summer had taken its toll on her body. She had lost nearly thirty pounds since arriving from New York, and her physical collapse seems to have been the body's surrender to fear; stored-up anxiety had finally been released to invade every cell like some aggressive cancer. As she grew progressively colder, her chest began to sear with pressure until she became fearful that she would not be able to breathe. Cramps and diarrhea compounded her frightful agony during the night. Alice was reduced to weeping uncontrollably. Mrs. Neel called her doctor.

Alice always said that what she had suffered was a nervous breakdown. Lay terms are usually inexact, but Alice captured the essence of the attack that would change her life. She said that she had succumbed to "Freud's classic disease: hysteria."[13] She finally simply collapsed under the weight of accumulated emotions that had been gathering since the first time she swallowed a "no," smiled, and said "yes."

On 16 August, Alice did not show up at the studio. She would never again cross that threshold.

Photos 14 to 18 are paintings that were done
at the Washington Square Studio,
Philadelphia, during the summer of 1930.

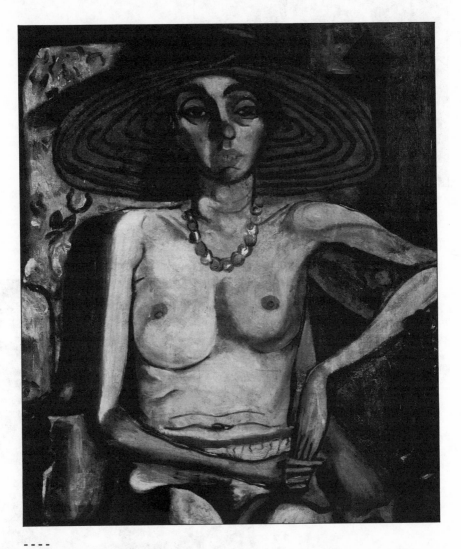

14. Alice Neel, "Rhoda Myers in Blue Hat." (Collection of the Neel
Family/Photo Courtesy of the Robert Miller Gallery, New York.)

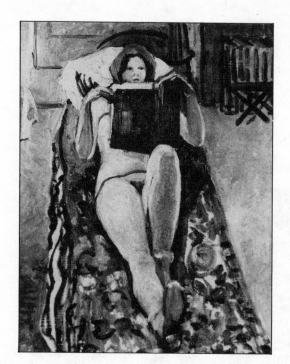

15.

Rhoda Myers,
"Alice Neel Reading."
(Collection of Holly Medary.)

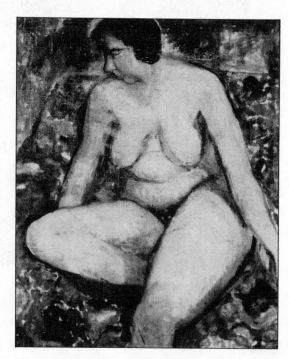

17.

Rhoda Myers, "Ethel Ashton."
(Collection of Holly Medary.)

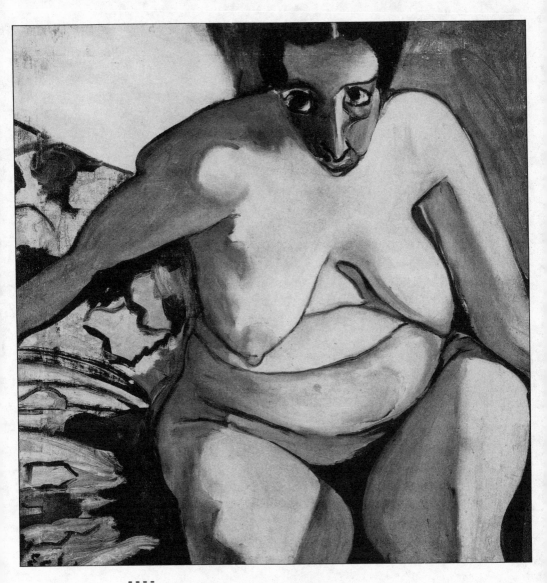

<u>16.</u> Alice Neel, "Ethel Ashton."
(Collection of the Neel Family/
Photo courtesy of the
Robert Miller Gallery.)

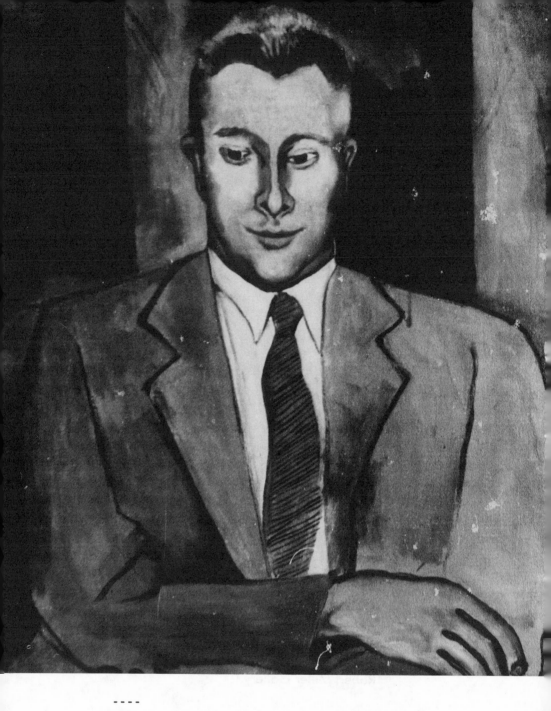

- - - -

<u>18.</u> Alice Neel, "Ben." (Collection of Holly Medary.)

MIND OVER
MATTER

--

W h a t e v e r it was would not go away—the chills, the perspiring, the cramps, the rough tightness that gripped her chest and, alternately, threatened to cut off her breathing or explode. Alice remembered it as like "dying every day."[1] And each day's death pushed Alice deeper into a gathering depression. In the best of times, her chronic tendency was to worry. In the late summer of 1930, her fertile mind followed in the footsteps of her body's agony. But she dared not upset her mother with her problems, so, as usual, she suffered quietly, continuing to keep locked inside herself a growing sense of general dread of the future, whether of dying or living may not have been clear even to Alice.

So severe was her pain, and so debilitating her state of mind, that she could not even drag herself to the studio to paint. Suddenly, that world had spun out of its orbit and circled somewhere out there, thousands of miles away from her bed in the small, back bedroom in Colwyn. And even as the physical pain diminished, Alice continued to hurt deeply, but in ways that her bewildered doctor did not understand. She would not go out; she was unable to paint. Depression settled into the emptiness, and made living even for a day some kind of inexplicable torture, the penalty for guilt.

For over two agony-filled months, Alice found herself crying for no reason. She did not respond to the inquiries from Rhoda and Ethel. She

may not have known about them, since Mrs. Neel politely, but firmly, turned them away. But even if she had learned of their concern, she probably would not have responded. Depression rudely shoves ennui into despair and shuts out the rest of the world. Alice descended and wallowed, either unable or unwilling to pull herself out.

When, in later years, Alice tried to account for her breakdown, she did not mention the loss of Santillana, Isabetta, or Carlos so much as the loss of opportunity that she herself had suffered. One time she invoked the same criterion for a happy, productive life that Virginia Woolf thought so important. She said, "If I'd had only five hundred dollars, I wouldn't have had the nervous breakdown. . . . I could have had a show."[2] On other occasions, she said that if her mother had only "taken Isabetta for a couple of years, everything would have been simpler."[3] Or if Carlos had taken her to Paris with him "it would've saved me."[4]

But when she was honest with herself, she was able to admit that she had reached the point when she was no longer able to cope with the demands made on her by her passion for painting, her love of Carlos, her guilt over her children, and her dread of the future.

The future. The catalyst that brought this swirling mixture of ingredients into a single, powerful, focused terror was the prospect of the presence in her everyday life of her mother. Even under the strain of loss and confusion, Alice possibly would have survived that summer if she had lived in New York or at the studio. She had learned, painfully, how to survive the loss of children and how to paint her way furiously through a time when Carlos was absent from her. But she never learned survival tactics for coping with her mother.

Around Mrs. Neel, Alice was eternally a child, worse, a girl. She reverted to her childhood behaviors once she was back in her family home, in the milieu of the most formidable person she had ever known. Alice, at one level, claimed that she admired her mother because "she could not compromise. She stood up to everything, and she had her own ideas and stuck to them."[5] Alice professed to regard this trait as a virtue. But directed against her, it was a devastating weapon. Although her socialization dictated that she repress her feelings in deference to others, it was primarily to her mother that she deferred. She might have felt the need to defer to everyone else. The difference is that others may not have expected it. Mrs. Neel did. It was only in the presence of her mother

that the bohemian painter faltered and disintegrated into an awkward adolescent.

She felt that she had never been able to ask room for her nervousness. "I'd never been able just to say, 'Look. I'm frightfully nervous.' "[6] So Alice the adult, the wife, and the mother moved into a household where she became Alice the child, compelled to expend her emotional reserve "to keep my mother happy as well. She was so superior, so sensitive. She couldn't bear anything."[7]

If she had gone to Paris. If she had had five hundred dollars. If she had been able to have a show. . . . In essence, if Alice had been able to function outside the shadow of her mother, everything would have worked out. She seemed able to survive anything except being sentenced to living every day with an overbearing, superior being whose own lifetime of frustration and disappointments had congealed into hostility against the world, but who, at that moment, was directing it all at her. Society had taught Alice that women were not expected to be serious artists. She did not always feel that she had a right to be a painter,[8] but in most of Alice's world, she was known as an artist. It was in her mother's home that she was made to feel irresponsible and selfish for wanting to paint.

It was not only the monumental questions that divided mother and daughter, but the thousands of small indignities that battered Alice. Would Alice the adult be allowed to go into the parlor? Would Mrs. Neel look accusingly at Alice when talking about her much-admired, gentlemanly son-in-law Carlos? Would Isabetta be brought into the evening conversation? How much emotional insult could be absorbed by a mute and withdrawn daughter?

Unlike her earlier return, in 1927, when she fled Havana, this time Alice did not harbor hope that Carlos would follow her. Consequently, her only realistic vision of the future in 1930 was her childhood in grotesque rerun. She could not accept such a future. And, since she was not strong enough to walk away from it or deny it, her small, pitiful response was to collapse in the face of it.

The Neel household was not a cheerful place in the best of times, but in the spring and summer of 1930, the small twin house was the scene of especially difficult circumstances. When Alice arrived unexpectedly to live, she discovered that her younger brother, George, whom everyone called Peter, had arrived earlier in the spring with his bride.

Mrs. Neel was already in a bad mood. As Alice's marriage was breaking up, Peter was trying also to work himself out of a sticky problem: He had fathered a son out of wedlock. In order to keep up appearances, he married the baby's mother, then left their son to be raised by her mother in Mansfield, Pennsylvania. Moving into the Neel home, they planned to wait a respectable interval before reclaiming the child.[9] They were sleeping in Alice's old bedroom. She was relegated to Albert's small room.

In addition, that summer Mrs. Neel was carrying on a discreet feud with her older son, Albert. When he married, at age thirty-nine, and moved out of the house, he had built a prefabricated house from Sears on a vacant lot behind the Neel's house, on a street that did not yet have city water and sewer connections. He had asked his mother if he could hook up to her lines. She had told him that he most certainly could not. Albert, who was used to Mrs. Neel catering to him, stewed. Between whinings, he sent his meek and subordinated wife over to the Neel's to collect water to feed his dogs or his racing pigeons or his fighting cocks. In first or second person, Albert's petulance filled the house those summer evenings when Alice returned from the studio.[10]

And, of course, the stock market crash, while scarcely affecting the family directly, stirred up a cloud of uncertainty at the Pennsylvania Railroad. Mr. Neel's clerical job was put in jeopardy by cutbacks at the company. He was not released for several years, when he reached the age of sixty-two, but the rapidly filling household existed in a climate that was strained and increasingly bordering on chaos.

By the end of October, everyone in the household knew that Alice was suffering a nervous breakdown, everyone except Mrs. Neel. When Alice retreated into a chronic sullenness, she would not acknowledge the problem, so it was left to Peter's wife and a friend to take Alice around to hospitals, ending up finally at the Philadelphia Orthopedic Hospital and Infirmary for Nervous Diseases. Once Alice was committed to the psychiatric wing, Mrs. Neel would not go to visit her.[11]

Mrs. Neel may have been embarrassed by the stigma that attaches itself to the family of someone who suffers a breakdown, or she also may have decided that Alice had brought her problems on herself. Her separation from Mrs. Neel, however, did not mean that Alice was spared the slings and arrows of condemnation. The psychiatrist who treated her, whom Alice called "the enemy," suggested that her breakdown was caused by her bohemian life-style.[12] Well-meaning doctors, grounded in Freud,

understood the terrible guilt of a woman who tried to reach beyond those boundaries that anatomy and society imposed. Either they did not accept her explanation that she was an artist or they considered it to be part of the problem. Whatever their technical diagnosis, they would not let her draw or paint. Instead, they wanted her to sew.

If Alice Neel had been born a man, she might not have suffered her nervous breakdown. A man would not have been told repeatedly as he grew up not to expect too much from life because he was only a man. As a boy, he probably would have been encouraged to take charge rather than repress whatever hopes or desires he had. And as an adult he would not have had to make any of those traumatizing choices that had become alarmingly routine in Alice's life. Would she marry? If so, would she have children? Would she then be content to be a wife and mother, or would she insist on satisfying her own needs? As a man, she would simply have chosen to paint and let someone else worry about having children and caring for them.

Alice often said that she wished that she had had a wife when she was young.[13] With someone to attend to the details of life, to cook and care for the children, she would not have had reason to feel guilty about wanting to paint. She did not suffer her breakdown because she was an artist, but because she was an artist and a woman. She had to choose between the two demands of her "awful dichotomy," and, according to society, her doctors, and her mother, she chose badly. Because she tried to be an artist, she had failed at being a woman.

In order to initiate recovery, her doctors tried to impose feminine therapies, preferably repetitive ones that would have a soothing effect. At first, Alice refused to sew. It is not just that she hated to sew, but to take up the dreaded craft of her mother and her older sister Lilly would be to surrender. She was already condemned to be forever reminded at home of her failure as a wife and mother. But to sew her way back to health and return to her mother's house to submit further to the enemy paralyzed her. Consequently, her response to their treatment was to "lay in bed all day," hoping instead to die.[14]

To cut Alice off from painting was to cut her off from the vital source of life itself. She said that if a woman gives up painting to raise children, she has probably given it up forever or decided to become a dilettante.[15] She held firmly to the assertion that if you are a serious artist and you have children, you must continue to paint.

If the people who populated Alice's life that autumn were incapable of seeing a woman as a serious artist, they would have had no hope of understanding that it was through her art that Alice had become more "connected with life."[16] By denying her art, her psychiatrists denied a part of her.

There was no one at the hospital who was able to see Alice's alternative vision of society, a vision she had glimpsed in Cuba, where life is more basic and art is indistinguishable from the fabric of life itself. Would her treatment have been different if one of her psychiatrists had penetrated to her soul and there discovered a need for painting so great that it had consumed most of the rest of her identity?

Alice was not to find out. Her doctors were unable to see her in any terms except the conventional ones that she had rejected. "They didn't understand," she said, "that where I wanted to go was not where they wanted to go. It was another voyage."[17] This creative, unorthodox woman presented an enigma to her doctors. Unable to regard her perspective as less than deviant, they likewise were unable to consider that her unhappiness had grown more from a conflict of ideologies and sensibilities than from guilt. They did not address her hatred of "everything normal" and "everything American."[18] They did not acknowledge what Alice considered her Latin American mentality.

For over two months, through an agonizing Christmas season, Alice fought her standoff at the hospital, growing more and more depressed by the life that lay in wait for her on the outside, the life her doctors were trying, responsibly, to prepare her to reenter.

When they did zero in on the area of her real problem, she fought them even harder. At least one psychiatrist explored her relationship with her mother and may have suggested that Mrs. Neel was part of her problem. But Alice's peculiar form of dependence on her mother almost always forced her to defend Mrs. Neel. The strongest criticism that Alice directed against her mother was to accuse her of not "being like these good mothers" when she would not take in Isabetta.[19] But at the hospital her defense was spirited enough to elicit the plea "give it up" from her doctor. The guilt that she had carried from childhood, her unresolved tensions, the contradictions that ruled her life, would all have diminished to manageable proportions if she had but transferred some responsibility for them from herself to her mother. But she could not. Alice's pathology led

her to charge her psychiatrist with trying to turn her against her mother.[20] That may have effectively blocked one avenue to recovery.

Even a totally unexpected visit from Carlos failed to rouse her. Alice had been in the hospital for nearly three months when, in January 1931, Carlos showed up. He had just returned from Paris to Havana, undoubtedly having been recalled by his father because of the collapse of the international sugar market, in which his father was a major player. He was contacted there by Alice's sister, Lilly. Apparently, Mrs. Neel decided that his return would possibly cure Alice. Not only were both she and Lilly the types to believe that women needed men, but Mrs. Neel adored Carlos.[21] Lilly, whose husband was a successful engineer in New York City, apparently paid for his trip to Philadelphia.

Why Carlos returned, however, remains a mystery. It had been almost a year since he had left with Isabetta. But there he was in January 1931, standing next to Alice's hospital bed. Alice's explanation was that he had come back to take her to Paris, but that it was too late, she was "too far out to be able to get well" and go with him.[22] But for some reason, her doctors released her from the hospital to return to her parent's home with Carlos. Since hers had not been a mental, but a nervous, breakdown, perhaps they, like Mrs. Neel, also assumed that now that her husband had returned she would be all right. If so, they miscalculated seriously. She had told them over the autumn that she wanted only the peace of the grave, but they obviously did not think her suicidal.

Within twenty hours of arriving home with Carlos, Alice tried to end her life. She described her decision to kill herself as having come to her that first night, when she heard the voices of her sleeping parents and decided that she was going mad. Madness would mean being recommitted, and she later said that she was not going to go back to the hospital that she had just left. Her dread of the hospital, coupled insidiously with her terror of her parents' house, left her no exit. When she had arrived home the previous day with Carlos, she was already in an agitated state from the taxi ride. She experienced "about a half hour of normality" after she arrived at the house,[23] and then, suddenly, everything reverted back to the way it always had been with her well-intentioned mother manipulating her into decisions about her future as a wife and mother. She fled to her bed to escape that old feeling that she was "being thrown against a wall all of the time."[24] There, she lay until her midnight decision to put her head in the oven.

When she was discovered the next morning by Peter, her head swallowed up by the gaping mouth of the stove, his initial reaction was to wonder whether it was Alice or Mrs. Neel who had decided to end it all.[25] She was rushed by ambulance to a hospital in Wilmington, Delaware. She was in no danger of dying from the gas, because she had not made the kitchen airtight, so, on her first day in the hospital, she tried a second time to kill herself, this attempt by swallowing broken glass.[26] A nurse heard the drinking glass shatter and removed it before Alice could carry through her attempt, but the incident was enough to warrant a hospital transfer back to Philadelphia Orthopedic, and reclassification from hysterical to suicidal. Within days, in January 1931, Alice was admitted to the suicide ward of Philadelphia General Hospital.

Mrs. Neel was the one who had to commit Alice, her only involvement in the whole ordeal. According to Alice, her mother just could not bear the idea that she was suicidal. In later years, Alice would absolve her mother of her judgmental neglect by claiming that she understood why Mrs. Neel had never come to see her in the hospital. In fact, she professed to admire her mother for it because it indicated that she had her own ideas and stuck to them, and was, therefore, unable to make the moral compromises necessary to visit her.[27] An admirable trait in memory, but at the time Mrs. Neel's deliberate absence must have cut deeply and reaffirmed the necessity to end it all.

How must Alice have felt when, later in January, Carlos returned to Havana? Alice was left alone to cope in a Kafkaesque world of mad people, disjointed meaning, and arrogant gatekeepers who would not accept her plea that she was an artist. To flee that world and her mother's world and Carlos's world, she thought of "every kind of suicide,"[28] but was unable to find a way that had not been anticipated by experts.

There are too many variables to make much of one sensitive woman artist succumbing to the attraction of death while another tempts death, teases it, but finally backs off from the seduction. Virginia Woolf was supposed to have drowned herself because she could no longer cope with a world that grew at once more complex and frightening. Alice decided, sometime in the spring of 1931, not to die. Virginia Woolf found no reason to live; Alice did. In the midst of a dirty, disease-filled institution populated by partially functioning people who walked the halls day and night moaning,

or acted out private interpretations of reality, Alice stumbled again onto art. She credited the rediscovery with saving her life.

The doctors may not have believed Alice when she told them that she was a painter, but a social worker did. It was in the spring, after Easter, when a young woman whom Alice had never seen before looked at Alice, who at thirty-one was painfully thin and wan but still beautiful beneath her abused surfaces, and said, "My God, why are you here?"[29] Alice told her that she was an artist. When, in response, the social worker gave Alice a pad and a pencil, her reconstruction began, painfully but spontaneously, as if her will to live had been waiting unobtrusively for the occasion to gain control. Alice drew other patients, but she would not draw the doctors.

At life's most basic level, the simple demands of art dictated that Alice must control her bodily functions. At the time she started to draw again, Alice was incontinent. But she had to learn to hold her bladder long enough to execute a drawing. It was torture,[30] but she imposed this first of many disciplines upon herself in order to do art. From that point on, she decided to get well.

So rapid was Alice's recovery that the same social worker recognized very soon that Alice should not be in that suicide ward, among those people. She convinced Alice's mother to send her to a private sanatorium both to speed and complete her reconstruction in a more humane environment. She had lived in the suicide ward for almost five months.

Dr. Ludlum's sanatorium inhabited a different place in the world from the brutal hospital. It had once been a farm among the rolling Pennsylvania hills, just outside Philadelphia, and still retained its bucolic flavor, with its out buildings and the spring wisteria flowering. Although they put Alice in the suicide wing, she was no longer a danger to herself. She had changed because she was working deliberately at cooperating and at disciplining herself. She continued drawing and began reading in order to exercise her brain.[31] Simply by giving Dr. Ludlum her word that she would not try to commit suicide, she convinced him after only a few weeks to allow her to move into a house on the grounds reserved for people who could be trusted with more freedom.[32]

For Dr. Ludlum, like the young social worker, Alice's delicate beauty seemed to make illness impossible, or at least unnecessary. He told her that she was so foolish to be ill, that if she just looked in a mirror she would find reason enough to get well.[33] That was not her way. Her beauty had

always been part of the problem. Did men like her for herself or her beauty? Dr. Ludlum, who thought she was so beautiful, offered to build her a studio on the grounds if she would like to stay and paint. Alice did not accept. She worked with perhaps more determination than she had ever manifested for any effort except painting in order to get well. Alice had rapidly learned Spanish when she had lived in Cuba, but she had lost it, beginning in New York, when she and Carlos had stopped talking. At Dr. Ludlum's that summer, she began recovering her Spanish by disciplining herself to read in Spanish every day.

Her art and her Spanish gave structure to her days. She looked forward to her work, as she called it, but the final stage in recovery was her growing interest in the events of the outside world. The world was still functioning in ways that again seemed important to Alice. The Depression was deepening, and the papers were filled with stories about families existing on a diet of stale bread or a major scandal that was reported in the summer of 1931 about hundreds of homeless women who were sleeping in the parks in Chicago. The Communist May Day march in 1931 was the largest ever in New York City. Her interest in suffering other than her own signaled significant recovery.

At the end of the summer, in early September, a year after her breakdown, Alice decided that she was coping well enough to try again to function in the outside world. She called her family to come get her. Dr. Ludlum did not protest. Albert came to drive her back to Colwyn.

Once at home, if her thoughts began to range to Rhoda's and Ethel's studio, Alice would have been sorely disappointed. Rhoda and Ethel were no longer there. They had split up. Rhoda had married and had given up painting. Ethel still lived at home with her parents, but had moved her studio a block off Washington Square, to the seven hundred block of Walnut Street. Their cherished studio was vacant except for a "To Let" sign that peered out from the north window overlooking Washington Square.

TO DIFFERENT
DRUMMERS

10.

R h o d a and Ben were married on 28 May, 1931, just about the time that Alice was being transferred to Dr. Ludlum's sanatorium. The attendance at their wedding spoke volumes about their lives. They wanted only a small wedding, and this time Mrs. Myers did not protest. Neither the state of her wealth nor her sympathies would allow the type of wedding that she had imposed upon Rhoda's sister, Grace. But, she did attend. She was the only member of Rhoda's family who accepted an invitation. Rhoda's father was not invited. He would have been unable to attend anyway.

The person Rhoda wanted most to be there was Ben's mother. Rhoda had virtually lived in the Medary house during the months before the wedding, and for the first time in her life felt that she knew a real mother. She "put all of the pent-up love I might have had for my own mother in my feelings towards her."[1] During those exciting months, Hannah Stadleman Medary was as attentive to Rhoda as she was to her own daughters. Rhoda believed herself fortunate to be marrying into the family of such a "loving, self-sacrificing" woman.

It is the most natural of postures to be anticipating the future on the eve of a wedding. But if Rhoda had looked backward, she would have been

reminded that the path that took her to the altar was littered with the jagged edges of broken relationships and failed lives.

Alice, of course, had disappeared from the studio in August 1930. Rhoda knew that Alice went "sort of out of her head."[2] It did not shock or surprise her. To Rhoda, Alice had become volatile and unpredictable. There was nothing to be done about her. And, within two months of Alice's breakdown, Rhoda's father was committed to the State Mental Hospital in Norristown, Pennsylvania.

Mr. Myers watched helplessly as the stock market crash consumed the remnants of his struggling contracting business. Added to the burden of continued lavish spending by his estranged wife, the collapse of his business brought to reality his often expressed fear of bankruptcy. Throughout 1930, Mr. Myers withdrew to his rooms and either would not or could not pay the bills that continued to be deflected from his wife's Germantown house to his isolated residence at the Art Club. His vengeful wife could not be budged from her twenty-room house; she still indulged her extravagant tastes on his charge accounts; he continued to maintain Grace in her pricey sanatorium in North Carolina; and he supported her child, Jimmy, who lived with Mrs. Myers ever since his father left his mother, perhaps a case of too many responsibilities too early in a marriage. William Myers seems to have tipped over the edge of sanity because of an expanding, consuming obsession with "the constable's black wagon," the ignominious transporter of debtors to the poorhouse, a vivid image from Dickensian London that lodged itself in the minds of the following generations as a powerful metaphor.[3] Rhoda's sister, Lorine, did not blame her father's mental collapse on the failure of his business, but on their mother, whose irresponsible spending forced him into a "nervous breakdown." As she said bluntly, "she drove him to the nut house."[4]

Mrs. Myers was livid when she discovered that someone, certainly not her, had committed William to Norristown. All she understood was that a valuable source of income had dried up. In her late fifties and as vain as ever, perhaps more so, Rhoda's mother began to spend more money as her place in the pecking order of life slipped. Her life had become one constant balancing act, executed so skillfully that even Rhoda, who was still accosted by bill collectors on her way into or out of the house, did not understand how her mother was able to maintain the pretense of wealth so long.

Despite the fact that Rhoda lived, or rather slept, at home, her mother

was, at best, a negligible figure in her life. Although she was still depen-
dent upon her mother for her housing, clothing, and a few meals, she
concentrated on minimizing her needs. When she needed money, for
paints or food, she went first to her sister Lorine or she touched Ethel. On
the only two occasions that she was able to force herself to go down to his
club to visit her father before his committal, she went only to ask for
money.[5] Mrs. Myers had taught her children well, by examples as well as
instruction, what fathers were for.

Mr. Myers was sent home from the hospital in December 1930. The
hospital would not discharge him to the Art Club, so, after fourteen years
of separation, he went to live in his wife's house. But his illness had
changed nothing; he was not welcomed home. No one apologized to him
for contributing to his breakdown or promised to change or help him
recover. His life with them was over, except for the bills to remind him
that he still had his wife. Mr. Myers, a haunted, frightened man, nearly
sixty years old, was recommitted in February. He never came out.

All of these traumas affected people who lived on the margins of
Rhoda's life. She had disengaged herself from her family effectively
enough to see the confluence of events from a distance, barely touching
her life except to bring her wedding closer. Mrs. Myers, with her reduced
income, was forced to sell her house on Wister Avenue. Lorine generously
invited her to live with her in a very modest house that she arranged to
buy in Mt. Airy. Rhoda would have no lodgings.

About the same time, the Medary family was deciding that despite
Ben's lack of a job, it was time that he got married. Without Mr. Medary's
presence, Ben lost what little drive and direction he had. He seemed
satisfied, even content, to drift, living at home with his mother in her
house in Bala-Cynwyd, fishing with his cronies, and hanging around
Rhoda's studio, irritating first Ethel and then Alice. It was his mother
who pushed for the wedding, probably wanting to put him in a position
where he would have to take responsibility and become a man like his
father. Ben selected a date.

During the spring of 1931, Rhoda planned her modest wedding with
the help of her future mother-in-law. And while she almost lived at her
house, she did not really notice that the reserved, aristocratic quality that
she so admired in Ben often came out at home as a demanding self-
centeredness. Ben and one of his brothers, Richard, another grown un-
employed man living at home, played the dual role of the "men" in a

male-dominant tribe and, at the same time, of terribly spoiled little boys. Rhoda remembered years later, from quite a different perspective, how Mrs. Medary took care of all of their needs, washing, ironing, and picking up after them, and how neither ever said thank you, or seemed to notice.[6]

At the dinner table, Ben absorbed himself entirely in his eating with such concentration that the others hesitated to ask him to pass the salt because they knew it would annoy him. Once, when a knife had not been put at his place, he said nothing, but neither did he begin eating. He sat immobile with "an unpleasant expression" on his face until Mrs. Medary noticed and excused herself to get him one.[7] On another occasion, when Mrs. Medary was too ill to come down to dinner, no one offered to take her dinner to her. No one made dinner. Ben suggested that they all eat out. Rhoda stayed at the house for a few days to take care of Mrs. Medary and make sure that she got meals.

But all of that was invisible to Rhoda. Revelation is usually shrouded by love. She was to be married. She was to have that magic chance to become the wife and mother that she had never had. All else faded, even her passion for art.

Ethel was not at the wedding. The debris of that relationship also littered Rhoda's life in 1931. The appearances of Ben and Alice at the studio in 1930 had irrevocably altered the comfortable ambiance of the late 1920s. His intentions and her intensity made a potent catalyst, generating the tensions that rippled between Ethel and Rhoda. When the electricity of the summer fizzled, Alice disappearing and Ben discreetly avoiding a terse and disapproving Ethel, the studio fell silent, and nearly vacant for long periods. Rhoda's attention was distracted by events outside of her beloved room with the northern exposure. Ethel receded increasingly into silence; whether it was over the loss of a friend or her unhappiness with Rhoda's other life is not clear.

The disintegration of their relationship occurred quietly. No one shouted. Ethel sent passive signals of displeasure that might have wounded Rhoda if she had been paying attention. Rhoda continued to paint at the studio occasionally, but without her legendary enthusiasm, which had been obviously redirected toward her Ben. When she finally told Ethel that she was getting married in May, Ethel simply stopped

talking to her. Tension gave way to hostility, and, in late winter, Rhoda moved her easel and her paints out of the studio forever. Ethel, she thought, was being so irrational that she neither went back nor invited her longtime friend to the wedding. When she went through with the marriage, "that was the end of the friendship."[8]

Sad. Unnecessary. But youth and love, and years of neglect, create their own logic. Rhoda needed Ben; she needed to be married; she needed to be loved at that moment more than she needed friendship. If she was unable to see in Ben the traits that would rub more and more roughly against her sensibilities, she was certainly not able to understand a person, even a friend, trying to warn her against what had grown to be her most compelling reason for living. She treated the dissolution of her friendship lightly, as if she had no real investment in it. She dismissed it with a throwaway line, "but we moved away anyhow."[9]

The wedding took place in Old Swedes Church, a historic building in South Philadelphia of unimportant denomination to Rhoda. She selected the place because she had sketched it and had fallen in love with the ancient structure. A young minister had interviewed them initially, but when they arrived and went into the church office to register, they found themselves with the Reverend Joseph Manual, a doddering elderly gentleman. She was giddy and Ben was appropriately nervous. As the old minister prepared the documents, Ben found a windup toy Caterpillar truck. He kept winding it up and sending it under the minister's chair. Everytime it hit him in the foot, Ben giggled like a boy.

During the ceremony, the old minister kept calling Rhoda by her mother's name, and Mrs. Myers was horrified to discover after the service that he had written her name, Nellie Haddock Myers, on the marriage certificate. Ben and Rhoda announced, amidst more giggles, that they would just go off and live in sin!

The newlyweds had one hundred dollars between them and blithely spent it all on a honeymoon. Ben, who had selected the date of the wedding, also selected the site of the wedding trip: date, the beginning of fly-fishing season; site, a resort in the Poconos next to a broad, meandering stream. Ben spent every day, all day, in combat with wily trout.

Rhoda was acquiescent. She enjoyed what was to be one of the happiest weeks of her life. As she admitted to a friend years later, she was a virgin

when she married, and her mother had so soured her opinion of men and sex that she approached her wedding night with more than a little apprehension. "Well," she related, "I did what I had to do and, you know, I liked it. I asked if we could do it again."[10] For the rest of the week, Rhoda was content to sit by the stream and marvel at "how skillful and beautiful"[11] her man was, and to anticipate doing again what she "had" to do.

The idyllic Poconos honeymoon evolved into the reality of an old center city fourth-floor walk-up in a building that was, ironically, part of Rhoda's grandfather Myers's estate. Ten dollars a month paid for three rooms in a building that Rhoda was one day, with her siblings, to inherit. Poverty still held a certain romance for her, a stronghold of Rhoda's mystique of the artist. She enjoyed scrambling to pay the rent and buy their food for a week on five dollars. Her favorite haunt was still the Italian market where, five blocks from Washington Square, she shopped at least once a week without once finding a reason to stop by her old studio to see if Ethel was still there.

She perfected the arts of haggling and coaxing for meat and vegetables, hunting unrelentingly for sweetbreads, at least until they stopped being cheap, after the butchers began to sell them to hotels. She tried to buy shad that contained roe whenever she could cajole the cart vender into letting her have it. Sometimes he did and sometimes he shook his head, shouting, "Whadda want, gold in it for that price?"[12]

While Rhoda sparred in the shops, Ben busied himself in the routine of the life he had settled into before marriage, before the crash, before the death of his father. Rhoda felt purposeful and fulfilled in her new adventure, but Ben's ever-present sense of having been born to the robe would not allow him either to accommodate himself to a struggling existence or to reduce himself to chasing after jobs on the streets. He hung around with his group of friends, young architects and pals from private school or Penn, fished whenever he could, and nursed his shiny Packard, which was the sole vestige of his former life.

Architects' jobs were simply not available, and Ben pointedly refused to do any other line of work. So Rhoda learned a trade, of sorts. An old lady, the cousin of a friend, who had made Rhoda's wedding ring, took a great interest in the newlyweds. She had a job making metal flower holders from a metal that Rhoda called lead. She gave Rhoda her job so that the newlyweds might have some income. A local merchant supplied Rhoda with pieces of the metal. She would roll a piece flat, cut it in patterns, and

III

Choices

up and take them home even though he knew that they lived in Trevose, Montgomery County, almost a two hours' drive each way. Paulette remembered Ben's gallantry clearly fifty-five years later.[15] Only Ethel and Alice; and perhaps a woman to whom he was engaged prior to meeting Rhoda; penetrated the patina of charm that masked a troubled soul.

If Ben was an impeccable gentleman around women, he was primarily a man's man. His priorities became painfully clear to Rhoda at the end of their first year of marriage. One day he discovered an unexpectedly bountiful trout stream in the Poconos. Wanting to share it with his friends; he persuaded the hotel owner to reduce his rates, then phoned a group of his pals and told them to come up from Philadelphia. He persuaded the proprietor to keep the kitchen open and to cook trout for his friends when they arrived. That began a three-day orgy of fishing, eating; and drinking into the night. The problem for Rhoda was that this festive outing occupied what was supposed to have been the last three days of their first wedding anniversary trip.

Ben and Rhoda had saved enough money to return to the inn where they had spent their honeymoon. The first year of marriage Rhoda considered fun, but a challenge, not exactly disturbing, but definitely divulging some revelations about Ben that were irritating. The trip was a reward, a celebration of their first year together, an extravagance for Rhoda. For Ben, it was a fishing trip. While driving north, they passed an inn that sat high on a bank above a fast rushing stream. Of course, it was fly-fishing season, as it had been the year before to the day. Ben suggested that they stop for one night, because the restaurant boasted an authentic French chef named One-Eyed-Charlie. Rhoda bought it, and they stopped.

Ben went off fishing. The next day, Ben told her that they should really stay another day because the trout were running. The second day, he pleaded for a third, and the sight of Ben begging her to do anything so touched her that she gave in. The fourth morning, Ben got up and went fishing without the formality of asking or the endearing strategy of begging. Rhoda was at first only irritated, not only with Ben, but with One-Eyed-Charlie who, she decided, was not a French chef and did not like women. If the food had been Cordon Bleu, she might have overlooked her husband's known passion for fishing, but One-Eyed-Charlie would not cook for her alone. Her irritation ballooned into anger on the imperious fourth day. She left a stinging note, took the car while Ben

pound them into crinkled holders. The merchant paid by the piece, so Rhoda worked afternoons and evenings rolling and pounding. She somehow even engaged Ben in the craft. One time they pounded loudly into the night until the neighbors, "two old maids, came up the stairs with ice bags on their heads and told us to stop."[13] The flower holders produced some income, but not nearly enough to live on.

As the economy worsened, some of their friends, even Ben's architect buddies, began receiving welfare. Ben would not allow Rhoda to apply. Rhoda claimed that she obeyed her husband, but someone did report their situation to the welfare people, for one day in the spring of 1932, "up four flights of stairs marched a very determined lady" who was intent on finding out all about the Medarys. After just enough questions to alert Ben to her purpose, "with great dignity he dismissed this kind lady, putting her out and shutting the door after her."[14] Several months later, they received, unsolicited, a welfare check for one hundred dollars. The checks came every month thereafter. Ben would not cash them, but he did not attempt to stop Rhoda from doing so. They lived off of that money until the W.P.A., but Ben would never admit to it among friends.

If he did quietly allow Rhoda to accept welfare money, he drew the line at eating welfare food. Rhoda was not too proud to collect tins of beef that were periodically distributed around the city. Ben sniffed at it, refusing even to come to the dinner table. Thereafter, Rhoda persistently but unsuccessfully tried a variety of ways to disguise it. Not even Rhoda's reminders that they were trying to save money for a first anniversary trip, or later for the arrival of a baby, could move him to eat free food.

No mere Depression was going to force Ben to compromise his standards or modify his practiced responses to life. Even at home, when the two of them were alone, Ben was the lord of the domain. The role called for him to be not so much autocratic as seignorial, as if he were going through life judging fine wines for his cellar. He was rarely rude, but he was insistent that his wishes take precedence over those of others. His demands were given as requests from one who expected to be indulged as a matter of course. To Rhoda, his "aristocracy," as she called it, was a source of public pride. Around company, he was unfailingly commanding and charming at the same time.

Women adored him for his manners. One evening, Rhoda invited one of her teachers at the School of Design, Paulette von Roekens, and her artist husband, Arthur Meltzer, to dinner. Ben insisted that he pick them

stood placidly in a stream, drove all the way to the Jersey shore, and "cried my eyes out on the sand dunes."[16]

Apparently unperturbed, Ben opportunistically converted the remainder of the spoiled anniversary celebration into a fishing party. He then called his aunt in Philadelphia, who drove up to the Poconos and took him home. The only sign of irritation, if there was any, was a note that he left for Rhoda the next day. It read, "What is to happen to our marriage if you keep running away?"[17]

Nothing came from the incident. Rhoda loved him. It was so easy to excuse "his way" or to continue to take secret pride in being married to a man who possessed so many of those traits that society valued. How happy she was to subsume her identity into his. Rhoda was more than content to see that Ben's needs were met, since marriage to him took care of so many of hers.

One of the prices Rhoda willingly paid for her new life was to give up painting, at least temporarily. One of the reasons was economic. Before her marriage, Rhoda usually asked Lorine for money for supplies. Lorine refused to continue to subsidize a sister she did not particularly like by politely reminding Rhoda that Ben was expected to take care of her now.[18] She would not ask her mother, and, of course, she no longer had Ethel to fall back on. And her father had died in the fall of 1931, leaving several small trusts, but nothing that Rhoda would have access to for nearly twenty years.

William Myers's death came as something of a surprise to the family. No one had been interested enough to follow the state of his health after he was returned to the asylum in 1931. No cause of death was given, but Rhoda was convinced that he either gave up passively or killed himself. Insane asylums do not publicize the latter. Either way, Rhoda felt a sting from her father's death. She was just beginning to glimpse the terrible pressures of his life during the months before it ended.

Rhoda traveled to Norristown to visit him just one time after her marriage. She saw that he had no fight in him. He just shook his head from side to side as they talked. The phrase that he kept saying to her was "such awful people." Rhoda did not know if he meant his family or the attendants at the hospital, but, she wrote later, either way he would have been right.[19] Over the next two decades, with the distance of time and experience separating her from her childhood, Rhoda would grow to

understand and love her father. She would discover that it was he who bought the second of the only two paintings that she ever sold, but in 1931 he was a pathetic, distant figure in her life.

Rhoda wanted to paint, but she claimed that they did not have enough money for her supplies. Brushes and oils and canvases were expensive, and she and Ben had only enough money for necessities. Rhoda said, maybe facetiously, that they flipped a coin every week to see if they would buy hamburger or fish bait.[20] Those were the two priorities, food and fishing. She sketched in those early years of her marriage, carrying her pad with her to the Italian Market and occasionally down to the river, but she seemed to find in marriage most of what she had gained through her art, a fulfilling life.

The fullness of that life grew by quantum leaps early in 1933, when Rhoda gave birth to a daughter. No Alician ambivalence for her. She wanted children, and she was prepared to make whatever sacrifices were necessary to rear them in a loving family environment. Rhoda gushed about Jacoba, whom she nicknamed Jakie, named after her grandfather. She was "a beautiful daughter whom I adored and was so proud of," a "great joy to me who made me feel that I would never be lonely again."[21] She doted on Jakie from the beginning, and, with the hundred dollars a month, Rhoda was able to pamper the baby and enjoy herself without making Ben have to choose between food and fish bait.

If Alice had been around to ask if she missed painting, Rhoda would almost certainly have said "no," or "maybe just a little," but she felt that her life had come together in that way that it does for a child who receives exactly the toys she hoped for at Christmas. If Rhoda had had the money for paints, she probably would not have painted. There was little need for self-indulgence for one who was going to be a totally committed wife and mother, and no room at all for the kind of selfishness that pushed her own mother to destroy her husband and alienate her children. She did not need money to live the life that she believed would fulfill her. In fact, she thought wealth had been at the root of her family's problems.

By 1933, exuberant, enthusiastic Rhoda was again living in the middle of a life that delighted and satisfied her. She had her husband and a child, a sense of purpose, and an identity that was, she thought, stronger than the identity that she had given up.

In the 1920s, Rhoda claimed not to have thought of men or marriage at all. She said that she was an artist who had no time for the frivolous

155 - TO DIFFERENT DRUMMERS

distractions of women.[22] All of that passed so quickly, so completely, that she seemed to put away her painting life without regrets or second thoughts.

She hung a few of her paintings from her studio years in her apartment. The rest were put casually away, in the basement of her mother-in-law's house. There they began to gather dust.

About the time that Rhoda was putting her canvases, and her profession, into storage, Alice was pulling hers out. And just as Rhoda was gaining new insights into herself, in 1931 Alice was reevaluating her own place in the scheme of the universe. It had been a year since Alice had painted. The reemergence of a desire to paint had triggered her will to live and sustained her spirits during her Herculean recovery. Never again would she go without painting for a day if she could help it. It was her life's alpha and omega.

That took care of the grand scheme of her life. The immediate problem was the necessity to navigate the first day and those that followed, for she returned yet again to that house in Colwyn. The conditions that had propelled her into a succession of institutions still existed, immutable and mocking: She could not paint in that house, and she was unable to live with her mother. Her first imperative was to get out before that little world again swallowed her up.

Where to go? The chapter on Carlos was closed forever. In an earlier life, she might have repaired immediately to the studio of Rhoda and Ethel, but the memories of the summer of 1930 were too fresh. Besides, the point was academic. Both were gone, swallowed up by conventional lives. Rhoda, of course, was married, and Ethel, still living with her parents, had moved to a new studio. If Alice had wanted to see either of them, she would have been able to find them from their families' addresses, but she did not try.

Who was left from the existence that Alice had abandoned a year before? Alice claimed that Nadya phoned her and invited her up to Stockton, New Jersey, where she and her husband, Egil, had taken a house.[23] Nadya, from the Sedgewick Avenue days—sensual, decadent Nadya. Nadya was the perfect antidote for the Neel family. She was passion and spirit and independence. Although married, her husband seemed negligible in her life. Her relationship with him was to find his whiskey bottles, empty

them, and fill them with water.[24] Nadya lived her own life; she supported herself. Alice hungrily accepted the invitation.

Nadya's place in New Jersey was refreshingly different from Mrs. Neel's stifling, orderly home. Alice was allowed to be both an artist and, despite her doctor's warnings, a bohemian. No one seemed concerned about those rituals that gave shape to the days in Colwyn, eating, cleaning, washing, cooking. They lounged and talked about interesting things, drank and maybe ate. People, mostly from New York City, came and went with irregularity, and the conversations that filled the house were either heavily political or shockingly hedonistic.

Men flirted with Alice at Nadya's. Despite her year of hospitalization, she was still uncommonly beautiful. Her face had acquired a roundness, with pudgy cheeks, her hair was short, abruptly cut and darker, no longer light blonde, but such temporary changes scarcely diminished a beauty. If anything, she looked younger than her thirty-one years.

She loved the attention of the men at Nadya's, for these were sophisticated New Yorkers. And Alice discovered that they found her amusing as well as attractive, and would cluster around in groups, not just to look, but to listen. She had only to do what Rhoda used to do so well, tell outrageously funny stories about what had been awful times in her life. Alice became adept at telling such stories, having a group of admiring men doubled over in laughter at her images of making grotesque faces at a cousin who had obviously come to see her only to see what a mad person looked like, or of her refusing to sew for a year in the hospital until everyone simply stopped trying to get her to sew, then quietly sewing the most complex outfit she could find.

Alice said that at Stockton she "began to return to real life."[25]

Part of real life was to be moving again among people of whom her mother would have disapproved. Foremost among them was a sailor named Kenneth Doolittle, who was older than Alice in both years and experience. At almost thirty-five, Doolittle was rakishly handsome. Unlike Carlos, he was not swarthy, but possessed light, reddish hair, a thick mustache, and knowing eyes. He was a vagabond whom later Alice romanticized into an entire counterculture. At various times, she described Doolittle as an able-bodied seaman who played banjo and sang workers' songs, and who was going to be in a movie as part of the French Foreign Legion,[26] a drug addict, but an interesting fellow,[27] a merchant

seaman who went off to fight in Spain and who swam the Ebro River,[28] and a left-wing intellectual.[29]

And he made Alice laugh. The sadness of the past year fell from her eyes over the winter of 1931–1932 in Stockton as Doolittle sang light ditties and told sea stories, seeming to want to impress her. She laughed convulsively when he tried his hand at drawing and mocked Alice's constant sketching.

He was not an artist. None of Alice's lovers would ever again be artists. Art was her arena, her space, the center ring where she performed. She let him make love to her and, over her mother's strong objections, moved in with him in Stockton during the winter. Then she moved with him to Greenwich Village.

New York City, Round Two: This time, Alice was not going to be stranded in a room on the Upper West Side. She and Doolittle moved in February 1932 into a small, dingy apartment at 33 Cornelia Street, really a short little alley slanting off Sixth Avenue to Bleeker Street, that housed stables and a mechanic's garage as well as a row of three-room apartments. The apartment, however, was surrounded by the most thriving artistic, bohemian center in the country.

Greenwich Village had once actually been almost a village, isolated within the lower extremities of Manhattan. Encompassing the scores of small streets between Fourteenth Street to the north and West Houston on the south, and from Broadway on the east all the way to the wharves on the Hudson River, the village had been for generations a cheap refuge from the growing metropolis. The mix of dense ethnic neighborhoods, shops, cafes, and available apartments in one- and two-story buildings attracted artists and writers into its cozy folds, and had sheltered such luminaries as Edna St. Vincent Millay and Theodore Dreiser before the Great War.

The Village's reputation as the center of bohemian life in America was well established when postwar "progress" rudely dragged it into the twentieth century. After 1917, Seventh Avenue became a wide swath of roadway that bisected the Village, and the West Side subway was opened. With the growth of Wall Street and the completion of the Holland Tunnel just south of the Village, it became one of the most traveled-through parts of Manhattan. By 1932, when Alice arrived there to live, its famed isolation was a historic relic. It was becoming a tourist mecca and popular homesite for Manhattan families.

The artistic/intellectual community tried to keep its offbeat character alive. In 1935, the Village was described by one of its inhabitants as the place for those who found "Anglo-Protestant values inapplicable and the money drive offensive" and who repudiated the social standards of "communities in which they had been reared."[30] The most they could hope for, however, was that the new rich would stay among the neat avenues on the east side of Sixth Avenue, below Washington Square, and that the bohemians would be left alone in their haunts on the west side of the Village.

Kenneth Doolittle was part of the offbeat intellectual community in the neighborhoods around Bleeker, Christopher, and Hudson Streets. His world was the natural place for Alice, and she threw herself into the intellectual and artistic life of the small community as much as into her painting. These years in the Village during the 1930s were probably the most politically active and the most social years of her life until the 1960s. Like her little community in Havana, the Village was an enclave of politics and socialism. And she arrived at the moment of its revitalization.

If the Village was in danger of being overwhelmed by the middle classes, the Great Depression put a stop to the danger. The Depression was still deepening when Alice arrived in New York in 1932, dragging down with it many of the monied classes. Increasingly, the Village began to regain its former sense of unity, forged out of a common poverty.

The Depression also helped to forge alliances. Intellectuals and labor leaders worked together to illuminate and address the issues of poverty. Through her association with Kenneth Doolittle, Alice found herself in the middle of a politically informed community for the first time since Cuba.

Doolittle seemed to know everyone in the Village. Through him, Alice met such Village fixtures as the poet Christopher Lazar and the writer Philip Rahv, the Communist longshoreman Paddy Whalen, and the left-wing activist Sam Putnam. The poet Kenneth Fearing smoked opium with Doolittle; Putnam slept for a while on a sofa in their apartment. All of them took an active interest in Alice. They helped to educate her into the politics of Depression America. Alice accompanied different men to meetings of the Artists' Union, the John Reed Club, longshoremen's rallies down on the East River, to political meetings and social welfare hearings. Within a year of her arrival in the Village, Alice was actively involved with and had been accepted by the political-intellectual community.

These were the people Alice captured on canvas in the early 1930s. She painted Doolittle and his friends. She painted the politicos of the left, the writers, the eccentrics, characters whom Damon Runyon could not have invented. And while she occasionally painted scenes of Depression New York, her energies flowed mostly into isolating and capturing the ethos of the individuals who made Greenwich Village live.

The years from 1932 until she left the Village in 1938 were the years when Alice began to concentrate on capturing what she later called the "*zeitgeist,*" the spirit of an age as it is reflected by the people who inhabit that age. Through a heavy use of symbols and a focus on faces, Alice began to record the *zeitgeist* of the 1930s.

Her acceptance as a painter, however, did not spread easily outside of a small group of admirers. Among other artists, Alice seemed to be "always kind of on the periphery." Within the art community, which was curiously quite separate from the political and intellectual radicals, Alice's reputation spread slowly, unevenly, where it spread at all.[31] One of her friends thought that her painting was "too original, too different" even for other artists.[32] Alice knew that her paintings, in comparison with the prevailing tastes for landscapes and regionalist art, were "wild and revolutionary."[33] Painting a man with three penises or a doll with an apple covering its vagina represented something more than freedom for Alice. Such outrageous canvases established and reinforced her reputation among her friends as the counterpoint to every stereotype they might have had of young, beautiful, blonde women.

Alice needed admirers more than colleagues. She craved attention more than collaboration because she was rock sure of her art, but was still unsteady in her identity as a woman, as a person apart from art. A friend from the Village said that "she bummed around with anyone she could get attention from."[34] If she joined groups or movements, it usually was because others wanted her to join. Even when she had strong beliefs, she rarely joined the group that fought for those beliefs. She signed up for membership in the Communist Party in the mid-1930s. It was "the" thing to do for anyone with a social conscience.

But when it came to art, she was a loner. Painting was an area of fierce independence. She did not join a school or academy either to learn or to teach. With the exception of the Artists' Union, which everyone joined because it was such an economic champion for artists, she belonged to no group of painters. And while she knew other painters, she did not consult,

give and take ideas, or compare her work. She might never have developed the contacts needed to penetrate the clubby world of art in the Village had it not been for the initiative of one of her early admirers, the painter and printmaker Joseph Solman.

In the summer of 1932, Village authorities set up an open-air market in Washington Square. The outdoor show was the first of the annual Greenwich Village Art Festivals, but at the time the more modest intention of the founders was to assist some of the fourteen hundred unemployed artists in New York City to show their work. Space was provided along the fences for artists to hang their works. Some 275 artists enrolled for the exhibition, among them Alice. Solman's gouaches hung less than ten feet away from Alice's exhibit, and as he studied her paintings of the Well Baby Clinic and the Ninth Avenue El, the elevated train, he admired the talent.

The young girl with the "dairy maid appearance" attracted him in unexpected ways. He watched, fascinated, as the local and irate Catholic priest demanded that she take down her portrait of Nadya, with hanging breasts and a baby on her lap, which Alice had provocatively entitled "Degenerate Madonna." He knew few people who were bold enough to hang that painting with that taunting title, but especially not this seemingly shy, harmless-looking young woman. Joe walked over and introduced himself and complimented her on her work, beginning a long friendship.

A few months after the outdoor art show, Solman was asked to do a local show by Joseph Kling, who owned the International Book and Art Shop on West Eighth Street. Kling had a small gallery in the back of the shop, where he exhibited works that he admired. Solman included three works by Alice as well as his own works, several by Max Spivak, and a fourth Village artist.

The show opened on 14 January 1933 and ran for a month. It marked the first time that Alice's works were hung in a gallery in America. However modest, her participation in the show was pivotal in authenticating Alice's claim to be a real, professional artist when the authorities from the Public Works of Art Project came in search of artists to support. Joe Solman, who was also a political activist, would help Alice at another critical point in her life, but Alice declined to join the groups that he organized. As he said, "There we all were, held together not by style, but by camaraderie, and then there was Alice."[35]

She may have remained on the fringes of artists' groups by choice, but at the many social gatherings in the Village, Alice increasingly shed her shyness. At parties, she became very good company. One of her signatures was that she could tell the "grimmest, most violent stories so that they were funny." Once at a party, she shocked and captivated a group of men by telling a story about having a baby, then instructing the doctor to sew her up and add a bow so that "it would be cute and pretty."[36]

As she became more popular and confident, her life with Kenneth Doolittle grew tumultuous. As she grew beyond him emotionally, those traits that in Stockton had been "mad," grew increasingly predictable and irritating. Her strong, able-bodied seaman diminished at close proximity to "a real male chauvinist" who "thought that he owned me."[37]

Alice's and Kenneth's life together, while intellectually alive, was difficult financially as well as emotionally over the course of 1933 and 1934. Neither of them worked regularly, and even their friends did not understand exactly how they managed. As Alice grew both disenchanted and stronger, her dependence on him lessened. When Kenneth smoked too much opium, he grew abusive, but Alice stopped backing down. Their fights became legendary among their friends.[38] But unlike the deterioration of her marriage to Carlos, her relationship with Doolittle was carried out in a social environment. Alice had escorts; she had sitters and colleagues and friends. And she had John Rothschild.

At the same outdoor art show where Alice was "discovered" by Joe Solman, she was also discovered by John Rothschild, a thin, balding young man who was indistinguishable from hundreds of others who looked at Alice's canvases, then walked by. Except that John stopped.

Alice was not terribly impressed by him. When she painted him from memory three years later, she did so as he appeared that day, in a nondescript jacket and a silly hat, its brim upturned. Her initial impression was that anyone who would wear that suit and that hat and still feel happy must be stupid. She thought that this new admirer probably "lacked some gray matter."[39] But he was earnest and charming, and he thought that her work was nothing short of brilliant. He invited Alice and Doolittle to his house. At the time, the summer of 1932, Alice's relationship with Kenneth Doolittle was still relatively new and fresh. Alice probably saw dollar

signs instead of erotic images when she regarded John. Maybe he would buy some of her paintings.

He did not. Neither did he go away. John began to admire Alice as much as he admired her art, and he started to frequent her studio on Cornelia Street. John, who she discovered was married, with two children, and a graduate of Harvard, offered her something that Kenneth could not. He gave her respite from her life as a bohemian. He was there to take her uptown to eat or out of town to get away.

Her new admirer was clearly from the other side of life. Alice assumed that John, as one of the Rothschilds, was rich. Actually, John's father, Alonzo, was a journalist, also a Harvard graduate who was one of the founders of the Ethical Culture Society and author of two books on Lincoln. John grew up in a household that was more intellectual than wealthy. He was well-bred and well connected in the New York intellectual community, and while his family was financially comfortable, he was not rich. He always had to borrow money in order to pursue Alice and assist her with her art.

Alice cared nothing for complex explanations. To her, John represented the "opposite" that she said that she was always searching for. She took John up on his offers to dine at the Harvard Club or to buy art supplies for her. Alice and John would be friends for forty-three years, until his death. But in those initial years, he was but one of her admirers, one who satisfied needs that others could not. She was not being hypocritical in allowing what she thought to be a gentleman of great wealth to entertain her and buy her things. Alice did not disdain wealth. Her objection was to the value systems that wealth nurtured.

In her experience, rich people lived lives that were dictated by selfishness and convention, which manifested themselves in that smug judgmental posture that she knew so well from the School of Design and from Cuba. John had avoided these. He appreciated her art and although he was a "square," he wasn't entirely conventional. She called him her "super-aesthete"[40] because of his opinion of her art. If, as Alice said, the purpose of life is to get as much experience as possible, then John's presence in her life was important. He offered her experiences that were normally denied poor artists in the Village.

Alice also simply liked to do the things that money could buy. She did not apologize for her catholic tastes, but said simply that "there was a kind of dichotomy in my life. I enjoyed the luxuries of the rich, but sympa-

thized with the poor."[41] To put her very pragmatic perspective another way, she explained, "I always liked the wretched, but I've always liked the elegant too."[42] John's money, the money he possessed and the money he borrowed, gained him a fingerhold in Alice's life in the early 1930s. She was quite willing to let him compete for her attentions from that position.

Alice's whole private life was a balancing act. She balanced the competing men successfully, at least for a few years, and the radically different world views they represented. She found the middle ground between her radical politics and John's class status. But perhaps her most skillful handling of divergent forces in her life was her relationship with her mother. Not once, but twice, Alice had quite explicitly repudiated her parents' values when she left home. But even after her breakdown and an almost impossible year coping with her mother, Alice was unable to let go. She needed her mother, from afar.

Once free from her daily domination, Alice began to relax, even in the presence of her mother. As long as there was a chance that Mrs. Neel would ever control her life again, Alice was wary, defensive. But in 1933, Alice was becoming increasingly secure in her ability to avoid ever having to go home to live again. She felt comfortable telephoning her mother once a week, on Saturday evening at nine o'clock, collect.[43] Mrs. Neel always accepted the charges. Although Alice was leading a life that Mrs. Neel strongly disapproved of, both daughter and mother seemed to ignore or overlook it in order to maintain a relationship.

In 1933, Alice had two of her paintings included in an international show at the Boyer Gallery in Philadelphia that had been arranged by the famous New York gallery owner, J. B. Neuman. He did not know Alice, but her works were suggested to him by one of Alice's Village friends who knew she was from Philadelphia. She returned and stayed with her family, but the visit was finite. She had a place to return to, so her mother's house had lost some of its terror. The following summer of 1934, Mrs. Neel and Alice jointly rented a house in Belmar, New Jersey. As long as they did not talk about what Alice was doing in New York, they found enough unused space between them to be comfortable.

It was pleasant to be away from Greenwich Village and Kenneth Doolittle in the summer of 1934, but the summer was a difficult one, for Alice's past rushed back into her life. Carlos, back in Havana from Paris, sent

Isabetta to stay with Alice, as a kind of entrée back into Alice's life. His mother had just died, and he wanted to go back to Alice.[44]

Closed doors opened. Isabetta, almost six, undoubtedly remembered little about the mother she had not seen since she was two. Alice did the only thing she knew how to do with a daughter—she painted her, a young, proud-looking six-year-old, hands on hips, naked. Alice could have gone back to Cuba with her daughter and her husband, who asked, but she chose not to, a decision she later called "stupid."[45] At the time, it probably was not. She may have felt that she wanted to have Carlos back, but all that she was doing to reconstruct her life would have come undone. A husband, a child—that "awful dichotomy" all over again.

Her life in New York won out. She let Isabetta return to Cuba. She returned to New York City, not so much to Kenneth Doolittle as to painting and to John Rothschild, whose pursuit of Alice heated up dramatically during 1934. He caught her on the rebound. She had pushed herself away from Carlos, who instituted annulment proceedings, and was drifting away from Doolittle, but her need to be loved, to be affirmed, by some extrinsic authority was as strong as ever. Her angel became her lover.

The treachery almost cost her her life. In December 1934, after an opium-smoking bout, Kenneth Doolittle's jealousy erupted into violence. He confronted Alice with charges of infidelity. John Rothschild had been too ever-present all fall, and Doolittle's ego was wounded. He owned her. That was the way he saw it, and that was the way she had behaved in the relationship. He paid the bills!

His anger raged irrationally, and then destructively. Alice had increasingly ignored Doolittle. He would make sure that she noticed him. She came in as usual, no explanations, no apologies. He confronted her. As she stood in helpless disbelief, he pulled out his curved Turkish saber and began to slash the paintings that had been stacked against the walls of their apartment. Possessed, he swung and swung with a fanatical determination, until all about him had been reduced to shreds.

Normally, a woman would have rushed out, but Alice would not. These were her children being massacred before her eyes. She tried to stop him, but her concern only enraged him, and he began to rip and tear her drawings and watercolors, then turned to her clothing, which he began to burn. Alice began frantically to gather into her arms the art that had not yet been touched, but her rash movement only seemed to remind him of

the source of his anger. He picked up his saber again and lunged at her. She pivoted in terror and fled out to the street. Sixty of her paintings and over two hundred of her drawings and watercolors lay in ribbons or in charred piles in the quiet aftermath of what Alice came to call her "holocaust."[46]

In December 1934, Alice left this volatile man with whom she had been living. But there were others with ready offers to take her in, including John Rothschild. The question was, did she want simply to move to another man?

A ROOM OF
ONE'S OWN

A f t e r Alice had left Dr. Ludlum's sanatorium and Rhoda had married, the two lost track of each other for over forty years. Their lives became separated not only by space, but sensibility. If Rhoda gave up art for family, Alice repossessed art with passion. If Rhoda relinquished her independent identity, Alice tenaciously grasped onto hers through a maelstrom of relationships.

They took on those polar roles that have typecast women ever since Eve created the part of temptress and Mary landed the role of handmaiden. One became the lover, the other the wife; one the bohemian, the other the helpmate. Rhoda seemed blissfully content with becoming the archetype of what Simone de Beauvoir would, a decade later, call the "other." Alice, however, evolved into a Virginia Woolf creation who insisted on a room of her own.

It was the W.P.A., the Works Progress Administration, that allowed Alice and Rhoda to lead the lives that they, at that point in time, desired. The W.P.A. was a federal government project begun in 1935 to employ people in the face of the most severe unemployment in the nation's history. At its height, 3.5 million workers owed their livelihood to the W.P.A. Alice and Ben were among them. The Federal Artists Project of the W.P.A. enabled Alice to remain independent by giving her a weekly income of her own for painting, and it enabled Rhoda to be wife and

mother by providing Ben with his first earned income during the marriage. Alice was able to paint, and Rhoda was able to watch with satisfaction as her husband resumed work as an architect.

At some point, decisions about life have to be reduced to dollars and cents. Living in the middle of the worst economic depression in the history of the nation, Alice and Rhoda stumbled through many such times. During the early years of the 1930s, Alice's life was frequently reduced to finding ways to live so that she would not have to return home. Years later, when Alice was given an opportunity to stress the importance of gender in art, she pinpointed a more fundamental division that came from the Depression. She said, "Both men and women are wretched and often it's a matter of how much money you have rather, than what your sex is."[1]

Poverty was a way of life in places like Greenwich Village, where over one thousand artists insured that there would be a chronic surplus of supply over demand, even in the best of times. But the Depression wiped out most of the markets that existed for those who called themselves artists. Consequently, like company towns when the major industry fails, the Village was hit especially hard by national economic retrenchment. In bad times, art is among the first "frills" to go. And given the marginal status of artists in American society, the question of what to do with artists in the midst of economic depression was, early in the Great Depression, a hot issue only among artists. The members of the art community had to band together to help keep each other alive.

The College Art Association, the C.A.A., centered in New York, organized early relief efforts. It provided employment for about three hundred artists, although it had carefully classified over fourteen hundred artists in New York City who qualified but were not on relief.[2] In the Village, the John Reed Club, where Alice attended one meeting, was an organizing center for activists before the formation, in 1933, of the Unemployed Artists Group, which became the Artists' Union. Activists from the Communists in the John Reed Club to educators in the C.A.A. found themselves working together to find money to permit artists to eat, and, at another level, to continue to produce art. The 1932 Washington Square Outdoor Art Show had been one attempt to generate new markets

by exposing as many artists as possible to the public. The Gibson Committee on Unemployment, which was encouraged by the C.A.A., was another. So desperate were the community of artists that the Artists' Union grew into a working ally of the Longshoremen's Union. Protests in the streets, sometimes violent, were one of the only ways that the powerless could make their suffering and their anger visible.

Alice existed somewhere in the middle of the emerging spectrum of activism. Along with a group of artists, she had registered with the College Art Association as an unemployed artist on relief. She joined the Artists' Union, but did not get too deeply involved in its politics. She attended meetings of different organizations, marched sometimes with friends, and empathized deeply with the poor and the unemployed. The erratic quality of her activism, either with the Artists' Union or her many friends in the Communist Party, was due to a complex combination of circumstances. Alice was not a leader or a joiner. She was a loner whom events pressed for commitment. She joined groups, but she made her real commitment on canvas and not in cabals or on committees.

The key to Alice's success at being accepted into private and public relief programs for artists was her reputation as a painter. From among the thousands of people who claimed to be artists, the relief agencies had to find ways to identify the serious professionals. The Washington Square Art Show and her modest participation in the small gallery show that Joe Solman had organized helped to validate her claim to being a professional artist. Similarly, her few canvases in a show at the Boyer Gallery in Philadelphia in early 1933 set her apart. Her contacts and the designation as professional artist put Alice among a relatively small number of men and women who were invited, at the end of 1933, to receive aid as part of the federal government's Public Works of Art Project, P.W.A.P., the first government-sponsored relief effort for artists.

One day she got an invitation from the Whitney Museum, which administered the P.W.A.P., to receive money every week just to paint.[3] She said proudly that the artists were not even picked for need.[4] Her selection was quite an achievement. The P.W.A.P., a precursor of the W.P.A., employed only 719 artists in the entire city, and of those only twelve percent were women.[5] Participants were selected on the quality of their work. They had to submit paintings to be reviewed by two of the staff of the Whitney. Alice had been recommended by someone, but her status as an artist and her competence were what earned her selection.

It was not just the honor, but the money. Receiving $26.50 a week, just to paint, represented the first regular income that Alice had earned from her art. It gave options to a woman who had experienced only a few in her life, and allowed her to look at her life. It may have contributed to her growing independence from Kenneth Doolittle at the end of 1933, at a time when he was becoming more possessive and demanding.

Doolittle had provided Alice with the means to live in New York City when she had no other options. Her selection by the P.W.A.P. freed her from total dependence on Doolittle and may have convinced her that she could support herself as an artist. Throughout the spring of 1934, Alice toyed with independence, living with Doolittle but dating, and in the summer she was able to share the house at the shore with her parents. But her flirtation with independence ended abruptly in the summer of 1934, when the P.W.A.P. ended, after only six months in existence. Alice was suddenly without an income once more. Her choices seemed to be either to deepen her dependence on Doolittle or to lessen it by increasing her dependence on John. She chose the latter and her "holocaust" in December was the price she paid.

Rothschild seemed ready to provide support for her, and to take her in. The problem, in early 1935, was that he was still living with his wife. To get Alice away from Doolittle, he moved Alice to a resident hotel on the Upper East Side, to Sixtieth Street, on another planet as far as Alice was concerned.

While John tried to figure out what to do with her, she stagnated in her effete surroundings and grew so weary from what she called "so much chit and chat about it"[6] that she moved back to the Village on her own, living in several different places. She had no problems finding friends to take her in, for, as Alice said, "I always looked very sissy and I was rather pretty. So I had a completely double life. I was myself, but for social reasons I was that other person. In one way it was very useful. It made all the boys crazy about me."[7] She was, in 1935, as attractive as she had been since she ran off to Cuba with Carlos a decade earlier. Village life agreed with her. Thin again, she had recaptured that ingenuous look in her eyes that, despite her thirty-five years, made her look girlish and vulnerable.

Other men tried to attract Alice, but, after December 1934, John Rothschild carried out his most relentless pursuit of Alice. His problem of what to do with her melted when he left his wife. That cleared the way for

him to offer Alice a summer at the Jersey shore. She accepted, and the two escapees tested their relationship in a little house at Spring Lake.

That summer of 1935, Alice was as carefree and as untroubled by thoughts of money as perhaps she had been since those early months in Cuba. John, to the outside world, would seem to have had everything. In addition to appearing to Alice to be enormously wealthy, he suffered from none of the insecurities of Doolittle. In fact, he possessed a self-confidence that bordered on arrogance. Alice, however, had but to ask, and John served up a feast of sensual pleasures, frolicking sex, and gourmet delights. Would any sane woman turn away from what appeared to Alice to be a rich, devoted man, highly literate, with a well-developed aesthetic sense? A man, moreover, who could guarantee that she would never have to go home again?

Spring Lake, however, seemed to convince Alice that while she was fond of John, she did not love him and could not live with him. The relationship failed the test of intimacy. After a summer that swung from the sexual play recorded in Alice's watercolor "Joie de Vivre" to the emptiness captured in "Alienation," she pulled back. John was not Carlos; he was not even Doolittle. He was neither exotic nor mysterious. John could be appreciated, but not lusted after.

Alice may have pulled back also because she demanded much from her lovers that John could not give. A friend once reflected that she might have been "a masochist," for she seemed to like "a macho kind of man who was violent with her."[8] Perhaps gentle men were too strong a reminder of her gentle father, which translated into a threat that she might become too much like her mother. Or possibly she simply gravitated to dark, mysterious foreign men for whom domination over their women was a cultural heritage. It is not that she was passive or submissive in the presence of strong men. Her intimate life was one area where Alice shouted and asserted herself and made demands. This mix of possessive men and an otherwise quiescent woman who became fiercely protective of certain areas of her life helped to make her personal life tumultuous and sometimes violent. John offered her none of that. The chemistry wasn't there.

It was the W.P.A., the Works Progress Administration, that allowed Alice to free herself from a total dependence on John or on anyone. In late September 1935, not long after she returned from Spring Lake, Alice was contacted by the new Federal government agency, the W.P.A., and offered an unexpected income of $103.40 a month to paint as part of the Federal

Artists Project of the W.P.A.[9] What timing! Alice no longer worried about finding a place to stay. The question was where and with whom. This munificent sum allowed Alice to rent her own apartment and, if she chose, to live alone, free from the distractions and complications of men.

Alice did choose to live alone. She found a little apartment, but one large enough to serve as a studio also, on West Seventeenth Street, north of the Village, near the river. John, who had freed himself to follow Alice and still expected her to live with him, even after the difficulties of the summer, took an apartment nearby on West Twentieth Street. He cooked for her and asked her out until she made herself perfectly clear that she was not going to live with him; he soon moved back uptown, where he continued to help her when she allowed him. For the first time in her post–art school life, Alice, at the age of thirty-five, finally had an independent income and a room of her own.

Alice was selected to participate in the W.P.A. as a "professional" painter in the elite easel division. The decision regarding which of four categories to assign artists—professional, skilled, intermediate or unskilled—was made by a committee of supervisors and artists. The decision about which division was most suitable for a person—mural work and art instruction were the two major categories—was made by the administrators of the program. Audrey McMahon of the C.A.A., who headed the program in New York City, said that painters who wished to work in the "creative" or easel division had to submit examples of their work, copies of their clippings, evidence of individual or group exhibitions, and, if possible, a track record that came from belonging to the stable of a known art dealer.[10] Although her formal credentials were minimally competitive, Alice's reputation among artists was such that she was included among the eighteen percent of the artists in the project who were invited into the easel division.

This division not only conferred prestige on the painters who were selected, but provided them with total freedom to paint. The bureaucratic approach to funding something as elusive as painting reduced artistic production to a fairly standard formula: An easel painter had four weeks to produce a painting that was 16×20 inches or 20×24 inches, five weeks for a 24×30–inch canvas, or six weeks for a 24×36–inch work.[11] The paintings were often selected by public officials to be hung in schools or courthouses.

While one of the national directors of the Art Project, Holger Cahill,

said that the primary concern of the project was the artist not the art, the painters had to carry their production to the project office, where the supervisor would choose the one the project wanted.[12] Alice's work often caused problems for her supervisors. It is an imperative among bureaucrats to categorize people. Otherwise, bureaucracies cannot work. Alice's style and subjects defied neat categorization. Even one of her admirers called her work "curiously original."[13]

Alice was loosely grouped with the urban-scene painters. Like her friends Herman Rose, Jules Halfant, and Joe Solman, Alice wandered the streets of the city in search of subjects that captured the suffering and the heroism of the age, what she would later refer to as the "*zeitgeist.*" But urban scene describes but one dimension that was observed by Alice's flylike eye. Its facets observed different and varied scenes from life: hopelessness on a street corner under the Ninth Avenue El, the electricity that ran through the anti-Nazi rallies on the docks, the power emanating from the clenched fists of Pat Whalen, the ethereal silliness of a naked lover frolicking with dancing pigs.

Alice painted "Pat Whalen" and "Joie de Vivre," her lighthearted image of John Rothschild frolicking, close together in time, adjusting herself to different aspects of life, constantly juggling the public and the personal, the political and the sensual. Art historians have noted simply that her paintings during this period were marked by "an unusual mingling of social commitment and subjective intensity."[14]

Alice reveled in the contrasts. As she wrote, "I always loved the most wretched and the working class, but then I also loved the most effete and most elegant."[15] A not unusual day for Alice was to wander the poorer neighborhoods in search of subjects, make a quick sketch, writing in the names of the colors, then go back to her apartment and paint the canvas from memory. Then she might be taken along by Raphael Soyer to a meeting of the American Artists' Congress for one of the dozens of talks she listened to on the role of the artist in the politics of the Depression, or follow along with Paddy Whalen to a longshoremen's rally. She was once arrested while picketing, but the police let her go, because they could not bring themselves to believe that such a fair maiden would involve herself with such thugs. Afterward, she might well dine at the Harvard Club or Longchamps with John and laugh with him about still another occasion when Alice's beauty saved her from arrest, or at least from being given a bad time.

Alice was flexible in her life, and she enjoyed the variety, but she would not make compromises in her art, even for the administrators of the W.P.A. who were paying her the money that allowed her to be independent. She painted what she wanted and submitted a canvas every five or six weeks to the offices on King Street. Sometimes her supervisor simply did not know how to reconcile the W.P.A.'s needs and Alice's fierce independence. On one occasion, she turned in to John Lonergan, her supervisor, a painting of a fish market in Spanish Harlem. Before he would accept it, he had her remove some of the blood, saying, "Not everyone likes blood as much as you do, Alice."[16] In 1943, when Alice was able to buy back the painting, she put the blood in again.

That was a minor problem. Another time, Alice was almost kicked out of the easel division and sent over to the teaching section. The canvases produced by the easel painters were intended to adorn public buildings—schools, post offices, hospitals. Administrators from these institutions would pore over the available paintings and select those they wanted. If an artist accumulated a large number of canvases that were not selected, her coveted place in the easel division was put in jeopardy. Alice was one of only three painters who found themselves in that awkward position, threatened with expulsion. Almost no one wanted paintings that were considered too heavy and morose.[17]

Audrey McMahon indicated to the Artists' Union her intention to make such a move. Before she could, Joe Solman, chairman of the union's grievance committee, went to W.P.A. headquarters to argue Alice's case. Of course, he could not argue that Alice would lighten up or that administrators were wrong in not selecting her paintings. He defended her on her merits as an artist, arguing that these could "not always be discerned by the well-meaning administration." McMahon gave in on all three cases once their artfully hidden merits were pointed out.[18]

The Artists' Union would have intervened to save any easel painter from being judged by bureaucrats, but Solman's defense of Alice went beyond a show of political unity. He and other artists such as Herman Rose believed that Alice was enormously talented. Rose took his students to her apartment to see her paintings. Others worked to secure for her the critical patrons and gallery connections.

Fewer than two dozen galleries dotted Manhattan in the 1930s. Art had no market; the fourteen hundred artists registered with the C.A.A. had pitifully few outlets for their work. And the rare individuals who owned

galleries tended to specialize in periods or styles, which further reduced the number of places where undiscovered contemporary American painters could hope to show their work. Fewer still were the artists who could even fantasize about having the more prestigious gallery owners, such as J. B. Neuman, look at their work. But Alice's active and connected friends brought her to his attention, not once but twice. Not only had she been included in his 1933 Philadelphia exhibition at the Boyer Gallery, but two years later Solman talked Neuman into visiting her studio.

Neuman made it a practice to carry three or four canvases of the more promising newer artists in his gallery. Reputations were made and broken on his judgments, so naturally Alice was advised to show him her best work. As he studied her work, she brought out her *"pièce de résistance,"* a nude of Joe Gould, a Village eccentric whom she painted with three layered penises, probably the most revolutionary, unconventional, bizarre painting from a period in which almost no one painted male nudes, let alone one so outrageously endowed. Neuman examined the work, pronounced it "slightly decorative" and left without inviting Alice to join his stable.[19]

Alice was also one of the few painters from among the emerging elite in the Village who were not picked by the Secession Gallery, Robert Godsoe's West Twelfth Street refuge for painters who were too radical or modern for the mainstream galleries. Nor was she included among the Ten, a group of nine men who organized to promote and exhibit their works as an alternative to the Secession Gallery. Alice was, however, invited to become a member of the New York Group, another informal collection of urban scene painters modeled on the Ten. It was as a member of this group, which included Jules Halfant, Herb Kruckman, Max Schnetzler, Jacob Kaiman, Louis Nisonoff, Joe Vogel, Jack Tworkov, and Herman Rose, that Alice penetrated the gallery scene in 1938.

Emily Francis of the Contemporary Arts Gallery on West Fifty-seventh Street had a reputation in the city for giving new painters their first one-person show, to get them started. Mark Rothko, Joe Solman, Earl Kerkem, and Louis Schanker had their first shows under Miss Francis's sponsorship. So did Alice. She had been appreciated in the right circles in the Village and came to Miss Francis's attention. A show was arranged, and for twenty days in May 1938 sixteen of Alice's canvases hung in the Contemporary Arts Gallery, her first solo show in the United States. The 14 May 1938 *ARTnews* noted the occasion by stating that "this artist

searches for both general forms and particular personalities . . . characters are made real and familiar to the observer . . . [the decorative basis of her work is] invariably subordinated to the mood of the subject."[20]

Alice's one-person show had been closed only two days when a group exhibition of the New York Group opened at the A.C.A. Gallery on West Eighth Street, the only other gallery that specialized in promoting experimental, undiscovered American painters. The A.C.A. had opened its doors during that fateful summer of 1932, when the art community was beginning to respond to the drought in art purchases. The intention of its founder, Herman Baron, was to provide space for the vigorous sponsoring of social art.[21] Baron was also one of the founders and the first editor of *Art Front*, an activist art journal, so the A.C.A. Gallery became a center not only for social activists to display their art, but to discuss their politics.

The New York Group artists were among several dozen painters who banded together to display as groups not because of similar styles, but because of a camaraderie, a social attitude that caused them to identify themselves with the laboring people. Of the New York Group, only Alice and Nisonoff were not mentioned by name in the review in *ARTnews*. This may only be significant in symbolizing her relationship with the group. She was not really an integral part of the group. One of the Ten described the New York Group in these terms: "Some were social expressionists, some were romantic expressionists and then there was Alice."[22] She felt that she was an appendage, that "they were so embarrassed that I was a woman."[23]

Her peripheral place in the constellation may have had just as much to do with her own tendency to orbit the edges of groups as it did with her gender. She may have been left circling the periphery of groups because they did not know how to interrupt the centrifugal force that kept her in her own orbit. Despite her gender and her loner reputation, they invited Alice in. That indicated one thing to her. She had to have been "a very good artist."[24]

The two May 1938 shows presented Alice's work on a silver platter, served generously to any passerby, as tempting canapés at a party. With fewer than two dozen galleries in Manhattan, such exposure in the two leading alternative galleries might have short-circuited her wait for fame—if there had been any demand for her work. But no one selected the

tantalizing canapés: No mainstream gallery picked her up for a show; no gallery owner was moved to add her to his or her stable. Not even the two galleries that exhibited her work followed up on the initial shows.

That was understandable for Emily Francis. The Contemporary Arts Gallery gave only first shows. But Herman Baron did not add Alice to the stable of the A.C.A. Gallery. He did not show her work again for over twelve years primarily because he "didn't see anything in her work."[25]

Alice was unable to maneuver her paintings into another gallery for six years. As it was with her W.P.A. production, she painted what she wanted to paint and left it up to others to see the genius on the canvas. Generally during these years, the "others" discerned little beyond caricature, morose individual catharsis or strident political propaganda. Perhaps the multiple facets of Alice's expression were too confusing and complex for the contemporary art world. As a Communist, she painted a torchlight parade against fascism; as an individual who had suffered greatly, she painted pictures that communicated one of her core creeds, that "no one on earth should suffer."[26] As a woman she painted frankly sexual scenes and intensely personal chronicles. She openly expressed in paint her love of the city or her affection for Latin culture and working-class values. It would take some time for the art world to "catch up" to Alice.

If the absence of professional acclaim for her work bothered her during the W.P.A. years, she did not communicate it to her friends. One of her fellow artists remembered her as rising above her many problems. If some bitterness, he wrote, "might at times have entered her speech—about her family problems, or about her financial straits, or the indifference of critical response to her work—her ready smile dissipated the discouraging thought. She was good company, and funny."[27]

Alice was sought-after company in the Village in the mid-1930s. Confident, funny, independent, she appeared at all the parties, the men clustered around her laughing uproariously at stories that women simply did not tell. She gave every appearance of having successfully put her life back together from those perilous depths of 1931 and her personal holocaust of 1934. She attributed her progress to her art. As she said, "When I painted I was completely and utterly myself. For that reason it was extremely important to me. It was more than a profession. It was even a therapy."[28] The lesson learned from a decade that had taken her from Philadelphia to

Havana to New York, and to New York a second time, from the con-
straints of marriage to the freedom provided by the W.P.A., and from the
ambivalence of motherhood to the certain and ironclad identity as an
artist, is that she had to paint in order to live. The rest of her life would
revolve around that fact.

Her resolve, however, did not mean that there would no longer be a
place for men. Quite the contrary. It was her private life that Alice seemed
unable to control. Between the beginning of 1936 and the end of 1941,
Alice lived with two different men, had a son by each, and moved from
the Village into the remoteness of Spanish Harlem. The reason her life got
so out of hand, as she said, was her complete devotion to art.[29] She
consciously created her art; the rest of life just happened. Alice had a room
of her own, but she chose to allow outsiders to come in.

She had been on the W.P.A. only a few months when, in early 1936, she
met José, a nightclub guitar player. John had taken her to the club, one of
their many evenings out. But, after John left her off at her room, she
returned to the club to see José, talented, handsome, Latin, the only man
she ever sought out and went after with the intention of inviting back to
her room. She did invite him home, and their romance began. José had
nothing to do with the worlds of painting, artists' unions, longshoremen,
eccentric intellectuals, or Marxist theorists. José represented still another
world into which Alice could wander when she wanted to or flee when she
had to, a world of lighthearted fun and animal passions.

Alice had once expressed regret that she had been too stupid to take
back Carlos when she had the chance in 1934. It is possible that José was a
substitute for the handsome Latin husband she had lost.[30] He became such
an integral part of her life that she spent her evenings at his club, increas-
ingly disappearing from the haunts where her intellectual, artistic friends
hung out. This withdrawal, never complete, was accentuated in 1937,
when Alice moved, first within the Village, and then, in 1938, out of the
Village, about ninety-seven blocks to the Upper East Side, into the alien
world of Spanish Harlem.

In the nineteenth century, the neighborhoods from the East River to
Central Park between 96th and 130th Streets was an elegant district of the
city that bordered on much of a Roosevelt family farm. First German
families and then Italian and European Jewish families carved out small
neighborhoods and lived in comfortable isolation from the churning
waves of newer, less respectable immigrants that splashed into Manhattan

after the turn of the century. That isolation eroded and then abruptly ended with the completion in 1919 of the Lexington Avenue line of the subway. The New York subway provided cheap, easy access to the area, transforming East Harlem into Spanish Harlem, and driving out the last of the Europeans. When Alice moved to East 107th Street, she was a rare Anglo among a settled community of Puerto Ricans.

Alice's friends in the Village were baffled by the move. She proffered a variety of reasons. On one occasion, she said that the Village had begun to get very "honky tonk."[31] She claimed to have grown sick of the Village because it was "degenerating," becoming more of a festival place, the residence of middle-class people who want to play at being bohemians.[32] Greenwich Village was also becoming more expensive and it was no secret that the W.P.A. was periodically cutting back on the stipends to artists in the easel division, so that by 1938 Alice was receiving only $91.10 per month.[33]

Whatever reasons compelled her to move away from the artistic center of New York, she stayed in her new area even after 1939, when her son by José was born and when José left her for another woman. She was aware that she was living outside of the mainstream and the eddies of the art world. When her friend, the artist John Graham, made the trek up from the Village to see her, she called him "somebody to talk to from the real art world."[34]

But she stayed. Possibly it was because she lived in a tremendous apartment with eleven windows much more cheaply than she could in the Village; maybe it was, as she liked to say, that Spanish Harlem was better suited to her needs as a painter because "there is more truth in ghettos now than there is in all these festival places."[35] Perhaps it reminded her of Havana.

For whatever reason, Spanish Harlem became her home, even though the next man whom she invited to live with her was hardly a Latino. Sam Brody was Russian by birth and European by background, a brooding Jewish-looking intellectual with a hook nose and heavy lidded eyes, the opposite of José, a curious antidote. Everyone talked about his genius, although few seemed actually to like him. Difficult to fathom, complex, Sam became, for most of Alice's friends from the Village, an unwanted presence, in her apartment and in her life. He was a photographer with pretentions to filmmaking, but he rarely applied himself and did not

accomplish much. Selfish and quarrelsome, Sam was sometimes violent, and Alice's friends, Joe Solman the painter, Phillip Bonosky the writer, and John Rothschild, could not understand why Alice tolerated him, or what attraction he held for her at all.

Alice met Sam in January 1940. She had given birth to José's son, Richard, the previous September, and had been deserted by José a few months later. Alice might simply have been lonely way up there in Spanish Harlem, the sole Anglo, or Sam might have caught her on the emotional rebound from José's desertion. He seemed to meet her needs. He was a consistently strong admirer of her painting, and that might account in part for his longevity with Alice, but the initial glue was physical and sexual. Sam Brody fathered Alice's second son, Hartley, who was born in September 1941, and lived on and off with Alice in a complex and difficult relationship for the next seventeen years.

The birth of two children in two years as Alice exited her thirties could have been one of the great traumas of her life. Certainly their births would alter her life-style. But unlike her disastrous experiences ten years before, she was not going to be undone by life this time around.

She became the mother of two sons, but she chose not to marry either father. That awful trap that had immobilized her when she was a young twenty-five-year-old "girl" did not have the power to lure her into its grip when she was an experienced woman both sides of forty. Her life with Carlos, marriage, commitment, was not going to be repeated. José had been fun. Often she stayed up until dawn playing, but her first loyalty was to her art. And after it ceased to be fun, when José was "out chasing other women," Alice put up with his philandering because "I never did like to lay the law down—and it left me free to do my painting."[36]

Freedom, that was her imperative. Men could exist in her life, and, while she wished she could have been more assertive toward them in all areas, she insisted primarily on her freedom to paint. The men of the New York Group, for example, "ran over me even though I was a much better painter."[37] Men would affect her life in certain areas, but they would never again govern her sense of who she was. It was a compromise that Alice learned to live with. The alternatives were unacceptable.

The W. P. A. continued to provide her with the means to retain her grasp on her own independence as a painter. It allowed her to live in her apartment and retain control of her children and paint her canvases.

Professionally, she wanted to dictate her own life, for, as she often said, "I did care about the fact that I was free to do as I damned pleased on canvas."[38] Men, others, would have to fit into that constraint.

The W.P.A. ended in the middle of the war effort in 1943. Alice had weathered the dissolution of the easel project and the transformation of a teaching assignment into war-related projects. Until the government could no longer justify subsidizing artists while America was at war, some artists were assigned to draw posters or illustrate training manuals. Alice was given the task of scraping the insignia from civil defense arm bands. She loved to say that she was one of the last eleven artists in New York City to be released from the remnants of the W.P.A. in 1943. Her pay transcript shows her termination date at 20 June 1942.[39]

For nearly ten years, Alice the artist had been supported from public funds and had produced one of the most varied, stimulating, bizarre, and eclectic group of paintings of any artist in America. When the W.P.A. folded, it left Alice with a walk-up apartment in a tenement in Spanish Harlem full of unsold paintings and no gallery outlet, two young children to support, a small but dedicated group of admirers, and a fierce sense of her own talent. As she approached middle age, she had no income but a powerful understanding of her own needs.

Such discovery had eluded Rhoda. Her soul-searching had been directed primarily at her husband.

THE SECOND

SEX

- -

12.

- -

W e r e people starving in Philadelphia in 1934? Were there artists organizing relief efforts and collaborating with William Gropper to establish a local John Reed Club? Rhoda did not seem to know. Just about the time that Alice was beginning to capture on canvas such moving scenes as the mother of seven explaining to the Russell Sage Foundation that her family lived in an overturned car, Rhoda's attention was riveted on Jakie, her baby. It was 1918 all over again, momentous events shaking the world outside her windows and Rhoda too absorbed in discoveries in her own life to notice.

If motherhood refocused most of her attention toward her child, it was her marriage to Ben that gave shape to her interests outside of her tight little world. Her social circle was composed of architects, Ben's friends. She gave up completely her contacts with the art world. Someone once asked Rhoda if she had known any artists on the Federal Arts Project and she had to answer that she did not: "I wasn't mixing with artists at the time." All of "our" friends on relief were architects.[1] Did she know of Ethel's role in the W.P.A. in Philadelphia?

Ethel Ashton continued to be very active in art circles after she closed the Washington Square studio in 1931, following Rhoda's marriage. Taking a new studio, at 731 Walnut Street, almost around the corner from Washington Square, she continued to paint seriously, having one of her

canvases accepted for the 1931 annual show at the Brooklyn Museum. After traveling for two years throughout South America, Cuba, and Mexico, she returned to live with her parents. In 1935, she joined the mural project of the artists' project of the W.P.A., and she executed several murals, including "The Wyoming Massacre" in the Tunkhannock, Pennsylvania, post office. All were outside of Rhoda's areas of interest.

In fact, Rhoda had no friends apart from her marriage. She and Ben entertained his pals around their kitchen table. The discussion was not about tempera but raking cornices and speckled trout. During those early years of marriage, she did not so much participate as listen to the men talk shop. Later in life, she was alarmed at the realization of how easily she had learned to defer, how effortlessly she had fallen into Ben's rhythms, and how willingly she had given up her life to become a part of his. Only in middle age was she able to look back and see herself hideously distorted into "a clinging vine type" who was "willing to drift along his easy way and worship him and praise him for any little thing until his inferiority disappeared."[2]

At the time, however, she did not see herself as submerging her needs to his, for she had no needs apart from her family. Rhoda's doting was probably, to some extent, a conscious reaction to her mother's pathological selfishness. Rhoda would spend no money, run up no bills, or otherwise make demands for herself from their meager income. Discretionary money belonged to Ben.

A few months after Jakie was born in 1933, and the apartment filled with the cries and gurgles of infancy, Ben and several of his friends rented a room a few blocks from the apartment, on Spruce Street. None was employed, so the room gave them a place to go during the day. The men, all architects, were supposed to be engaged in planning and discussions, and one, Louis Kahn, who would one day become a renowned architect, told Rhoda that he was working on a new concept, a porous wall. But she suspected that they shared the six dollars a month rent just to have a place to get away from their wives and children.[3] She understood.

The impact of the Great Depression on the psyches of people who lived during its reign of terror was powerful. Unemployment, despair over the present, and hopelessness for the future can shroud even the most healthy individual in a pall of uncertainty. While Rhoda's happiness was scarcely dented by the economic collapse of Western civilization, Ben seemed to have had enormous difficulty handling the dependence, powerlessness, and vulnerability imposed upon him by poverty.

But it was not the Depression alone that caused Ben's feelings of inadequacy. He suffered from the same kind of feelings of inadequacy that infects many sons of fathers who dominate their lives and groom them for succession, then have the poor judgment to desert them through death. Historians call it the Richard Cromwell complex after a seventeenth-century son whose only sin was that he was incapable of following in the footsteps of his father, the Lord Protector of England. He lost the kingdom; Ben lost his job, his partnership, and probably his fledgling self-esteem following Mr. Medary's death in 1929.

Mr. Medary was a towering figure. His death occasioned a front-page story with photo in the *Evening Bulletin* and an even longer testimonial with picture on the second page of the *Philadelphia Inquirer*. Not only was he a "nationally known architect" and collaborator with Frank Lloyd Wright, but he was the winner of awards from professional associations and the recipient of an honorary doctorate of fine arts from the University of Pennsylvania.

And then there was Ben. It is not that he was unemployed and on welfare, but that he had been released from his father's firm even before the Depression had forced the firm to close. He did not know how good an architect he was for he had never tested himself. Possibly he had held back even while his father was alive because he did not want to discover that he was not good. But more likely he did not strive to become a partner and a respected architect because he had not really wanted to be an architect at all.

Ben had wanted to be a painter, but Mr. Medary would not allow it. No son of his was going to work at "a woman's task."[4]

Ben dutifully followed in his father's footsteps, as expected of someone named "The Third." He attended the University of Pennsylvania and joined the Zantzinger, Borie, and Medary architectural firm and gave up the nonsense about painting. His failure seemed to be one of will, for even after his father's death and his own dismissal from his father's firm, he did not dash it all and run off to Rhoda's studio to paint. He first had to crawl out from under a towering shadow that was no longer there.

Being the son of Milton Bennett Medary, II, however much private ambivalence it caused, carried with it a certain public standing. Along with the curse came some advantages. Ben was one of the architects in the country who were asked to join the architects' project of the Works Projects Administration, when it began in 1935, and who were invited to

work in Washington. He was not asked because of his reputation, but because of his father's. He was invited to Washington, D.C., to work on designing post offices because of his name.[5] In the fall of 1935, he and two friends rented a room in Washington and began work on the project. Early in 1936, Rhoda and Jakie joined him.

Rhoda did not mind leaving Philadelphia. There was almost no one left from whom she had not already drifted away. And the new area was unexpectedly attractive, especially to someone who had been living in a tenement. Ben was able to arrange for a small house in Fairfax Court-house, Virginia, what Rhoda called a "lovely little house with an old-fashioned garden." It was one of the oldest houses in the town and was always bathed in the fragrance of flowers.[6]

They moved in 1936, the same year that Rhoda gave birth to their second child, a son, whom they named Milton Bennett Medary, IV. If she could have arranged for the announcement of his birth to be attended by trumpets, she would have, so unabashed was her happiness. He was, simply, her "beautiful, large, healthy baby with a wonderful disposition who would smile and go to anybody" and was "so strong and big, so eager and capable."[7] Freud would have been gratified at Rhoda's sense of completeness at the birth of a son.

Rhoda at last had everything in her life in order: Ben was working, they had two exceptional children, and they were living in their lovely little house. She possessed a vivid image of perfection in this life and it was the day-to-day interactions of a loving family. In her mind, it was but hers to arrange.

First came her children. Before it was deemed either fashionable or necessary for mothers to involve themselves closely in the education of their children, Rhoda spent hours teaching Jakie, making sure that her daughter, whom she thought of as extremely intelligent, was challenged. Rhoda was justifiably proud when Jakie was admitted to first grade a year early, at the age of five.[8] Med, as they called their son, got even more attention because Rhoda felt that he grew up quickly and always wanted to grow faster. She and Ben called him "the Little Man" since he always acted older than he was. As with Jakie, Rhoda was personally gratified with the intelligence and sweetness that Med possessed. If early in the

marriage Rhoda had willingly given her sense of independence to Ben, she totally abandoned it to her children.

After three years of working, in 1938, Ben had earned enough and Rhoda had insisted that they save enough to buy a 160-acre farm on a hill in the country outside of Fairfax Courthouse. There, the children could have land and a pony. They were able to purchase the old farmhouse and its land for forty-five hundred dollars. It had no electricity or running water when they moved in, so Rhoda was always amazed that Ben consented to buy it. But the farm did come with two cows, a pig, chickens, a little horse, called Shorty, and a black neighbor named Dick Jones who charmed Rhoda into hiring him for occasional work. He explained that he had worked the farm for the previous owner and, after careful consideration, had decided that he would like to work for such a nice family.[9]

The farm on Pope's Head Road may have been the backdrop for Ben's happiest years also. Although he was not a demonstrative man, Rhoda sensed that his love for the children was as great as hers, possibly springing from the same sources. His way was to let them do whatever they wanted to do. If Rhoda set down rules that he did not agree with, he did not discuss them with her, but "circumvented her to make sure that the kids could do what they wanted."[10] As with other aspects of the marriage, Rhoda at first privately enjoyed this conspiratorial trait. Life on a farm with small children does not force that many decisions, so his tendency to indulge them their desires was not initially a problem with Rhoda.

Ben's demonstrativeness emerged, as usual, with his friends. The grandest party he ever gave was a barn party for the men in his office, the architects who designed post offices with him. It consisted of a lot of dancing with beer barrels on their heads, piling into the hay loft, and possibly other activities. It was hard to tell exactly. Rhoda and the children were not allowed to come out of the house until the last party goer had departed. But they watched the whole time, the three of them, from the bedroom window. They delighted in watching their husband and father prance down the driveway carrying an old ladder made from tree limbs, and carrying guests up to the barn. Rarely was Ben as abandoned as he was when dancing around the barnyard with a ladder on his head, smacking it against the side of the barn.[11]

★ ★ ★

The fairy tale that Rhoda was trying to write, however, never quite materialized. First, the character development began to go awry; then the plot started to unravel. The disintegration, as Rhoda charted it, began with an automobile accident just two years after they had moved to the farm, in 1941.

Pope's Head Road was a glorified cow path, narrow and, in places, steep. The few locals who drove the road did so slowly, honking before the crest of a hill or the turn of a sharp bend. Rhoda was driving home after a day of shopping. Jakie was sitting on the front seat beside her. When the bread truck, driven by a teenager, came roaring over the hill and smashed head-on into them, both Rhoda and Jakie were catapulted through the windshield. Thirty years later, those few seconds were still spilling out consequences that Rhoda found almost too painful to write about. The course of her life, their lives, was irrevocably altered.

Mother and daughter were crushed and mutilated in the crash, and for weeks lived only threadlike existences in an Arlington hospital. Ben did not budge from their bedsides for the first four days, when both were unconscious and expected to die, and consented to return to the farm, where Med was being cared for by neighbors, only after Rhoda came to, wired, casted, and bandaged, but expected to live. The prognosis for Jakie, which was sadly fulfilled, was not good. She also would live, but she would "not be the same."

While Rhoda's jaw absorbed the brunt of her impact against the windshield, and splintered into eight pieces, Jakie hit full force with the top of her head. No one knew exactly how seriously her brain was damaged, but the changes in Rhoda's bright and cheerful little girl rendered a technical measurement superfluous; the accident scrambled her ability to see and pushed her almost nine-year-old ability to read and write back into infancy. And, even as she grew stronger physically, her levels of confusion and impatience first neutralized her sweet disposition, then pulverized it.

Rhoda could scarcely function as a human being when she came home from the hospital. She could not talk because of the wires that held her jaw together. Full leg casts on both legs practically immobilized her, but she was determined to hobble about on crutches. The strain on Ben to care for Med was great. Immediately after the accident, he took his five-year-old son to stay with friends. Two couples each kept him two weeks, but, as Rhoda was later told, both men returned him after the wives "became ill

and had to be put to bed" because he wet the bed and behaved so outrageously.[12] Rhoda was helpless to do anything about Med, whose behavior deteriorated in nursery school as it had with their friends, or about Ben, who, in another life would have hired women to care for his children, but who owed hundreds of dollars for round-the-clock nurses for Jakie while she was hospitalized and, therefore, had to be nursemaid himself.

But the real strain began several months later, when Jakie came home. Rhoda was herself still recovering when she had to begin to care for a young girl who had lost all sense of perception and would walk off the top stair or the porch if not restrained. Her brain would not tell her what it was that she was seeing, so someone had to feed her and dress her at first. Rhoda knew that Jakie was aware of what was going on around her. She simply could not process information that came from her eyes, and that critical, but isolated, inability seemed to heighten her frustration, for she knew what she wanted to do, but could not.

Rhoda watched helplessly as Jakie's disposition changed, altering the atmosphere in the old farmhouse. In the midst of tragedy, some good always surfaces: Friends cooked for them, nurses donated some free time, the surgeon did reconstructive surgery on Rhoda's face without charging her, and even the miserly old coal dealer drove all of the way out to the farm to tell them to forget about his bill. But the unexpected participant was Ben. His aristocratic reserve deserted him when he had to take charge of his family, and his sense of propriety dissolved in the face of multiple kindnesses from others. For months in 1941, Rhoda's Ben became the kind of man she wanted. But the scale of their tragedy was so enormous that she was not able to appreciate the change for years. At the time, the accident stained that whole terrible hill on Pope's Head Road.

The W.P.A. ended in 1943, but because of the war effort it was likely that Ben would have been kept on the government payroll. They were keeping architects, but he did not find out if he could stay. In the winter, he quit his job. Rhoda knew that it had been years since he had enjoyed his work, but his decision was not just a professional one. They could not live there on that farm any longer. The ghost of past laughter haunted rooms in which Jakie screamed at the little brother who now seemed to be her enemy,[13]

or just cried out her frustration. Too many memories forced premature decisions, made out of logical sequence, but in an order that made sense to people who needed above all to move.

Rhoda and Ben sold the farm as quickly as they were able, in February 1943, right after Ben got another job, but long before the family could move to a place near his job. They sold the farm for exactly what they paid for it, despite their improvements, and the existence of a war-fueled economy. Profit was not a motive for selling. They offered their horse, Shorty, to Dick Jones, who had become one of their best friends. Dick offered them one hundred dollars for the useless little animal. Rhoda doubted if they could have "gotten fifty dollars for Shorty from anybody else. I think giving us one hundred dollars was Dick's way of settling things with friends he felt at the time were having bad luck."[14]

Through his contacts in Philadelphia, Ben found out about a job in Florida, advertised by a building company that had done work for his father. The company needed a squad leader to take charge of deck fittings for the cement boats being built in their shipyard. The position had nothing to do with architecture, but it paid well ($340 a month), it was an immediate opening, and it was not in the area of Washington, D.C. In February, Ben said yes. By the end of March, he was at work at Hooker's Point Shipyard, Tampa, Florida. The farmhouse was a memory. Rhoda and the children were living in an apartment house in Philadelphia.

Rhoda was able to walk by the spring of 1943, although she had to push herself with deliberate, stiff-legged motions. Jakie, almost ten years old, had regained her ability to function in a three-dimensional world, but she still could not read or write, and was growing perceptibly moody. Rhoda despaired when she would fly at Med in a jealous rage and "beat him over the head with her fists."[15] The three of them lived essentially without relief from each other while waiting for Ben to find them a house. It was midsummer before he called and told them to come.

Although the trip seemed to take forever, it ended only two days after it started, in laughter and even a moment of joy for Jakie. Getting train tickets for Florida during a war took weeks, and then Rhoda managed to buy only coach tickets. When she boarded at Philadelphia's Thirtieth Street Station with two children, a dozen suitcases, and a canary cage, complete with chirping canary, she found herself on a car that was filled

with soldiers and without functioning air conditioning. There had been a time when Rhoda boarded her family's private railway car with her nanny and her cat. It must have seemed a bad dream in the steamy summer of 1943, when, for the first twenty-four hours, they sat "soaking wet" from the heat between two soldiers, in a seat designed for two, and during the second day froze after the conductor moved them to the only car that had air conditioning.

Rhoda was afraid that she was going to ruin her new outfit, the one she wore to dazzle Ben. Her outfit had been made by an old lady who lived in their apartment house who said that she should be wearing sexy clothes when she saw her husband after so many months. So Rhoda let her design and sew a dress that must have been quite a hit on a train full of soldiers. The black satin dress had a draped skirt and low neckline and was worn by Rhoda, under instructions, in tandem with a svelte black hat with a large red feather "shooting out the front." Ben liked simple, plain clothes. When he saw her alighting from the train in a stained and wrinkled satin dress, crushed hat with bent red feather, he broke into uncontrollable laughter. "What in the hell do you have on?"[16] She stood stiffly, grim-faced, biting her lips to keep her composure as it dawned on her how ridiculous she must look in the middle of the afternoon in the heat of Florida, standing in her satin cocktail dress. She tried to hold in her giggle, but it grew to a smirk and then a laugh of lumberjack proportions. She never wore it again without the two of them laughing until Rhoda's eyes teared.

Ben had a small house waiting for his family in Passa Grill, on the Gulf coast, and a kitten for each child. The curve of a smile appeared on Jakie's lips as she picked up her kitten.

New job, new house, new state, new start, fresh beginning, clean slate. Rhoda did not know how Ben was going to fare working in a field outside of architecture. It was enough that they were away from Pope's Head Road. The rest would follow.

Ben worked hard at his job and he did his work well.[17] He did not seem to like or dislike his work, but he visibly loved Florida, the ambiance and especially the fishing. When he was not at work or with the family faithfully every Sunday, he was in the Gulf, reveling in his new pastimes of surf casting, off-shore trolling and deep-sea fishing. The Medary's refrig-

erator was always "jammed" with dozens of varieties of fish. With the rationing of meat, Ben had the only excuse he needed to fish.

His second love was being with friends. Ben made male friends easily with his easy ways and his dry wit, and one of his coworkers at the yard was married to a Philadelphia woman whose family knew both the Medarys and the Myerses. That was enough of a connection to generate first interest and then friendship. In twelve years of marriage, Bob and Betty Imhoff were the only couple to become close friends to both Ben and Rhoda. The couples spent Sunday afternoons together at the beach. The two families, including the children, although quite different ages, played, frolicked in the surf, and picnicked, and then retired to the Medarys for what they laughingly called "high tea," that is, large cups of tea with a spoonful of rum floating on top.

The Imhoffs regarded both Ben and Rhoda with affection. Ben they considered a big, gentle bear of a man who was very well educated and quiet, but who possessed an unfailing talent for ending another's conversation with funny "one-liners" that would "flatten everybody with laughter."[18] But for the most part, Ben seemed content to watch everyone else at a gathering as if he either preferred not to get into the mix or was contemplating a *bon mot* that would flatten everybody.

Betty Imhoff enjoyed Ben, but she admired Rhoda. Walking stiff legged, and painfully when the weather was all wrong, Rhoda took care of all of the domestic side of life from shopping and cleaning to washing all of the clothes by hand and cooking on an ancient stove in their small rented house. Betty thought that Rhoda possessed a special creativity, a "wonderful imagination" for cooking, always improvising so that they never knew what a pie crust was going to contain until they bit into it, and then they might discover raisins or sweet potatoes or apples.

But mostly Betty admired Rhoda for raising two children essentially alone. She noted that while Ben and Rhoda were "very hospitable" with guests, they rarely spoke to each other. Ben almost never disciplined the children, or spoke negatively to them. Rhoda made the decisions on how they were raised, and when they foundered, she made bold decisions. Med began public school soon after arriving in Florida, and as the new boy from the north in a small school, he was constantly being set upon until he was so scared to walk to school that he would hide behind a set of garbage cans until the bell rang. Rhoda hired a recently hospitalized, recuperating pilot to teach Med how to fight. Med adored the man and

learned from him until he was able to beat up the biggest bully in the school.[19]

More importantly, Rhoda tried to confront Jakie's problems boldly, not so much from inspiration as from frustration. Every time she pushed Jakie to try something new in her rehabilitation, Jakie would go to her father, who would tell her that she did not have to take the step if she did not want to. Rhoda grew exasperated at the extent to which Ben undermined her efforts to push Jakie or discipline Med. To Betty, Rhoda showed "immense courage" in ignoring everyone and putting Jakie into Med's class at school, a ten-year-old in the second grade. Jakie was so angry and humiliated that she learned to read just to escape being in her brother's class of seven-year-olds.[20]

To outsiders, even close friends, the Medarys were a "normal" family. People did not know of Rhoda's growing disillusionment with the twists and turns her fairy tale was taking. First of all, she hated Florida—the sand, the bugs, the ringworm that would not die, the drunken soldiers from the nearby hospital for the battle-fatigued, and the marital infidelity among the wives of service men, which she regarded as rampant. And the fish. She loathed fish, but it constituted her main diet, and its smell radiated from her refrigerator and rose from her bathroom scales, where Ben once weighed a fish that was too heavy for his fish scales.

The only things that she found at all pleasing in Florida were the sunsets. Following the late afternoon rains, the setting sun transformed flat, undistinguished Florida into a land of rugged contrasts. "The heights in Florida," she wrote, "are in the sky at sunset."[21]

But it was more than Florida.

It was Ben. By 1944, after they had been in Florida a year and had been married for thirteen years, Rhoda sensed that he was falling back into his "aristocratic" ways, not at all like what she had seen after the accident. Except for the evening meal and Sundays, Ben was rarely home. When he was with the rest of the family, he visibly relinquished control to Rhoda and seemed to remove himself psychologically from his occupied space. He began even to eat his dinners as if they were solo activities. He ate his main course very rapidly, then moved to the couch in the dining room to sleep until the others had finished and dessert was on the table. He was annoyed if dessert was not ready when he returned to the table. Following the meal, he almost always returned to the couch to sleep for most of the evening.[22] That in itself is not an unusual behavior for a man approaching

his middle forties, and Rhoda might not have made too much of it if repairing to the couch and falling asleep had not been his response to every demand on his time from Rhoda.

Ben and Rhoda did not have fights, but neither did they have talks, for he withdrew whenever Rhoda tried to involve him in her life or theirs. In the face of this passivity, Rhoda found herself gradually taking the initiative in their lives. When, several years later, she became aware that the transference had taken place, she saw that her changing behaviors almost certainly contributed to their growing estrangement. She began to nag Ben, to prod him into making decisions.

Ben complained about his work in sort of a low moan, but the most he would do about any unhappiness he felt was to stay out of Rhoda's way when she got on her soapbox to tell him that they ought to move if he was unhappy with his job. Rhoda began to perceive that Ben's habitual response to any problem was to ignore it. As her accumulated frustration pushed its way to the surface, she found herself screaming at him to discipline Med or talk to her or respond to her. If Ben had been mean or abusive, Rhoda at least would have been able to isolate and name the evil and know what she was fighting. But her enemy was elusive—the lack of initiative and involvement, the absence of enthusiasm, the inability to love life. As Rhoda lamented, "I wanted him to like doing things."[23]

Incongruously, when the family went on picnics, which was their favorite collective pastime, they all seemed to enjoy themselves, as if such outings were theatrical events in which reality was, by mutual consent, suspended. The same let's-have-a-good-time attitude kicked in at social events and gatherings with the Imhoffs. It was not that Rhoda was unrelievedly miserable during the Florida years. She just was not happy the way she expected to be. As she later wrote, "I had made a great success at my art and wanted to do great things with him. I did not want to drag him up. I wanted him to sail over all obstacles with me."[24]

She was not unhappy when, in 1945, cutbacks at the shipyard occasioned by the end of the war forced Ben into looking for another job. The Imhoffs had returned to Philadelphia during the previous year, when Bob took a job with United Engineers. Ben could have applied for a job there, but he chose not to. Perhaps he did not want to return to Philadelphia to

play on his father's home field again. Maybe his motives were not so calculated. He loved the South.

The job that he took was in Lafayette, Louisiana. Neither he nor Rhoda ever said what his job was, but it paid less than he was earning in Florida. The family purchased an old car. They were able to load all of their possessions in it and on it, and, at Rhoda's suggestion, they drove back roads, to get the flavor of each region, and stayed at farmhouses by knocking on doors and asking if they could rent a room cheaply. The trip was a hot and uncomfortable one, the kids were fussy, they were stranded in a steamy crossroads town in the panhandle of Florida for three days while they waited for a new radiator, and when they arrived in Lafayette there were no houses or apartments to rent. The four of them took two rooms, connected by a hallway in which Med slept, in a rooming house.

Their stay in Lafayette lasted barely a year. Ben did not like his job or their accommodations. He thought it uncivilized to live at a place where the tables were covered with stained oilcloths.[25]

Rhoda's memories of life in Lafayette were happy and personal. She made friends with two women, and the three of them took outings while the children were in school and sometimes on Saturdays. Their most memorable occasion was having dinner with Cornelius Vanderbilt in St. Martinsville. Neil, as Rhoda was instructed to call him, was touring the South in a large aluminum trailer writing stories for a New York paper. At the town museum, he fell in behind Rhoda and her friends, one of whom, the one "Neil" seemed to be following, was an attractive sculptress. She would not go to dinner alone with him, so the three of them accompanied the stocky man in the gaudy sports coat to a nearby restaurant where they had steaks, despite his attempts to convince them to order inexpensive items.[26]

But what stood out most strongly that day was Ben's reaction. Rhoda called him from the restaurant to tell him why she and her friends would be late and to ask him to call the other two husbands. Shortly, Ben called the restaurant to tell her that the other two husbands were very upset. Rhoda understood the message to come from Ben as well, and it touched her. She said that it was "the only time my husband showed any worry as to who I was with or where I went."[27]

The tempo of life was different in Louisiana. Living in a converted hotel with its staff and other guests presented the family a challenge to display a

veneer of exterior politeness. They ate their meals in a public dining room and negotiated the rest of their lives in small rooms surrounded by other tenants. The decorum and gentility that was so much a part of Ben's persona became the norm for the family as a whole. They behaved civilly, as people behave who know that they are being watched. Rhoda was pleased with the experience, for it meant that circumstances had invested them with a sense of family, an island of unity, if for no other reason than to keep up public appearances.

But living arrangements were not up to Ben's standards, and after only ten months he was complaining about his job. The combination made the stay in Louisiana temporary. Rhoda appreciated the state much more than Florida. She and Ben had visited plantations and sugar mills and developed a taste for Cajun cuisine served in lazy restaurants with ceiling fans. Rhoda had admired the French Creole people, who, she thought, carried a sense of aristocracy with them. But she especially embraced the color of Louisiana, from the white heat of the sun to the lush greens of wild vegetation. Nevertheless, she again began to push her husband to find a job at which he would excel, one that he would love. They moved west across Texas and New Mexico. Ben found a job with a young architect in Tempe, Arizona.

Heat, unremitting heat, blasted the southwest desert during the summer of 1946. The only apartment they could find, or afford, was on the second floor of the house of Ben's employer, an oven that was cooled by running water sprayed across the roof by a fan. Rhoda spent two years in perpetual physical discomfort. The heat exhausted her, and the antidote to the heat, their water spray, aggravated her sinuses. The inhabitants of the Salt River basin had, of course, worked out life-styles and invented amenities that made life comfortable. If Rhoda had been able to participate in the culture of the region, she would not have been unhappy with something so insignificant as temperature. But her neighbors, the parents of children who were Med's and Jakie's age, the boss and his wife, were, in Rhoda's mind, as cold as the desert was hot.[28]

One of the reasons that Rhoda wanted to move west in the first place was the friendly reputation of Westerners. Maybe Ben would like his work and her children would discover friends. A congenial environment might give her a fighting chance of keeping her family from drifting apart. But the Medarys had settled in Tempe at a tense time. In the fall, Mexican children would be entering the public schools for the first time.

A system of segregation that rivaled that of the South regulated the patterns of life among the white population as well as among Mexicans and Indians. Ben and Rhoda came up against a closed community of whites, who, while not yet under siege, displayed a suspicion of outsiders.

They were not invited to the famed barbecues, which comprised a whole social environment revolving around the cookout chimneys that rose from the backyards in white neighborhoods. No one asked them for drinks among the poinsettias that bloomed in lush gardens on Christmas day or invited them to pick lemons or grapefruits from their gorged fruit trees. Rhoda had doors slammed in her face when she asked one neighbor to take her son to the hospital and another if her son could come over to play.[29] She grew to despise the diligent, humorless, hardworking white elite in the town and took pride in Med's friends, most of whom were Mexican and Indian.

As usual, Rhoda's life was focused on her family. She had hoped that Arizona would be the "happy spot on this earth, just for us and our children."[30] Determined to maintain a strong sense of family, Rhoda continued to organize outings on which everyone was expected to go. Weekends were still set aside, whenever possible, for picnics. They would all take the bus to Patsy Junction and walk to the Superstition Mountains and eat sandwiches above the stretching desert. But weekends did not compensate for the boredom and the estrangement and the general unhappiness that pervaded the family during the rest of the week.

And that same determination that pushed Rhoda to organize picnics also pushed her to recreate her family as they once were or might have been. To somehow undo Jakie's disabilities and Med's growing independence and Ben's dissatisfaction with his work, to counter the malaise, Rhoda became increasingly intrusive in the lives of her husband and children. Knowing what needed to be done, she told the others and then kept after them to do it. Her frustration fed her energy. As her sense of deterioration grew, she seemed to redouble her efforts to lead and push and direct.

She became more assertive in her children's lives in those unwanted ways of worried mothers, but Rhoda's frustration vented itself increasingly toward Ben. Her Ben, the most handsome man she had ever met, became "poor Ben." She realized that she was not going to make him into her Prince Charming. "For years," she wrote, "I was always making the sacrifices, moving from one part of the states to another, hoping Ben

would find it there. But he always found the same gripes and the same longing to move on and I thought the next place will be it. I was always trying to drag Ben up to my standards and [was] secretly building up resentment against him."[31]

Her insight did not lessen the resentment. It had been too long in the building to disappear suddenly. If to some extent Rhoda's deference to her husband was a role she accepted in order to be a good wife, she also recognized, earlier in the marriage than she was able to articulate it, the flaw that she later called his inferiority. What at first were attractively masculine traits, such as decisiveness, she eventually began to see as selfishness. Reserved, aristocratic ways, viewed from a different perspective, began to grate as uncaring aloofness. Seen from a more acute angle, Ben's lackadaisical manner looked ominously like a frightened, defensive posture. Ben was not an easy man to live with, but in the early years of marriage, the rewards for Rhoda were sufficient compensation for whatever sacrifices she made, and most of them were quite small anyway, like not painting.

Rhoda was given reason for hope once again in 1948 when Ben decided to take a job at the Philadelphia company where his friend Bob Imhoff worked. She did not know what prompted the move. All she knew was that she was "mighty glad to leave that apartment and that part of the U.S.A."[32]

They bought a car, packed all of their possessions in the trunk or tied them on the roof, and set off for home. During a stopover in Phoenix, an incident occurred to remind Ben of his lowly standing in his profession after his thirteen-year sojourn. They visited the Arizona Biltmore, a luxury hotel built by Frank Lloyd Wright. While they were there, they encountered the famous architect. Ben introduced himself. Because Wright had known Ben's father well, he invited them to visit him at Taliesin the following Sunday. Ben was quite pleased to have been so honored, and on Sunday they arrived to be ushered into a large living room, where they watched Wright walking the grounds with a prosperous-looking couple. They had been waiting a long time when Mrs. Wright came into the room and was startled to see them. She hurried away, and a few moments later a student came in and politely ushered them out the front door and away.

Ben, naturally, was furious. Many years later, in Philadelphia when Gimbel's Department Store was giving an exhibit of Wright's work, Ben encountered the old man, who recognized the Medarys and came forward to greet them. Ben waited until the last moment, then turned around and walked away, leaving Frank Lloyd Wright standing with his hand extended.[33]

If their odyssey across the Sunbelt contributed little or nothing to Ben's professional development or his contentment, the journey, with its exotic landscapes and eccentric color, did nothing to stimulate Rhoda to paint. The excuses from the early years of the marriage had collapsed with the Depression. The W.P.A. had provided Alice with enough money to paint, and it provided the Medarys with enough discretionary income to buy a farm. Money, especially during the war years, was no longer a usable excuse.

Certainly, Rhoda's primary attention during these years was given to her family. After the automobile accident, she especially devoted her time to Jakie. But time also eroded the excuse that she could not take time away from her family, that she was not going to be selfish. The children had grown into school age by the time they had settled in Louisiana. Yet Rhoda had filled her days socializing with her two friends and sightseeing. And Ben? Rhoda's emerging assertiveness in their relationship did not, apparently, suggest to her that she might have given more time to her own interests.

It is not that Rhoda forgot about art or no longer thought of herself as an artist. Although Rhoda never actually painted during her Florida years, she talked about art and referred to herself as an artist, and inadvertently convinced others to think of her as an artist. Betty Imhoff clearly remembered Rhoda as an artist when they all lived in Florida.[34] Rhoda cultivated her artist's eye and saw what she considered marvelous opportunities for a painter in Louisiana and Arizona. She called Louisiana "an artist's delight,"[35] and described the Arizona desert as "out of this world, marvelous colors."[36]

But not once did she set up an easel or mix a palette of sandy desert colors. She never said whether the thought crossed her mind and she vetoed it or whether her preoccupation with the gulf that existed between her fantasy life and her real life absorbed all of her creative energy.

One day she would try to understand why her passion for painting had disappeared so completely from her life for so many decades. But in 1948 she did not have the advantage of distant perspective or the luxury of quiet, deliberative time. She was living right in the middle of a life that had grown unexpectedly complex and had gotten out of hand, albeit ever so slightly.

Perhaps Philadelphia, home, would be her spot on earth.

ART FOR

ART'S SAKE

13.

A s long as the W.P.A. existed, Alice met her friends and acquaintances every Friday morning at the administration building on King Street, when they all picked up their weekly stipend. Payday grew into a minor social event when artists dropped off their required paintings, collected their money, and chatted over coffee at nearby restaurants. Alice enjoyed these mornings, but of course, they stopped after the W.P.A. ended in 1943, an unheralded casualty of the war effort, part of the piecemeal disintegration of the special social fabric of the Depression. After 1943, friends would occasionally see Alice at a union meeting or a gallery or a mutual friend's show, but increasingly "that was all."[1]

She had been an enthusiastic presence at communal meetings and a familiar figure walking along Bleecker Street or up Greenwich Avenue toward Chelsea, but a conspiracy of personal circumstances converged to keep Alice from her haunts of the 1930s. She had moved into the folds of a smothering culture in Spanish Harlem, where she was living with Sam, a man whom her friends knew to be brilliant and quarrelsome, talented but self-absorbed, who possessed an eccentric jealousy and a capacity for violence that simply scared most people away. She had no income after the W.P.A. ended and, of course, Alice was raising two children, her sons who had been born in 1939 and 1941.

So much had changed so quickly. The children demanded so much

attention, and, unlike her last experience with child rearing, when Carlos took over Isabetta's care, this time Sam only complicated the situation. Like a child himself sometimes, he was often selfish, jealous, and demanding. She had to worry about him, and she had to worry constantly about where money was going to come from. Her response to crises that threatened to tip over into disaster was to paint. Accumulating problems in her narrowing life would have to be addressed, but first Alice had to paint. She constantly adjusted her life to accommodate Sam and her schedule to accommodate two infants, so that she painted during the afternoons or late into the night, when they were asleep. But her imperative was to paint, "that's all, like I always did."[2]

Just as she had painted the intellectuals and characters of the Village in the 1930s, she painted the face of Spanish Harlem in the 1940s. Alice had said of the Colwyn of her childhood that there were things to paint, but no one to record them. She recorded Spanish Harlem on her canvases, the perishable soul of illness and poverty and childhood among an otherwise inarticulate people. Consciously, she explored the depths of suffering and the eruptions of humanity that were an everyday part of life in an invisible section of a great metropolis.

Alice also painted still lifes and cityscapes. She explored the edges and recesses of her own mind and, in the summers at the shore, captured the shimmering sea on canvas. But mostly she painted the human figure, torsos that communicated perhaps too much, hands that held special meaning, and faces that yielded, rather than masked, interior truths.

In 1944, her style and subject matter were still revolutionary enough to capture the attention of Rose Fried, the owner of the Pinacotheca Gallery on West Fifty-eighth Street. Her gallery was known as the independent little gallery that took up unpopular causes and took risks with new or unconventional styles. Rose invited Alice to hang twenty-four of her paintings from the previous twelve years, including some of the highly personalized symbolic paintings composed shortly after Alice's recovery in 1932, the ones that survived Doolittle's saber.

This was Alice's big opportunity to have the uptown crowd, the art world, see her work. She picked her works carefully. Nevertheless, they generated the same bafflement that usually greeted her paintings outside of a small group of her admirers. The review of the show in *ARTnews* asserted that her paintings possessed a "kind of deliberate hideousness

which makes them hard to take even for persons who admire her creative independence." The reviewer who penned this criticism grudgingly added that her work was at least "plainly serious" and "thoughtful."[3] One work was praised, but nothing sold, and Alice was not added to the Pinacotheca's stable of artists.

This was her last show of the 1940s; it was evident that Alice's figures were not commercially viable. To undermine further their tenuous position, the whole genre of the figure was beginning to fall into disfavor.

Art styles are inevitably pushed into obsolescence. A combination of social forces and internal pressure from every generation of eager new painters constantly challenges the vitality of current styles, eroding interest in them and eclipsing them. With the end of the Depression, social realism's usefulness was widely questioned. Whereas art had been a social or political statement, now that the war effort was winding down, a new wave of socially irrelevant art was pushing into the galleries of New York. Abstract expressionism, abstraction that celebrates sensa as ends in themselves, became the rage. The Pinacotheca Gallery, like dozens of others, rushed to garner the hottest painters.

Alice was not among them. Her figures, which so recently had seemed too risky for gallery owners, suddenly were transformed into rather passé statements of little interest to those unfamiliar with the subjects. The time was ripe for Alice, like Willem de Kooning, to make the changes necessary to remain in the avant-garde. But she would not. She did not object to abstract expressionism, but she did object to the new style forcing "all of the other pushcarts off the street."[4] Alice clearly understood the new direction of art, but chose to resist it.

Alice remained committed to the human figure as the center of her art. Her faithfulness to a belief in the importance of the human being stretched beyond an ideology of humanism. To Alice, artists have an obligation to history, not just to record, but to interpret the richness and complexity of the life of the period in which they live. She believed "that more is communicated about an era and its effect on people by a revealing portrait than in any other way."[5]

At one level she felt morally compelled to keep the faith, to paint the face of injustice she so eloquently displayed in the boredom expressed by Judge Harold Medina as he presided over the 1949 trial of eleven Communists who were charged with conspiring to advocate the overthrow of the government, or the face of suffering she powerfully portrayed in the face

of a young, cachectic, Harlem tuberculosis patient. Less dramatically, but equally importantly, she recorded everyday faces, those of her boys and the children of the neighborhood, her father in death, and her frail mother suffering. Alice explored through her painting not just the *zeitgeist*, but finally her own soul. "Art," she believed, "is the search for yourself."[6]

Painting intensely every day provided Alice with an affirmation of her sense of self, separate from anyone else, and at the same time it invested her with an ability to transcend life itself. She said, "I would leave myself behind and enter the painting and the sitter and afterward feel lonely and disoriented."[7] She was so drawn in to the process by the power of the creation that afterward she was exhausted and spent. Life at those moments was worthwhile; she became an important human being whose work was justified.

To keep her lifeline intact, Alice was willing to pay any price. "Well, for me art is everything (even though I have these sons and everything else); instead of buying clothes I bought art materials."[8] In order to paint, she sacrificed those amenities around which women are supposed to shape their lives: "comfort, security and worldly pleasures."[9] The most difficult part of being a painter was not the sacrifice of material things, for Alice believed that for art's sake you had to give up everything. The most difficult part was living with the selfishness that painting demanded. "You can't worry about your family and those things. If you want to get ahead, you just have to go. You can't worry about people."[10]

The decision was easier to make than keep. Alice had not planned to have children again, but she had them. They were reality, and Alice did not allow reality to throw her again by denying it. She became a devoted mother, unorthodox and probably more interesting than most mothers, but fully accepting that she had two small children. The beds might not be made, but she tried to make her boys feel accepted and part of her life. She avoided what had once been her awful dichotomy by simply accepting that she was first a painter.

She even looked like a mother in the 1940s. Having outgrown her bohemian days, she wore ordinary clothing, print dresses and cotton print blouses and skirts over her increasingly lumpy figure. She wore her beautiful reddish blonde hair simply, flowing freely or carelessly piled upon her head. But even plain, straight hair, parted down the middle,

untended, scarcely detracted from her serious beauty. At forty-five, she continued to look unself-consciously beautiful.

In order to keep her equilibrium as a woman, Alice had to learn to do what men do naturally, that is, maintain a sense of herself at the center of her own life. She said, "Women were always the sacrificers, you know, and I used to feel guilty about being an artist because I used to think the way the normal world thinks. I couldn't, so I became the world's best conniver."[11] In order to put her interests first, she had to overcome a lifetime of conditioning. Despite her experiences with Carlos and Isabetta, and her resolve to paint, she still fought every day for her separate identity. What she learned during her internal struggles was that "to be an artist, a woman must have the will of the devil."[12]

She must have mastered the will of the devil in order to put up with a mate who by her own account was "rather a wild, mad creature."[13] She once said that all of her men were freaks. That was so, she explained, "because when I chose a man, I did like men do. I chose someone who could amuse me and charm me rather than someone who could pay the rent."[14] But she admitted that she lost control of this part of her private life "because I was so involved in painting; the other stuff I never bothered about."[15]

In order to paint, not only did she suffer physical deprivation, but she knowingly cut herself off from the art world, from commissions and gallery exhibitions, and from the press that covers mainstream art. It was a price that she had to pay in order to be who she was, that consciously constructed unconventional self. If Alice had truly been a conniver, she would have become an abstract expressionist, at least part-time, for a selective audience who would rush to become her "market."

She might have connived as a woman to get men to do her bidding, but not as a painter. She refused to compromise her art. When she found herself alone in the art world, she assumed that everyone else was out of step. As she later said, "I am my own movement. I have never followed the leader. Every decade the universe changes. I was never willing to give up my version."[16]

Alice's version of the universe as expressed through her art was appreciated only by a small cadre of ardent admirers. In addition to Sam, whose enormous admiration for her work might have been one of the strongest ties Alice had with him, there continued to be a handful of painters,

friends from the 1930s whose styles and interests went off in different directions, but who were strong enough to know that Alice, mired in her own eccentric stance, was a truly gifted painter. In the 1940s and 1950s, Alice grew dependent upon her friends to promote her work. As she neared fifty, she was growing increasingly passive in advancing her career. Others stepped in.

One friend was Herman Rose, who had been a member of the New York Group during the Depression. He brought Alice to the attention of Abram Lerner, who was assistant director of the A.C.A. Gallery, where Alice had had her first one-person show in the 1930s, and where Herman Baron was still director. Lerner convinced Baron, who still saw nothing of merit in Alice's work, to give her a small show, and in December 1950, opened his gallery to seventeen of her paintings.[17]

Lerner, like most people who met Alice, was fascinated by the talent and the contradictions that existed in this complicated woman of such "lovely and delicate" features. He worked closely with Alice on arranging the show and therefore had a front-row seat from which to watch the mercurial flow of complexity as well as a natural nervousness over her first show in six years. At one moment agreeable, at another contrary, meek, yet in a flash demanding, Alice demonstrated to Lerner a "tremendous ego." Her "marked sweetness" covered undertones of "unpleasantness and a touch of paranoia."[18] Some days she was impossible to work with, and on others, when she and her two boys frequented the exhibit, her enthusiasm and charm filled every corner of the gallery and "won everyone over."

The A.C.A. exhibit was the first showing of her work in over six years, and much rested on the public reactions. The reviews were mixed, but the critics noted several areas of strength in her work. The reviewer for *Art Digest* said that her work had vigor, a warm earthiness, and a careful sense of color that did not lack force even if it remained quiet. The review acknowledged the quality of her draftsmanship and her strong "well-realized" hands.[19] Stanton Catlin of *ARTnews* wondered at the subjects—somber projections of city tenement life—and while he noted the strength and dignity that emerged from a long and intimately felt association between artist and subjects, he thought the paintings were unevenly executed and demonstrated a roughness of technique.[20]

Not bad paintings if one liked echoes of an earlier age, a sort of rough residue of social realism, and if one found draftsmanship important to a

painting, and if success depended upon an appreciation of intimately held associations between artist and subjects. Apparently, however, these were assumptions that swayed neither the critics nor Herman Baron. Nothing came of the show. Alice receded back into the shadows of tenement consciousness and began to grow despondent.

The art world may not have appreciated Alice's work, but there was one group of New Yorkers who regarded Alice's work as both good and important. The members of the American Communist Party recognized Alice as one of the few New Deal painters who had kept the faith. Alice had stayed in the Communist Party after the W.P.A. folded, during the war, and into the McCarthy era, when it was neither fashionable nor safe to be tinged with red. She had joined in the 1930s, when almost all artists were political radicals. A friend and party member claims that Alice was a Communist all of her life, even during her last years when she was so popular with the mainstream of American life, but that society felt more comfortable thinking of her as a colorful eccentric or as an outrageous old lady rather than as a serious-minded social critic and party member.[21]

Certainly in the decades after the Depression, Alice's continuing empathy for the poor, who haunt her canvases, kept her deeply involved with what appeared to be the only champions for the oppressed, the Communist Party. The party recognized Alice as a member, and Alice actively pursued her connection.

One source of support for Alice and her children was doing illustrations for party publications. She illustrated Phillip Bonosky's story "Walk to the Moon," published in the *Daily Worker*, and his "I Live in the Bowery," published in the Marxist cultural monthly *Mainstream and Masses*. The collaboration with Bonosky, who had been on the W.P.A. Writer's Project in Washington, D.C., led her to do the drawings for a collection of his short stories that was put together after her death under the title of *A Bird in Her Hair*. Alice also did the drawings for Bonosky's first novel in 1952, but the publishers, after seeing them, rejected every drawing.[22]

The community of the radical left was an important one for Alice during these years in the desert. Occasionally she was asked by editors of *Mainstream and Masses* to do illustration projects. At their offices on Lower Broadway, she met some of the most important activists in an age when political activism was becoming increasingly dangerous. She met Mike

Gold, the writer for the *Daily Worker* and author of the influential *Jews Without Money*, who probably best embodied the spirit of the 1930s and whose enthusiasm almost matched Alice's. And she met Bill McKie, the Scotsman who "beat" Henry Ford in the great Ford strike, and whom Alice just had to paint. And when V. J. Jerome, the noted Communist, was released from prison, she went to his home to visit him.

Alice seemed to find in her association with the political left the camaraderie based on a sense of social justice that had been so much a part of the political associations in the village during the Depression, associations that the art community had largely abandoned. Whereas she once demonstrated with the Artists' Union, in the late 1940s she marched with the Communists, in one May Day parade pulling her two sons in a red wagon the length of the march. The party seemed to be the only combatant left actively fighting for the rights of the working classes and the poor among whom she lived. And only the left seemed to appreciate her art.

It was Mike Gold who arranged for an exhibition of Alice's work at the New Playwrights Theatre during April and May 1951. Until it was killed off by McCarthyism, the New Playwrights staged performances of plays mostly by young left-wing writers, social realists who could find no other outlets for their heavily political plays. Still a force in the intellectual-political life of the city, the party sponsored these plays. Although they called their theater the New Playwrights, they occupied no single building, but moved around the city, usually arranging for space in abandoned or underused churches. Alice's show was in the basement of an old church.

Of the twenty-four paintings that Alice hung, some not even framed, all were "*zeitgeist*" paintings, authentic Neel commentaries on poverty, suffering, pride, injustice, and inequality. She pulled paintings from the early Depression when official agencies studied poverty and juxtaposed them with the quiet, invisible suffering of her own neighborhood at that time. Her canvases, without apology, bridged the gulf that separated the timid 1950s from the vigorous, activist 1930s, swollen with strikes and demonstrations.

Her audience for this exhibition, unlike that at her one-woman show of just three months earlier, understood these paintings. Few, if any, art critics wandered in to marvel at the draftsmanship or to labor over the incongruity of the art that was hung in such an amateur fashion. This was real art, the people's art. Abstract expressionism would have been as out of

place on these poorly lighted undercroft walls as a portrait of Senator McCarthy. Alice was painting for her people.

Mike Gold also helped put a catalog together for his friend's show. In the Foreword, he summed up her half century of accomplishment:

Alice Neel has never allowed them to dehumanize her. This is heroic in American painting where, for the past fifteen years, humanity has been rejected, its place given to mechanical perversions, patent-leather nightmares, and other sick symbols of a dying social order. . . . In solitude and poverty, Alice has developed like a blade of grass between two city stones. She has become . . . the first clear and beautiful voice of Spanish Harlem. She reveals not only its disparate poverty, but its rich and generous soul.[23]

Alice was accepted seriously as a comrade, a pioneer of socialist realism with something important to teach. The next year, 1952, she was invited to talk at the party's school, the Jefferson School on Sixteenth Street and Sixth Avenue.

It was to be her first formal presentation to an audience. She had attended lectures there and knew that the audiences were intelligent and critical. She was as nervous as a young woman on her first date. She did not know what she would say, what she would have to say that would be worthy of a talk. Sam made a set of color slides of her paintings, and Phillip Bonosky coached her into "just talking" about them, explaining who the people were and why she painted the scenes. If she painted the souls of her sitters and captured the *zeitgeist* of an age, then her paintings should speak for themselves with the frugal addition of explanations of motive or context. Alice's nervousness faded after the first few slides as she introduced her audience to the souls portrayed by her brush. Her presentation was an enormous success.[24] Alice had developed the style of presentation that would carry her through her years of fame, although her audience in 1952 was quite limited.

The political left embraced Alice, but it did not have much to offer her by way of rewards. Bonosky commissioned his portrait by Alice and had to pay her off in installments. As usual, her work was admired and respected, but almost never purchased.

★ ★ ★

While Alice did not have many admirers of her work, the few who saw magic on her canvases were fiercely loyal, and uncommonly interested in seeing her succeed. Joe Solman, a longtime friend from her Village days, made another attempt to get Alice's work before the public three years after her New Playwrights exhibition. Solman, the painter who had first sponsored Alice in a 1932 show in the Village, took advantage of his solid ties with Herman Baron to talk Alice into being the second presence in an exhibit at the A.C.A. Gallery in 1954. Baron was giving Captain Hugh Mulzac a show and Solman, seeing Alice's gathering depression, traded on his friendship with Baron to get his friend included and to write, anonymously, the introduction to the exhibition catalog in which he compared her work to that of Edward Monck.[25] As usual, nothing came of the show; Alice took her paintings down and despaired that she would ever be understood or accepted by the art world.

The person who was most involved in supporting Alice during these barren decades of the 1940s and 1950s, however, did not try to get her shows, but patrons. John Rothschild had no connections in the gallery world, but he knew important and rich people in the city, and he worked hard to bring Alice to their attention.

Since their torrid affair of the mid-1930s had turned ice-block cold, the two had contorted through a series of aftershock relationships. Normally, in the real world, when a woman leaves one man for another, it sends a fairly clear signal that the first relationship has ended. But, as in so many other ways, Alice did not play by conventional rules. Her relationship with John twisted around into a series of abstract shapes. And it survived.

From Alice's perspective, the reason is not hard to find. As she often admitted, John offered her temporary respite from poverty. Neither José nor Sam had much money, which allowed Alice her measure of independence from them, but which meant that she lived in poverty. So, John continued to take Alice out for the sorts of evenings that people who live in tenements in Spanish Harlem only dream about. But during her years with José and Sam, John offered Alice more. He gave her encouragement, unequivocal support in her decision to continue painting her way. And from John Rothschild, that meant money.

John's motives in encouraging a relationship that was repeatedly spoiled or interrupted by Alice or by other men are remarkable ones. From the

beginning, that meeting at the Washington Square Art Show in 1932, John was convinced that, as a painter, Alice was in a class by herself. She was, he believed, destined for nothing less than greatness.[26] Although these motives continually churned together with love, lust, affection, and admiration, John remained constant in his profound appreciation of her talent. As their relationship reached into accumulating years, John became more and more intent on bringing Alice to the attention of potential patrons.

And he was willing to borrow money in order both to promote Alice and to allow her to continue painting. He was not, as Alice thought, rich. While he dressed well and dined elegantly, throughout their whole relationship he lived on credit. Alice was not to discover the extent of his catastrophic financial debt until his death in 1975, when she learned that he died owing at least one million dollars. She was reported to have whooped gleefully, "What a great way to die, owing money."[27]

"Open Road," John's educational travel agency, had been committed to international education since the early 1920s. John had been taking American students to Europe since immediately after World War I, and, as soon as the United States recognized the U.S.S.R., he ran student tours to the Soviet Union. John had run the program not to make money, but to promote international education and understanding. It almost always ran at a deficit, in part because John used expensive journalists such as Edward R. Murrow to lead the tours. And, of course, after 1939 the war terminated the whole concept.[28]

John moved within a social set that was vastly different from Alice's left-wing, working-class associations. His was an equally vibrant intellectual elite. It included the people who were at once rich and liberal, who considered making him editor of *The Nation* and who organized a White House reception by Eleanor Roosevelt to support his wartime ventures of "Open Road" tours of America and a volunteer corps of city kids to the countryside. While such ventures did not make money, they did allow John to establish myriad social contacts, and at war's end he began to try matching the monied people he knew with Alice.

One of John's main goals was to help Alice live so that she could paint. He understood that she had to be free to concentrate on her art. If he could have afforded to, he might simply have supported her. But living constantly in debt, and having to live at an expected level, John, ironically, could not even afford to buy any of her paintings himself. He found her important patrons and arranged for a few grants, unofficial stipends from

wealthy friends. And occasionally at the same time that he was trying to work himself out from his own debts, John would contribute materially to Alice's upkeep.[29] She was able to send her two boys to private school, then boarding school and college, with the help of scholarships and almost certainly with John's assistance, which allowed her to concentrate on her painting almost exclusively.

John was not at all secretive about the support he arranged for her. If he did not help her support herself, he wondered aloud, who would? He did not want or expect anything from her. It was enough for John to know that he might be instrumental in making artistic history.[30]

What he could do was to bring people to her apartment to see her work. John must have exploited more than a few friendships by enticing people to go into Spanish Harlem and sit in a dilapidated tenement apartment while Alice pulled out sixty or seventy paintings, explaining each of them. In the otherwise desperate 1940s, he brought to her a number of commissions, probably all that she had.[31]

More often than not, however, the commissions fell through. Frequently Alice painted commissioned portraits only to have them returned. She would say that she would do a portrait differently, but "over and over again" her painting revealed basic uncomfortable truths about the sitter, the *zeitgeist* that she could not avoid expressing in her unconventional manner, rendering the painting unsuitable as a commissioned work. She would end up with the painting.

Her most infamous return was her 1948 painting of Patricia Ladew, heiress to the Standard Oil of New Jersey fortune, whom Alice painted nude, her genital area quite exposed. Ladew returned the painting indignantly. Alice tried to placate her by painting red panties over her exposed pubic area, only to have the work rejected a second time. As usual, Alice accepted the returned painting, removed the red panties, and added the canvas to her growing collection.

Alice consistently frustrated John. He would go off to Alice's with one of his possible commissions, knowing in his heart that "she's going to ruin this."[32] Often she would. Once he took an "enormously" wealthy person to visit her, hoping that Alice would convince the man to sit for a commissioned portrait. She seemed more interested, however, in convincing the bewildered visitor to take her dog, a boxer that she wanted to give away. She seemed either to forget the purpose for the visit or consciously to ignore it.

Alice possibly could have become a successful commission artist, except for several traits that were quintessentially Alice. The most crucial was that she probably did not want to become a commission artist. Just as she did not want to become an abstract expressionist, she held to her sense and standard of what art was. Ever since 1930, when she painted in the flaws of Rhoda's fiancé, she did not paint politely. Like Hogarth, she would not flatter the rich. Alice must have been torn at least on occasion by knowing how much money she could have made if she had but . . .

Instead, her measure was honesty. She did not paint with her thumb on the scales. She painted what she saw, and it was up to the sitter to accept or reject her vision. Once Alice was told that she was being "rather cruel" in rendering the hands of one of her sitters. Alice, offended, retorted, "I wasn't cruel, nature was."[33]

John felt frustrated when she lost a commission, but he and his son Joel, who began living with John in 1949 and became well acquainted with Alice, were also usually amused by finding in the rejected portrait the "broken wing," that is, the flaw that Alice had seen and painted in.[34] John and Joel were convinced that Alice was constitutionally unable to paint someone who did not have a flaw. She started to paint Joel several times and could not finish.

Another problem barring Alice from becoming a successful portrait painter was that when dealing with the rich, she was her natural self, mercurial, unpredictable, usually enthusiastic, but always in danger of falling into rudeness. Her embarrassing lack of decorum may have sprung from a genuine nervousness, but it would not have been out of character for Alice to intend to insult, possibly to remind everyone just how unpleasant artistic prostitution is to an artist. It is also likely that Alice, certainly seeing nothing at all wrong with her paintings, was startled afresh every time a sitter turned down a painting.

She attributed her failure in selling her work to having no talent for the "business of art."[35] On another occasion, she sighed that she never painted paintings to sell in the first place, and that she "was just not a pusher."[36] John thought simply that she was self-defeating when it came time to sell herself.[37] Whether by inclination or intent, Alice seemed at times her own worst enemy, but John kept bringing people to her or arranging for them to meet with her at his apartment on East Eighty-first Street.

John remained steadfast even though the relationship was one-way and despite the difficulty of trying to work with Alice while having to avoid

Sam. John always had to schedule sittings or introductions when Sam was out and when Alice was in a mood and a condition to see a potential sitter. These dual tasks became more and more difficult. Sam grew more and more unpredictable, threatening visitors to the apartment with a knife, alternately belittling himself and demanding attention. The Communist Party expelled him for being too unstable,[38] but Alice's friends like John Rothschild risked running into him in order to see her.

Alice kept telling her friends that she was going to leave Sam,[39] but until 1958 she was unable to bring herself to act decisively. Always ambivalent about men, dependent and at the same time autonomous, Alice hesitated to make decisions. She later lightly dismissed her tolerating a painful relationship, full of friction and sparks, for so long by saying that she wasn't paying attention, and so long as both were free to come and go, she felt no pressure to end it. But the emotions that weaved through an eighteen-year relationship were capable of inflicting enormous pain. And Alice suffered.

Working with Alice grew more and more challenging in the 1950s, not only for John, but for others as well. The lack of recognition sat heavily on Alice, wearing against her normal ebullience. Her mother died in 1954, nine years after her father. Mrs. Neel had gone to New York to live with Alice in the year before her death, a sad old woman, but still possessing her superior attitude. Alice was a dutiful and solicitous daughter during her mother's final illness, taking her to the hospital as a welfare patient,[40] having long before set aside whatever fear or dependency she once possessed.

But the death took its toll. The disappearance of an institution does not go unnoticed, and, as Alice said, she did not really become her own woman until she was finally, irrevocably on her own. Mrs. Neel died at a time when Alice was already despondent. Phillip Bonosky, whom Alice used to take on exuberant walking tours of the city, giving him what he called an art education by pointing out new colors and different ways of looking at the faces they passed, worried about her depression. It was so unlike her to be down for any length of time. But in the mid-1950s, Alice seemed to stop enjoying life. Spontaneously one day, she blurted out a confession to him that must have been gnawing away at her for a long time. She said that she felt so miserably isolated that "I would bite rat tails if it would get me recognized."[41]

The physical signs of a distressed woman erupted everywhere. Alice

grew fat. Sometimes in the past she had been a bit plump, pleasantly so, and Abram Lerner had considered her "lumpy" in the early 1950s, but, by the mid-1950s, she ballooned and became, as a friend said, "grossly fat."[42] Her disheveled dress and unkempt hair accentuated the red eyes and puffy cheeks of someone who drank too much. At parties with friends such as the Rothschilds, Alice sometimes drank irresponsibly, testing relationships by insulting everyone in the room, and making shambles of conversations. On one such occasion, she drank a potent alcohol mixture as if it was water, and "before long she keeled over." She was carried to a bed where she slept through until the next afternoon.[43]

Alice's friends often did not know how to react to the deterioration of such a strong, lively woman. She was becoming, to some, intolerably self-centered, more than usual, and was capable of erupting in an irrational anger, perhaps directed against the world as a whole, but often directed against John Rothschild. She exploited John and his unsinkable sense of cooperation,[44] then would savage him in front of everyone.[45] The "undertones" of unpleasantness beneath her marked sweetness, which Abram Lerner had noticed earlier in the 1950s, percolated to the surface at mid decade.

John, who had enjoyed her acerbic humor, now simply tolerated her sometimes naked meanness. Through a second and a third marriage for him, he had maintained his close friendship with her, for art's sake. His persistence and his tolerance grew like a hardy perennial from his unshakable belief that she was unique, one of a kind, the best painter, man or woman, in her genre, and that she needed more room than most people for she needed to be able to paint.[46]

Other friends tried to sustain her spirit. She maintained a close friendship with the Bonoskys, Phillip and Faith, at whose apartment many meals were shared. Joe Solman and his wife Ruth were always pleased to have Alice to dinner. When she needed to, Alice would make her way to their apartment on Second Avenue, near the Village, and talk, often entertaining Ruth with her stories while the two prepared a meal together. Each of these long-lived friendships gave her something, but neither was able to deliver the one thing that Alice wanted most—recognition by the art world as the great painter she believed herself to be.

The art dealer Geza De Vegh met Alice in 1956, when she was at the depths of her despondency. He commented that "Alice was absolutely demoralized and thinking of quitting painting."[47] For Alice that would

have been the final surrender. De Vegh, who perhaps deservedly came to think of himself as her mentor, not only encouraged her to continue painting, but arranged through a friend to have Fordham University show some of her works in 1957.[48] The attention generated by this show helped to reconstruct some of her self-esteem. De Vegh painstakingly convinced her that she could not stop painting, that she had "a historic mission to save the figure," and demonstrated his dedication to her work by restoring twenty-seven of the canvases slashed by Doolittle twenty-three years before.[49]

She had painted only erratically in the four or five years prior to 1958, less than she had in previous years. As she told an interviewer who asked if her attention to painting had dropped off at mid decade, "I don't know. . . . I always kept painting, only some years I did much more than in others."[50]

Finally realizing that she needed help, Alice sought professional help and underwent psychoanalysis beginning in 1958. Unlike her disastrous encounter with "doctors" in 1930, she was treated by a sympathetic doctor,[51] who not only understood that she was a painter but understood that she undervalued her worth as an artist, and possibly as a woman. She needed to be bolstered up, challenged. He worked with Alice for two years, challenging her to send her paintings to shows. He argued that if she thought she was as good as the other artists who were showing, she had to send her work out.[52]

Alice dutifully worked through a series of mental blocks about her art and about herself. She had to overcome her phobia about parting with her paintings. Attributing her hoarding of her work to the pack rat in her, Alice had avoided confronting her inability to send her paintings out for showing or sale. By the late 1950s, Alice had accumulated scores of canvases stacked one against the other, extensions of the old plaster walls of her apartment. There sat aging Joe Gould and dusty, naked Rhoda squeezed in among painterly snapshots of Alice's growing children, discarded lovers, a dead father and dying mother, dark memories of an infant dying and Nazi marches, and light renderings of fresh snow on Village rooftops. With just a few anemic exceptions that barely left a gap in her expanding collection, the paintings that she sent out to shows or possible patrons always returned to take their place among the collection of souls in the ranks against the walls. Alice still owned the body of her work, and

the presence of these paintings finally became reminders that the art world did not know that she existed and that it was partially her fault.

She could no longer excuse her lack of aggressiveness in trying to sell her paintings by explaining lamely, "If I painted a good picture, it was enough to paint a good picture."[53] Her analyst threw such reasoning back in her face. How badly did she want her work to become known? She would bite rats' tails. How much was her work worth? She did not know. About the time of her revelations, Alice painted a carpenter, a black man, and was amazed to find out that he knew "just how much his work was worth."[54]

Alice credited her therapist with her recovery and what would become her new boldness in marketing her art. But her reconstruction was more than the uncovering of the artist. It was the recovery of the woman. She began to take control of her life. In 1958, she got rid of Sam,[55] simply kicking him out after all those years. Although he married and moved to California, he remained a tangential part of Alice's life for decades, taking photographs of her for important occasions and, as usual, supporting her work. And with her sons at school, one at boarding school and the other at university, Alice was able to concentrate on herself, completely and without guilt.

Physically, she began to reimpose the daily disciplines that focused on painting, took control of her eating and drinking, lost weight, and recovered the piercing center of her eyes. Her transformation did not occur overnight, for her problems had been building for years. Art was not only her therapy, but her incentive.

Increasingly for Alice as she neared the end of her fifth decade, her professional life shifted gears. She began to give more attention to the disposition of her finished products, her peopled canvases.

It was time. Art as process had affected her life over the decades and had helped to invest her with enough granite and resiliency to allow her to recover from the loss of her mother and regain her own sense of self. Her analyst had challenged her to send out her work, but what work? Galleries had shown her portraits of the fringe types in society, Puerto Rican children and Marxist leaders, intensely personal visions of a world that was alien, and probably upsetting to the power brokers in the art world. But in 1959 and 1960, Alice was learning that in order to get a viewing of any kind she would have to change her subjects. She began to recalculate the means of achieving recognition in ways that had previously eluded her.

She did not stop painting the face of Spanish Harlem altogether, but she did shift the weight of her attention away from the types of people who sat for her in the 1940s and 1950s. "Of course," she said, "it was foolish to paint them because that doesn't get you anywhere in the art world. I was there for so many years, I was finished with it."[56] Her shift was not a cynical rejection of her long-held ideologies and perspectives, which she retained, but a professional decision. Businesspeople make such adjustments to the flow of the market as routinely as they write memos, but for Alice, who always claimed to have no talent at all for the business of art, divorcing practice from belief was a monumental leap.

Earlier in her life, Alice would have been unable to screw up the courage to seek out someone of the stature of the poet Frank O'Hara. Only when John Rothschild or Phillip Bonosky had presented her with a sitter would Alice paint someone outside of her circles of friends and neighbors. But in 1959 she went after O'Hara, not once, but twice, when she decided that she was not pleased with the first innocuous portrait of him. She also took the initiative to paint people who could arrange shows and write articles. She took the art writer Hubert Crehan home from a party and showed him some of her latest canvases, not the dark personal visions of the previous decade, but the recent works of O'Hara and Miles Kreuger.

The recognition that Alice craved leapt across the space that separates hope from reality as she entered her sixties. The glimmer of potential fame lighted the horizon through such cascading events as the inclusion of her work in the fall 1960 A.C.A. Exhibition of double portraits, followed by the reproduction in the December *ARTnews* of her second, more complex, portrait of "Frank O'Hara." Geza De Vegh sponsored a one-woman exhibition of her work at his Old Mill Gallery in New Jersey that same year. This show not only helped to promote Alice's work, but fit in with a growing interest in the figure.

The new visibility of Alice's portraits and the art world's rediscovery of the figure began to complement each other, feeding each other's success until they eventually became inseparable. Did the god of justice invest Alice's canvases with the power to wound the Goliath of abstract expressionism? Or had the long-lived movement simply grown old and tired, part of an inevitable organic cycle, just at that moment when Alice had poised herself for an assault on the art world? Self-fueled change is as much a part of the art world as of the fashion market. What stimulated the

Museum of Modern Art to devote a show to "The Return of the Figure" in 1962? Or prompted New York's Kornblee Gallery to do a show on the figure in the same year? Was Alice's inclusion in both a fueling force or a convenient example to substantiate a phenomenon already under way?

Whether cause or effect, Alice's work was at the forefront of the new fascination with the human figure. Hubert Crehan, whom Alice had taken to her apartment to see her works, contributed to the symbiotic relationship between Alice and the resurrection of the figure with a major article about them both in a 1962 issue of *ARTnews* entitled "Introducing the Portraits of Alice Neel."[57] Alice, who a decade earlier could not convince art critics that either realism or draftsmanship mattered, was touted as the savior of the living and breathing genre of portrait painting. She was finally being recognized for her uncompromising integrity, her talent, and her ability to fathom the psychological truths of her subjects. Before the art world that had repeatedly blackballed Alice, she was suddenly paraded as one of its leaders.

To Alice, sitting on the verge of vindication, the view was gratifying in more ways than one. The future promised an unfolding of major recognition, but these initial accolades also meant that she had been right in her single-minded perseverance. "I always thought," she said, "that they were wrong and I was right."[58] She had her own view of what was happening within the art world. She said simply, "I think people developed more."[59]

Photos 19 to 24 represent a small sampling of Alice's work, 1933–1974.

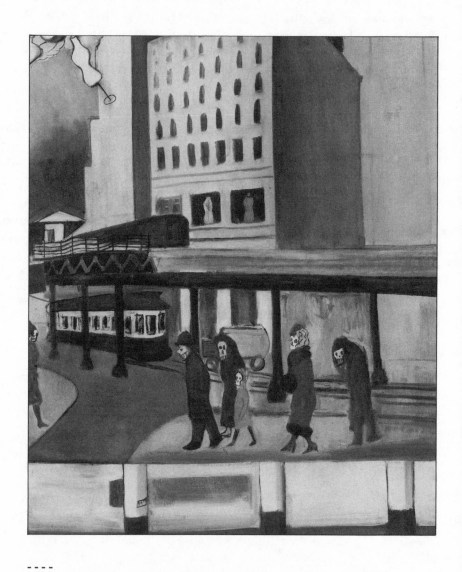

19. "Synthesis of New York" (1933), a commentary on the Great Depression. (Collection of the Neel Family/Photo courtesy of the Robert Miller Gallery.)

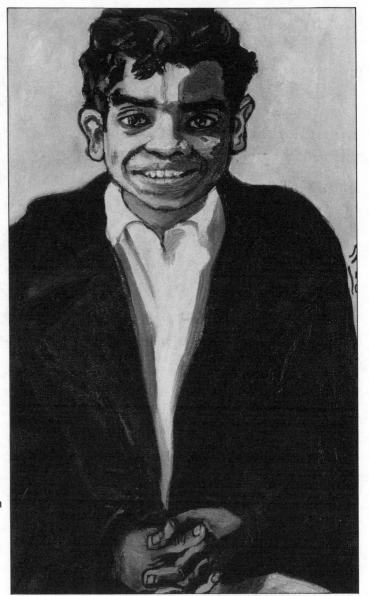

21.

"Georgie Arce" (1955), from the Spanish Harlem days. (Collection of the Neel Family/Photo courtesy of the Robert Miller Gallery.)

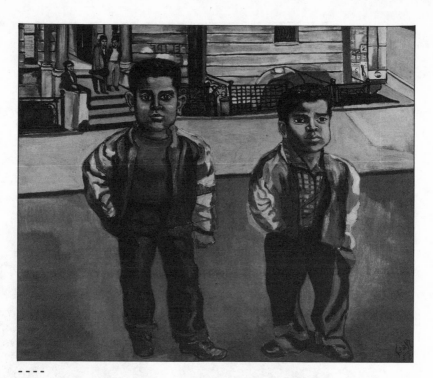

20. "Dominican Boys on 108th Street" (1955).
They asked Alice to paint them, and are among the
scores of her paintings of "local" people in Spanish
Harlem in the 1940s and 1950s. (Collection of the Neel
Family/Photo courtesy of the Robert Miller Gallery.)

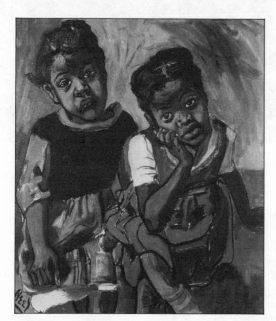

"Two Black Girls"
(1959), from the same
period. (Collection of
the Neel Family/
Photo courtesy of the
Robert Miller
Gallery.)

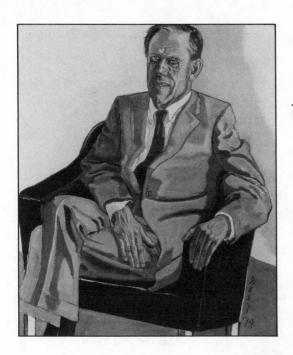

- - - -
24.

"Jack Baur" (1974).
Director of the Whitney
Museum of American Art,
Baur gave Alice her first
major exhibition in 1974.
She told him he would not
like her portrait of him—
he did not like it and did
not buy it. (Photo courtesy
of the Robert Miller
Gallery.)

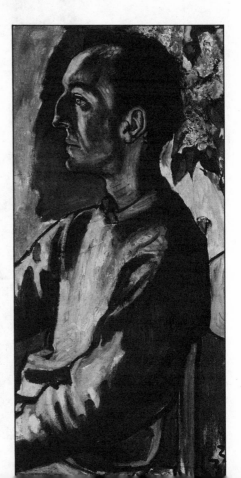

- - - -
23.

"Frank O'Hara" (1960). The first
of two paintings of the poet that
she did, important because it
marks Alice's decision to be more
aggressive in getting sitters and
to go after recognizable figures.
(Collection of the Neel
Family/Photo courtesy of the
Robert Miller Gallery.)

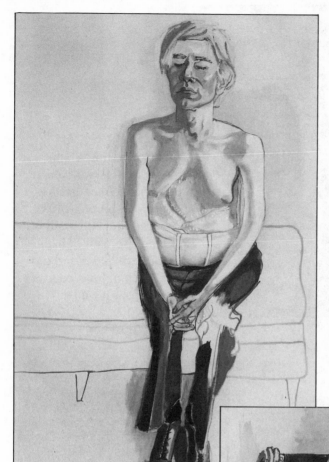

25.

"Andy Warhol"
(1970). (Collection
of the Whitney
Museum of
American Art, New
York.)

26.

"Henry Geldzahler" (1967).
Former associate director of
American Art, the
Metropolitan Museum of
Art. (Collection of the
Metropolitan Museum of
Art, New York.)

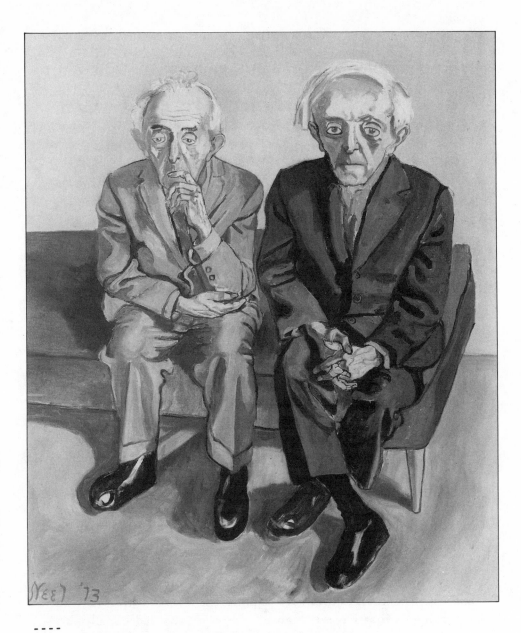

27. "The Soyer Brothers" (1973). (Collection of the
Whitney Museum of American Art/Gift of Arthur M.
Bullowa, Sydney Duffy, Stewart R. Mott, Edward
Rosenthal, and Purchass.

THE END OF

INNOCENCE

- - - - - - - - - - - - - - - -

14.

- -

T h e r e were times after Rhoda and Ben returned to Philadelphia when she wanted to paint, when she scratched the archaeology of her twenty-year marriage and exposed the surface of ancient feelings. But she did not.

When they arrived back in Philadelphia in 1948 and lived again in an apartment in center city, at Twelfth and Chancellor, Rhoda felt history rush over her. These were the people she had once painted. These were her streets. She had been able to resist painting the lush greenery of Louisiana and the rust and clay sunsets of Arizona. Could she ignore the disquieting attraction of her favorite fish market, the summer plantings in Washington Square, or her beloved Italian market, just a brisk walk away?

As her family settled in, Rhoda walked the rectangle of blocks that William Penn had so meticulously laid out, but only to shop or run errands for two teenagers who were beginning school and a husband who was starting fresh at United Engineers, a respectable old Philadelphia company. They all needed her. Perhaps with her continued attention, the pieces would finally fit into place. She believed that she was their only real hope for becoming a close and happy family.

The other three were centrifugal forces pulling away from the center. Two were teenagers. Rhoda had spent countless hours during their travels working with Jakie. Now fifteen, Jakie had caught up with her class, but

Rhoda still considered her emotionally fragile from her car accident nearly a decade before. The other, Med, was a handsome young man of thirteen, the incarnation of his father. The third force was her husband, who Rhoda prayed would throw himself into his job with dedication and find the satisfaction that so far had eluded him.

But Philadelphia, the alpha and omega of their curious odyssey, did not break the sequence of failure that had dogged them since Virginia. The city where, in 1931, Rhoda's marriage marked what was to have been the opening chapter of a storybook tale that would end with "and they lived happily ever after," instead became the scene of the final tragic chapter of a relentless Gothic novel.

Ben's job provided more money than he had ever earned, over five hundred dollars a month. For the first time since Virginia, ten years before, they had a realistic chance of buying their own house. The future should have looked different to Rhoda, giving her some hope that somehow there was reason to indulge in the luxury of optimism. This hope was her life, permitting her no indulgences, no distractions. When some precious personal time presented itself, she was too physically tired or too emotionally weary or too guilty to consider collecting together the supplies, arranging a palette, setting up an easel, or considering a subject that somehow slid through the rusty mechanisms of her artist's mind. Alice once said that a woman cannot be a part-time painter. Rhoda proved the proverb.

The Medarys bought a house in 1950. To the neighbors on modest Gravers Lane in the fashionable Chestnut Hill section of Philadelphia, the middle-age couple who bought the old three-story stone Victorian house appeared to be conventional, perhaps more private than neighbors prefer, and not especially happy looking. The big, quiet husband, they learned, drew the details on engineering designs at a company downtown. He did not seem to like his work. They had heard that he was really an architect. The teenagers were rebellious, not unusual, and the diminutive wife was certainly in charge of the family. Her loud, sometimes shrill, voice was often audible from within the thick walls.

By the time the Medarys arrived in Chestnut Hill, Ben was living a

minimal life. He ate and slept, leaving the house to go to work, to the shore, where he was building a small house, or, with decreasing frequency, to go fishing. He visibly stopped listening to Rhoda and fell defensively into a series of listless rituals that kept him out of her way, eating dinner rapidly and immediately leaving the table to lie down, or sleeping, usually with his clothes on in a separate room, without any announcement that he was retiring for the night. Evenings or weekends, when he was not at the shore building, he often sat for hours looking out of the third-floor window, a sad-looking solitary figure scrutinizing the street with binoculars. Whenever Rhoda cornered him and demanded that they talk about matters that needed attention, Ben would walk away and lie down.[1]

A lack of response to talking negates the power of words. The logical response is to stop talking. The human response is to talk louder. Rhoda's was to scream at Ben, demanding a response. If he tried to avoid her, she learned to go after him. Often she chased him out of the house, once wielding a rolling pin and chasing him the length of the side yard until he ducked in the back door and locked it behind him. But like many frustrated wives, Rhoda undercut the threat inherent in every outburst by continuing to look after his needs, ironing his shirts upon demand, washing and cleaning for all four of them, giving in to his requests (never demands) for sex as a good wife should, even when she felt estranged or physically ill.[2] She took responsibility for trying to discipline Jakie and Med, only to discover that Ben countermanded her by continuing to tell them to do whatever they wanted,[3] but Rhoda continued to discipline them, and yell at them, perhaps as much from habit as from the possibility of success.

Rhoda knew that she was a toothless viper, all puff and no sting. She also knew that she could not simply give up and walk away as Ben had, severing the final thread of her marriage. One of the reasons was close at hand in Philadelphia—her mother. Mrs. Myers, now eighty-two years old, was still living with Lorine, in nearby Mount Airy. The vain little woman who had destroyed her own marriage and wrecked Rhoda's childhood was still wholly absorbed in herself, living on an allowance from Lorine and shoplifting all of the beauty aids around which she still built her life.[4]

Selflessness was the key to a successful marriage. Vain, selfish women destroyed marriages and wrecked childhoods. These were the truths that Rhoda carried as something old and tested throughout her marriage. In

her innocence, twenty years before, she had abandoned art in order to serve her husband, to be the wife and mother she had never had. At what point does one give up the dream and acknowledge a failure as massive as that of Nellie Myers? Not after only twenty years. Rhoda's commitment was too substantial; her sense of loss would be too great. She would be admitting not only that her marriage had been a mistake, but that she had wasted what might have been productive and rewarding decades as a painter.

Ben's apparent intent to let their marriage die with a whimper seemed to awaken in Rhoda a renewed determination and a new insight. For years, she had rationalized her verbal bombardment of her dispirited husband to be constructive nudgings and urgings. But their return to Philadelphia only highlighted the damage that had been done by her "nudging and urging" across five states in pursuit of success and happiness. Rhoda, reflecting on all those years in Virginia, Florida, Louisiana, and Arizona, realized that she had accomplished exactly the opposite of what she had desired by dealing in this fashion with her husband's lack of initiative. By pushing him to move from place to place, she had compounded the problem.

This insight hurt her sharply. It was not that Ben had been unable to find a job and a city that gave him happiness, but that he was never searching. He was, she decided, an adolescent who was only running away from things—his father's success, his early failures, and his own insecurities. So while she thought that she was helping him search for success, she was, in fact, only constantly reminding him that he was a failure. Back in Philadelphia, she determined to stop pushing him and tearing down his self-image; she had to find ways to build up his fragile, insecure ego.[5]

Rhoda's best hope for this "rebuilding" was in the one area that remained protected by a thin veneer of civility between husband and wife, their mutual appreciation of artists. Although the two had stopped doing most things together as a couple, they still enjoyed an occasional evening entertaining artist friends. For their individual reasons, both looked forward to having such local artists as Ben Spruance and John Hathaway, and aspiring artists such as the Imhoff's son Christopher over to their house. Rhoda remembered Ben Spruance from her studio days on Washington Square, and her husband and John Hathaway had been friends as young men during the 1920s. Both Spruance and Hathaway had, over the years,

become successful studio artists as well as professors in local college art departments. During these evenings, Ben and Rhoda often slipped into a light bickering, but these intimate parties provided the last vestiges of congeniality in a tense and dreary relationship.

Rhoda loved to play the part of the chatty, knowledgeable hostess, and Ben seemed to enjoy the intelligent conversation that ranged from art to politics. Although he seemed to be a dour sort to his neighbors, these small gatherings of artists saw a different man, quiet with a gentle smile, a relaxed man who listened to others' conversation until just the right moment, when he entered with a thrust—one sentence that seemed to cap off the topic with a sharp and highly entertaining wit. His guests waited for Ben's foray into their arguments and stories. He rarely disappointed them.

When Ben was interested enough in life to participate, he exuded what Rhoda still acknowledged as a "big, lovable charm." People, she admitted, "always like him" because he's a soft-spoken gentleman of the old school who is never rude and appears to be brilliant because he has so cultivated timing his subtle remarks in any conversation.[6] Rhoda arranged these small parties because she hoped that the attention and the inevitable laughter he caused would help to bolster his ego.

If Rhoda cultivated relationships with artists, she carefully avoided the area of art itself. Painting may well have been since the beginning of their marriage one of the sharpest rapiers lodged in Ben's fragile ego, one that Rhoda may have unknowingly plunged into that deep, hidden place from which the self-image emerges. The unspoken tension over the place of art in their lives probably dated back to the years before their marriage, but Rhoda's innocence over the unevenness of their innate artistic abilities precluded an understanding that this could be a problem. As she gradually became aware of Ben's insecurities, her instincts probably did not relate any connection between her success as a painter and his failure.

Ben had never wanted to be an architect. But he had submitted meekly to the wishes of the senior Mr. Medary, studied where his famous father had studied, and entered the career that had made his father famous. Meantime, he secretly painted while giving a modicum of attention to his father's business, enough to be kept in an office run by his father. Perhaps with the bold youthful hope of breaking out, he had submitted several of his stolid and sturdy oils to the panel of the annual show at the Pennsylvania Academy of Fine Arts. None was accepted. In the year of his

father's death, however, the Annual Watercolor Show panel at the Academy accepted two of his watercolors, both of rivers. The acceptance was neither the encouragement he wanted nor the affirmation he needed to continue painting. By the time his father's death had removed the source of his direction, he was neither an accomplished architect nor a confident painter.

In 1929 and 1930, when he was a fixture at Rhoda's and Ethel's studio, he never attempted to paint there, but watched quietly as Rhoda and Ethel had their paintings accepted by the academy for its annual show. Rhoda certainly knew about his watercolors. Did she know about his oils? His rejections? Did she wonder why he did not get swept up in the seductive atmosphere of a studio, or did she just assume that his relationship with art was a dalliance, a mistress she had made him forget?

Although neither Rhoda nor Ben painted during their marriage, art was a constant presence. Throughout their travels, Rhoda never forgot her roots. She was a wife and mother, but she was—or had been—a painter. She did not have to paint to be a painter, for art had already contributed an integral element to her persona, impossible to distill out. She talked like a painter and pointed out to companions the colors they should be looking at and the shape of the teeth of the man they just passed on some Louisiana street. Betty Imhoff, her longtime friend from Florida, thought that Rhoda was one of the most interesting persons she had ever met, one who exhausted her emotionally: "Rhoda pulled me into experiencing life with her."[7]

Is it possible that Rhoda's dynamic artistic persona was still another imagined insult to Ben's delicate sense of self, another assault on his ego? Rhoda began to think so. In Philadelphia, even if she had found the time and energy to paint, she would not have opened her paint box. If Ben imagined a rivalry, she did not want to contribute to his imaginings. Alice Neel had said after her own failed marriage to Carlos that artists should never marry each other for life becomes a rivalry. Rhoda married another artist without realizing, or appreciating, it. She understood in the early 1950s that she could not paint as long as she was married to Ben for, as she wrote, "I don't think at 50 years old anybody is going to be able to change. Ben is always going to be the limited person he is," and she did not want to challenge his ego any further.[8]

Rhoda's insight, accurate or not, came too late to have any effect on her marriage. Ben had given up despite the congenial façade they were both

able to erect in front of friends on those few and ritualized occasions when they saw them. If Rhoda's suspicions were accurate, exposing Ben to those successful artists his own age would probably have had the effect of reminding him ever more of the completeness of his life's failure.

But most of the marriage was not played out among their circle of artists. And in their everyday life together, Rhoda could not engage in amenities. The marriage frustrated her enough so that she fought back blindly—shouting, screaming, and letting Ben know with shrill insistence that she was unhappy, disappointed, and angry.

As her marriage began to swirl out of control, Rhoda was sucked into the vortex where she constantly bumped against the needs and demands of others. If self-preservation told her to pull back and withdraw more into herself, her total frustration pushed her back into the whirlpool. The more relationships disintegrated, the harder she pushed, the more she nagged, the louder she screamed, the tighter she recoiled in terror at her own shrewish behavior.

She knew that she was no longer shouting at Ben in order to rouse him to action. Certainly by the mid-1950s, she was venting anger, more than a decade of pent-up resentment. Her outbursts could do nothing but more damage, but she was no longer in control. He had spoiled her dream and ruined her life. He had to know that.

Rhoda's whole retrospective fantasy of her marriage turned out to be air. The goals and aspirations that Rhoda had convinced herself were hers and Ben's were not. They were hers alone. Everywhere she thought they might find "their place," he found only new frustration and she collected more resentment. Looking back, Rhoda wrote that "there must have been plenty of women married to adolescent men who make a go of their lives, and love their men instead of holding a thousand resentments against them," and it saddened her that she was not such a woman.[9] She also knew that she was no longer capable of the effort. The emotional bonds had been irrevocably severed. She no longer cared and she finally dared to admit it to herself.

Rhoda stayed in her marriage after her revelation. Women who were raised in the early 1900s and who married in the 1930s did not dissolve their marriages lightly. The weight of tradition weighed heavily upon them, and Rhoda was not immune from the expectations of her era despite

her father's escape from his marriage to Rhoda's impossible mother. But Rhoda was incapable of leaving Ben simply because she no longer loved him, even if convention had permitted her the choice. Several knots, some small and subtle, still tied the rope that secured her marriage.

Twenty-five years of marriage often produces a momentum that is sometimes harder to stop than to allow to roll sluggishly on. Roles rigidify into routines that no longer generate warmth, but nevertheless seem preferable to all of the unknowns that accompany new routines. When a marriage is defined by its routines and not its relationships, the dissolution of a relationship need not have any effect on the partners' behavior. Ben was neither a threat nor especially a bother to Rhoda. He did not ask for much from her during those last years of the marriage. She ironed his shirts and fixed his meals as part of her routine. The estrangement within their marriage did not create a home divided so much as a house stripped of its soul—not division, but the absence of anything worth dividing.

Then, of course, there were the children, the strongest of all knots. In the 1950s, Med and Jakie were growing through their teens in what Rhoda perceived to be a difficult passage and, remembering her own unhappy adolescence, she resolved not to allow her children to grow up without parental attention. But by the mid-1950s her attention was increasingly expressed negatively. She worried that her daughter was developing into a young woman who was bitter toward everyone, especially her. Rhoda alternated between working with Jakie to overcome her lingering reading and writing disabilities from the accident and nagging at her to work harder.[10] Jakie turned twenty in 1953, but Rhoda regarded her as a young adolescent. She had finished high school, through the perseverance and determination of Rhoda as much as any other cause, but she was still Ben's "little girl." Med, a handsome and extremely bright and outgoing teenager, Rhoda saw as an emerging incarnation of his father, self-centered and most capable of ignoring her while charming everyone else.

Rhoda complained that it was not fair that in a house of what were "practically four adults" she was expected to do everything. Toward her children as well as her husband, she knew that she was "turning into a shrew," but she could not help herself. Whenever the family went to the shore, she would get up at six to collect, wash, and pack all of the items that they needed. She complained that the three others would drift down

about nine o'clock, eat, and then just wait around until she finished getting ready. If they were not able to leave until eleven or noon, "they complain about half the day being wasted. And then when I get to the screaming point, Ben and his son will go out and just sit in the car and wait."[11]

Finally, when Med was away at Brown University and Jakie was in her twenties, still living at home, Rhoda took a job outside of the home, her first in over twenty-five years of marriage. In 1956, she became a salesclerk in the notions section of a five-and-ten-cent store in nearby Flourtown, a modest job representing movement toward a modest independence. Like so many middle-age women who reluctantly admit that their home and marriage no longer offer enough of the rewards that they want or deserve, Rhoda loved her job. The store was a physical area that was hers, a space of her own away from her house and her routines, peopled by acquaintances who offered her alternative ways of expressing herself. Flashes of the old Rhoda, the vivacious young woman who swept in and out of Paulette Van Roekens's studio in the 1920s or the young mother who intellectually exhausted Betty Imhoff in Florida with her interests and energy, began to appear in conversations with coworkers and in exchanges with customers. Her life was not easier, but for a few hours a day she could escape from it.

Money played only a minimal role in Rhoda's satisfaction with her job. The Medarys had never enjoyed anything but a modest income. Even the neighbors knew that Ben "didn't make a lot of money," that "he did not have a good paying job."[12] Ben bought few things, but marshaled their money to indulge Jakie her clothes, and to send Med to the select Penn Charter private school and then to an Ivy League university. Without Rhoda, he probably would have been unable to provide for his only son. She received occasional, irregular payments from her grandfather Myers's estate, which trickled down through the decades and maneuvered past her mother and sneaked past her brothers, nothing large, but enough to provide a margin that allowed her and Ben to have more amenities than ever before. They bought the house in Chestnut Hill with $5,000 from Rhoda, financing the remaining $7,000. A small inheritance of $650 allowed them to purchase nine lots at Barnegat Lighthouse on Long Beach Island in New Jersey, where Ben built their modest shore house, on Twenty-ninth Avenue, overlooking the bay. It is one of the many ironies of their marriage that Rhoda's family's money, or the minute fractions that

233 - THE END OF INNOCENCE

she inherited, probably contributed to Ben's diminishing sense of self-esteem, another reminder that he had not measured up to the promise of his birth.

Ben committed suicide in March 1963, on a Saturday, just as the daffodils in the back garden displayed their yellow promise of new life. He shot himself in the head, in the third-floor bedroom that had become his refuge from everything in the world that pursued him. He left no note and waited until Rhoda was away for a weekend, the very first time she had left the house overnight by herself.

Neighbors called the police, who broke in and found the body lying in spattered blood. No one could find Rhoda, but her sister Lorine, who still lived with their mother in Mt. Airy, was contacted. No-nonsense Lorine, who scarcely knew the husband of her sister, took charge, and efficiently and unceremoniously disposed of his body. She told the police, "Get that man out of here. Put him some place, any place you want, but don't leave him here."[13] She began to clean up the room, but Med came home to finish the project.

Rhoda was at her friend Betty Imhoff's house in the country, west of Philadelphia. Driven by that same feeling of impending closure that probably haunted Ben, she had fled her house in frustration, telling a neighbor that she had to get away, that she was just "fed up."[14] Whatever the shape of her marriage, Rhoda was shocked—more than shocked, devastated—by the news of her husband's self-inflicted death. Under the best of circumstances, death has a way of overshadowing the deficiencies of life, rendering problems irrelevant and reducing estranged relationships to unwanted memories. But suicide leaves no room for perpetuating decades-old feelings of resentment. They dissolve at the utterance of the word.

Rhoda was immobilized. When she learned of the suicide she was unable to confront the reality of the event and so she remained with Bob and Betty Imhoff, her only close friends, who sat with her and embraced her and consoled her in ways that she would not be consoled at home. Med, her son, cleaned out parts of the house and left. Jakie was not at home. In 1958 she had left home abruptly, without announcement. She had been twenty-five at the time, but both Med and Rhoda regarded her as a child who ran away from home. Both were devastated. There was no one at home for Rhoda.

It was a week before she was able to return home, a week during which she began the painful process of trying to answer the question "Why?" Guilt is an inevitable companion to suicide. Before she could return home, Rhoda had to try to figure out her culpability in Ben's death, her place in his life.

Because Ben was such an enigma to so many of his acquaintances, his death by his own hand only added one final enigma to a succession that had made him a mysterious recluse, a painfully quiet henpecked husband, a witty, thoughtful artist, a failed architect, or an aristocratic gentleman of the old school. The only neighbor who knew him at all well speculated that it must have been hard on him to have followed an internationally known father and to have turned out himself to "be nothing."[15]

His sister-in-law Lorine thought that it might have had something to do with the disappearance of Jakie. There had been no notes or phone calls or reassuring words sent through friends. Jakie simply disappeared. Both Ben and Rhoda had been frantic as the weeks passed into months and the months into years, but their separate handling of the crisis exaggerated even more dramatically than usual the gulf that existed between them. Rhoda drew portraits of Jakie and distributed them around the city and mailed them to newspapers. She went downtown to view every corpse of unknown women who had been murdered or killed in accidents.[16] Ben withdrew deeper into himself.

Rhoda did not know why he killed himself. Rhoda's son, Med, blamed his mother "entirely" for his father's death.[17] Rhoda worked her way through self-recrimination for not having been there to stop him. Then she moved to the next step of grief, blaming herself for his death, for she believed strongly that Ben was incapable of making the decision to kill himself. He was, she thought, a person who did not grapple with the hard problems of life, and, consequently, was not especially bothered by them, certainly not enough to kill himself.[18] Therefore, the blame had to rest with her. Could she have pushed him too hard?

Her need for an answer plagued her for months and lingered for years. She went from one fortune teller to another asking her question. Friends were both baffled and concerned for her because she was so visibly worried about Ben after his death, as if an old love was remembered and embraced. She stopped her search only after she remembered how unnaturally euphoric Ben had been during the ten days preceding his death, how unlike the withdrawn self he had been since Jakie had disappeared.[19]

She consulted one last medium, who, after conferring with Ben, assured her that he was resting peacefully and that he did not want to be disturbed.[20]

In the spring of 1963, the dream for which Rhoda had given up art lay shattered at her feet. Her husband of thirty-two years was dead and both children were gone, both physically and emotionally. The previous twenty years she had lived, often unhappily, trying to make her youthful decision work. Ironically, during those same twenty years, her friend from the past, Alice Neel, had also struggled to keep her youthful dream on course. Both had many occasions to doubt the wisdom of their decisions, and both considered abandoning the lives they had chosen. But, just at the time of Ben's suicide, Alice's youthful dreams seemed finally to have been kissed by a prince and were one by one being transformed into an unexpected, sparkling reality. Rhoda's future seemed empty and barren. She could not have imagined that, like Alice, she, too, would find great satisfactions ahead of her, because of art.

IV

Triumphs

A TIME TO REAP

A l i c e called 1963 her breakthrough year. The signs, the tantalizing suggestions, had been there for a year or two, but in that year two events occurred that were especially important to her. She acquired her first real patron, a woman who bought five of her paintings and gave Alice her first significant income since the W.P.A. folded twenty years before. Later in the year, Alice's works were picked up by a mainstream gallery, the Graham Gallery on prestigious Madison Avenue. Recognition, finally. People interested in buying her paintings. Important people wanting to show them. The key to success was becoming known. As Alice said, "I never got any publicity at all until 1963."[1]

Publicity was the one crucial element that had eluded Alice in her quest for recognition as a "great" painter. She had been helpless in arousing interest so long as the art world was looking in a different direction or evaluating art by criteria that she would not deviate to meet. But once art critics and gallery owners and possible patrons looked her way and noticed, amidst the swirl and spatter of abstract expressionism, the portraits by this pleasant-looking woman in her early sixties, she was ready for them.

When they at last began to consider portraiture, what they saw on Alice's canvases was an incredible variety of faces and figures, perhaps the broadest spectrum of people—ages, classes, races—to have been born

from the brush of any painter in American history. Hundreds of canvases, a buried treasure trove, chronicled Alice's America over forty years, and even if any one portrait was not enough to capture the attention of the new category of viewers, the "oeuvre" as a whole was compelling. These were not shallow, complimentary portraits of distinguished middle-aged white men and women. They were substantive, probing statements about the people who populated America's cities, from the victims of the Depression to Alice's more recent, and timely, subjects, people who inhabited the art world itself. One art historian wrote that Alice had made portraiture "something more generous, more democratic and more expressive than it had been before, and in doing so she has, over four decades, created an unparalleled record of New York's inhabitants."[2]

Alice had a mission, which she articulated in a statement she wrote for an offbeat publication by Al Leslie and Robert Frank called "The Hasty Papers: A One Shot Review," just before fame began to descend upon her. She wrote:

> I decided to paint the human comedy—such as Balzac had done in literature. In the 30s I painted the beat of those days—Joe Gould, Sam Putnam, Ken Fearing. . . . I have painted "El Barrio" in Puerto Rican Harlem. I painted the neurotic, the mad and the miserable. Also, I painted the others, including some squares. . . . Like Chichikov I am a collector of souls.

She used the timely statement again and again over the next decade to explain herself to people who did not even know the language of figure painting. Alice thought, of course, that her paintings should, and could, stand by themselves. But as her works began to receive publicity, and her name began to appear in art publications, Alice presented a receptive art world with another serendipitous discovery, herself, an authentic "character." No passive and demure grandmotherly woman was she, content to stand beside her canvases and smile appreciatively at onlookers. Alice brought life to her menagerie of faces. She had stories to tell about each of them, and every story peeled back another layer of life, exposed another facet, which was, to many in her new public, as alien as the sociology of Tibet.

The paintings were good. With Alice's commentary, they were extraordinary. She invested them with context and personality. Each became part

of a vivid tapestry of an age depicting what Alice called the "*zeitgeist.*" Alice made her early shows and interviews into happenings punctuated with funny stories, poignant insights into the life of the sitters, explanations of her symbolism, and punchy one-liners. She had gotten New York's attention; she was not going to let the possibility of fame slip through the fingers of a fickle art community. She became her own best publicist.

Since the 1930s Alice had consciously countered her natural image as a pretty and conventional woman by overcoming shyness to project herself as an intelligent iconoclast, tough and confident. She had perfected the telling of outrageous stories, such as those that had captivated Joe Solman during the Depression years in the village. Her unexpected combination of beauty and coarseness, of charm and wit could command a room.

But Alice, by 1963, was practiced in more than style. She possessed strong beliefs, not exactly complete ideologies, but passionately held opinions about the excesses and the shortcomings of American values. Existing as she had, in her political and cultural subcultures, giving slide lectures at the Jefferson School, and admiring the Latin cultures from Cuba to Spanish Harlem helped to make her into a formidable presence whenever her paintings were shown.

Alice made the most of what might have been her fifteen minutes of fame. She converted it into a lifetime of celebrity. The art world may have enjoyed Alice immensely, but for how long? Her paintings were appreciated, but not purchased. One of the curators of the Graham Gallery complained privately that nobody was buying her work.[3] If people would not purchase them, she would take her paintings to the people. Alice and her slide show of her works became a popular art form in themselves across Manhattan in the mid-1960s. She and her works became as much a part of the *zeitgeist* of the tumultuous 1960s as any form of social statement.

The woman who had been the classic outsider had wandered into an iconoclastic age in which the outsiders were beginning to take charge and iconoclasm was the basis for developing subcultures that were imposing themselves on the conventional, white, male culture against which Alice had been remonstrating for over thirty years. The 1960s were made for Alice. Here, finally, was an age that recognized her as a prophet. They provided her with a time, finally, to reap.

To some extent, fame changes everyone it touches. Some become cor-

rupted by its rewards; others make the adjustments necessary to accommodate adulation. Alice made few changes in her life or public persona. Although the nature of her sitters changed as she began to paint members of the art crowd, Alice still came across as the unconventional chronicler of the offbeat. As one of her admirers called her, she was still the "poet of the ugly, the lyrical, the down and out, bohemian to the core."[4] That was one of the strongest images of Alice as she and her past became known. Her years of struggle and deprivation emerged in the public light in the form of heroic stories. Alice, of course, encouraged the imagery.

The decades before the 1960s had been difficult ones for Alice, but never in her stories. Her public memories of those tough and heartless decades were not only sanitized, they were funny. She liked telling the story about the time the F.B.I. agents came to interview her during the McCarthy days, certainly a scary episode, but Alice was not intimidated; she was cool and iconoclastic. They said, "Lady, we don't think there's anything wrong with you, but you paint an awful lot of peculiar people." So Alice told them that the only people she did not have were F.B.I. agents, and asked them to pose, and that brought them over to her side.[5]

In 1962, as she was toeing her way into the spotlight, Alice moved from her walk-up flat in Spanish Harlem. To interviewers who asked her why she moved at that time, she was delighted to respond that she had not intended to move and did not want to move. As she told one inquirer, "I was just put out. I never would have left. They divided the whole house in half and rented each half for much more."[6] Her landlord offered her a larger apartment on the other side of Central Park, the West Side, on upper Broadway.

Her rambling eight-room apartment at 300 West 107th Street was not upscale, and Alice preferred it that way. The clutter from her Spanish Harlem apartment followed her, the canvases stacked against the walls or inside wooden frames, the jars of paintbrushes, and the books. Her easel, of course, sat in the front room, the one flooded with northern light, and the three rooms where she painted contained what would become her famous assortment of chairs to which she would direct her sitters. Overall, the general lack of pretension was most compatible with the way Alice liked to be seen, that is, as a woman who was too honest, or maybe just too old, to be corrupted by fame.

Of course, Alice did make changes in her life as fame began to capture her within its demanding grasp. Alice had a new "*zeitgeist*" to paint, the 1960s, her new world. Her canvases had to change, to reflect not only the startling changes that engulfed the art world, but the even more compelling changes brought about by the tumults of rebellion, among them, the civil rights movement. While Alice admitted, "The wretched faces in the subway, sad and full of troubles, still worry me,"[7] she increasingly refocused her painterly attention. Her paintings of blacks caught in the white system, like the bewildered and anxious draftee, and the black movement leaders so eloquently portrayed in her painting of Hugh Hurd, whom she described as a panther about to spring, or the thoughtful James Farmer, spoke of her sense of what the decade was all about.

Alice's commitment to social involvement was too strong and well formed to be overthrown even when she was finally in a position to choose among her friends and suitors. She continued her long connection with the Communist Party and kept in close touch with Phillip Bonosky. She participated in party forums when invited, such as the symposium on Art and Women's Liberation held on 17 April 1971, and sponsored by the *Daily World* Symposium. Alice was not shy about her sympathies. Her attitude toward American involvement in Vietnam was unequivocal. She said, "I think it was a vast, frightful mistake. . . . America should move out."[8] She marched against the Vietnam War, but, more like Alice, she contributed her art to the protests.

She continued to express concern about American policy toward Cuba and spoke about her affinity for international peace and for the Soviet Union.[9] The parade of visitors to her apartment could notice the poster of Lenin tacked to her kitchen wall. If they listened closely to comments that she made either sitting at her kitchen table or speaking before a college crowd, they would hear not just outrageous observations by a charmingly eccentric old woman, but serious social criticism by an experienced critic.

And, of course, when feminine consciousness, part of that larger awakening that swept America in the 1960s, blended into the women's movement, Alice was a ready-made symbol of its ideals. If Virginia Woolf had once complained that women writers had no models, women painters and feminists from all areas of life in the 1960s could look to Alice to find a model who had long ignored the conventions that kept women subser-

vient to men. Alice's history, repeated again and again for women's groups, told of a woman way back in the dark ages who circumvented the gospel of Freud and ignored the propaganda of Margaret Mead in order to paint.

Alice promoted the image. She liked to point out that when she started out it was a different world. "Women," she once said, "had less opportunities and were apt to let a man who was inferior dominate her to a certain extent. In fact, women took the art of men a little more seriously when I started out."[10] She "started out" in the early 1930s. "I never fought the fight out on the street, but when I was in my studio I didn't give a damn what sex I was."[11]

The Friedan decade made not a dent in her attitudes. Alice said that "the 50s were supposed to be the years where all the husbands took their wives out to the suburbs and the women conformed more. In the 50s I lived in Spanish Harlem, and I just worked as I had always worked." The secret to her life was, she said, "that I never in any way felt I was inferior to men."[12]

Those kinds of comments and the continued proliferation of fresh and electric faces on her canvases helped to make Alice, within three years of her emergence from obscurity, into a "media" personality. In January 1966, the art column of *Newsweek* magazine was devoted to this "new" and novel artist. The author, Jack Kroll, called Alice "the most powerfully original portrait painter of her time," a painter who is "uncanny at bodying forth the history of compromise, surrender and curdled victory that is written in the flesh of human beings."[13] How far from the condemnatory paragraphs that followed her shows in 1944 or 1950 to the judgment that Alice was the "heir of the European expressionist painters."[14] And within two years of that judgment, one of the "lions" of art criticism, Hilton Kramer, who was no fan of Alice's work, grudgingly wrote about this woman who seemed to have become something of a "legend" on the New York art scene.[15] A few years later, in 1970, a writer from Chicago, Franz Schulze, referred to her as "the fabled Alice Neel."[16]

How gratifying for a woman approaching seventy to have so many suitors, to be asked by *Time* magazine to paint a cover portrait of Kate Millet or to be sought by galleries all over Manhattan, but to be retained year after year for multiple shows by her gallery, the Graham. It was a great time for Alice. She referred, simply, to that period of her life, the late 1960s, as "more my day than it has ever been."[17]

How satisfying for a woman who for decades could not attract sitters

except from within her narrow circles of acquaintances to be courted by the rich and famous. Celebrities and other artists sat for her: the Soyer brothers and Henry Geldzahler, curator of contemporary art at the Metropolitan Museum of Art; the critic John Perreault, who suggested that Alice paint him, nude; and the essentially shy Andy Warhol who allowed her to paint him in his most vulnerable pose, corseted, his naked chest exposing the wounds from a recent assassination attempt, and then admited or boasted that Alice was the only woman ever to frame him.

Jack Baur, the Director of the Whitney Museum, told Alice that he wanted her to paint him. She knew that he was one of the most powerful art brokers in the city and could advance her career. Still, she looked him over carefully, then said, "No you don't."[18] He persisted until she finally said yes, but she warned him he would not like it. His portrait, which she estimated would take three sittings, took nine. He didn't like it. Did he want to buy it? "No, no, not at all."[19]

To some who sought her out she said yes, to some no. But even when sought after, she maintained her standards. The surest way to be painted by Alice was still to be selected by her, chosen for whatever reason her eye uncovered, even if she knew that the person would not or was unable to buy the painting. Consequently, as her fame grew, so did her storehouse of her own paintings.

Alice's fame grew within art circles throughout the country, but the 1960s provided her with an even larger body of followers, seemingly unnatural allies for a plump, graying, rather innocuous-looking lady. How rewarding it was for Alice, whose life-style and opinions were once condemned as immoral, to become a celebrity among a generation of young people. As Alice's fame grew, her reputation as a feminist and populist and socially aware painter spread to what became, collectively, her most natural following, college students. Increasingly, after 1965, she and her paintings were sought after by colleges and universities, and the initial requests, in 1965, came from such diverse institutions as Clemson University, Tougaloo College in Mississippi, the University of Oklahoma, Patterson State College in New Jersey, and Dartmouth. Thereafter, the invitations from dozens of colleges a year clogged her mailbox.

She loved these occasions. It was not just the traveling, which she adored, or the adulation. She loved talking to young people. Alice's advice, her accumulated wisdom, must have appeared almost handmade

for young women, and young people in general. In an age when all adults were suspect, Alice avoided the stigma that age automatically imposed upon others. Students appreciated her iconoclasm and understood her humor. They related naturally when she said that she admired them, the young, for "they are not going to accept anything they do not want."[20]

Alice had only to give her standard slide show of her paintings to gain immediate credibility with any group of college students. Just a short sentence about each slide of one of her paintings revealed volumes about her life and credibility:

"I ran off to Cuba with him. We painted all the time."
"Look at her. She's pure Women's Lib in 1930."
"He was a rather mad sailor that I lived with."
"She was the head of the W.P.A. when I was on it and all she wanted to do was fire people."
"If they had paid attention to paintings like this, the Nazis might not have had a chance to kill all those people."
"He was one of the real beats of the thirties."
"TB was everywhere in Spanish Harlem."

Audiences applauded her and laughed; they gathered around her to ask questions, to listen to the stories and to experience a woman the age of their grandmothers whose insights and humor were theirs. She almost always left behind her stunning reviews of an unexpected performance and winning interviews. Writers in the 1960s were always amazed "while talking to her" to discover "how extremely young she is in her thoughts and reactions to situations."[21]

But perhaps the most gratifying college experience Alice had was for her, a woman who was sometimes quite an embarrassment to her art school, to be designated by her alma mater, Moore College of Art, to receive an honorary doctorate in recognition of her stature as the college's most famous alumna. The Philadelphia School of Design for Women had merged with Moore forty years before, and the resulting school was ecstatic to find Alice among its graduates. She was delighted enough with the recognition to send an announcement to her friends through the pages of the *Daily World*, but she did suggest in her letter that Moore College certainly took long enough to "discover" her as its most famous "alumna."[22]

The ceremony at which she was awarded her degree was preceded by a

major one-woman show at the school. From 15 January to 19 February, Moore sponsored a forty-year retrospective including over sixty-five of her works, almost all of which had never been shown in Philadelphia. Then, on 1 June 1971, at the school's graduation ceremony, Alice was awarded the doctorate of fine arts.

For almost a decade, Alice had read laudatory reviews of her work and had learned to accept compliments as her due, but how quietly fulfilling to have her alma mater publicly read its statement justifying the conferment upon her of its highest award, acknowledging, somehow officially, in these words, that the world finally understood her:

Alice Neel, your people are real: they have presence on the street and in the galleries where your works hang. One is transfixed by your penetration of character. Yours are portraits which express inadequacy, hostility, virility, energy—each with unique face and feature. Only after the impact of the personality does one remember to look at shadows, facets of light, the lines that contain the portrait—to be astonished at the formal excellence of each work. You have done in art what writers do in the characterization in a novel. You have called yourself a collector of souls; you have said that you would like to make the world happy. Every savior must see as you have seen: the sorrow, the pain, the madness—the human need—before any act of salvation is possible. We confer this honor upon you because you have seen, have pitied, have loved, and kept a record.

A savior. That's what they said. Perhaps a bit exaggerated, a bit. Ten years before, they had not known her name, and now here they were, hundreds of them, a large and sympathetic audience. Here were the students, of course, young women, her natural disciples. But then here were all the adults, the demographics overwhelmingly white, too old to be hippies and too well dressed to be Communists or political radicals. They probably did not know exactly where they stood on America's incursions into Cambodia or Vietnam in general. The majority probably voted for Nixon, but here they were, an audience of conventional people with conventional values who routinely condemned Cuba without knowing anything at all about it and who probably lived soda-cracker lives, all sitting ready to listen to her every word. What delicious irony.

What did she want to tell this audience, this microcosm of middle

America? She told them about herself and how important it was that they were living in an age of change, that they had to recognize it and value it. She said:

> This is a great era of change and it is very exciting to be an artist—even with the terrible things that are going on, such as the war in Vietnam and the fact that society is almost in a state of chaos. . . . Destruction and bitter criticism are a reflection of the overall picture. However, great attention is being paid to art, and the artist is being lifted out of his idiosyncratic alienation (witness me) and all society is taking an interest in him. . . .
>
> The women's lib movement is giving women the right to openly practice what I had to do in an underground way. I have always believed that women should resent and refuse to accept all the gratuitous insults that men impose upon them. The woman artist is especially vulnerable and could be robbed of her confidence. . . .
>
> I have only become really known in the sixties because before I could not defend myself. I read a quote from Simone de Beauvoir saying that no woman had ever had a worldview because she had always lived in a man's world. For me, this was not true. I do not think the world up to now should be given to the men only. No matter what the rules are, when one is painting one creates one's own world. Injustice had no sex, and one of the primary motives of my work was to reveal the inequalities and pressures as shown in the psychology of the people I painted. . . .
>
> Never has prejudice of all sorts come under attack as it has today. There is a new freedom for women to be themselves, to find out what they really are. . . .
>
> Now things have changed and there are hopeful signs that a new humanism is taking place. Everything is being questioned, all relationships, education, Western man, and the very ethos of the West. Allen Ginsberg chants Buddhist chants.
>
> It is a great time to be an artist. . . .[23]

Alice could not say that about earlier periods in her life. But now she was stage center. Otherwise quite conventional people were falling in love with her. As the 1970s proceeded, Alice stood next to the possibility of major fame. She did not feel at all uncomfortable.

REMEMBRANCE OF

THINGS PAST

16.

--

T h e time that had elapsed between 1931 and 1963 was infinitely more than thirty-two years for Rhoda. Chronology was simply inadequate to measure the light-years that separated the young, cheerful, and irreverent artist from the crushed, jaded, and tired widow. Unlike Alice, who had persevered through three decades of unrequited painting, but was finally reaping her generous rewards, Rhoda had persevered through three decades of marriage only to find herself with nothing, no acknowledgment that her youthful decisions had any merit, without any rewards.

Ben's final act closed a marriage that at the end, Rhoda confided to a close friend, was careening from crisis to crisis.[1] His suicide, however, did not end the crises in her life; it only magnified them, exaggerating Jakie's absence and Rhoda's new estrangement from her son, Med. Rhoda was left with almost nothing of value, except her self-esteem. She possessed an ungracefully aging house with a basement full of her youthful paintings, all neglected, kept from being insistent reminders of what might have been only by the relentless demands of an unforgiving present. At first, there was no room for nostalgia.

Ben Spruance was chairman of the Department of Fine Arts at Beaver College, a small liberal arts college in Glenside, a Philadelphia suburb near Chestnut Hill. Soon after he heard of his friend's death, Ben visited Rhoda. As a gesture to an old friendship, he asked her if she would

consider becoming a part-time clerk in the art supplies store in his department. The job actually paid less than Rhoda's position at the dime store, but Rhoda barely hesitated in accepting the offer.

As the summer of 1963 wore on, however, Rhoda began to get unaccustomedly nervous. Often she crossed the street to Mrs. Allen's to fret and seek reassurance that she would do well in her new job.[2] What on the surface was a simple, almost simplistic, job loomed for Rhoda as a challenge for which she might not be totally prepared. The intimidating factor was art, which elevated a safe sales job to some kind of link, a connection to her past for which she had to be worthy. Mrs. Allen had constantly to reassure her that she would perform well.

Beaver College was built on a hilly sixty-acre estate topped by an ornate, gray-stoned replica of an English castle, the folly of a sugar baron during the gilded age. At the bottom of one of the sides of the hill, in what had originally been the heating plant and servants' quarters, was the art department. Tucked quietly inside, the art supplies store consisted of a windowless cinder-block room crammed with supplies, accessible only to the manager and the clerk who had deftly to navigate the narrowest of aisles. Transactions were conducted through the upper open half of a Dutch door. Hardly an exciting environment—except to Rhoda, for she was dealing with art supplies and art students.

A sense of welcome *déjà vu* began to creep into her days at Beaver. The small college was in so many ways like the Philadelphia School of Design. It was a women's college, that kind of acceptable place for parents to send their daughters if they were not accepted by the more prestigious institutions. Most of the students were expectedly conventional and studied expectedly conventional subjects. But at the core were the art students, always a little more interesting, not bohemian, but a bit more offbeat, more likely to undertake causes, to be aware of currents stirring in New York, or to read Jack Kerouac's *On the Road* or Sartre's *No Exit*.

Like Rhoda and her clique back at the Philadelphia School of Design for Women, the fine arts students regarded themselves, in their humble surroundings, as somehow special, sharing a camaraderie that comes from feeling, at the same time, embattled and superior. Rhoda began to think of the art department as the "jewel" of the college. Once her initial nervousness quickly passed, she settled in, happier than she had been in years. She "loved" Beaver College and its art department.[3]

If the tragedy was that Rhoda gave up her satisfying life as a painter to

follow her fantasy of marriage, her salvation was that she began to remember what she had given up.

Over the years following 1963, the art store became the center of her life. She stayed longer than her half-day requirement and began to learn the students' names, and to talk with them as one of the teaching staff might. She increasingly regarded her job as almost a calling, once telling a member of the faculty that the reason for her employment by the college was her knowledge of art.[4] Rhoda spent hours studying art supply books and suggesting to the store manager items that they might purchase, although that was the responsibility of the art faculty.

Buying and selling art supplies could not long remain for Rhoda a purely commercial set of transactions. The seductive feel of the drawing instruments and the inviting virgin surfaces of the drawing paper eventually worked their power. At first, it was primarily pencils with soft, thick leads for stroking in bold heads and the thatched hair of youth, and pads, small but grainy. Soon she began to sketch the children of her neighborhood, many of whom started to show up periodically at Rhoda's house.

If the adults in the neighborhood found Rhoda to be an undesirable neighbor, abrasive and neglectful of her property, their children loved her, probably for many of the same reasons. Rhoda's love affair with children went back, of course, to those years when her own were young and full of enthusiasm. After the sting of Ben's death softened, and with it that unhealthy focus on self, Rhoda opened her ramshackle house to the neighborhood children. No doting and sweet old lady, she regaled them with stories, fantastic tales all told in a loud, raspy, eruptive voice that she was reclaiming from her youth. And she taught them how to draw, not tightly or rigidly, but expansively. She urged them not to take so long on individual drawings, but just to "put it down, be free, get the shapes down."[5]

They adored her.[6] Her style was to treat them as people and, therefore, not to direct their every movement. Usually she would teach them how to shape soft clay and let them experiment. It was their freedom, their spontaneity, that attracted her to both children and art students. The former would take risks when Rhoda was teaching them, just as the latter retained that capacity in their studies.

Rhoda did not act like "real" grown-ups were supposed to, especially as she remembered how much fun it was (as well as exasperating to others) to forget conventions. In 1965, she took Mrs. Allen's two boys to the New

York World's Fair and tried to show off by breaking into all of the lines, successfully, something that she would not have dared do while Ben was alive.[7] After 1965, when she bought a large used Cadillac, she also loved to take children for rides around Chestnut Hill. She had driven while Ben was alive, but not for fun. At stoplights or when she parked, she always bumped other cars gently, explaining that people would not have put bumpers on cars unless they expected drivers to bump other cars.[8]

Gradually, she regained her youthful flair in dress, a visual statement of her recaptured persona. Reds and blacks, her favorite colors, increasingly began to appear in her wardrobe. So did turtleneck sweaters, usually worn under Native American shawls or heavy woven sweaters, along with the two accessories that Rhoda was most fond of: ornate Peruvian jewelry and wide-brimmed hats of bright colors. To adults, she probably seemed to grow more and more eccentric, but she did not care what most adults thought of her. She was dressing for herself, expressing who she was remembering herself to be, who she wanted to be again.

In the midst of her rejuvenation, Rhoda was also learning the intricacies of being a grandmother. Her son Med had fathered three children in two failed marriages in different states. Rhoda found out about her grandsons and her granddaughter after the fact, when her status was unclear and her relationship with the mothers nonexistent. And while she was not a part of their lives, Rhoda was so anxious to be a real grandmother. Delicately, she worked out arrangements with the mothers of her grandchildren and began, in the mid-1960s, to see them.

About the same time, in 1966, Jakie returned home as abruptly as she had left, bringing with her a husband and three daughters.[9] Shocked, hurt, and delighted, Rhoda was drowned in a cascade of emotions. Her daughter was back in her life. Rhoda would have to sort out her deeper feelings about Jakie's disappearance and Ben's death. At the time, she welcomed Jakie back, and when she realized how warm her marriage was, accepted her new son-in-law and her granddaughters.

The shock of discovering so many grandchildren where there had been none was humanely lessened when Rhoda learned that they were all going to live in their respective homes, far enough away in bordering states not to change her life too much, but close enough to visit and enjoy. But no matter where they lived, the addition to her life of so many grandchildren would disrupt it, redirect it, pull at it, push it around, and revitalize it as

much as the unexpected arrival of the Ghost of Christmas Future in the humbug life of Ebenezer Scrooge.

Despite the difficulties, Rhoda made herself a part of all of their lives. She invited them to her house when she could and accepted them into her home when asked to. When she was able to get Max and Holly and Milton Bennett Medary, V, all Med's children, for vacations, she would take them to Lorine's summer place off the coast of Maine and there play both artist who sketched them endlessly and indulgent grandmother. Jakie and her large family had constant financial needs for which they asked Rhoda's help. She regularly gave them financial assistance, often in exchange for much needed repair work on her house.

Her grandchildren added to the new life in her house, but Rhoda had already invested the old dowager of a structure with a vitality that brings smiles to the faces of aging dowagers. Rhoda had begun to retrieve her thirty-five- and forty-year-old paintings from the basement and in cycles to clean them of their gathered dust, and hang them in her cluttered dining room, where she lived. She hung her Alice Neel painting of Ben above the battered upright piano, then complemented it with her own works from the same period.

Rhoda had kept most of her nearly fifty canvases in the basement after she and Ben had bought their house on Gravers Lane in 1950. Before that, they had been kept for her by Mrs. Medary, and although Rhoda took them back after 1950, she ignored them until after Ben's death. But increasingly after 1965, as she came back to her earlier life, her dining room grew into a gallery, a visual remembrance of her talent.

Such a display of ancient works and the effort to maintain a visual display of things past can, and usually does, betray a mind whose morbid preoccupation with the glories of another age has edged it into an unhealthy pathology. Rhoda could easily have become like those pathetic actresses who were cast away in the prime of their lives, but who still paint their faces and try to convince the dwindling number of visitors that their career was the height of Hollywood's greatness. Rhoda enjoyed her works, but neither took people in to see them nor dwelled upon them herself. If anything, they reminded her that she had talent and it was time to use it again.

In 1965, Rhoda came into some money, which allowed her to increase still further the dimensions of her expanding world. She sold all of her lots

at Barnegat Light, except for the one that held the house that Ben had built, for twenty-five thousand dollars, and with some of the money and the same enthusiasm as the two Beaver art students whom she took with her, Rhoda boarded a jet and flew to Ireland. The trip, her first to Europe since 1928, gave her more pleasure than anything she had done in decades.

She stayed at the small house, almost a cottage, of the father of her friend and neighbor Mrs. Allen. He lived in Donnegal, a rugged northern province on the Atlantic coast, on the side of a mountain overlooking the ocean. Rhoda had never seen such a big sky or angry ocean.

The expansive scenery lured Rhoda into her first attempts at painting in decades. She worked only in watercolors that summer, but turned out dozens of textured sheets of paper covered with delicate capturings of misty mornings and robust renderings of a virtually untamed country-side, all reflecting the uncertain days of summer on the northern Irish coast.

And she was with art people who, like her, painted the days away into dusk and in the evenings talked of interesting things in local pubs. Rhoda came back feeling more like an artist, bolder, more confident than at any time since her youth. She even had a small body of work to show to her friends at the college.

As if they were parts of a collage, facets of her old identity attached themselves to Rhoda. Her artist's persona delighted some, impressed some, and irritated others. Increasingly, Rhoda Medary became a figure on campus who was hard to ignore, and about whom most on campus had strong opinions. Art students either loved her or were intimidated by her as she told them what it was they wanted. After she was made manager of the art store in 1966, it became her fiefdom, where she could either share with quiescent freshmen the latest acrylics or contradict the instructions of a professor who obviously was not up on the most recent innovations.

Faculty members often grew exasperated with her opinions about those whom she felt to be incompetent or inattentive. But even after the death of her sponsor, Ben Spruance, in 1967, the new chairman, Jack Davis, who was no fan, kept her on, a fixture in the department whom one inherited along with the department cat. Anyone who had even a passing acquain-tance with her understood the importance of her position, not only to her happiness but to her existence.

Like Alice, Rhoda was never especially grateful for other people's indul-

gences of her. She also seemed to expect them, not rudely but as a matter of course. She liked to think of herself as an equal, a member of the faculty. She ate almost every day in the faculty dining room, and she did so without a hint of a sense that she ought not to be there.

In fact, she was rather a hard-to-ignore presence, and became a dubious sort of legend at the college by walking into the dining room and, before going through the serving line, just standing, waiting until her favorite professors came in so that she could join them, or studying the room to see which table looked as if it would be the most interesting to join. Even after she sat down, if the conversation at another table appeared more stimulating or entertaining, or if there was laughter, she would collect her china and silverware, her cup and saucer, and move to that table. She explained herself by saying simply that life was too short and she was too old to spend unnecessary time with dull people.[10]

By the early 1970s, Rhoda's remembered persona, the unconventional artist, was fully resurrected and she wore it naturally. Time had wrought its changes, of course. Innocence had given way to a long-acquired cynicism. In her earlier life, Rhoda had not seemed to have a care in the world, but in the second go-around she lived out her image amidst waves of family crises that usually required money to rectify. But her sense of self sustained her. The voice was raspy, but it had rediscovered its forcefulness and her laughter erupted with its old intensity.

She felt herself to be Rhoda the artist when, finally, she found herself in the same room with her old studio partners, Alice Neel and Ethel Ashton.

The occasion for their reunion after forty years was an alumnae show at the Moore College of Art in the spring of 1973, two years after the college had conferred the doctor of fine arts upon Alice. Fifteen graduates had been invited to hang representative paintings in a show called "Alumni Hangables." Alice returned for the small show with her 1930 nude of Ethel Ashton.

Alice had not seen Ethel since the summer of 1930. After the breakup of the studio on Washington Square, Ethel had lived a quiet life in Philadelphia, boarding with her parents until their deaths in 1949, and then living alone in an apartment on Walnut Street. With the end of the W.P.A. and her participation in the mural project, she continued to paint, and entered canvases in the annual shows of such places as San Francisco and Chicago until 1946, when she abruptly stopped showing her works. By then, she was painting in the abstract expressionist style, although no one

knew it, not even her closest relative, a nephew, until after her death, for she would show her work to no one.

In 1959, she had become the librarian at the Pennsylvania Academy of Fine Arts School, where she gained a wonderfully warm reputation as an encouraging and supportive grandmother figure among the painting students. Even they did not know that she was a painter. Several faculty members urged her to show her work, but she refused. She always worried that she was not good enough to show her works.[11] The older she got, the less secure she became about her talent.

When Ethel arrived at the Moore gallery in 1973 to see the alumnae show and to see Alice, she found that Alice had hung, in the most prominent place, the nude of her from the summer of 1930, bold and unmistakable. She was overwhelmed with embarrassment, and then with anger.[12] The painting humiliated her, and, mortified, she walked out of the show. Rhoda thought that it was one of life's funniest moments, and she and Alice laughed at Ethel's expense until their sides hurt as much as Ethel's heart. They had not intended to hurt, but somewhere along the path of aging, their friend had become brittle, unable to laugh at herself.

Amidst this laughter, Rhoda and Alice renewed their friendship. Neither seemed the least sentimental at what might have been a touching reunion, with Ethel, of the three musketeers. And neither saw her again. She died two years later, in May 1975.

There they were, in the same room, for the first time in forty-three years. Laughing. While neither Alice nor Rhoda had seriously tried to contact the other over the decades, they seemed genuinely happy to see each other. Alice looked prosperous, her white hair neatly brushed over her forehead and pulled back, her plump body covered unceremoniously by a dark wool dress and large beads on a long string. She smiled easily, the way successful people do. Ironically, it was Rhoda who looked like the stereotype of the artist. Thin, wiry, and stooped over as if from hours in front of an easel, she wore her graying hair straight back, gathered into a bun, wisps flying wildly away. She wore a floor-length hand-woven skirt made up of large, colorfully decorative squares, a wool vest, and an oversize antique silver pendant accenting a black turtleneck sweater.

The Ethel incident seemed to trigger an eruption of nostalgia that neither indulged in on her own. Was it fifty years ago that Rhoda graduated and "deserted" Alice to go to Europe, a half century since Alice began to dislike the School of Design so much? She was not nearly as

condemnatory now. The school was not good, but it was not bad. Was the studio on Washington Square still there? No. Rhoda had been by a few years before and seen that it had been replaced by a large apartment building.

Talking amidst the constant motion of a show meant sharing Alice with others, so Rhoda invited her back to Philadelphia to visit her. Alice accepted, and later in 1973, a time of year neither remembered, Alice took the train to Thirtieth Street Station, where Rhoda picked her up in her elegant old black Chrysler. They spent the weekend at Rhoda's old house, looking at Rhoda's paintings and talking.

Reunions after decades of separation rarely live up to their advance billings. Time and space have a way of propelling even close friendships into different orbits, but forty-three years does violence to a friendship that was not especially close during its last years. Rhoda had bragged to a few friends that Alice Neel was coming to visit her with the pride of familiarity, so the visit was something of a disappointment, nothing negative, just the absence of a closeness that Rhoda had hoped for. Alice talked about herself, too much, Rhoda thought, as if she assumed that anyone with her wanted to hear all the details.[13] Sometimes when Rhoda was talking, Alice interjected a statement that was wholly unconnected, indicating that she had not been listening or that it was time to take control back.

Alice and Rhoda choreographed themselves through a visit of a day and a half. They laughed about the look on Ethel's face at the show and about how vain people can be. Much of the time, however, they spent talking, lovingly and in detail, about their grandchildren. But when Rhoda talked about her marriage, it was one area that interested Alice. She was fascinated with Rhoda's experiences and her tragedies, perhaps remembering the warnings that she and Ethel had given her.

Sometimes they were like sisters, at others they sparred, seeming to test the limits of their newly reestablished relationship, unsure of the rough and tender places after so many years. Flashes of sisterly affection were offset by a nasty, cutting remark, as if there existed between them a leftover competition from the stone age. Rhoda was not unhappy when the visit ended.

For Rhoda, the meeting was traumatic beneath the laughter and the talk. She had not been invited to submit a painting to the alumnae show. No one at Moore knew that she painted or that at one time she had been more celebrated than Alice. There was no way to deny the fact that Alice

had gone on to fame, but Rhoda felt that if she had continued to paint she would have been a better painter than Alice.[14]

She convinced herself that Alice had achieved her fame not on the merit of her painting, but on her skill at using people.[15] Jealousy, envy, and regret all bubbled to the surface when she saw Alice in 1973. These were natural reactions on seeing Alice celebrated by so many, but deep in her heart Rhoda knew that Alice was an excellent painter and that her own failure to attain greatness stemmed not from Alice's success, but from her own choices. She was finally able to admit that she had made the wrong choices. She wrote, "What a waste, for I was not a good mother or wife and I could have been a fine artist."[16]

Her comfortable artist's persona was not enough. Seeing Alice so closely was a sharp reminder of what success looked like. No one knew that she was a painter, or, more accurately, that she had been a very good painter, except Alice. Rhoda and Ethel were, back in the summer of 1930, "as close to friends" as Alice ever had.[17] Rhoda had to wonder what levels she might have achieved if the three of them had been able to carry out their plans to paint together, or if she and Alice had been able to remain friends. Would Alice's determination have rubbed off on her? Would she have continued to paint?

For Alice's part, the renewed friendship in 1973 filled her with a combination of affection, "I-told-you-so" pity and scorn. She regarded Rhoda as a talented painter, one who might have gone on to great things, but one who had wasted her talent by not painting every day, through marriage and despite children. Alice would, in the future, use Rhoda as an example of what can happen when women give up art for life.[18]

Even as Rhoda talked about the past, Alice was planning an even more magnificent future. In mid-1973, she was in negotiations with the Whitney Museum of American Art for a major one-woman retrospective.

Photos 28 and 29 represent several post-1975 canvases that Rhoda painted following a forty-five year hiatus in her work.

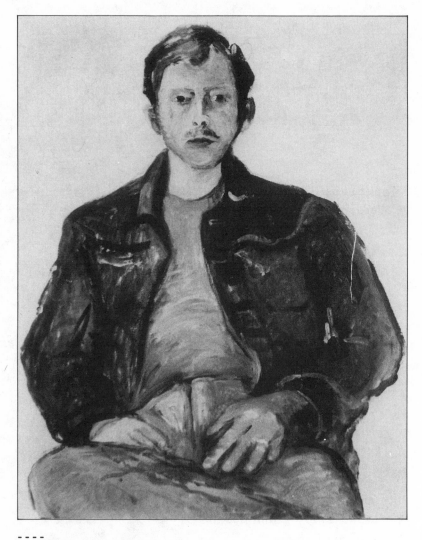

28. "Mike the Cop" (1975).
(Collection of June and Mike Donovan.)

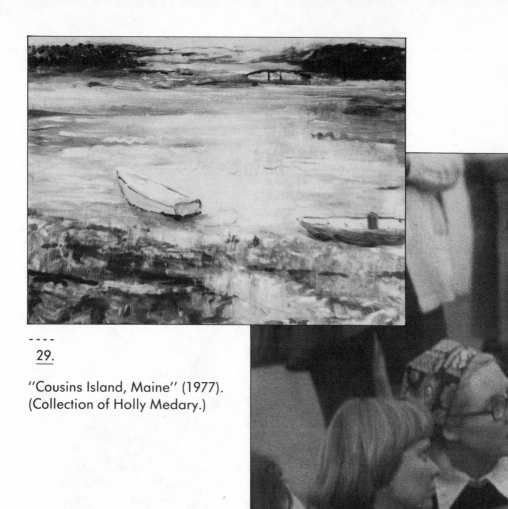

- - - -
29.

"Cousins Island, Maine" (1977).
(Collection of Holly Medary.)

- - - -
30.

Alice was perhaps most at home
on college campuses. In this 1976
photo she is talking with students
at Beaver College following a
public address at the opening of
her show. (Photo courtesy of
Beaver College Art Department.)

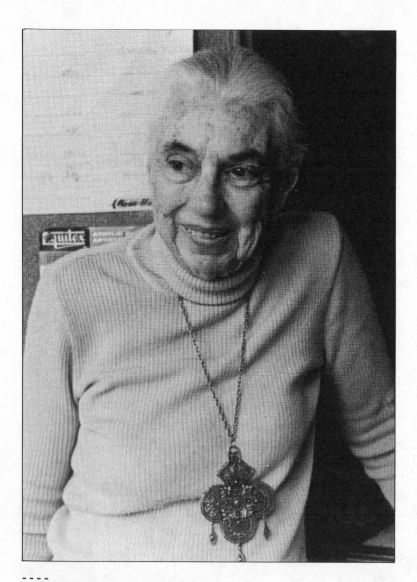

31. Rhoda in 1976 as Manager of
the Art Supplies Store at
Beaver College. (Photo courtesy
of the *Log*, Beaver College.)

FINALLY,
VALIDATION

17.

--

J a c k Baur, director of the Whitney Museum of American Art, first
met Alice Neel in the early 1970s, when, together with artist Ilya Bolo-
towsky, they were asked to jury a show in North Carolina. Bolotowsky,
an abstract artist whom Alice had known since the Depression, was
studying an abstract painting, a "terrible" painting full of red, according
to Baur. Alice walked up, looked at the painting for a brief moment, and
said, "My God, it looks like an infusion of menstrual flow." Everybody,
including Bolotowsky, blanched.[1]

Jack Baur never quite believed that Alice was real. He was charmed by
her serene and gentle appearance, but never lost his capacity to be freshly
shocked, in an amused way, by her rough humor and what he called her
vinegary interior. As it was with so many men Alice had met during her
lifetime, Jack was as fascinated by her as by her art.

He decided to give her a show after he had seen the full extent of her
work, hundreds of canvases that sat around the large rubber plant in her
apartment, a plant that took up "a third" of her studio like a "consuming
snake."[2] All of those bared souls. They were a rich, textured, visual
history, a feast for wary eyes that had watched the transformation of
American art from abstract expressionism to the unsatisfying minimalism
of pop and op art. Here was substance.

Alice's one-woman retrospective opened on 7 February 1974, and she

took stage center. Even as the show opened on a cold winter's day, controversy, like the snow, swirled around the Upper East Side museum. Some feminists in the art community and others who had been watching the evolving confrontations between activist women's groups and the major New York museums thought that the Whitney was just responding to demands that Alice be given a show. The Ad Hoc Committee of the Art Workers' Coalition had begun to petition and picket the Whitney in 1970. The Women Artists in Revolution (W.A.R.) had also begun to focus on the Whitney.[3] In response to the gathering storm, the museum had promised to hold a major Georgia O'Keeffe exhibition and two additional one-woman shows, and some observers made a connection between the pickets and the promises and concluded that Alice's show's road was "paved with petitions from the art community."[4]

Influential groups within the art and feminist communities thought that a major show for Alice was long overdue. She deserved the show not only because her work was important, but because she had labored, unacknowledged, in the trenches for so many decades. Those who called for the Whitney to hang a major show for Alice were joined by Alice. She had been unabashedly talking about it for years, and it sat so heavily on her mind that she began talking about the justice of a show to anyone, whether they could pull strings on her behalf or not. The man at the local grocery store probably knew as much about her case for a show as Jack Baur.[5]

Baur had given his reasons, and they were persuasive. Her figures were among the most important in American history; her contribution to the survival of figure painting was second to none. But, whatever the reason behind mounting the Neel retrospective, Alice was where she loved to be—at the center of attention. Her crowded, gala opening catapulted her to a level of fame that controversy only enhanced. Others might debate, but she knew what the exhibition meant to her, where it fit into her life.

Few people would have appreciated the real nature of the triumph conferred on Alice with the success of her Whitney retrospective. Most observers recognized the inherent importance of a body of work that helped to define the culture of America, but the exhibition was first, and foremost, a personal and private triumph. It was to Alice the culmination of her life's work "where everything added together." "The show," she said, "finally convinced me that I had a perfect right to paint. I had always felt in a sense that I didn't have a right to paint because I had two sons and I

had so many things I should be doing and here I was painting. After the show I didn't feel that anymore."[6]

Finally, validation. I am good at what I do. I have a right to be doing it. After years, decades, of painting to the exclusion of almost everything else, Alice claimed that she was still haunted by the ghost of conventional taboos. If she had any lingering doubts about the wisdom or morality of her life choices—and most who knew her would say that she showed no signs of questioning her talent or her place in the world—they were dispelled on the second-floor gallery of the Whitney Museum that winter of 1974.

It was fitting that Rhoda was there for Alice's triumph, squeezing past talking couples to see the paintings that Alice had done after they had gone their separate ways after 1931. She enjoyed her heady experience, rubbing elbows with the art world and being able to claim a more intimate, and without question a more long-standing, acquaintance with the artist than most people with whom she chatted.

Rhoda and Alice did not see very much of each other during those two days. Alice was in demand and Rhoda was very much the country cousin, visiting the big city, but out of her league. She did not mind. Actually John Rothschild, who was living in Alice's sprawling apartment, was a charming host, and as always, a gentleman. He made Rhoda feel very comfortable.

After Rhoda left for Philadelphia, Alice, who had been the center of attention among hundreds of admirers, still mentioned that she thought John had given Rhoda entirely too much attention.[7]

Alice's triumph was of major proportions, sweeping New York before it. Rhoda returned to Philadelphia feeling pleased for Alice, yet wistful, as if her friend's triumph was still another reminder of failure to become an artist. But if tragedy was one of the sources of Rhoda's condition as she turned seventy-two, irony became the other. The beginnings of her triumph date to that same winter of 1974.

The process was set in motion quite unwittingly one Sunday when Rhoda invited a new faculty member, his charming wife, and their two young sons, age five and two years, over for tea one Sunday afternoon in

early March. She had never had a faculty family over to her house before. But Rhoda loved to be around families if the parents showed respect as well as love for their children by not yelling and commanding, and constantly correcting them. And the Whitney exhibition experience had moved her to want to share her paintings with someone from the college community.

It was obvious to the couple that Rhoda did not entertain much. The old house was dark inside. Late afternoon light butted helplessly against the shuttered windows, and they had to pass down a dark hallway, past a dark sitting room, to get to the cluttered dining room with its high ceiling of peeling paint, a veneer of dust on a menagerie of randomly placed objects, and an amalgamation of barely maintained old, heavy furniture.

Most unexpected were all of the paintings that covered the walls, most unframed, hanging on nails, and a portrait of a gray man with gray hair, wearing a gray suit, and looking a bit askew, hanging without prominence above a painted and battered upright piano. He was not particularly interesting in himself, but the fresh memory of the Alice Neel show at the Whitney just a month before made the bold letters N E E L that tumbled down the lower left-hand corner of the painting, the bottom of the L precariously balanced above the numbers 1930, jump out to any viewer.

"That?" said Rhoda to what she seemed to think of as a peculiar query. "Yeah, its an Alice Neel, a portrait of my husband. She didn't like him at all." In response to further excited questions, "She did that at my studio. A long time ago. . . . The rest of these? They're mine."

Her guests were incredulous, politely incredulous. And when she told them that she had many more in the basement just collecting dust, they wanted the whole story about her. Rhoda did not need more prompting questions. A gush of remembrances spilled from her, introduced by a simple, "Oh, yeah, Alice and me, we go way back."

It took little prompting by the professor's wife for Rhoda to promise to bring all of her paintings up from the basement. The following Sunday, when the three of them spent an entire afternoon poring over canvases, all of which had been meticulously cleaned, Rhoda, much like Alice, if for a smaller audience, talked comfortably about every painting, the people, why she chose them as sitters, what each portrayed about the age in which it was painted, about Washington Square, and her beloved studio.

"Would it be all right," asked her visitors, "if we invited someone to see

your paintings next week?" It was a confident Rhoda who in her raspy voice agreed. But her confidence dissolved when, the following Sunday, her friends brought with them the chairman of the Fine Arts Department at Beaver College. Jack Davis, an experimental, innovative painter disagreed with her on almost every issue from political to aesthetic. He had not been told whose house he was going to for fear that he would not go. Rhoda did not appreciate his work at all, an opinion with which he was quite familiar, not that the artistic opinion of the art store manager bothered him very much. If he saw no merit in her work, he would probably not even bother to mask his opinion behind a polite façade.

As a gesture of politeness to the two people who had brought him, he looked at the paintings. Rhoda watched him closely, suspiciously, while he studied each painting thoughtfully, pulling each away from the stacks against the wall, setting a few aside, holding the odd one up, and searching back to find individual canvases. She wasn't at all sure that she trusted him. This was not just some young history professor with a gracious wife. Davis was an experienced art critic with what Rhoda believed to be bizarre tastes. She tried to appear unconcerned, oblivious to the drama taking place in front of her.

Finally, Davis sat down at the carved oak dining room table and said, "These are not done in a style that I like, but, for their genre, they are very good. You should have a show."

Being given a one-woman show at the Beaver College gallery, while not the Whitney Museum, was no less an honor for Rhoda Medary. The month before Davis was arranging with Rhoda for her show, the campus gallery had been hung with a one-woman show of Lee Krasner's oils, collages, and works on paper. The following spring, in 1975, when Davis scheduled Rhoda's show, hers followed an exhibition of the works of Faith Ringgold. Alice Neel would have a show there in 1976. Rhoda regarded her show with the same combination of disbelief and euphoria that barren women must feel when told they are pregnant. She greeted the birth with an overwhelming sense of pride and unparalleled accomplishment.

The triumph was sweet. It swirled around inside her like the white wine in the glass she carried. The year was 1975, and Rhoda, who had just turned seventy-three, stood as a queen in the center of the Beaver College Art Gallery, surrounded by over two dozen of her paintings and scores of

people. Friends, faculty members, administrators, students, and people from the community and Philadelphia clustered around her to pay long overdue tribute. She had invited Alice to come to Chestnut Hill to stay with her for the opening, as she had attended Alice's the year before, but Alice's schedule, or perhaps her preference for not being a supporting player to Rhoda, would not permit her to come.

The gallery was one large, high-ceilinged rectangular room, modern with floor-to-ceiling windows letting in the northern light. Occasionally, Rhoda led groups or individuals along the walls where her paintings from fifty years before were hung—the largest canvas of Skinny, the others of neighbors at Washington Square, street kids, artists, the shy young black girl, her friends, male and female. Interspersed were canvases of her cityscapes, the fish market, the square in full bloom, Manayunk, and her landscapes, including her hurried cornfield.

Rhoda did few things gracefully, but she still looked very much within her milieu as she turned away offers to purchase, responded to questions, listened attentively to Philadelphia gallery owners who wanted to display her works, while at the same time trying to overhear every conversation in the room about her paintings. She was not used to being the center of attention, and she did not want to miss any of it. This was her day, her Warholian piece of fame.

Finally, validation. "I was good at what I did." Regret may still have lurked beneath her smiling face, but it had been pushed down deeper and covered with a long-overdue feeling of satisfaction. Rhoda had once been an artist, and she was being celebrated again as an artist. As it was for Alice, late in life Rhoda was presented a gift, a precious occasion to reassess who she really was and what was important in life.

Rhoda decided that it was time to take out her paint box, fill it with tubes of oils, and rummage through the upstairs closet to find her old easel.

TOO MUCH

EXPERIENCE

Epilogue.

W h e n Alice Neel died in October 1984, Americans mourned the passing, but celebrated the life of one of America's most important artists. She was given lengthy obituaries. She deserved them. She deserved to have Judith Higgins in *ARTnews* cite her special genius as delivering up the innermost lives of the people she painted. She deserved to have William Blair of the *New York Times* call her portraits unconventional and intense. Alice was remembered by the same variety of eulogists—Andy Warhol, Allen Ginsberg, and Mayor Edward Koch—who had populated her life and her canvases.

During the ten years between her Whitney Show and her death, Alice continued painting the characters of the world, but also its celebrities, included among them a nude of herself, in her eighty-first year. But she pushed further. At great personal expense, she arranged to have a one-woman show of her work in Moscow. Aided by her longtime friend and comrade, the writer Phillip Bonosky, who wrote the catalog copy for the exhibition, she realized a long-cherished goal to have her works shown in the Soviet Union. As usual, she moved easily in diverse circles, so that she felt as comfortable in Moscow as she did appearing on the Johnny Carson show or as the guest of honor for a sit-down dinner for 139 people at Gracie Mansion, the official residence of the mayor of New York City.

Alice continued to paint every day until she was no longer physically

able. She probably would have said that what finally killed her was, appropriately, her greed for experiencing life to its fullest. She once said that life consists of getting as much experience as you can, until it kills you; "then," she said, "you've had too much." By the time experience finally caught up with her, Alice was almost eighty-five years old and completely comfortable with her place in the order of the universe. She died a painter.

When Rhoda Medary died in July 1981, few mourned her passing, few celebrated her life, few noticed. The Philadelphia newspapers fitted the announcement of her death into the alphabetized columns of tightly printed obituaries that mark the end of ordinary, unremarkable lives. In the scheme of the world, Rhoda deserved no more. An obit writer would have been hard-pressed to find for her enough of the events, the public artifacts, and the testimonials to validate the importance of her life. Rhoda departed this life as she had lived it—invisibly.

Oh, she once had an exhibition at a local college, years before, in 1975, but few remembered beyond a small group of professors, scattered alumnae, and longtime friends. She retained her job as manager of the art store until she could no longer work, but for the first time since Ben's death she began to entertain in her home and became more than a clerk in the minds of her acquaintances in the college community.

Rhoda enjoyed her local celebrity and felt gratified that three of the most important city galleries continued to show her works, although she still would not allow them to be put up for sale.

Most important, Rhoda resumed serious oil painting, with a brighter palette than in the 1920s, but with the same bold strokes that had initialed her canvases nearly a half century earlier. She also, like Alice, died an artist, content, having enjoyed her last years immensely.

Rhoda finally learned what Alice had discovered decades before, that painting was central to her identity as a woman, that art has the power to shape lives.

NOTES

Prologue

1. Jack Baur, director, Whitney Museum of American Art, interview with the authors, 13 January 1987 (hereafter cited as Baur, interview, 13 January 1987).
2. Baur, interview, 13 January 1987.
3. Alice Neel, interview with Terry Gross on "Fresh Air," National Public Radio, 22 October 1981 (hereafter cited as A.N., interview with Gross, 22 October 1981).

Chapter 1

1. Louise Kolb Hollingshead, classmate at the School of Design for Women, 1922–1925, interview with the authors, 4 March 1987 (hereafter cited as Hollingshead, interview, 4 March 1987).
2. Rhoda Medary, interview with the authors, 16 February 1977 (hereafter cited as R. M., interview, 16 February 1977).
3. R. M., interview, 16 February 1977.
4. Catherine Morris Wright, *Color of Life* (Houghton-Mifflin, 1957), p. 45 (hereafter cited as Wright). Catherine Wright was a student at the Philadelphia School of Design for Women during the period when Alice and Rhoda were students there.
5. *Design for Women: A History of the Moore College of Art* (Wynnewood, Pa.: Livingston Pub. Co., 1968), p. 54 (hereafter cited as *Design for Women*).
6. R. M., interview, 16 February 1977.
7. R. M., interview, 16 February 1977.
8. Rhoda Medary, *Memoirs*, #1, "Looking Back" (hereafter cited as R. M., *Memoirs*, #1).
9. Rhoda Medary, *Memoirs*, #2, "Early Youth—1923" (hereafter cited as R. M., *Memoirs*, #2).
10. R. M., *Memoirs*, #2.
11. Hollingshead, interview, 4 March 1987.
12. R. M., interview, 16 February 1977.
13. Alice Neel, in conversation with the authors, 31 March 1976 (hereafter cited as A. N., conversation, 31 March 1976).
14. R. M., interview, 16 February 1977.

15. A. N., conversation, 31 March 1976, and R. M., interview, 16 February 1977.
16. R. M., interview, 16 February 1977.
17. Rhoda Medary, *European Travel Journal*, 1923 (hereafter cited as R. M., *Journal*).
18. R. M., interview, 16 February 1977.
19. R. M., *Memoirs*, #2.
20. Alice Neel, from a lecture given at Bloomsburg State College, Pennsylvania, 21 March 1972 (hereafter cited as A. N., Bloomsburg lecture, 21 March 1972).
21. A. N., conversation, 31 March 1976.
22. Alice Neel cited in Cindy Nemser, *Art Talk: Conversations with Twelve Women Artists* (New York: Charles Scribner's Sons, 1975), p. 115 (hereafter cited as A. N. in Nemser).
23. R. M. interview, 16 February 1977.
24. R. M. interview, 16 February 1977.
25. Alice Neel cited in Rita Mercedes, "Alice Neel Talks with Rita Mercedes," *The Connoisseur*, September 1981, p. 2 (hereafter cited as A. N. in Mercedes).
26. A. N., Bloomsburg lecture, 21 March 1972.

Chapter 2

1. Alice Neel as quoted in Eleanor Munro, *Originals: American Women Artists* (New York: Simon and Schuster, 1979), p. 121 (hereafter cited as A. N. in Munro).
2. George Neel, Alice's nephew, interview with the authors, 18 July 1987 (hereafter cited as G.N., interview, 18 July 1987).
3. Alice Neel as interviewed by Lucia Flavia, *East Side Express*, 23 February 1978 (hereafter cited as Flavia, *East Side Express*).
4. Flavia, *East Side Express*.
5. A. N. in Munro, p. 122.
6. G. N., interview, 18 July 1987.
7. A. N. in Munro, p. 122.
8. Alice Neel cited in Patricia Hills, *Alice Neel* (New York: Harry N. Abrams, 1983), p. 12 (hereafter cited as A. N. in Hills).
9. A. N. in Nemser, p. 7.
10. A. N. cited in Judith Higgins, "Alice Neel and the Human Comedy," *ARTnews*, October 1984, p. 72 (hereafter cited as A. N. in Higgins).
11. A. N. in Higgins, p. 72.
12. A. N. in Munro, p. 121.
13. A. N. in Munro, pp. 121–23.
14. Munro, p. 121.

15. Alice Neel in John Gruen, "Collector of Souls," art column, *Herald Tribune*, 9 January 1966 (hereafter cited as A. N. in Gruen).
16. A. N. in Munro, p. 122.
17. A. N. in Munro, pp. 121–22.
18. A. N. in Nemser, p. 132.
19. Hills, p. 12.
20. A. N. in Hills, p. 12.
21. Alice Neel in Judith Higgins, "Alice Neel: 1900–1984" in "The Vasari Diary," *ARTnews*, December 1984, p. 14.
22. A. N. in Munro, p. 122.
23. Munro, p. 122.
24. A. N., Bloomsburg lecture, 21 March 1972.
25. Alice Neel, broadcast interview with Terry Gross, WHYY-FM, Philadelphia, 22 October 1981 (hereafter cited as A. N., interview with Gross).
26. A. N. interview with Gross.
27. Alice Neel cited in Patti Goldstein, "Soul on Canvas" *New York*, July 9–16, 1979, p. 78 (hereafter cited as A. N. in Goldstein).
28. Nancy Neel, Alice's daughter-in-law and assistant, interview with the authors, 20 January 1987 (hereafter cited as N. N. interview, 20 January 1987).
29. A. N. in Munro, p. 123.
30. A. N. in Munro, p. 122.
31. A. N. in Hills, title page.
32. A. N. in Hills, p. 13.
33. A. N. in Munro, p. 123.
34. Hills, p. 13.
35. Munro, p. 123.
36. A. N. in Hills, p. 13.
37. A. N. in Hills, p. 13.
38. *Design for Women*, p. 55.

Chapter 3

1. Rhoda Medary, *Memoirs*, #26, "Ocean City" (hereafter cited as R. M., *Memoirs*, #26).
2. R. M., *Memoirs*, #26.
3. R. M., *Memoirs*, #26.
4. Rhoda Medary, *Memoirs*, #37, "My Mother" (hereafter cited as R. M., *Memoirs*, #37).
5. R. M., *Memoirs*, #37.
6. Rhoda Medary, *Memoirs*, #13, "Fire—Ocean City" (hereafter cited as R. M., *Memoirs*, #13).

7. Rhoda Medary, *Memoirs*, #18, "Come Day, Go Day, God Bring Sunday" (hereafter cited as R. M., *Memoirs*, #18).
8. R. M., *Memoirs*, #37.
9. R. M., *Memoirs*, #26.
10. Rhoda Medary, *Memoirs*, #31, "Truth Is Stranger than Fiction" (hereafter cited as R. M., *Memoirs*, #31).
11. Rhoda Medary, *Memoirs*, #21, "Easter Sunday" (hereafter cited as R. M., *Memoirs*, #21).
12. R. M., *Memoirs*, #18.
13. Rhoda Medary, *Memoirs*, #24, "I Remember" (hereafter cited as R. M., *Memoirs*, #24).
14. R. M., *Memoirs*, #1.
15. R. M., *Memoirs*, #1.
16. R. M., *Memoirs*, #1.
17. Rhoda Medary, *Memoirs*, #15, "Remembering" (hereafter cited as R. M., *Memoirs*, #15).
18. R. M., *Memoirs*, #15.
19. Rhoda Medary, *Memoirs*, #39, "Jno Haddock Married Mary F." (hereafter cited as R. M., *Memoirs*, #39).
20. R. M., *Memoirs*, #1.
21. Rhoda Medary, *Memoirs*, #38, "Mrs. Lynn" (hereafter cited as R. M., *Memoirs*, #38).
22. R. M., *Memoirs*, #26.
23. R. M., interview, 16 February 1977.

Chapter 4

1. Wright, p. 48.
2. A. N. in Hills, p. 15.
3. Mrs. Dorothy Croneheim Lathrop, classmate at the School of Design, interview with the authors, 17 December 1986 (hereafter cited as Lathrop, interview, 17 December 1986).
4. *Design for Women*, p. 42.
5. A. N. in Hills, pp. 14–15.
6. *Design for Women*, p. 42.
7. R. M., interview, 16 February 1977.
8. *Pennsylvania School of Design for Women Catalog*, 1925–1926, p. 22.
9. *Pennsylvania School of Design for Women Catalog*, 1923–1924, p. 39.
10. A. N. in Munro, p. 123.
11. R. M., interview, 16 February 1977.
12. *Design for Women*, p. 44.
13. R. M., *Memoirs*, #2.
14. A. N. in Munro, p. 124.

15. A. N. in Hills, p. 15.
16. A. N. in Hills, p. 16.
17. Hollingshead, interview, 4 March 1987.
18. Hollingshead, interview, 4 March 1987.
19. Wright, p. 47.
20. R. M., *Journal*, 1923.
21. R. M., *Journal*, 1923.
22. R. M., *Memoirs*, #3, "Studio—1923" (hereafter cited as R. M., *Memoirs*, #3).
23. A. N. in Munro, p. 124.
24. A. N. in Munro, p. 124.
25. R. M., interview, 16 February 1977.
26. R. M., interview, 16 February 1977.
27. A. N. in Munro, p. 124.
28. N. N., interview, 20 January 1987.
29. A. N. in Munro, p. 124.
30. A. N. in Hills, p. 16.
31. A. N., article, "By Alice Neel," *Daily World*, 17 April 1971, p. M–7.
32. R. M., interview, 16 February 1977.
33. Lathrop, interview, 17 December 1986.
34. A. N. in Hills, pp. 16–17.
35. N. N., interview, 20 January 1987.

Chapter 5

1. A. N. in Munro, p. 125.
2. A. N. in Munro, pp. 124–25.
3. A. N. in Hills, p. 20.
4. A. N. in Higgins, p. 73.
5. A. N. in Nemser, p. 116.
6. A. N. in Hills, p. 20.
7. A. N. in Hills, p. 20.
8. A. N., interview with Gross, 22 October 1981.
9. A. N. in Hills, p. 21.
10. A. N. in Hills, p. 21.
11. A. N. in Munro, p. 125.

Chapter 6

1. Paulette Van Roekens, instructor at the School of Design for Women, interview with the authors, 8 October 1986 (hereafter cited as P. V. R., interview, 8 October 1986).

2. G. N., interview, 18 July 1987.
3. G. N., interview, 18 July 1987.
4. A. N. in Nemser, p. 116.
5. A. N. in Munro, p. 125.
6. A. N. in Hills, p. 21.
7. A. N. in Nemser, p. 117.
8. G. N., interview, 18 July 1987.
9. G. N., interview, 18 July 1987.
10. A. N. in Hills, p. 26.
11. A. N. in Goldstein, p. 78.
12. A. N. in Hills, p. 29.
13. A. N. in Munro, p. 125.
14. *Ft. Lauderdale Museum of Art Exhibition Catalog*, Ft. Lauderdale, Florida, February 1978 (hereafter cited as Ft. Lauderdale catalog).
15. A. N. in Hills, p. 41.
16. G. N., interview, 18 July 1987.
17. A. N. in Hills, p. 32.
18. A. N. in Hills, p. 29.
19. A. N. in Mercedes, p. 2.
20. A. N. in Goldstein, p. 78.
21. A. N. in Goldstein, p. 78.

Chapter 7

1. R. M., *Memoirs*, #2.
2. R. M., *Memoirs*, #3.
3. Charles and Christine Ashton, Ethel's nephew and his wife, interview with the authors, 18 February 1990 (hereafter cited as C. & C. Ashton, interview, 18 February 1990).
4. R. M., *Memoirs*, #1.
5. P. V. R., interview, 8 October 1986.
6. R. M., *Memoirs*, #1.
7. P. V. R., interview, 8 October 1986.
8. R. M., *Memoirs*, #2.
9. P. V. R., interview, 8 October 1986.
10. Lorine Myers, Rhoda's sister, interview with the authors, 10 August 1986 (hereafter cited as L. M., interview, 10 August 1986).
11. Rhoda Medary, *Memoirs*, #36, "Brother—Childhood" (hereafter cited as R. M., *Memoirs*, #36).
12. R. M., interview, 16 February 1977.
13. R. M., *Memoirs*, #2.
14. R. M., *Memoirs*, #1.

15. R. M., *Memoirs*, #7, "So I Married Ben, 1930" (hereafter cited as R. M., *Memoirs*, #7).
16. L. M., interview, 10 August 1986.
17. R. M., *Memoirs*, #1.
18. Rhoda Medary, *Memoirs*, #6, "The Depression—1929–1930" (hereafter cited as R. M., *Memoirs*, #6).

Chapter 8

1. R. M., interview, 16 February 1977.
2. R. M., interview, 16 February 1977.
3. R. M., interview, 16 February 1977.
4. A. N. in Hills, p. 32.
5. A. N. in Munro, p. 125.
6. Higgins, p. 73.
7. A. N. in Hills, p. 30.
8. Johnson, *Studio International 193*, p. 175.
9. Johnson, *Studio International 193*, p. 178, calls the bold, full-length studies of naked people—not traditional nudes—a "genre" that Alice created.
10. A. N. in Munro, p. 125.
11. R. M., interview, 16 February 1977.
12. A. N. in Cindy Nemser, "Art: Alice Neel: Portraits of Four Decades," *Ms.*, October 1973, p. 49 (hereafter cited as Nemser, *Ms.*).
13. A. N. in Munro, p. 125.

Chapter 9

1. A. N. in Hills, p. 33.
2. A. N. in Munro, p. 125.
3. A. N. in Hills, p. 32.
4. A. N. in Hills, p. 35.
5. A. N. in Hills, p. 36.
6. A. N. in Munro, p. 127.
7. A. N. in Munro, p. 127.
8. Mercedes, *The Connoisseur*, p. 3.
9. G. N., interview, 18 July 1987.
10. G. N., interview, 18 July 1987.
11. G. N., interview, 18 July 1987.
12. A. N. in Munro, p. 125.
13. A. N., interview with Gross, 22 October 1981.
14. A. N. in Hills, p. 33.

15. A. N. in Nemser, p. 125.
16. Mercedes, p. 3.
17. A. N. in Munro, p. 125.
18. A. N. in Hills, p. 33.
19. A. N. in Hills, p. 32.
20. A. N. in Hills, p. 35.
21. G. N., interview, 18 July 1987.
22. A. N. in Nemser, p. 119.
23. A. N. in Munro, p. 126.
24. A. N. in Hills, p. 35.
25. A. N. in Munro, p. 126.
26. A. N. in Munro, p. 126.
27. A. N. in Hills, p. 36.
28. A. N. in Munro, p. 126.
29. A. N. in Hills, p. 38.
30. A. N. in Munro, p. 126.
31. A. N. in Munro, pp. 126–27.
32. A. N. in Hills, p. 38.
33. A. N. in Hills, p. 39.

Chapter 10

1. Rhoda Medary, *Memoirs*, #35, "Ben's Mother" (hereafter cited as R. M., *Memoirs*, #35).
2. R. M., interview, 16 February 1977.
3. R. M., *Memoirs*, # 36.
4. L. M., interview, 10 August 1986.
5. R. M., *Memoirs*, #36.
6. R. M., *Memoirs*, #7.
7. R. M., *Memoirs*, #7.
8. R. M., interview, 16 February 1977.
9. R. M., interview, 16 February 1977.
10. Joan Schmidt, faculty member at Beaver College, interview with the authors, 10 November 1987.
11. R. M., *Memoirs*, #6.
12. R. M., *Memoirs*, #3.
13. R. M., *Memoirs*, #1.
14. R. M., *Memoirs*, #1.
15. P. V. R., interview, 8 October 1986.
16. R. M., *Memoirs*, #6.
17. R. M., *Memoirs*, #6.
18. L. M., interview, 10 August 1986.
19. R. M., *Memoirs*, #36.

20. R. M., interview, 16 February 1977.
21. Rhoda Medary, *Memoirs*, #42, "My Daughter" (hereafter cited as R. M., *Memoirs*, #42).
22. R. M. interview, 16 February 1977.
23. A. N. in Hills, p. 41.
24. A. N., talk at Philadelphia Free Library, 16 October 1983.
25. A. N. in Hills, p. 41.
26. A. N. in Hills, p. 44.
27. A. N. in Munro, p. 127.
28. Jerry Tallmer, "Tornado with Paint to Burn," *New York Post*, 4 November 1978, p. 16 (hereafter cited as Tallmer).
29. Judith Higgins, *ARTnews*, October 1984, p. 73.
30. Caroline F. Ware, *Greenwich Village: 1920–1930*, (Boston: Houghton Mifflin Co., 1935), p. 235.
31. A. N., interview with Gross, 22 October 1981.
32. Solman, interview, 13 January 1987.
33. A. N. in Nemser, p. 123.
34. Solman, interview, 13 January 1987.
35. Solman, interview, 13 January 1987.
36. Solman, interview, 13 January 1987.
37. Ft. Lauderdale catalog, n.p.
38. Solman, interview, 13 January 1987.
39. A. N., talk at the Philadelphia Free Library, 16 October 1983.
40. A. N. in Higgins, p. 74.
41. A. N. in the Ft. Lauderdale catalog, n.p.
42. A. N. in Tallmer, p. 16.
43. G. N., interview, 18 July 1987.
44. A. N. in Hills, p. 53.
45. A. N. in Hills, p. 56.
46. A. N. in Munro, p. 128.

Chapter 11

1. A. N. in Nemser, p. 121.
2. Audrey McMahon, "A General View of the W.P.A. Federal Art Project in New York," pp. 51–76, in Frances O'Connor, *The New Deal Art Project* (Washington, D.C.: Smithsonian Institution Press, 1972), p. 55 (hereafter cited as McMahon in O'Connor).
3. A. N. in Munro, p. 127.
4. A. N. in Nemser, p. 122.
5. Marlene Park and Gerald E. Markowitz, *New Deal for Art* (Hamilton, N.Y.: Gallery Association of New York, 1977), pp. 4, 20 (hereafter cited as Park and Markowitz).

6. A. N. in Hills, p. 57.
7. A. N. in Nemser, p. 123.
8. Solman, interview, 13 January 1987.
9. Archives of American Art, Washington, D.C., General Services Administration, W.P.A. Transcript of Employment.
10. McMahon in O'Connor, p. 55.
11. Joe Solman, "The Easel Division of the W.P.A. Federal Art Project," in O'Connor, *The New Deal Art Projects*, p. 118 (hereafter cited as Solman in O'Connor).
12. Park and Markowitz, p. 17.
13. Solman in O'Connor, p. 117.
14. Ann Sutherland Harris and Linda Nochlin, *Women Artists: 1550–1950* (New York: Alfred A. Knopf, 1976), p. 323.
15. A. N. in Hills, p. 64.
16. Park and Markowitz, p. 80.
17. Solman, interview, 13 January 1987.
18. Solman in O'Connor, p. 119.
19. Solman, interview, 13 January 1987.
20. "New Exhibitions of the Week," *ARTnews*, vol. 36, 14 May 1938, p. 20.
21. Herman Baron, "The A.C.A. Gallery: Impressions and Recollections," in *Thirty-One American Contemporary Artists* (New York: A.C.A. Gallery Publishers, 1959), n.p.
22. Solman, interview, 13 January 1987.
23. A. N. in Hills, p. 77.
24. A. N., as quoted in Lynn F. Miller and Sally S. Swenson, *Lives and Works: Talks with Women Artists* (Metuchen N.J.: Scarecrow Press, 1981), p. 125.
25. Joe Solman, interview with the authors, 9 September 1989.
26. A. N. in Munro, p. 128.
27. Hananiah Harari, artist, letter to the authors, 18 August 1989.
28. A. N. in Nemser, p. 123.
29. A. N., as told to the *Harvard Crimson*, 5 April 1979, p. 10.
30. Higgins, p. 74.
31. A. N., interview with Gross, 22 October 1981.
32. A. N. in Nemser, p. 124.
33. Archives of American Art, General Services Administration, W.P.A. Transcript of Employment for Alice Neel.
34. A. N. in Hills, p. 66.
35. A. N. in Nemser, p. 124.
36. A. N. in Nemser, *Ms.*, p. 50.
37. A. N. in Hills, p. 77.
38. A. N. in Ted Castle, "Alice Neel" in *Art Forum*, 1983, p. 38.
39. Archives of American Art, General Services Administration, W.P.A. Transcript of Employment for Alice Neel.

Chapter 12

1. R. M., interview, 16 February 1977.
2. R. M., *Memoirs*, #8, "1947" (hereafter cited as R. M., *Memoirs*, #8).
3. R. M., interview, 16 February 1977.
4. R. M., interview, 16 February 1977.
5. R. M., interview, 16 February 1977.
6. R. M., *Memoirs*, #40, "My Son" (hereafter cited as R. M., *Memoirs*, #40).
7. R. M., *Memoirs*, #40.
8. R. M., *Memoirs*, #42.
9. R. M., *Memoirs*, #1.
10. Bob and Betty Imhoff, interview with the authors, 27 September 1986 (hereafter cited as Imhoff, interview, 27 September 1986).
11. R. M., *Memoirs*, #29, "The Barn Party" (hereafter cited as R. M., *Memoirs*, #29).
12. R. M., *Memoirs*, #44, "Ollie, Virginia" (hereafter cited as R. M., *Memoirs*, #44).
13. R. M., *Memoirs*, #42.
14. R. M., *Memoirs*, #1.
15. R. M., *Memoirs*, #44.
16. R. M., *Memoirs*, #41, "Florida" (hereafter cited as R. M., *Memoirs*, #41).
17. Imhoff, interview, 27 September 1986.
18. Imhoff, interview, 27 September 1986.
19. R. M., *Memoirs*, #44.
20. Imhoff, interview, 27 September 1986.
21. R. M., *Memoirs*, #41.
22. R. M., *Memoirs*, #7.
23. R. M., *Memoirs*, #8.
24. R. M., *Memoirs*, #8.
25. R. M., *Memoirs*, #27, "Louisiana" (hereafter cited as R. M., *Memoirs*, #27).
26. R. M., *Memoirs*, #27.
27. R. M., *Memoirs*, #27.
28. R. M., *Memoirs*, #30, "Our Stay in Arizona, 1943" (hereafter cited as R. M., *Memoirs*, #30).
29. R. M., *Memoirs*, #30.
30. R. M., *Memoirs*, #8.
31. R. M., *Memoirs*, #8.
32. R. M., *Memoirs*, #30.
33. R. M., *Memoirs*, #30.
34. Imhoff, interview, 27 September 1986.

35. R. M., *Memoirs*, #27.
36. R. M., *Memoirs*, #30.

Chapter 13

1. Solman, interview, 13 January 1987.
2. A. N., interview with Gross, 22 October 1981.
3. "The Passing Shows," *ARTnews*, March 1944, p. 20.
4. A. N. in Hills, p. 80.
5. A. N., "I Paint Tragedy and Joy" in "The Art of Portraiture, in the Words of the Artists" *New York Times*, 31 October 1976, art column (hereafter cited as A. N. in *New York Times*, 31 October 1976).
6. A. N., interview with Carolyn Keith, "Alice Neel: Portraits of Souls," in *Cityside*, 23 October 1978, p. 7 (hereafter cited as A. N. in Keith).
7. A. N. in *New York Times*, 31 October 1976.
8. A. N. in Miller and Swenson, p. 125.
9. A. N. in *New York Times*, 31 October 1976.
10. A. N., interview with Gross, 22 October 1981.
11. A. N. in David Berliner, "Women Artists Today," *Cosmopolitan*, October 1973, p. 218.
12. A. N. in Keith, p. 6.
13. A. N. in Ann Sutherland Harris, "The Human Creature," *Portfolio*, December 1979–January 1980, p. 72.
14. A. N. in Patricia Foote, "Neel Has Feel for What's Real," *Seattle Times*, 18 October 1979, p. C10.
15. A. N. in Marietta Dunn, "Coming of Age in Art and Life," *Kansas City Star*, 15 October 1978, p. 8K.
16. A. N., interview as reported in "Alice Neel, Dispassionate Collector of Souls," *Cleveland Plain Dealer*, 24 December 1978, p. D1.
17. Abram Lerner, former assistant director, A.C.A. Gallery, letter to the authors, 19 December 1986.
18. Lerner, letter, 19 December 1986.
19. "Alice Neel" in *Art Digest*, 1 January 1951, p. 17.
20. Stanton Catlin, "Alice Neel," *ARTnews*, January 1951, p. 49.
21. Phillip Bonosky, interview with the authors 8 September 1989 (hereafter cited as Bonosky, interview, 8 September 1989).
22. Bonosky, interview, 8 September 1989.
23. Archives of American Art, Washington D.C., Mike Gold, from the Foreword of the catalog of her exhibition at the New Playwrights Theatre, 23 April 1951, n.p.
24. Bonosky, interview, 8 September 1989.
25. Solman, interview, 9 September 1989.
26. Joel Rothschild, John Rothschild's son and friend of Alice, interview with the authors, 8 September 1989.

27. John Rothschild, art dealer, no relation to Alice, telephone conversation with the authors, 23 August 1989.
28. Rothschild, interview, 8 September 1989.
29. Rothschild, interview, 8 September 1989.
30. Rothschild, interview, 8 September 1989.
31. Rothschild, interview, 8 September 1989.
32. Rothschild, interview, 8 September 1989.
33. Ellen Johnson, "Alice Neel: Fifty Years of Portrait Painting," *Studio International 193*, March 1977, p. 175.
34. Rothschild, interview, 8 September 1989.
35. A. N. in the Fort Lauderdale catalog, n.p.
36. A. N. in Keith, p. 6.
37. Rothschild, interview, 8 September 1989.
38. Bonosky, interview, 8 September 1989.
39. Rothschild, interview, 8 September 1989.
40. Bonosky, interview, 8 September 1989.
41. Bonosky, interview, 8 September 1989.
42. J. K. Roberts, professor of history, University of Regina, friend of Alice's in 1950s, conversation with the authors, 5 March 1990.
43. J. K. Roberts, letter to the authors, 13 March 1990.
44. Bonosky, interview, 8 September 1989.
45. Rothschild, interview, 8 September 1989.
46. Rothschild, interview, 8 September 1989.
47. Higgins, p. 77.
48. "Alice Neel, 1900–1984" in *Asbury Park Press*, 13 January 1985, Arts and Leisure Section.
49. Higgins, *ARTnews*, p. 77.
50. A. N. in Ted Castle, "Alice Neel" in *Art Forum*, 1983, p. 37.
51. A. N. in Hills, p. 189.
52. A. N. in Hills, p. 103.
53. A. N. in Hills, p. 103.
54. A. N. in Higgins, p. 75.
55. A. N. in Hills, p. 100.
56. A. N. in Higgins, p. 77.
57. Hubert Crehan, "Introducing the Portraits of Alice Neel," *ARTnews*, October 1962, p. 45.
58. A. N. in Higgins, p. 77.
59. A. N. in Nemser, p. 130.

Chapter 14

1. R. M., *Memoirs*, #7.
2. R. M., *Memoirs*, #8.

3. Imhoff, interview, 27 September 1986.
4. L. M., interview, 10 August 1986.
5. R. M., Memoirs, #8.
6. R. M., *Memoirs*, #8.
7. Imhoff, interview, 27 September 1986.
8. R. M., *Memoirs*, #8.
9. R. M., *Memoirs*, #8.
10. R. M., *Memoirs*, #7.
11. R. M., *Memoirs*, #7.
12. Mrs. Walter Allen, friend and neighbor of Rhoda's, interview with the authors, 24 July 1986 (hereafter cited as Allen, interview, 24 July 1986).
13. L. M., interview, 10 August 1986.
14. Allen, interview, 24 July 1986.
15. Allen, interview, 24 July 1986.
16. L. M., interview, 10 August 1986.
17. Imhoff, interview, 27 September 1986.
18. Bette Landman, interview, 11 June 1986.
19. Imhoff, interview, 27 September 1986.
20. Allen, interview, 24 July 1986.

Chapter 15

1. Nemser, *Art Talk*, p. 130.
2. Harris, *Portfolio*, p. 75.
3. Solman, interview, 9 September 1989.
4. Stephan Salisbury, "Alice Neel" in Art Column, *Philadelphia Enquirer*, Sunday, 4 March 1984.
5. A. N. in "Talking about Portraits," *The Feminist Art Journal*, Summer 1974, p. 15.
6. Nemser, *Art Talk*, p. 128.
7. Ft. Lauderdale catalog, n.p.
8. A. N. in Ruby Scott, "Time's Cover: Everything Shows in the Face," *Bermuda Mid-Ocean News*, 12 September 1970, p. 5 (hereafter cited as Scott).
9. Bonosky, interview, 8 September 1989.
10. A. N. in Scott, p. 6.
11. A. N. in Miller and Swenson, p. 129.
12. A. N., interview with Gross, 22 October 1981.
13. Jack Kroll, "Curator of Souls," *Newsweek*, 31 January 1966, p. 82 (hereafter cited as Kroll).
14. Kroll, p. 82.
15. Hilton Kramer, "Alice Neel," *New York Times*, Art Column, 20 January 1968.

16. Franz Schulze, "Three Artists Defy Trend," *Chicago Sun-Times*, 15 October 1970, p. B4.
17. A. N. in Scott, p. 6.
18. Baur, interview, 13 January 1987.
19. Baur, interview, 13 January 1987.
20. A. N. in Scott, p. 5.
21. Scott, p. 5.
22. A. N., in letter to *Daily World*, 2 February 1971, p. 8.
23. A. N., as excerpted from her doctoral address, Moore College of Art, Philadelphia, Pennsylvania, 1 June 1971.

Chapter 16

1. Imhoff, interview, 27 September 1986.
2. Allen, interview, 24 July 1986.
3. Imhoff, interview, 27 September 1986.
4. Landman, interview, 11 June 1986.
5. Holly Medary, granddaughter, interview with the authors, 28 July 1989.
6. Allen, interview, 24 July 1986.
7. Allen, interview, 24 July 1986.
8. June Donovan, Rhoda's niece, interview with the authors, 30 August 1989.
9. L. M., interview, 10 August 1986.
10. R. M., interview, 16 February 1977.
11. C. and C. Ashton, interview, 18 February 1990.
12. P. V. R., interview, 8 October 1986.
13. R. M., interview, 16 February 1977.
14. Landman, interview, 11 June 1986.
15. Marcie Wolk, friend of Rhoda's, interview with the authors, 3 June 1986.
16. R. M., *Memoirs*, #1.
17. N. N., interview, 20 January 1987.
18. N. N., interview, 20 January 1987.

Chapter 17

1. Baur, interview, 13 January 1987.
2. Baur, interview, 13 January 1987.
3. Corinne Robins, *The Pluralist Era: American Art 1968–1981* (New York: Harper and Row, 1984), pp. 56–58.
4. Pat Mainardi, Review in *Art in America*, 4 May 1974, p. 107.
5. N. N., interview, 4 February 1990.
6. A. N. interview with Gross, 22 October 1981.
7. N. N., interview, 20 January 1987.

BIBLIOGRAPHY

General Materials

"Alice Neel." *Art Digest,* 1 January 1951, vol. 25, no. 7, p. 17.

"Alice Neel, Dispassionate Collector of Souls." *Cleveland Plain Dealer,* 24 December 1978.

"Art and Women's Liberation." *Daily World,* 17 April 1971.

Baron, Herman. "The A.C.A. Gallery: Impressions and Recollections," *Thirty-One American Contemporary Artists.* New York: A.C.A. Gallery Publishers, 1959, n.p.

Bass, Ruth. "New York Reviews: Alice Neel." *ARTnews,* January 1981, vol. 8, p. 167.

Berliner, David. "Women Artists Today." *Cosmopolitan,* October 1973, p. 218.

Bonosky, Phillip. "Social Comment of Alice Neel." *Daily World,* 30 October, 1970, p. 8.

Bosworth, Patricia. *Diane Arbus: A Biography.* New York: Alfred A. Knopf, 1984, pp. 141–44.

Brand, Jonathan. "Art Mailbag: Puting Down Pearlstein—and Kramer." Letter to the editor, *New York Times,* 29 June 1969.

Burstein, Patricia. "Arts." *People,* 19 March 1989, vol. 11, no. 11, pp. 63–64.

Castle, Ted. "Alice Neel." *Art Forum,* 1983, vol. 22, no. 2, pp. 36–41.

Catlin, Stanton. "Alice Neel." *ARTnews,* January 1951, vol. 49, no. 9, p. 49.

Cochrane, Diane. "Alice Neel: Collector of Souls." *American Artist,* September 1973, vol. 37, no. 374, pp. 32–37.

Crehan, Hubert. "A Different Breed of Portraitist." *San Francisco Sunday Examiner and Chronicle,* 7 March 1971.

Crehan, Hubert. "Introducing the Portraits of Alice Neel." *ARTnews,* October 1962, vol. 61, no. 6, pp. 44–46.

Design for Women: A History of the Moore College of Art. Wynnewood, Pa.: Livingston Pub. Co., 1968.

Donohoe, Victoria. "The Art Scene: Homecoming. "Collector of Souls Displays Portraits at Moore." *Philadelphia Inquirer,* 24 January 1971, p. 8.

Dunn, Marietta. "Coming of Age in Art and Life." *Kansas City Star,* 15 October 1978.

Fine, Elsa Honig. "Women and Art." In *Women's Studies and the Arts,* E. Honig Fine, Lola B. Gellman, and Judy Loeb, eds. Women's Caucus for Art, 1978, p. 21.

Flavia, Lucia. "Expressions." *East Side Express*, 23 February 1978.

Foote, Patricia. "Neel Has Feel for What's Real." *Seattle Times*, 18 October 1979.

Forman, Nessa. "Art: Lady in the Light, Masks Off, Souls Bared on Canvas." *Sunday Bulletin* (Philadelphia), 24 January 1971, section 2.

Fort Lauderdale Museum of Art Exhibition Catalog, 8–26 February 1978. Fort Lauderdale, Florida.

Georgia Museum of Art. *Alice Neel: The Woman and Her Work*. Athens: Georgia Museum of Art, 1975.

Goldstein, Patti. "Soul on Canvas." *New York*, 9–16 July 1979, pp. 76–79.

Gross, Terry. "Interview with Alice Neel." Broadcast tape, WHYY-FM Philadelphia, Pa., 3 March 1983.

Gruen, John. "Collector of Souls." In Art Column, *Herald Tribune* (New York), 9 January 1966.

Harris, Ann Sutherland. "A Note on Alice's Greatness." *ARTnews*, November 1977, p. 113.

Harris, Ann Sutherland. "The Human Creature," *Portfolio* (December 1979- January 1980) pp. 70–75.

Harris, Ann Sutherland, and Linda Nochlin. *Women Artists: 1550–1950*. New York: Alfred Knopf, 1976.

Hess, Thomas B. "Sitting Prettier," *New York*, 23 February 1976, pp. 62–3.

Hess, Thomas, and Elizabeth Baker, eds. *Art and Sexual Politics*. New York: Macmillan, 1971.

Higgins, Judith. "Alice Neel and the Human Comedy," *ARTnews*, October 1984, vol. 83, no. 8, pp. 70–79.

Higgins, Judith. "Alice Neel: 1900–1984" in "The Vasari Diary." *ARTnews*, December 1984, vol. 83, no. 10, p. 14.

Hills, Patricia. *Alice Neel*. New York: Harry N. Abrams, 1983.

Johnson, Ellen H. "Alice Neel: Fifty Years of Portrait Painting." *Studio International 193*, March 1977, pp. 174–79.

Kantrowitz, Andrea. "What Is to Be Done? Alice Neel: The Empathetic Eye." *The Harvard Crimson Arts Weekly*, 5 April 1979.

Keith, Carolyn. "Alice Neel: Portraits of Souls." *Cityside* (Milwaukee, Wis.), 23 October 1978.

Kramer, Hilton. "Alice Neel." *New York Times*, 20 January 1968.

Kroll, Jack. "Curator of Souls." Review of Second Exhibition at Graham Gallery, *Newsweek*, 31 January 1966, p. 82.

Leone, Vivien. "The Story of a Portrait." In *Chelsea 48: Traveling East and Elsewhere*, 1989, pp. 76–86.

"M.B. Medary Dies, Noted Architect." *Philadelphia Inquirer*, 8 August 1929, pp. 1 and 2.

Mainardi, Patricia. "Alice Neel at the Whitney Museum." *Art In America*, 4 May 1974, pp. 107–8.

Mainardi, Patricia, ed. "Talking about Portraits." *Feminist Art Journal*, Summer 1974, pp. 13–16.

McMahon, Audrey. "A General View of the W.P.A. Federal Art Project in N.Y.C. and State." In O'Connor, Francis V., ed., *The New Deal Art Project: An Anthology of Memoirs.* Washington, D.C.: Smithsonian Institution Press, 1972, pp. 51–76.

Medary, Rhoda. *European Travel Journal*, 24 July 1923–6, November 1923 (unpublished).

Medary, Rhoda. *Memoirs* (unpublished). See separate listing.

Mercedes, Rita. "Alice Neel Talks to Rita Mercedes." *The Connoisseur*, September 1981, vol. 208, no. 835, pp. 1–3.

Miller, Daniel. "Interview with Alice Neel." Broadcast tape from *Fresh Air*, WWHY-FM Philadelphia, Pa. 10/22/81.

Miller, Lynn F. and Sally S. Swenson. *Lives and Works: Talks with Women Artists.* Metuchen, N.J.: Scarecrow Press, 1981.

Mueller, Roxanne T. "Alice Neel on Canvas." *Fort Wayne News Sentinel*, 26 October 1979.

Munro, Eleanor. *Originals: American Women Artists.* New York: Simon and Schuster, 1979.

Neel, Alice. "By Alice Neel." *Daily World*, 17 April 1971, p. M-7.

Neel, Alice. "Alice Neel." From her journal, reprinted in the *Museum of Art Exhibition Catalog*. Fort Wayne, Ind., 1979.

Neel, Alice. "A Statement." *The Hasty Papers: A One Shot Review.* Alfred Leslie, ed. New York: Alfred Leslie, 1960.

Neel, Alice. *Doctoral Address.* Moore College of Art, Philadelphia, Pa., 1 June 1971. Archives of American Art, Washington D.C.

Neel, Alice. "Talking about Portraits." *Feminist Art Journal*, Summer 1974, vol. 3, no. 2, pp. 13–17.

Neel, Alice. "I Paint Tragedy and Joy" in "The Art of Portraiture, in the Words of the Artists." *New York Times*, 31 October 1976.

Neel, Alice. Lecture given at Bloomsburg State College, Pa., 21 March 1972. Archives of American Art, Washington DC.

Neel, Alice. "Letter from Alice Neel." *Daily World*, 2 February 1971.

Neel, Alice. Letter to Floyd Amsden (27 July 1976). Archives of American Art, Smithsonian Institution, Washington, D.C.

Neel, Alice. Speech given at the Philadelphia Free Library, Pa., 16 October 1983.

Nemser, Cindy. "Alice Neel: Portraits of Four Decades." *Ms.*, October 1973, vol. 11, no. 4, pp. 48–53.

Nemser, Cindy. *Art Talk: Conversations with Twelve Women Artists.* New York: Charles Scribner's Sons, 1975.

New Playwrights Theater, The. "Alice Neel." *The New Playwrights Theater Exhibition Catalog.* New York, 23 April–23 May 1951.

Noble, Patricia. Letter to Alice Neel (28 October 1976). Archives of American Art, Smithsonian Institution, Washington, D.C.

Nochlin, Linda. "Some Women Realists: Painters of the Figure." *Arts Magazine*, May 1974, pp. 29–33.

O'Connor, Francis V., ed. *The New Deal Art Projects: An Anthology of Memoirs.* Washington D.C.: Smithsonian Institution Press, 1972.

Park, Marlene, and Gerald E. Markowitz. *New Deal for Art: The Government Art Projects of the 1930s with Examples from New York City and State.* Hamilton, New York: Gallery Association of New York, 1977.

"The Passing Shows." *ARTnews*, March 1944, vol. 43, no. 3, p. 20.

Pennsylvania School of Design for Women. *Catalog 1923–1924.* Philadelphia, Pa., 1924.

Pennsylvania School of Design for Women. *Catalog 1925–1926* Philadelphia, Pa., 1926.

Price, Aimee Brown. "Artist's Dialogue: A Conversation with Alice Neel." *Art Digest*, 1982, vol. 39, no. 8, pp. 136–42.

"Reed to Feature Two N.Y. Artists." *Oregonian*, 13 January 1962.

Robins, Corinne. *The Pluralist Era: American Art 1968–1981.* New York: Harper and Row, 1984.

Rubenstein, Charlotte Streifer. *American Women Artists: From Early Indian Times to the Present.* Boston: G. K. Hall and Co., 1982.

Salisbury, Stephan. "Alice Neel." In the Art Column, *Philadelphia Inquirer*, 4 March 1984.

Salisbury, Stephan. "Alice Neel, 84, Whose Fame as a Painter Came Late in Life." Obituary, *Philadelphia Inquirer*, 16 October 1984, p. 10-C.

Schultze, Franz. "Art: Three Artists Defy Trend." *Sunday Sun-Times* (Chicago), 15 October 1970.

Scott, Ruby. "Time's Cover: Everything Shows in the Face." *Bermuda Mid-Ocean News*, 12 September 1970, p. 5.

Shannon, David A. *Between the Wars: America 1919–1941*, 2d ed. Boston: Houghton Mifflin and Co., 1979.

Shields, Art. "Book Review: New Volume Examines Class Struggle in U.S." *Daily World*, 7 June 1979.

Smith, Roberta. "Art: Alice Neel Show." *New York Times*, 19 December 1986.

Tallmer, Jerry. "Tornado with Paint to Burn." *New York Post*, 4 November 1978.

Trevithick, Claudia. "Alice Neel—Born Feminist." *Midwest Art*, March 1975, vol. 2, no. 1, p. 2.

Trexler, Connie. "The Hard and Easy Truths of Alice Neel: Collector of Souls and Painter of People." In Week Ender Section, *News-Sentinel* (Fort Wayne, Ind.), 8 September 1979.

"The Vasari Diary: The Mayor Wouldn't Pose Nude." *ARTnews*, January 1982, vol. 81, pp. 15–16.

Ware, Caroline F. *Greenwich Village: 1920–1930*. Boston: Houghton Mifflin, 1935.

Willard, Charlotte. "In the Art Galleries." *New York Post*, 16 January 1966.

Willard, Charlotte. "In the Art Galleries: New Faces." *New York Post*, 27 January 1968.

W.P.A. Transcript of Employment for Alice Neel, General Services Administration: 1935–1942.

Wright, Catherine Morris. *Color of Life*. Boston: Houghton-Mifflin, 1957.

Personal Interviews

Allen, Mrs. Walter (neighbor of the Medarys, 1950–1981). Chestnut Hill, Pennsylvania, 24 July 1986.

Ashton, Charles and Christine (nephew of Ethel Ashon and his wife). Wilmington, Delaware, 18 February 1990.

Baur, John I. H. (director of the Whitney at the time of Alice Neel's Retrospective). New York, New York, 13 January 1987.

Bonosky, Phillip (writer and editor of *Daily World* and close friend of Alice Neel's). Washington Heights, New York, 8 September 1989.

Donovan, June (niece of Rhoda Medary). Glenside, Pennsylvania, 30 August 1989.

Hollingshead, Mrs. Louise Kolb (artist and classmate of Alice Neel and Rhoda Medary, 1922–1925). Abington, Pennsylvania, 4 March 1989.

Imhoff, Betty and Bob (friends of Rhoda Medary). Rural, Pennsylvania, 27 September 1986.

Imhoff, Christopher (artist and longtime friend of the Medarys). 8 and 20 August 1989 (by telephone).

Landman, Dr. Bette (professor of sociology and friend of Rhoda Medary). Glenside, Pennsylvania, 11 June 1986.

Lathrop, Mrs. Dorothy Cronehem (classmate of Alice Neel's). 17 December 1986 (by telephone).

Lerner, Abram (former assistant director of the A.C.A. Gallery). 19 December 1986 (by letter).

Medary, Holly (granddaughter of Rhoda). Chestnut Hill, Pennsylvania. 28 July 1989 and 21 January 1990.

Medary, Rhoda (artist and manager of Beaver College art store). Chestnut Hill, Pennsylvania, 16 February 1977.

Myers, Lorine (sister of Rhoda). Coast of Maine, 10 August 1986.

Neel, George (nephew of Alice Neel). Rural, Pennsylvania, 18 July 1987.

Neel, Nancy (daughter-in-law of Alice Neel and business manager). New York, New York, 20 January 1987 and, by telephone, February and March 1990.

Roberts, J. K. (professor at the University of Regina and friend of Alice in 1950s). 4 March 1990 (by telephone) and 13 March 1990 (by letter).

Rothschild, Dr. Joel (son of John Rothschild). New York, New York, 8 September 1989.

Rothschild, John (framer and friend of Alice Neel's). 23 August 1989 (by telephone).

Solman, Joseph (painter, printmaker, and friend of Alice Neel's). New York, New York, 13 January 1987 and 9 September 1989.

Van Roekens, Paulette (artist and teacher at the Philadelphia School of Design for Women during the period when both Alice Neel and Rhoda Medary were students there). Huntington Valley, Pennsylvania, 8 October 1986.

Wolk, Marcie (friend of Rhoda Medary's). Glenside, Pennsylvania, 3 June 1986.

Memoirs of Rhoda Medary

(consisting of forty-six separate documents, 1975–1979)
1. Looking Back
2. Early Youth—1923
3. Studio, 1923–1930
4. Our Wedding
5. Early Morning
6. The Depression—1929–1930
7. So I Married Ben, 1930
8. 1947
9. Two Letters to Nancy
10. Sunday Afternoon
11. The Dance Recital
12. Fire
13. Fire—Ocean City
14. My Three Young Friends
15. Remembering
16. Barber Shop
17. Spring, You're It
18. Come Day, Go Day, God Bring Sunday
19. The Shore
20. Trips to Grandfather's
21. Easter Sunday
22. The Nap
23. Doctors
24. I Remember
25. Spain, 1979
26. Ocean City

27. Louisiana
28. Power of Words
29. The Barn Party
30. Our Stay in Arizona, 1943
31. Truth Is Stranger than Fiction
32. The Cat
33. Uncle Fred Stadelman
34. My Oldest Sister
35. Ben's Mother
36. Brother—Childhood
37. My Mother
38. Mrs. Lynn
39. Jno Haddock Married Mary F.
40. My Son
41. Florida
42. My Daughter
43. Divorced
44. Ollie, Virginia
45. Paper Dolls
46. The Grandson

INDEX

ABOUT THE

AUTHORS

GERALD BELCHER is a historian. He received his bachelor's and master's degrees from the University of Michigan and his doctorate from the University of North Carolina at Chapel Hill. He has written in the areas of seventeenth and eighteenth century British history, and has coauthored two books on writing, but his primary interest is women's history, which he teaches at Beaver College in Glenside, Pennsylvania.

MARGARET BELCHER is an acquisitions editor for nursing trade and textbooks at Springhouse Corporation in Springhouse, Pennsylvania. She is a registered nurse, received her bachelor's degree from the University of Michigan, and has been a practicing critical care nurse and a clinical editor for nursing reference books.

This is their third collaboration on a major project in their twenty-seven years of marriage. The first project is now a professional juggler and performer. The second is a student at Beaver College.

The Belchers prepared to write this book together (while managing to stay married) when Margaret taught Gerald to ski and he taught her to play tennis. Their second book, a novel set in the 1940s, is in progress.